The Cosmopolitan Screen

THE COSMOPOLITAN SCREEN

German Cinema and the Global Imaginary,
1945 to the Present

STEPHAN K. SCHINDLER AND LUTZ KOEPNICK, EDITORS

THE UNIVERSITY OF MICHIGAN PRESS *Ann Arbor*

Copyright © by the University of Michigan 2007
All rights reserved
Published in the United States of America by
The University of Michigan Press
Manufactured in the United States of America
⊚ Printed on acid-free paper

2010 2009 2008 2007 4 3 2 1

A CIP catalog record for this book is available from the British Library.

Library of Congress Cataloging-in-Publication Data

The cosmopolitan screen : German cinema and the global imaginary, 1945
 to the present / edited by Stephan K. Schindler and Lutz Koepnick.
 p. cm. — (Social history, popular culture, and politics in
 Germany)
 Includes bibliographical references and index.
 ISBN-13: 978-0-472-09966-5 (cloth : alk. paper)
 ISBN-13: 978-0-472-06966-8 (pbk. : alk. paper)
 1. Motion pictures—Germany—History. I. Schindler, Stephan K.
II. Koepnick, Lutz P. (Lutz Peter)

PN1993.5.G3C673 2007
791.430943'09045—dc22 2006033987

ISBN-10: 0-472-09966-3 (cloth : alk. paper)
ISBN-10: 0-472-06966-7 (pbk. : alk. paper)

Contents

Acknowledgments

The idea for this anthology originated at the Sixteenth St. Louis Symposium on German Literature and Culture entitled "Between the Local and the Global: Revisiting the Sites of German Cinema," which was held in spring 2002 at Washington University in St. Louis. We would like to thank the conference participants and the contributors to this volume for the engaging reflections on German film. We are grateful for the institutional support we received for this project and would like to thank the Department of Germanic Languages and Literatures, the Sam Fox School of Design and Visual Arts, the International Activity Fund, and the College of Arts and Sciences at Washington University, in particular Edward Macias, Executive Vice Chancellor and Dean of Arts and Sciences. We also appreciate the generous funds we received from the Fritz Thyssen Stiftung and the Deutscher Akademischer Austauschdienst (DAAD).

We are indebted to Erika Rinker and Rick Strudell for their help in editing individual contributions during the early phases of this project. Peter Latta of the Filmmuseum Berlin—Stiftung Deutsche Kinemathek assisted in gathering most of the illustrations for this volume. Unless noted otherwise, all stills and images appear with the permission of the Filmmuseum Berlin—Stiftung Deutsche Kinemathek. Special thanks to Eileen G'Sell for assembling the index of this book. Last but not least, we would like to express our gratitude to Geoff Eley and to Jim Reische at the University of Michigan Press for their enthusiasm about, and open-minded support of, this volume.

Introduction

Against the Wall? The Global Imaginary of German Cinema

Stephan K. Schindler and Lutz Koepnick

> If you can't change the world, change your world.
> —*Gegen die Wand* (Head-On, 2004, dir. Fatih Akin)

I

German cinema always played a prominent role in the normative writing about national cinema as it occupied film studies until the early 1990s.[1] Generations of critics hailed expressionist cinema of the early Weimar period as German cinema at its most German, a curious blend of cultural sensibilities, iconographic traditions, and nineteenth-century philosophies of individual self-expression.[2] Weimar cinema, in this understanding, bundled diverse aesthetic meanings and practices into a homogenous stylistic language, its viability largely resting on the notion of culture as nationally particular and unified. Though the actual number of expressionist films may not have exceeded forty productions shot over a period of about five years, expressionist cinema exemplified not simply the most defining features of German cinema, but the essence of German culture and art as it encountered the traumas of modern life. In fact, so consistently did generations of critics read masterworks such as *Das Kabinett des Doktor Caligari* (The Cabinet of Dr. Caligari, 1920, dir. Robert Wiene) or *Nosferatu* (1922, dir. F. W. Murnau) as symptomatic expressions of the essence of German cinema circa 1920, that German expressionist cinema for these critics had the power to demonstrate the very concept of national cinema.

A similar, albeit at the same time intriguingly inverted perspective, has been brought to bear on the emergence and success of the New German Cinema in the 1970s. American critics in particular, in search

for innovative alternatives to Hollywood mainstream filmmaking, were quick to canonize the films of Rainer Werner Fassbinder, Werner Herzog, Volker Schlöndorff, Margarethe von Trotta, and Wim Wenders as part of a national cinema of aesthetic experimentation and political opposition. Expecting the films of German directors to address the most burning questions of postwar German history, namely the legacy of the Nazi dictatorship and the memory of the Holocaust, the American perspective on New German Cinema recognized strategies of national dissent and aesthetic disidentification as the core of what in the 1970s made German filmmaking German. Whereas expressionist cinema had once brought to light the deepest recesses of the German soul and its desperate struggles with the onset of social modernity, New German Cinema placed avant-garde sensibilities in the service of deflating the myths of modern German nationhood. It became national precisely by rallying against the idea of the national, often mingling antifascist with anti-American sentiments. It traded in powerful images of otherness—think of Fassbinder's staging of deviant sexualities, Wenders's obsession with America, Herzog's journeys to the Amazon—in the hope of dispelling what modern nationalism had done to German history and national identity. To be a good German director in the 1970s was to challenge the destructive traits of modern Germanness; to make good films was to produce vehicles that situated directors and viewers in minority positions whose negativity encapsulated the vision of a better Germany, one emancipated from the devastating spells of the past.

The role of both expressionist filmmaking and New German Cinema in the foundation of German film studies, in particular in the United States, in the late 1970s and 1980s can hardly be overestimated.[3] Though these two movements sought to articulate the aesthetic, the historical, and the national in fundamentally different ways, both supplied a nascent academic discipline with a normative canon of good objects whose semantic and formal wealth could be played out against commercial filmmaking. The focus on art house productions and their artistic negotiations of modern German identity thus served a dual purpose: it provided the burgeoning project of German film studies with cultural respectability vis-à-vis other academic disciplines, and it helped defend this new discipline's exploration of cultural particularity against the simplistic suspicion of energizing nationalist agendas. To investigate the critical negotiation of the national in German art and avant-garde productions of the 1920s and 1970s respectively, for the founding generation of German film scholars, was thus to skirt at once

the Scylla of nationalist concepts of cultural specificity and the Charybdis of the blurring of cultural particularities in the wake of the universal ambitions of Hollywood entertainment. It seemed legitimate to displace the false universality of commercial genre productions with the authentic universalism of artistic experimentation, and the catastrophic localism of German national history with the discriminating relativism of critical political practice and intervention.

To write about national cinemas, prior to the 1990s, essentially meant to support semi- or noncommercial film practice, to commend the critique or subversion of mainstream conventions, and to privilege auteurism over popular filmmaking. Much of this project has undergone fundamental revisions over the past two decades as we have witnessed, in particular in the Anglo-American context, a momentous reconsideration of the category of national cinema. Whether scholars have sought to locate the national in specific stylistic registers, industry operations, thematic orientations, or reception strategies, more recent work on national cinemas has largely seen the category of the national in dialectical opposition to the international appeal of Hollywood cinema. National cinemas are no longer considered as historically preceding the global hegemony of Hollywood; rather they are seen as a critical response to, as an attempt to place an accent on, invert, debunk, displace, or merely mimic, the boundless regime of commercial Hollywood products. Moreover, in contrast to the earlier writing about national cinema, this newer focus on national cinemas—documented for instance by Routledge's national cinema series[4]—now also includes the analysis of popular alternatives to Hollywood. Rather than exclusively identifying the national with the aesthetic and counterhegemonic, and the popular solely with Hollywood commercialism, the scholarship of the 1990s and after has asked us to recognize various national cinemas as cinemas that have always been quite familiar with categories such as genre and stardom. Rather than identifying the national with certain formal features such as the exaggerated shapes of expressionist filmmaking or the painstakingly long shots and extended dialogues of New German Cinema, recent writing has explored national cinemas as cinemas that were and still are by no means embarrassed about their popular films, audiences, and preferences.

In face of this rethinking of the category of national cinema, German film studies' initial concentration on the textual symptomologies of domestic art films appeared increasingly out of synch with the profession's overall interest. Close readings of individual masterworks continued to produce many insights about the aesthetic sensibilities of

German art and avant-garde directors, but they often resulted in a reification of certain films into basic units of interpretation whose boundaries became less and less permeable. Symptomatic reading strategies were able to highlight the intricacies of distinct textual features, but they no longer seemed able to map how cinema might at once energize, and be energized by, the richness of highly particular historical and institutional contexts—contexts that might include, but also vastly succeed, issues of national symbolization, memory, and identity formation. One of the most noticeable moves of German film studies in the 1990s was therefore to explore German cinema's own popular idioms, traditions, and institutional trajectories. In the particular German context this reorientation toward the mass cultural dynamic of film production, distribution, and consumption could not do without a turning of critical attention to the cinema of the Nazi period, when German filmmaking arguably was most national and popular. Rather than separating good from bad objects, German film studies now suddenly found itself in a situation exploring all kinds of films as expressions, confrontations, or negotiations of fundamentally bad times.[5] Soon to be followed by a thriving interest in the cinema of the 1950s,[6] it was this initial focus on Nazi cinema, on how Nazi films and studios sought to reshape the contours of German filmmaking and displace Hollywood's international hegemony, that served German film studies as a critical engine to join ongoing debates about the issue of national cinema and partake of the culturalist turn of humanistic scholarship in general.

It is one of the historical ironies of the development of German film studies, in particular in the United States, that this renewed exploration of the national in the 1990s occurred precisely during a period in which we experienced an accelerated dissolution of the modern nation-state at the global level, that is, the emergence of a new post–cold war order marked and marred by ever more transnational streams of influence and transaction. While economic exchanges, political interventions, environmental risks, refugee crises, new technological achievements, and cultural materials throughout the 1990s increasingly traversed and unhinged national boundaries, scholars of German film (and literature)—animated by the historical fact of German unification in 1989–90—eagerly investigated the cultural production of national identity, present or past. There is clearly no need to read what became a fervent preoccupation with the national as a sign of parochial interests. After all, scholarly methods and theoretical orientations do not emerge from a political vacuum or occupy a self-generating universe.

Instead, they are most persuasive when they are able to reflect, absorb, and work through the experience of specific historical developments, in this case the uneven process of national unification in Germany. What is interesting to note, however, is the fact that this new interest in the national was soon to be challenged by the emergence of yet another new German cinema around 2000, a cinema eager to unhinge the conceptual boundaries of the national in the name of some kind of new geopolitical or transnational aesthetic; and that the surfacing of a younger generation of filmmakers such as Fatih Akin, Thomas Arslan, Vanessa Jopp, Dani Levy, Christian Petzold, Hans-Christian Schmid, and Tom Tykwer urged German film studies once again to readjust its theoretical vocabulary and analytical perspective. It is this recent budding of global, transnational, and cosmopolitan sensibilities in the heart of German film culture that defines the conceptual point of departure for *The Cosmopolitan Screen;* it is this latest turn of German cinema that inspires the following attempt not only to map the landscapes of postwall German filmmaking, but reassess the history of postwar German national cinema from a different perspective.

II

Consider the films of Fatih Akin, a Hamburg-born director whose films have helped revamp the topographies of postwall German cinema, and whose 2004 *Gegen die Wand* (Head-On) collected the first German Golden Bear award at the Berlin Film Festival in almost twenty years.

Three young men of Turkish, Greek, and Serbian descent respectively get in trouble on the mean streets of Hamburg, not because of their diverse ethnic backgrounds, but simply because they want to follow their hearts, fail to control their pride, and ignore the bonds of mutual friendship. A shy German math teacher travels all the way to the boundary of Europe in search of the wrong woman; he will cross many a geographical and emotional divide only to find the right woman along the way, to discover a different and more relaxed self, and in the end traverse the bridge that separates Europe from Asia, old from new. A disheartened alcoholic of Turkish descent, after trying to commit suicide, meets a suicidal Turkish woman twenty years his junior in Hamburg. She marries him, not out of love, but to break away from her family's traditionalism and live life to the fullest. When they discover mutual feelings for each other, he kills one of her lovers in rage. Released from a German jail years later, he desperately tracks her down in Turkey, yet the person he encounters has started yet

another life and no longer seems to challenge the conventions she once defied.

Akin's world is one in which geographical, psychological, and emotional boundaries determine people's trajectories yet never entirely contain their lives and movements. It is a world in which the crossing of extant cultural borders, the traversal of physical landscapes as much as of psychological mindscapes, the reconstitution of one's identity between old and new is experienced as the order of the day. Akin's most memorable characters—the reformed gangster Gabriel in *Kurz und schmerzlos* (Short Sharp Shock, 1998), the hapless math teacher Daniel in *Im Juli* (In July, 2000), and the impassioned Sibel in *Gegen die Wand*—are existential nomads ready to leave a past of stifling conventions behind and to embark on ongoing processes of dislocation that change the very way in which physical and symbolic spaces shape our existence in time. Though many of Akin's characters occupy ethnic minority positions in Germany, their director's aim is not to map the German present as one entrenched in brutal fights about identity politics.

Akin's Germans might be of Turkish or Greek descent, but rarely do we see them struggling over questions of ethnic difference per se, nor do we witness any attempt to understand their quarrels as being determined by their hyphened subject position as, say, Turkish-German or German-Turkish citizens. Akin's new Germany is one of ongoing flux and ceaseless becoming, of performative self-redress and transformation. It is not one in which people contently cling to how past generations defined individual and collective identities in mutually exclusive terms or sought to strike balanced compromises between seemingly disparate identifications. What makes Akin's Gabriels and Sibels interesting and novel on German screens is how they think of their identity as something inevitably multiple and inconsistent, as something structured by a logic of addition and parallelism rather than a rhetoric of either-or. They speak Turkish at one moment but switch to German in the next without really noticing. While they can be tremendously urban and urbane, they may also turn insular and provincial in the blink of an eye. Facile markers of identification such as "German" or "Turkish," or any possible blend thereof, are thus simultaneously too wide and too narrow to describe what drives their itineraries and modes of self-realization. What makes them interesting, in sum, is that they draw our attention to the extent to which German society today, in our post–September 11 era of combative nationalisms and stalwart cultural reifications, is one of surprisingly transnational

Kurz und schmerzlos (Short Sharp Shock, 1998, dir. Fatih Akin). (Courtesy Film-museum Berlin—Deutsche Kinemathek.)

and globalized sensibilities, one in which people can be various things at once and construct multiple homes and temporalities within one and the same space.

Akin's films are indicative of a sea change in postwall German cinema. They run counter to the light urban comedies that flooded German cinemas in the first half of the 1990s, and to the sweeping historical melodramas and heritage films that have come to engross German audiences since the final years of the last millennium. Though they clearly have entered the market in different shapes and sizes, German comedies and historical melodramas derived their formulaic popularity not least from their efforts to renegotiate the terms of social consensus after unification. Their tears, sighs, pleasures, and moments of laughter served the purpose of consolidating the social fabric, removing lasting residues of historical ruptures and painful traumas, and thus, reinventing a language of identification in which the national and the popular could happily go hand in hand.[7]

Akin's world, too, is filled with melodramatic intensities and hilarious excess, but nothing could be more wrong than to see the voyages of his characters across different European territories and mindscapes as

catalysts of populist accord and affective historical consensus. Eager to live multiple lives and take second chances, the protagonists of this newest German cinema call into question the very figures of temporal closure and spatial unity that secretly inform postwall German cinema's many tales of unifying the body politic. Identity for these heroes is never simply a mechanism grounding their lives in homogenous spaces and times. Instead, it involves a simultaneous logic of de- and reterritorialization, one whose most striking impact is to multiply the sites of possible existences, memories, visions, and identifications, and one in whose wake identity emerges, not as a result of categorical efforts to separate self and other, but as an ongoing process of negotiating one's own strangeness and the other's seeming familiarity. Whatever we might want to call the identity of this latest set of film heroes is their ability to live out a heterogeneous amalgam of differences. Whatever we might call their home and place of belonging never simply exists in the singular, but meets the eye of the viewer as a space of unruly multiplicity, fragmentation, and dislocation, as a space of competing and often incompatible temporalities.

III

Filmmakers such as Fatih Akin have given German film scholars cause to realign their compass of historical and theoretical analysis. For Akin's films, whether set on the gritty streets of Hamburg, along empty eastern European freeways, or against the backdrop of the Bosporus, draw our attention to the extent to which transnational identifications today form the heart of what we might call the local in our present, while desires for territorialization and a grounding of identity in space and time spread out across an ever more expanded, at times material, at times puzzlingly immaterial, global map. Though the characters of Akin's films have not ceased to struggle with questions of belonging and territoriality, they do not shy away from pursuing multiple identifications and parallel localizations—a simultaneity of dissimilar experiences, pleasures, and personal histories no longer compatible with the conceptual templates that informed former discussions about the national. Akin's films designate a dire need to change our questions about the place of German cinema in the larger economy of moving images. They urge us to push issues of agency, identity, and cultural creativity beyond the conceptual paradigm of the national and, in doing so, rethink the location of the national and the local within the ever more global economy of images and sounds.

New conceptual paradigms may reflect certain cultural or social

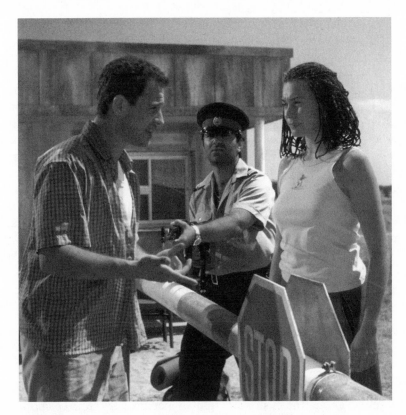

Im Juli (In July, 2000, dir. Fatih Akin). (Courtesy Filmmuseum Berlin—Deutsche Kinemathek.)

transformations of the present, but they allow us to ask new questions about the past. This volume is designed to do so. Its task is to trace how German cinema has engaged the vectors of the global, trans-national, and cosmopolitan not simply during the past decade, but ever since the end of the Nazi period, and how it has thereby sought to define its place within a new Europe of decentered national bound-aries and multilateral orientations. Though one could imagine push-ing the time frame of this anthology back to the 1920s or even to the beginnings of cinema around 1900, the historical scope of this volume must be understood as programmatic and by no means arbitrary. It was one of the ironies of Nazi politics and cinema that, in its orches-trated efforts to fuse the national and popular into one hegemonic mechanism, it not only produced a cinema of German exile in both

Europe and even more so in Hollywood, but also a subsequent history of cinematic division and competition. The Nazis' ideological drive to redefine cinema as essentially national thus resulted in an institutional process of displacement and multiplication whose logic prevents our viewing the history of postwar German film as unified. By noting the work of exiled filmmakers in Hollywood in Gerd Gemünden's essay in this volume, this book draws awareness to the advent of global, transnational, and cosmopolitan orientations as an ironic counterpoint to the Nazis' aim of cinematic nation-building. Though scholars may differ about how to approach the work of German exiles in Hollywood,[8] the exiles' stories of displacement and transformation mark both a historical and an epistemological moment in whose wake we no longer can view the history of German cinema as unfolding in the singular, as conforming to one dominant vision or institutional imperative. It is with the work of German exiles in film industries other than the German of the Nazi period that the history of German cinema as a cinema of global engagements and cosmopolitan orientations took its beginning; it is their careers, productions, and silences that henceforth defined German cinema as a cinema of ongoing contestation and pluralistic multiplicity, of taxing deterritorializations and disparate territorializations.

IV

To speak about the history of global perspectives and cosmopolitanism orientations in modern Germany—in film, literature, and culture in general—no doubt means to open a can of worms. As the somewhat belated academic debate about the role of German colonialism in the late 1990s has shown, the continued interest of German authors, image makers, and ideologues in other cultures and in geographical mobility has produced stunningly different political interpretations. In her 1997 book *Colonial Fantasies,* for instance, Susanne Zantop has read the history of eighteenth- and nineteenth-century German cosmopolitanism as a preview of coming imperial attractions.[9] Curious about the world beyond the messy boundaries of pre-unified Germany, German intellectuals prepared the ground for colonial missions long prior to the actual beginning of state-sponsored imperialism in Germany in the 1880s. Eager to remake the world in their own image, they experienced the absence of factual colonies as a boost to their own colonialist imagination. Russell Berman, by contrast, in his 1998 *Enlightenment and Empire,* has argued that the belated onset and historical brevity of manifest colonial politics in modern Germany helped

to establish a climate of thinking about the other that fused cos-
mopolitan desires to enlightenment ideals of critique and self-transfor-
mation.[10] Rather than fantasizing about the homogenization and sub-
jection of other cultures, German intellectuals—so goes Berman's
answer to Zantop—transcended given boundaries with the aim to
complicate extant templates of experience and question the contours of
the familiar.

This is not the place to trace the arguments of Zantop and Berman
in further detail. Suffice it to say that their approaches have informed
different attempts to chart the meaning of cosmopolitan sensibilities in
precolonial Germany, but also the remarkable investment of German
culture in sites of otherness and difference after the demise of German
imperialism in 1918 or 1945 respectively. What is more important to
point out here is that the accelerated processes of globalization that we
have observed since the early 1990s, and that are under investigation in
various essays of this collection, should give us some cause to wonder
about the continued applicability of both Zantop's and Berman's con-
ceptual matrix.

As we understand it in the pages of this collection, globalization
must be seen as both an empirical development and a normative or
epistemological project. When used as a descriptive term, globalization
describes the emergence of what Michael Hardt and Antonio Negri
have called "a *decentered* and *deterritorializing* apparatus of rule that
progressively incorporates the entire global realm within its open
expanding frontiers."[11] Under the aegis of globalization, flexible and
fast-paced streams of commodities, investments, political directives,
human bodies, technologies, symbolic practices, and aesthetic mean-
ings increasingly traverse dissimilar spaces without recognizing the
boundaries of the modern nation-state as a defining limit. But to speak
of globalization in an empirical sense does not necessarily mean to see
it as a mere process of all-inclusive cultural homogenization, one that
would remake the entire world according to the image of McDonalds,
MTV, or Microsoft. Though there can be no doubt that recent drives
of globalization have produced defined winners and losers, no global
economy can do without its local cultural articulation and inflection.
Manufactured in a Turkish sweat shop by German sports clothing
giant Adidas, a David Beckham soccer jersey sold and worn in a street
market in Tunisia might mean to local residents something quite dif-
ferent than to a Spanish fan of Real Madrid, or for that matter, to a
supporter of the English national team. What people call Indian food
not only tastes quite different all across the world, it has also changed

the ways in which people cook in India. And Mexican audiences have been reported to cheer enthusiastically when Mexican authorities, in Roland Emmerich's blockbuster *The Day after Tomorrow* (2004), refuse to allow U.S. citizens to cross the border and thus escape from their self-produced climatic disaster.

On the other hand, it has become virtually impossible to think of local identities and perspectives today as being constituted and maintained without any reference to the seemingly boundless travel of goods, policies, beings, and intensities that mark our current condition. Nongovernmental organizations (NGOs) that seek to counteract disastrous economic implications of global capitalism engage and navigate globalized spaces as much as terrorist networks such as Al-Qaeda. In their use of advanced telecommunication devices, antiglobalism protests contribute to the spread of global transactions and forms of solidarity as much as they preserve the autonomy of native economies or cultures. All sorts of political and religious fundamentalisms today are not simply constituted in radical opposition to the onslaught of images we encounter on the screens of our computers, television sets, and movies theaters, but seek to fortify or reinvent the fixity of certain boundaries through the channels of transnational media conglomerates.

Rather than erasing the local, the reality of globalization leads to an unprecedented dynamic in which the local and the global exist in mutual interdependence. One here simultaneously needs and produces the other without requiring the mediation of the national or the nation-state's institutional mechanisms of regulating the political, legal, economic, and cultural aspects of everyday life. And yet to speak of the relation of the local and the global as a dialectic of the near and the far, the old and the new, the familiar and the foreign, seems to miss the point. For to wear our soccer shirt with the magic number 23 in Mahdia is not necessarily to deny the textures of Tunisian traditions in the name of a global culture of commodified celebrity. Instead, it can mean to situate oneself simultaneously within a local and a global economy of symbolization no matter whether this possible multiplicity is consistent with others' interpretations or not. While it would be foolish to deny that current processes of globalization place enormous pressure on given structures of historical experience and temporality, it is also important to recognize that these processes lead to a new geography of being and becoming in whose context the vectors of the local and global can no longer be properly grasped according to linear models of

history and progress. Local and global do not act as each other's antitheses; instead, they are like Russian wood dolls, one at once containing and enabling the other within the confines of what from the outside may look like the unity of an identical subject.

In the production of a world of open-ended differences and similarities by the concurrent localization of the global and globalization of the local, striking normative and epistemological implications of globalization become clear. What we might call the cosmopolitan gaze of current academic study entails critical perspectives that, rather than recognizing a nation's boundaries as the constitutive markers of individual and collective identities, explore the globe as a symbolic topography in which local, national, ethnic, religious, and transnational traditions penetrate, amalgamate, and contest each other in shifting configurations. The cosmopolitan perspective refuses to read identity formation as a mere antagonism between clearly defined friends and enemies, as a give-and-take between self and other, or as a dramatic dialectic between master and slave. Though we have no reason to celebrate the hybridity and multiplicity of globalized identity formations today as an automatic sign of resistance, noncompliance, or emancipation, the global gaze is one for which national, cultural, or ethnic borders no longer provide singular or essential parameters of analysis.[12] The primary focus of this gaze is not on how local cultures seek to shut out what is different and other, nor on how modern media of imaginary transport invite us to temporary losses of our selves, but on how people struggle over and with the recognition of cultural differences in spite of the fact that stable boundaries between us and them have become elusive, contingent, or entirely self-reflexive. To examine cultural phenomena from the vantage point of globalization is to consider the conditions under which people past and present have been able to enact their desires for the adoption of different and often incompatible ways of seeing the real; for navigating a world in which the foreign appears strangely familiar while the home may strike us as ever more exotic; for assuming disparate viewpoints on and probing multiple modes of identifying with the unknown; for envisioning alternate universes and inhabiting parallel symbolic spaces. It should go without saying, however, that such an inquiry includes the examination of how asymmetrical streams of money, political power, and technology regulate, modulate, or inhibit the renegotiation of cultural boundaries and identities; and of how the very facticity of global capitalism often denies the normative underpinnings of cosmopolitan epistemologies.

V

No medium has been more effective than cinema in transporting its users into parallel universes and inviting them to experience the world from shifting points of view. Walter Benjamin located cinema's constitutive specificity in its ability to burst asunder the world of the familiar "by the dynamite of the tenth of a second, so that now, in the midst of its far-flung ruins and debris, we calmly and adventurously go traveling,"[13] Though cinema has often fostered narrowly nationalist causes and fueled the viewer's exoticist desires, the medium's formal syntax—its inherent logic of ongoing doubling and dislocation—qualifies film as an ideal catalyst and training ground for developing what we might want to call a cosmopolitan vision. To be and become other, to experience the essential contingency of how we constantly draw and redraw boundaries around and between us, to probe different ways of looking at things—isn't all this cinema's innermost promise? Isn't all this what cinema's quasi-transcendental program and normativity, deeply embedded in the medium's constitutive operations, yet in most cases contained, disguised, displaced, abused, or dismantled by the kind of narratives and agendas this medium seems to serve? Do we not inevitably enter a world of global orientations and cosmopolitan deterritorialization whenever a film's first image leads our senses to places never visited before as such, no matter whether or not our objects of pleasure seek to endorse sedentary homes and strictly bounded existences?

The Cosmopolitan Screen traces German cinema's negotiation of the global—German film's embrace, adaptation, modification, and rejection of a cosmopolitan perspective—both before and after this cinema knew of what we have come to call globalization. While the contributions to this volume explicitly focus on how German postwar cinema wrestled with the existence of different cultural boundaries on an ever-more shrinking global map, they more specifically investigate the extent to which this cinema's images, sounds, and narrative arrangements since World War II sought to unleash or contain the very logic of deterritorialization, displacement, and doubling that distinguishes the filmic medium. Most of the essays presented here pursue this end by directing our attention to issues of representation and cultural discourse, rather than to the institutional level of industry and historical reception. This is not to say, however, that this volume ignores the particular role of material production and historical exhibition in the construction of cinematic meaning. On the contrary: in dialogue with the

theoretical legacies and analytic practices of North American film studies, the authors of this volume explore the extent to which economic mandates and diverse modes of reception become legible in the formal shapes and textual energies of individual films themselves.

Part I concentrates on the troubled landscape of German filmmaking in the immediate wake of the Nazi period, and rather than depicting a period of incessant longings for protective homes and timeless identifications, it draws our attention to the language of rupture, discontinuity, and deracination that structured many of this era's films. In the opening chapter, Gerd Gemünden situates the exile of German-speaking filmmakers in Hollywood as both an integral moment of German film history and a potential source of aesthetic productivity. Focusing on the career of Billy Wilder, Gemünden not only encourages us to develop a differentiated view of how the exile experience multiplied and energized the sites of German filmmaking, he also emphasizes the active role of recipients, critics, and historians in ascertaining what, in an era of dispersal and diaspora, may count as German cinema. In the second chapter of this part, Johannes von Moltke takes a fresh look at the most ridiculed product of 1950s German film culture: the *Heimatfilm*. In stark contrast to dominant readings of this hegemonic genre, von Moltke unearths its covert preoccupation with contemporary experiences of technological modernization and geographical mobility, a dynamic whose constitutive anxieties unsettled the very boundaries this genre sought to reconstruct in its efforts to provide meaning and stability after Hitler. Sabine Hake's contribution, on the other hand, leads us into territories animated by what we might consider the return of the *Heimatfilm*'s repressed: the exoticist sceneries of 1950's revue films. As Hake allows us to meet a cast of "strange" characters and scenes habitually omitted from the pages of German film historiography, we realize how much postwar German cinema, even at its seemingly most national, depended on images of ethnicized alterity in order to define its own identity. In the last chapter of this first part, Lynne Tatlock and Joseph Loewenstein trace the curious give-and-take between 1950s German filmmakers and the Hollywood entertainment apparatus by comparing different adaptations of Erich Kästner's famous 1949 children's novel, *Das doppelte Lottchen*. With each remake, according to Tatlock and Loewenstein, viewers not only were transported farther away from the sites of Kästner's original story, but confronted with different paradigms of constructing space and measuring spatial distance; the greater the remake's distance from Kästner's original story in time and space, the

more viewers came to occupy a nowhere land that neither required nor produced any knowledge about certain localities and their geographical limits.

Most histories of German film see the New German Cinema of the 1960s and 1970s as a rejuvenating moment of postwar filmmaking—a series of interventions with long-term effects on German filmmakers despite this cinema's historical demise in the early 1980s. Digging deeply into the tormented geography of the German soul after Hitler, the celebrated directors of the New German Cinema allowed German filmmaking once again to stand in the limelight of worldwide attention. All four chapters of our second part seek to revise this understanding of the international stance of New German Cinema and how it affected later generations of filmmakers. John Davidson's chapter explores the representation of labor in three features of this period, including one produced by East Germany's DEFA studios. Images and narratives of work, according to Davidson, provided potent descriptions of local existences and concrete conditions of life, but they also allowed German cinema to illuminate, and inscribe itself in, a larger transnational economy of monetary exchanges and symbolic transactions. Lilian Friedberg and Sara Hall, in their joint contribution, explore Werner Herzog's neocolonialist fantasies as played out in his films set in the Amazon rainforest. In contrast to earlier critics, however, Friedberg and Hall focus not on Herzog's trade in images and dreamlike visions, but on how his films engage the viewer in an asymmetrical barter of sounds and acoustical experiences, one in whose context neocolonialism erases cultural particularity by willfully defining the meaning of, and difference between, "music" and "noise." Though the third chapter of this part carries us beyond the period normally considered the heyday of New German Cinema, it takes off where the imperial imaginary of New German filmmakers such as Herzog left their audiences, with open questions and puzzling trepidations. In her contribution Caryl Flinn examines a number of paradigmatic negotiations of German-Turkish identity in German films of the 1980s and 1990s. What Herzog's films simultaneously defined and denigrated as noise now reappears in the figure of trash: instances of alterity and deterritorialized flux that threaten the integrity of a filmmaker's text precisely because good intentions transformed these instances into signs of the abject and incommensurable. In the last contribution in this part, Hester Baer examines the paths of what she calls women's cinema toward and away from the heyday of auterist filmmaking during the 1970s. The definition and history of German film, for Baer, is unthinkable without

the impact of female actresses and directors, even though some of the most visible interventions took place, not during the celebrated reign of New German Cinema, but in the course of the Weimar Republic and within the context of postwall filmmaking and its more relaxed approach toward the popular.

New German Cinema's global success rested on its ability to do what international audiences, and in particular leading American critics of the 1970s, expected the postwar generation of German filmmakers to do, namely to expose the sins of their fathers and struggle with the meaning of what it might mean to be German after Auschwitz. Recent controversies about films such as Oliver Hirschbiegel's *Der Untergang* (Downfall, 2004) indicate the extent to which the Nazi past not only haunts German cinema, but remains the linchpin of how German cinema seeks to define its identity and garner market shares in the context of today's global economy of images. The task of part 3 is to explore the peculiar negotiation of national and global perspectives in German cinema's engagement with the Third Reich since the 1960s. While some essays of this part explore how certain filmmakers have recalled the Nazi past—this seemingly most German of all topics—by adapting to the aesthetic, political, and economic expectations of transnational audiences, other contributions investigate the extent to which German cinema pictures the Holocaust as a trauma of global proportions urging German filmmakers to formulate a nationally particular response and cinematic style. Hanno Loewy's contribution examines the degree to which German cinema in its dramatization of the Holocaust has actively borrowed from universal genre conventions. Stressing the global dimensions of the Holocaust, Loewy not only suggests that such generic borrowings may steer the stories this cinema wants to tell in unforeseen directions, but also that examinations of the Holocaust in German film should thus be emancipated from the place they have occupied in much existing historiography as yet one more feature of a German cinematic *Sonderweg*. Stephan Schindler's chapter at once continues and inverts Loewy's perspective. Schindler's aim is to trace how different German films and television productions have sought to define the specificity and international relevance of German cinema by staging the genocidal project of Nazi politics as a scenario of absence, repression, and displacement. When recalling the Holocaust, German cinema's narrative arrangements and images of Jewish victims cannot be understood in a cinematic vacuum; instead, they must be seen as complex responses to how other film industries, Hollywood in particular, have tried to turn the negativity of

German history into a story both compelling and shocking. In contrast to Loewy's underlying suggestion, Schindler argues that the absence of viable Holocaust representations continues to characterize Geman cinema as specifically German. Examining the narrative shapes and ideological energies of Joseph Vilsmaier's flawed German blockbuster *Marlene,* Eric Rentschler's chapter maps out how German popular cinema of the postwall era has sought to rewrite the past in order to redress itself as a self-confident national cinema. According to Rentschler, Vilsmaier's project of historical and national reconciliation ironically relies on gestures of transatlantic reappropriation: Vilsmaier not only repatriates the iconic image of Marlene Dietrich, but systematically cleanses her image of whatever could trigger painful memories and trouble the present.

Whereas part 3 illuminates recent German cinema's battles with and for the national in a time of rapid cultural globalization, the contributions of part 4 investigate postwall projects eager to explore cinema's cosmopolitan potentials without drawing a triumphalist picture of current processes of political, economic, and cultural globalization. In fact, for some of the films and filmmakers highlighted in this section, to engage cosmopolitan sensibilities, among other, means to confront the way in which the monetary streams of global capitalism shrink, accelerate, and short-circuit the locations of individual experience and the aesthetic. Comparing the work of German director Tom Tykwer and Danish filmmaker Lars von Trier, Gertrud Koch analyzes how religious motifs in the films of both directors not only inform the creative development of different stylistic registers, but energize new types of narrativization that stretch across the boundaries that have structured our previous understanding of national cinema and cultural particularity. In particular von Trier's "Catholicism" provides a language of visual and narrative experimentation that enables viewers of dissimilar backgrounds to live in, rather than merely look at, pictures. By probing the work of Austrian filmmaker Michael Haneke in France, Fatima Naqvi's chapter interrogates the status of images in societies of seemingly unbound exchanges and transactions. As importantly, she draws our attention to the curious "minor position" of Austrian filmmakers within the larger context of German cinema and to the fate of national film industries in a time of inter- or pan-European co-productions. Nora Alter, by contrast, directs our focus at the work of two filmmakers, Harun Farocki and Hartmut Bitomski, whose more recent work has challenged the global world order's networks of economic and military dominance. While both filmmakers may have turned their

back on addressing peculiarly German themes, traditions, and audiences, their searing confrontation with global capitalism and its flexible management of local identities must be seen as part of a new geopolitical aesthetic whose critique of globalization goes hand in hand with a critique of what defines the integrity of a cinematic text. The last chapter of this part, and of the book, introduces the reader to a number of recent avant-garde projects that experiment with digital technology in order to question, not simply the future of national cinemas, but that of celluloid film as we know it. As discussed by Alice Kuzniar, the media art of Bjørn Melhus displaces conventional notions of identity, locality, and materiality to such an extent that its own locatedness can only be seen through its markers of absence; in Melhus's age of virtual telemediation, neither the national nor the local is a category useful in understanding the individual's hybrid constructions of identity, meaning, and perception.

VI

Spatial metaphors have come to dominate our conception of how contemporary media of telecommunication and virtualization reshape the structures of individual and collective experience. Expressions such as *gate, port, platform, site,* and *stream* let us think of the impact of new technologies as primarily topographical in nature, resulting in a complete submission of time and temporality to the exigencies of space. As Kuzniar's chapter reminds us, however, digital mass communication, as it engages more and more aspects of life across the global map, does not take place in a historical or temporal void. Film studies today cannot afford to ignore how current technologies of digital production and distribution are transforming the very object of study in both formal and institutional terms. But that our current cultural conditions privilege pixels over projections, and computers over celluloid, does not mean that our relatively young discipline already has to go out of business again. On the contrary. Never have we had more reasons to study the fabrication, dissemination, and reception of moving images and their role within a larger cultural, economic, and political dynamic.

The survival of film studies as an academic discipline, however, largely depends on its ability to transcend narrow definitions of its objects of study, their technological base as much as their frameworks of meaning and sites of origin. Neither the paradigm of celluloid nor that of the national appears sufficient to understand the pleasures, profits, and politics invested in today's circulation of moving images.

The future of film studies depends on its readiness to reflect critically on the historical constitution of both its objects of analysis and its own institutional practices. Neither strain of reflection can do without the other, and both are deeply affected by the different vectors of globalization that today reshape our view of time and place, past and present. One of the central tasks of this volume is to show that globalization, in spite of its alleged privileging of space over time, of geography over history, is itself a historical fact; and that the categories of our study and enjoyment of moving images do not exist outside of the flow of time. A second, equally important task, however, is to display the adaptability and polycentric plurality of German film studies as a discipline. As they map the different locations of German cinema within a larger field of transnational exchanges and identifications, the authors of *The Cosmopolitan Screen* want to invite productive debates among the discipline's different traditions as well, in particular its Anglo-American and European trajectories. And whenever they emphasize the fluidity and mobility of German filmmaking over time, the contributors to this volume also aspire to move German film studies into the future in such a way that they won't crash against unwavering walls like the hero of Akin's acclaimed 2004 film.

Notes

1. For a good summary of these debates, see Stephen Crofts, "Concepts of National Cinema," *The Oxford Guide to Film Studies,* ed. John Hill and Pamela Church Gibson (Oxford: Oxford University Press, 1998), 385–94.

2. See, of course, the classics: Siegfried Kracauer, *From Caligari to Hitler: A Psychological History of the German Film* (Princeton: Princeton University Press, 1947); and Lotte Eisner, *The Haunted Screen,* trans. R. Greaves (Berkeley and Los Angeles: University of California Press, 1979). For important rereadings of their perspectives and of Weimar cinema see Thomas Elsaesser, *Weimar Cinema and After: Germany's Historical Imaginary* (London: Routledge, 2000).

3. See in particular Timothy Corrigan, *New German Film: The Displaced Image* (Austin: University of Texas Press, 1983); Eric Rentschler, *German Cinema in the Course of Time* (Bedford Hills: Redgrave, 1984); Anton Kaes, *From "Hitler" to "Heimat": The Return of History as Film* (Cambridge: Harvard University Press, 1989); and Thomas Elsaesser, *New German Cinema: A History* (New Brunswick, NJ: Rutgers University Press, 1989).

4. Susan Hayward, *French National Cinema* (London: Routledge, 1993); Tom O'Regan, *Australian National Cinema* (London: Routledge, 1996); Pierre Sorlin, *Italian National Cinema 1896–1996* (London: Routledge, 1996); Sarah Street, *British National Cinema* (London: Routledge, 1997); Sabine Hake, *German National Cinema* (London: Routledge, 2002); Nuria Triana-Toribio, *Spanish National Cinema* (London: Routledge, 2003); Ruth Barton, *Irish National Cinema*

(London: Routledge, 2004); and Yingjin Zhang, *Chinese National Cinema* (New York: Routledge, 2004).

5. See Eric Rentschler, *The Ministry of Illusion: Nazi Cinema and Its Afterlife* (Cambridge: Harvard University Press, 1996); Linda Schulte-Sasse, *Entertaining the Third Reich: Illusions of Wholeness in Nazi Cinema* (Durham: Duke University Press, 1996); Klaus Kreimeier, *The UFA Story: A History of Germany's Greatest Film Company, 1918–1945,* trans. R. and R. Kimber (New York: Hill and Wang, 1996); Sabine Hake, *Popular Cinema of the Third Reich* (Austin: University of Texas Press, 2002); Lutz Koepnick, *The Dark Mirror: German Cinema between Hitler and Hollywood* (Berkeley and Los Angeles: University of California Press, 2002); and Antje Ascheid, *Hitler's Heroines: Stardom and Womanhood in Nazi Cinema* (Philadelphia: Temple University Press, 2003).

6. See, for instance, Johannes von Moltke, *No Place Like Home: Locations of Heimat in German Cinema* (Berkeley and Los Angeles: University of California Press, 2005).

7. Eric Rentschler, "From New German Cinema to the Post-Wall Cinema of Consensus," *Cinema and Nation,* ed. Mette Hjort and Scott MacKenzie (Routledge: London, 2000), 260–77; and Lutz Koepnick, "Reframing the Past: Heritage Cinema and Holocaust in the 1990s," *New German Critique* 87 (Fall 2002): 47–82.

8. For a variety of critical approaches, see the special issue of *New German Critique* 89 (Spring–Summer 2003) on film and exile, edited by Gerd Gemünden and Anton Kaes.

9. Susanne Zantop, *Colonial Fantasies: Conquest, Family, and Nation in Precolonial Germany, 1770–1870* (Durham: Duke University Press, 1997).

10. Russell A. Berman, *Enlightenment or Empire: Colonial Discourse in German Culture* (Lincoln: University of Nebraska Press, 1998).

11. Michael Hardt and Antonio Negri, *Empire* (Cambridge: Harvard University Press, 2000), xii.

12. See, for instance, Ulrich Beck, *Der kosmopolitische Blick oder: Krieg ist Frieden* (Frankfurt am Main: Suhrkamp, 2004).

13. Walter Benjamin, "The Work of Art in the Age of Mechanical Reproduction," *Illuminations: Essays and Reflections,* trans. Harry Zohn, ed. Hannah Arendt (New York: Schocken, 1969), 236.

Postwar German Cinema Reconsidered: Far from Home

Gained in Translation

Exile Cinema and the Case of Billy Wilder

Gerd Gemünden

> The word "translation" comes, etymologically, from the Latin for "bearing across." Having been borne across the world, we are translated men. It is normally supposed that something always gets lost in translation; I cling, obstinately, to the notion that something can also be gained.
>
> —Salman Rushdie[1]

> Those who don't understand the past may be condemned to repeat it, but those who never repeat it are condemned not to understand it.
>
> —Eva Hoffman[2]

I

In her memoir, *Lost in Translation: A Life in a New Language* (1990), Eva Hoffman chronicles her experience of life as an immigrant in Canada and the United States. Hoffman spent the first thirteen years of her life in Kraków, before immigrating with her family to Vancouver, BC, in 1959. Having to leave her beloved home was a traumatic experience that, as the chapter titles of her book have it, disrupted a blissful childhood through a sudden expulsion from "paradise," casting her into a Canadian "exile." Written thirty years after she left Poland, Hoffman's memoir recalls her move from one culture and language to another as a complex transition that presented her with unknown challenges. She writes:

> I have to translate myself. But if I'm to achieve this without being assimilated—that is, absorbed—by my new world, the translation has to be careful, the turns of the psyche unforced. To mouth foreign terms without incorporating their meanings is to risk becoming bowdlerized. A true translation proceeds by the motions of under-

standing and sympathy; it happens by slow increments, sentence by sentence, phrase by phrase.[3]

For all exiles and émigrés, this act of translation is a process that must compensate for loss and displacement, and it is fraught with contradictions and ambiguities. As far as her career is concerned, Hoffman does very well—as a Harvard Ph.D. and staff writer for the *New York Times,* Hoffman can certainly take pride in the achievements of her life in a new language. But she seems reluctant to underscore the ideology of upward mobility as the American way of life, and to confirm the belief that immigrants can indeed better their lot in this country. Celebrating these professional rewards would eclipse the price she had to pay on a personal level. But there is also little in Hoffman's memoir that celebrates what Edward Said calls the contrapuntal dimension of exile—the way in which the experience of loss forces exiles to be inventive, creative, mobile, and resourceful—all of which would certainly apply to Hoffman's professional career.[4] Whereas Said's otherwise deeply pessimistic assessment of exile celebrates the plurality of vision that comes through the negotiation of two cultures, Hoffman laments the fall into relativity and uncertainty that exile has brought about:

> Weightlessness is upon me; I am here, feeling the currents of conflict and warmth, but from that other point in the triangle, this is just one arbitrary version of reality. . . . [I have] an awareness that there is another place—another point at the base of the triangle, which renders this place relative, which locates me within that relativity itself.[5]

Even after thirty years, North America remains for Hoffman a "new world." In order to come to grips with this discomfort, she constructs a nostalgic version of Kraków, an Eden of stability, certainty, and order—no matter if it was a hostile order. At least one knew one's enemy. According to this bipolar view, one is either an American or a foreigner, and America itself is a homogeneous place, the other of home. To be sure, Hoffman's position is not that of Adorno's programmatic denial of assimilation and his celebration of obstinate subjectivity. Adorno, we may recall, claimed, "For the intellectual, inviolable isolation is now the only way of showing some measure of solidarity. All collaboration, all the human worth of social mixing and participation, merely masks a tacit acceptance of inhumanity."[6] Hoffman, instead, looks for ways "to lose my alienation without losing

myself,"[7] and that threat is always kept in check by the nostalgic image of Kraków.

Eva Hoffman's experience of what she herself calls an exile provides a remarkable contrast to that of Billy Wilder. Born in 1906, Wilder also grew up in Kraków. He was ten when his father moved his family to Vienna for fear of Russian troops; he moved to Berlin at age twenty, to Paris at age twenty-seven, and to the United States at age twenty-eight. Hoffman's Kraków was that of cold war Poland, Stalinism, and everyday anti-Semitism; Wilder's, that of life in the outer provinces of the Austro-Hungarian empire, prewar uncertainties, and anti-Semitism. The Hoffmans, of the same generation as Wilder, were Holocaust survivors who decided to emigrate because they saw no future in the Poland that had emerged from World War II. They left of their own free will, though as Eva Hoffman writes, "that choice was so overdetermined that it could hardly have been called 'free.'"[8] Wilder's was a step-by-step transition from Kraków to the United States that spanned many years and had Wilder arrive in the United States at a much later age. Wilder made the decision to leave the country himself, and even though he made it in the face of Hitler's rise to power, it was not completely contrary to his career plans. In fact, it was in a certain way a completion of Wilder's self-styled Americanization of his youth in Vienna and Berlin.[9] Whereas Kraków meant home for Hoffman, Wilder's sense of not being one of the natives goes as far back as his upbringing as a German-speaking Jew in Polish peasant country. This sense was reinforced time and again wherever Wilder moved. For the Viennese, he was a Polack from the province; for the Berliners of the Weimar Republic, he was an Austrian; for the Nazis, he was a Jew; for the Parisians, he was a German-speaking émigré; and in Hollywood, he was a central European refugee from a faraway continent. When he returned to Germany after the war, it was as an American citizen in a U.S. uniform, an "Emigrant" who had sided with the enemy. But even in the United States, he never fully assimilated. Even after becoming a major screenwriter and director, Wilder would feel the sting of being considered an intruder. After a screening of *Sunset Boulevard* (1950), Louis B. Mayer attacked the director as a foreigner who had bit the hand that fed him, demanding that he "be tarred and feathered and run out of town."[10]

In many ways, Wilder's nomadic identity—a term he would vehemently reject, to be sure—was the key to his commercial success in Hollywood. Wilder's intellectual mobility—his capacity to quickly grasp a character or situation, and to exploit it to his own advantage by virtue of his power of speech—was a personal trait, but it needs to be

understood historically. Having effectively lost his homeland, Galicia, as a result of World War I, and having been denied Austrian citizenship because of anti-Semitic sentiment in 1919 (a sentiment Wilder, unlike Hoffman, would not forget), Wilder was literally homeless. Wilder's cultivation of flexible roots instead of lamenting rootlessness was his way out of this predicament. At a time when German and American film studios were as fiercely competitive as they were compatible, the aggressive internationalism of the film industry of Weimar Berlin provided Wilder with a professional training that would make his move to the United States more of a transition than a translation.

To put the difference between Hoffman and Wilder most bluntly: if Hoffman's memoir carefully tallies the losses of cultural translation, the films of Billy Wilder show us how that process can also be a gain. There is a decidedly transcultural dimension to Billy Wilder's work, a status of being in-between nations, and drawing on very distinct cultural sensibilities. Often celebrated as a master of Hollywood entertainment, his fluency in the language of classic Hollywood film always retained a strong European accent. His overwhelming commercial and critical success, including six Academy Awards, shows that he understood what the American public wanted, and yet his insights into their minds are clearly those of an outsider. Films such as *Double Indemnity* (1944), *Sunset Boulevard,* or *The Apartment* (1960) belong in the pantheon of American film, but they also attest to the plurality of vision of the foreign-born artist. Although Billy Wilder had his eye on America from the very beginning of his career, the European baggage he carried with him would always be present. American culture completed Wilder's character, but it also remained alien. Throughout his U.S. career, Wilder would draw on his German and Austro-Hungarian background, frequently rewriting his own earlier work, adapting European plays, or simply infusing his American material with generous helpings of Jewish humor, Viennese fin de siècle decadence, or Weimar Germany modernism. If his early scripts at UFA (Universum Film AG) attest to his fascination with things American—speed, gangsters, Hollywood stardom, and life in the modern metropolis—his American films revisit Germany and Europe from the perspective of a thoroughly Americanized artist and U.S. citizen, confronting the traditions of the Old World with the achievements of the New.

II

If I have been dwelling at length on the question of biography, it is because theorizing biography is central to a theoretically more ambi-

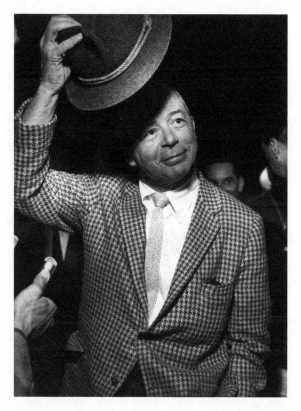

Billy Wilder. (Courtesy Filmmuseum Berlin—Deutsche Kinemathek.)

tious approach to the study of exile cinema. Yet research inspired by biography is separated from positivism by a very fine line, and positivism, together with the influence model, has been a long-standing paradigm in exile studies that in my view has outlived its productiveness.[11] I am using Billy Wilder as a case study that tries to articulate *both* the importance of biography for the study of exile cinema *and* the location of German exile cinema within the history of German and Hollywood cinema. I am taking my cue from Lutz Koepnick's study on Nazi and exile cinema, in which he examines the bifurcation, the special path, of German popular cinema of the 1930s and 1940s. With the symptomatic title *The Dark Mirror,* this study understands Nazi cinema and exile cinema as the unequal and uncanny twins of Robert Siodmak's classic noir. Nazi cinema was bent on duplicating Hollywood's industrial proficiency, making necessary an internal American-

ization in order to combat Hollywood's hegemony in Europe and, more importantly, to imbue modern distraction and commodity consumption perfected by Hollywood with eminently political functions. Emphasizing the home and the national on screen at the expense of a demonized Other (be that England, America, or the Jew), Nazi cinema was very attuned to international standards of production and marketing, the use of genre conventions and the star system, and the viewing practices of its audience. By contrast, exile cinema—Berlin in Hollywood—was the contemporaneous cinema of those professionals driven out of Nazi Germany and occupied Europe for racial and political reasons. The survival of these émigrés within the U.S. film industry depended on their individual abilities and willingness to comply with Fordist and Taylorist modes of production. Both cinemas, argues Koepnick, are halves that do not make up a whole: "Poised between Hitler and Hollywood, the golden age of German cinema . . . owed its existence to processes of division, displacement, and doubling that cannot be reintegrated into any kind of unified national narrative."[12] The cinema of Billy Wilder is particularly suited to trace the processes of deterritorialization and reterritorialization that mark the disappearance of Weimar cinema and its resurfacing on the Pacific coast.

What is the position of German exile cinema in Hollywood?[13] Certainly, it has to be understood as a cinema in the state of being in-between. Drawing on traditions of Weimar cinema, it is also an essential part of the Hollywood studio system. Far from being an "unlucky hybrid," as film historian Jan-Christopher Horak claims,[14] it is precisely this in-betweenness that marks exile cinema as one of creativity and ingenuity. With its vocabulary of cultural mimicry, hybridity, liminality, and nomadism, postcolonial theory currently provides the most sophisticated tools to understand this status. Particularly, the work of Hamid Naficy has tried to theorize the relationship between film, television, and diasporic communities.[15] Yet it must be emphasized that the above critical terms can have meaning only if attached to historic specificity. A desire to formulate an unfixed notion of universal subjectivity often blurs the historical coordinates of specific experiences. It is important, therefore, to note that none of these terms is subversive or emancipatory per se, and that the fetishization of difference only leads to its disappearance. Thus, the notion of the exilic, as I employ it here, has to be considered not an essence but as a position, contingent upon political choices—or lack thereof—under concrete historical circumstances.

How do we read for exile? The exiled professionals had very limited

possibilities to create films that could draw attention to the political cause of their displacement—both *from* Germany and *within* the United States—and articulate strategies for overcoming such displacement. The highly regulated system of film production in the Hollywood studio system of the 1930s and 1940s, the Production Code Administration (PCA) guidelines and restrictions regarding the representation of sexuality, religion, and politics—including the politics of foreign countries—on the screen, and the fact that apart from anti-Nazi films most genre films were decidedly apolitical, all set very definite limits to what exiles could communicate to a contemporary audience. To be sure, there were films, especially after Pearl Harbor, that employed a strong thematic concern with exile, most famously *Casablanca* (1942), "everyone's favorite émigré film," as Thomas Elsaesser has noted.[16] Among Wilder's films, *Hold Back the Dawn* (1941) stands out, because it tells the story of a Romanian immigrant waiting in a Mexican border town for his chance to cross into the United States. Yet in most films in which exiles were involved, exile itself is seldom manifest on a thematic level; the exilic dimension must be located elsewhere. Wilder himself quipped that in the 1930s, exile had simply lost its attractiveness as dramatic plot device: "The tale of a refugee was a sensation when Alexandre Dumas and Victor Hugo told it, but now, when I tell my tale, everybody just yawns."[17] The main trope through which exile cinema is able to articulate its concerns is therefore allegory. Joel Fineman comments, "Historically, we can note that allegory seems regularly to surface in critical or polemical atmospheres, when for political or metaphysical reasons there is something that cannot be said."[18] As critics such as Paul de Man, Craig Owen, and Walter Benjamin have shown, allegory revolves around clarity and revelation as much as around concealment and obscurity. For de Man, allegory stands in fact for "the impossibility of reading," or for a certain illegibility.[19] Thus, "reading for exile" involves uncovering not only the way in which the exilic dimension becomes articulated but also the ways in which such an uncovering has to remain precisely an impossible task.

How is the empirical subject inscribed in the films themselves? Focusing on a single director, I do not want to follow an auteurist approach. In the case of Wilder that would not be entirely inappropriate, given the fact that he never filmed a script he had not written himself, a rare achievement among Hollywood directors and unmatched by any other émigré of the period. Auteurist approaches often neglect the complex negotiations that film professionals must undergo in order to insert

themselves successfully into the studio system. Wilder's oeuvre itself makes no claim to such auteurism, nor did Wilder, who ridiculed the subjectivism of the Nouvelle Vague and their "Santa Claus aesthetic."[20] Wilder's films cover a wide range of genres; the celebrated titles mentioned earlier stand next to rather forgettable features. Apart from the western, there is no genre in which he did not dabble. Moreover, Wilder never developed a unique visual style (unlike Lang or even Sirk), priding himself on editing and mise-en-scène in which the camera work became invisible. Wilder was a company man who never thought of himself in opposition to the studio system (though sometimes to its moguls). As his biographer Ed Sikov writes, "At an early age he learned to work the system, in middle age he became it, and he hung on as long as he could, to his own enormous benefit."[21]

An auteurist approach seems particularly problematic in regard to exile cinema, where any notion of authentic experience, personal style, or handwriting needs to be put immediately into quotation marks. Exile cinema has a profound performative dimension where strategies such as mimicry and masquerade, cultural camouflage, impersonation, and ethnic drag are employed by the exiles to meet the demands of the studio system's notion of what German and Austrian culture is all about. Although Wilder's films often highlight this performative dimension on a thematic level—just think of his many cross-dressing characters—I would not label him "an ultimate auteur." By ultimate auteur I mean a director whose lack of industrial power and aesthetic control resurfaces on the narrative and visual level of a film as a story of being "out of control," thereby turning the film into an allegory of its director's experience of displacement, dispossession, and deprivation (an argument sometimes made in regard to Robert Siodmak or Edgar Ulmer).

III

Despite such reservations about auteurism, I believe that biographies do matter for the study of exile cinema. No two exiles are alike. Exile may be the universal experience of the twentieth century, as Edward Said claims,[22] but it is also a singular fate. Exile directors are empirical subjects whose experience, however fragmented or performative, is reflected in their films. Unlike other notable exile film professionals such as Fred Zinnemann, Friedrich Hollaender, or Curt Siodmak, Billy Wilder did not write an autobiography. The only sources (outside of his films and scripts) through which we can approach how Wilder reflects upon his experience of exile are his numerous interviews,

including the interview books by Hellmuth Karasek and Cameron Crowe as well as several biographies, which in turn rely heavily and often uncritically on Wilder's own account.[23] These interviews have become famous for Wilder's one-liners that bespeak his quick and often dark humor, and the eagerness of the interviewee, just as the scriptwriter, to avoid boring his audience, thereby blurring the line between private revelation and public entertainment. In fact, as Crowe has perceptively observed, from early on Wilder was keenly aware of the importance of constructing a certain persona in order to succeed in show business: "Perhaps the greatest character creation of young Billie Wilder . . . is Billy Wilder himself."[24] As a result, the persona almost always eclipsed the person, and while Wilder was eager to speak about scripts, stars, and work on the set, he was reluctant to talk about his childhood and his relationship to his parents. When the subject turned to more private topics, Wilder could be detached and incommunicative; his penchant for jokes was a mechanism for cover-up.

Given the insignificance Wilder ascribed to his private life and the difficulty of making personal films in the industry, the degree to which biography can become an important subtext of a film seems indeed negligible. But perhaps we are looking for it in the wrong places. At the beginning of this essay I contrasted Hoffman's story of exile, the story of loss, with that of Wilder, the story of gain. Are the two models really that simplistic? Eva Hoffman may be nostalgic in her reconstruction of her Kraków childhood, but she feels a necessity for this particular reconstruction of her past because it anchors her in a world of increasing uprootedness and displacement. It also keeps one from cultivating one's exilic status as a perpetual Other who feels "unimplicated in the mundane, compromised, conflict-ridden locality [she] inhabit[s]."[25] "[W]ithout some move of creating homing structures for ourselves, we risk a condition of exile that we do not even recognize as banishment."[26] The targets of her critique are the postmodern notions of nomadism and diaspora, where the vision of exile is no longer one of despair but of comedy.

The phenomenon Hoffman attacks is the effect of post-Glasnost, post–cold war globalization, and as such has little to do with how Wilder's generation experienced exile. Yet Hoffman's critique of an eagerness to shed one's past articulates a deficiency, a loss *of* translation in Wilder's cultural assimilation. The fundamental difference between Hoffman's and Wilder's experience of exile is the way in which they position themselves vis-à-vis the Holocaust. Eva, as the daughter of Holocaust survivors, believes children of her generation were "too

The Emperor Waltz (1946, dir. Billy Wilder). (Courtesy Filmmuseum Berlin—Deutsche Kinemathek.)

over-shadowed by our parents' stories, and without enough sympathy for ourselves, for the serious dilemmas of our own lives."[27] Marianne Hirsch has called this predicament postmemory, explaining, "Post-memory characterizes the experience of those who grow up dominated by narratives that preceded their birth, whose own belated stories are evacuated by the stories of the previous generation shaped by traumatic events that can neither be understood nor recreated."[28] Hoffman's nostalgia for Kraków may be the nostalgia for a period in her life when she did not yet understand the full force of her parents' history in Poland.

Wilder, in contrast, is a survivor from Nazi Germany by virtue of the fact that he got out in time. As he told Crowe, "I came here because I didn't want to be in an oven."[29] That is the extent to which he talks about that part of his life. Hoffman's probing memoir brings to our awareness the ruptures and the repression of memory in Wilder's own sparse accounts of exile, forcing us to read his silence as a symptom of the guilt of the survivor. What is missing in Wilder's cultural trans-

The Emperor Waltz (1946, dir. Billy Wilder). (Courtesy Filmmuseum Berlin—
Deutsche Kinemathek.)

lation is that which could not be carried across—because Billy could
not persuade his mother to follow him out of Germany, she died in
Auschwitz.

Are there, then, attempts in Wilder's cinema to communicate to the
American public the experience of dislocation, persecution, and indeed
the Holocaust? There are in Ernst Lubitsch's cinema,[30] and I think
there are attempts as well in Wilder's cinema, no matter the film's sub-
ject matter or genre. On a very obvious level, there are the gas chamber
scene in *Double Indemnity* (shot, but not included in the final film), the
motif of the homeless and the displaced that underlies *The Apartment,*
the point-of-view of the outsider and underachiever that shapes films
such as *Ace in the Hole* (1951), *The Lost Weekend* (1945), *Sunset Boule-
vard,* and *Hold Back the Dawn.* The only film Wilder regretted not
making was *Schindler's List* (1993), as Steven Spielberg secured the
rights before Wilder could.

More instructive in this regard, however, is a film that on the surface
could not be further from representing the Holocaust. *The Emperor*

Waltz (1946) was made upon Wilder's return from Germany, where he had served in the Office of War Information with the task to de-Nazify the German film industry. A musical set in the Vienna of 1901 starring Bing Crosby and Jean Fontaine, it has all the makings of Lubitsch's escapist sexual comedies—spoofing the monarchy with its patriarchy and obsolete traditions while at the same time relishing in the popular strudel-and-schmaltz aesthetic. Wilder's only venture into this genre, the film revolves around the parallel love stories of Virgil (Crosby) and the Countess von Stoltzenberg-Stoltzenberg (Fontaine) and their respective dogs, a mutt called Buttons and a purebread poodle, Scheherazade. While the love between the noble countess and the crass American salesman cannot take the hurdle of etiquette and tradition, the animals follow their instincts freely. When Scheherazade has a litter of pups, the father of the countess orders them to be drowned, an act Virgil averts in the last moment by tearing the dogs away from Dr. Semmelgries (Sig Ruman, notably the only actor in the film to speak with a German accent). With the puppies under his arm, he races to the ballroom of the palace where the emperor is just entering to the tune of "Gott erhalte Franz, den Kaiser." Here he confronts the emperor: "They're not pure enough for you, huh? Not quite your sort. Freaks! Little mongrels you wouldn't have around. So what are you going to do? You're going to shake them off that great big noble family tree of yours. And let them rot, as if nothing had happened." In a moment, *The Emperor Waltz* has shifted from fluff to a film about genocide, registering Wilder's own somber experiences of editing *Die Todesmühlen,* a documentary about the liberation of the concentration camps, and forcing his American viewers, if only for a brief moment, to reflect on the horrific reality of the Holocaust and perhaps on the ways in which they were entangled in it.

When asked by Cameron Crowe about this film, Wilder quipped: "The less time you consume in analyzing *The Emperor Waltz,* the better."[31] It is the premise of reading for exile that the text knows more than its author.

Notes

1. Salman Rushdie, *Imaginary Homelands: Essays and Criticism, 1981–1991* (New York: Penguin, 1991), 17.
2. Eva Hoffman, *Lost in Translation: A Life in a New Language* (New York: Penguin, 1990), 278.
3. Hoffmann, *Lost in Translation,* 211.

4. Edward Said, "Reflections on Exile," *Out There: Marginalization and Contemporary Culture,* ed. Russell Ferguson et al. (Cambridge: MIT Press, 1990), 357–66.

5. Hoffmann, *Lost in Translation,* 170.

6. Theodor W. Adorno, *Minima Moralia: Reflections From Damaged Life,* trans. E. F. N. Jephcott (New York: Verso, 1974), 26.

7. Hoffmann, *Lost in Translation,* 209.

8. Eva Hoffmann, "The New Nomads," *Letters of Transit: Reflections on Exile, Identity, Language and Loss,* ed. André Aciman (New York: New Press, 1990), 45.

9. The journalist Hans Sahl described Wilder in the 1920s as "a slender young man who wore his hat slanted, buried his hands in his pockets, and played the American long before we [i.e., Sahl and his friends] had even discovered America." Hans Sahl, *Memoiren eines Moralisten* (Munich: DTV, 1990), 100.

10. Qtd. in Otto Friedrich, *City of Nets: A Portrait of Hollywood in the 1940s* (Berkeley and Los Angeles: University of California Press, 1986), 421.

11. I do not have the space here to elaborate on the shortcomings of the influence model. For a critique of the model for the study of film noir see Thomas Koebner, "Caligaris Wiederkehr in Hollywood? Stummfilm-Expressionismus, 'Filmemigranten' und Film noir," *Innen-Leben: Ansichten aus dem Exil,* ed. Hermann Haarmann (Berlin: Fannei & Walz, 1995), 107–19; and Thomas Elsaesser, "A German Ancestry to Film Noir?" *Iris* 12 (1996): 129–44. See also Elsaesser, "Ethnicity, Authenticity, and Exile: A Counterfeit Trade? German Filmmakers and Hollywood," *Home, Exile, Homeland: Film, Media, and the Politics of Place,* ed. Hamid Naficy (New York: Routledge, 1999), 97–123.

12. Lutz Koepnick, *The Dark Mirror: German Cinema Between Hitler and Hollywood* (Berkeley and Los Angeles: University of California Press, 2002), 1.

13. Some of the following remarks reiterate observations offered by Anton Kaes and me in our introduction to a special issue of *New German Critique* 89 (2003) devoted to film and exile.

14. Jan-Christopher Horak, "German Exile Cinema, 1933–1950," *Film History* 8 (1996): 387.

15. Cf. Hamid Naficy, *The Making of Exile Culture: Iranian Television in Los Angeles* (Minneapolis: University of Minnesota Press, 1993); *The Accented Cinema: Exile and Diasporic Filmmaking* (Princeton: Princeton University Press, 2001); and *Home, Exile, Homeland.*

16. Elsaesser, "Ethnicity, Authenticity, and Exile," 100.

17. Qtd. in Volker Kühn, afterword to *Menschliches Treibgut,* by Friedrich Hollaender, trans. Stefan Weidle (Bonn: Weidle, 1995), 348.

18. Joel Fineman, "The Structure of Allegorical Desire," *Allegory and Representation,* ed. Stephen Greenblatt (Baltimore: Johns Hopkins University Press, 1981), 28.

19. Paul de Man, *Allegories of Reading: Figural Language in Rousseau, Nietzsche, Rilke and Proust* (New Haven: Yale University Press, 1979), 205.

20. As he told Cameron Crowe in an interview: "I am not arty. I never make a setup that is obviously wrong. I never shoot through the flames of the fireplace in

the foreground, because that is from the point of Santa Claus." Cameron Crowe, *Conversations with Wilder* (New York: Knopf, 1999), 119.

21. Ed Sikov, *On Sunset Boulevard: The Life and Times of Billy Wilder* (New York: Hyperion, 1998), ix.

22. Said, "Reflections on Exile," 357.

23. Apart from Crowe's and Sikov's books quoted earlier, there are Hellmuth Karasek, *Billy Wilder: Eine Nahaufnahme* (Munich: Heyne, 1995); Maurice Zolotow, *Billy Wilder in Hollywood* (New York: Limelight, 1987); and Kevin Lally, *Wilder Times: The Life of Billy Wilder* (New York: Henry Holt, 1996).

24. Crowe, *Conversations with Wilder*, xiii. Or as Audrey Wilder, Billy's second wife, has it: "Long before Billy Wilder was Billy Wilder, he behaved like Billy Wilder" (qtd. in Sikov, *On Sunset Boulevard*, 6).

25. Hoffmann, "The New Nomads," 55.

26. Hoffmann, "The New Nomads," 63.

27. Hoffmann, *Lost in Translation*, 230.

28. Marianne Hirsch, *Family Frames: Photography, Narrative, and Postmemory* (Cambridge: Harvard University Press, 1997), 22. My reading of Hoffman's memoir is indebted to Hirsch's wonderful and nuanced discussion.

29. Crowe, *Conversations with Wilder*, 19.

30. See my essay "Space Out of Joint: Ernst Lubitsch's *To Be or Not to Be*," *New German Critique* 89 (Spring–Summer 2003): 59–80.

31. Crowe, *Conversations with Wilder*, 279.

Convertible Provincialism

Heimat and Mobility in the 1950s

Johannes von Moltke

> Das gemütliche Wirtshaus demoliert der Farbfilm mehr, als Bomben es vermochten: er rottet noch seine imago aus. Keine Heimat überlebt ihre Aufbereitung in den Filmen, die sie feiern, und alles Unverwechselbare, wovon sie zehren, zum Verwechseln gleichmachen.
>
> —Theodor W. Adorno[1]

I

Among the stock phrases to which screenwriters for the Heimatfilm have returned over and over again in its long history, one encapsulates a certain narrative pattern, as if to allow an underlying generic formula to surface on the level of plot and dialogue: "Wer nie fortgeht, kommt nie heim" (Who does not leave, cannot return home). Uttered, for example, at strategic moments in the plot of Luis Trenker's *Der verlorene Sohn* (The Prodigal Son, 1934), Veit Harlan's *Die goldene Stadt* (The Golden City, 1940), and Wolfgang Liebeneiner's *Die Trapp-Familie* (The Trapp Family, 1956), the phrase maps out an abortive journey (opposite to that, say, of the road movie), which only takes the protagonists of the Heimatfilm away from home the better to teach them the value of Heimat. The logic of this recurring motif would thus appear to be as circular as its perpetual return over the decades: (narrative) trajectories are initiated with the sole purposes of facilitating a return; the lessons to be learned on such quests never lie at the (foreign) destination, but at the point of origin. As Dorothy puts it, when asked by the good witch in Heimat- and road-movie *The Wizard of Oz* (1939, dir. Victor Fleming) what she learned: "It's that . . . if I ever go looking for my heart's desire again, I won't look any further than my own back yard."

However, as recent studies of film genre have stressed, genres are

historical processes that "may, for sure, be dominated by repetition, but they are also marked fundamentally by difference, variation, and change."[2] Thus, as it is iterated through three different films, the German version of the notion that "there's no place like home" plays out with somewhat different results: while the prodigal son comes home to an apotheosis of Heimat at the end of *Der verlorene Sohn,* the homecoming of the prodigal daughter in *Die goldene Stadt*—while also glorified within the fascist aesthetic as a form of self-sacrifice—ends with her suicide. Liebeneiner's version of the story made famous by *The Sound of Music* (1965, dir. Robert Wise), finally, marks perhaps the most significant variation on the theme of departure and return: although the sequel to *Die Trapp-Familie* in particular suppresses the historical dimension of exile and works hard to conclude its chronicle of the Trapp family singers' rise to fame on a note of Heimat regained,[3] the substitution of the Green Mountains of Vermont for the Salzburg Alps does short circuit the logic of return. Thus, towards the end of *Die Trapp-Familie in Amerika* (The Trapp Family in America, 1958, dir. Wolfgang Liebeneiner), Maria (Ruth Leuwerik) will offer a revision of the generic formula when she pragmatically explains to her husband, "Wer seine Heimat verloren hat, der muß zusehen, wo er eine neue findet" (whoever has lost his Heimat must see where he can find a new one). In Liebeneiner's film, as in many other *Heimatfilme* of the 1950s, continued displacement rather than any ultimate return has become the condition of narrating Heimat.

The following remarks aim to explore further this nexus between mobility, displacement, and Heimat as the basis for the popularity of the Heimatfilm during the 1950s. For this purpose, I look first at historical frameworks of restoration and modernization, arguing that the ideological function of the Heimatfilm consisted in finding imaginary solutions to the putative conflict between these two tendencies. Loosely following the useful framework recently advanced by Rick Altman, I then attempt to locate the genre's historically specific concern with displacement and mobility in the three registers Altman defines as pertinent to any theoretically informed and historically sensitive discussion of genre. I begin with the inscription of movement on the *semantic* level of particular props and motifs, and then move on to discuss their *syntactic* function in the way the Heimat genre negotiates issues of mobility and displacement. My goal is thus to reveal something about the genre's *pragmatics:* its construction within the historical context of the 1950s and the inscription of a specific form of generic address. Mapping the contours of a topography of the genre in this

sense will allow us to determine with more precision the historical meanings of Heimat as the central topos of West German cinema during the 1950s.

II

Both contemporary glosses and retrospective accounts have led us to think of the first postwar decade in West Germany as utterly conservative, static, and fearful of any experimentation. Such accounts tend to circle around three overlapping trends in particular, all of which would appear to privilege a set of static, if not backward-looking values: in this view, the 1950s were the years of "reconstruction" (*Wiederaufbau*), "normalization," and "restoration." The success of the Christian Democratic Union's 1957 campaign slogan "Keine Experimente!"—an enduring favorite when it comes to finding catchwords to gloss the decade—would be attributable in part, at least, to its condensation of these three trends in a politically potent formula. In this broad view, which Lutz Niethammer has described as the obstinate "myth of the 1950s,"[4] the decade is seen to connect backward to an era before the Third Reich: whether described critically as the restoration of tendencies dating back as far as pre–World War I imperial Germany, or conservatively as some vague sense of normalization that would undo the "aberrant" tendencies of the Nazi regime, all areas of society, politics, and culture appear to follow a common logic of repression and return. But as Frank Stern rightly reminds us, this myth may have blocked some necessary differentiations. "The perception of the 1950s as a period exclusively defined by social and political restoration," Stern argues, "may not be sustainable in the light of historical and cultural analysis."[5] Among other things, such analysis would have to account for the fact that the effort at restoration, normalization, and reconstruction during the 1950s went hand in hand with a set of developments that social and cultural historians have begun analyzing under the heading of "modernization"[6]—among them not only the modernization of the domestic sphere itself, but also changing patterns of consumption, labor, and mobility, rapid technological and industrial advances, as well as the multiple forms of engagement and (dis)identification with the United States that came to be labeled as "Americanization" during the 1950s. In these and other aspects, everyday life during the 1950s reflected a growing and pervasive sense of momentous change that would appear to have been the flip side of conservative efforts to stabilize postwar society by maintaining a sense of status quo and avoiding experimentation. If, on the one hand, the

1950s were characterized by a "retreat to traditional values, by confor-
mity in questions of political attitude, by a longing for a premodern
state of things,"[7] on the other hand this was a decade of intense and
often rapid transformation.[8] In this view, the 1950s did away with any
vestiges of the preindustrial order that might have survived the Third
Reich; in the ongoing modernization of Germany, the 1950s marked
the "point of no return."[9]

If "modernity" and "modernization" by and large were not the
terms that contemporaries used to describe this transformation, as
Wolfgang Welsch has suggested,[10] an overwhelming sense of social and
cultural transformation was captured instead in the proliferation of
"wave" metaphors used to describe shifting patterns of mass consump-
tion. Indeed, the so-called *Heimatfilmwelle* that was set off by
Schwarzwaldmädel (The Black Forest Girl, 1950, dir. Hans Deppe) and
Grün ist die Heide (The Heath Is Green, 1951, dir. Hans Deppe) was
hardly the only wave to wash over the Federal Republic during the
1950s. With monetary reform and the inauguration of the Marshall
Plan in 1948 as the driving forces, citizens soon experienced a massive
Konsumwelle that crested in various *Fresswellen, Kleidungswellen,* and
Einrichtungswellen,[11] they took to the roads in the *Motorisierungswelle*
and the *Reisewelle,* and even as the cinemas were awash with the
Heimatfilmwelle, entire rural areas were forced to deal with the after-
math of the postwar *Flüchtlingswelle.* The ubiquitous wave metaphor
is obviously problematic for its naturalizing rhetoric, which in each
case suggests the inevitability of a natural catastrophe; at the same
time, its seemingly unlimited applicability to all areas of culture and
society during the 1950s indexes a perceived dynamism that allows us
to speak of "modernization" as part of "reconstruction."

These two tendencies immediately suggest two wholly different tem-
poralities: if the 1950s looked backward as a decade of restoration, the
"Miracle Years" also set their sights firmly on the future. In addition,
the double process of "reconstruction" and "modernization" in West
Germany must be seen in terms of two seemingly competing *spatial*
dimensions, both of which, taken together, constitute the signature of
the decade. Specifically, if the restorative tendencies of the 1950s clearly
map onto received notions of Heimat as dwelling, home, belonging
and stability, and a "central norm of domesticity,"[12] this should not
blind us to the simultaneous remapping of the postwar German land-
scape through different forms of displacement and mobility. In various
guises—from involuntary to voluntary, from individual to collective,
from geographical to metaphorical—movement constitutes the second

spatial signature of the mobilized society in postwar West Germany.[13] Though it may appear cynical to speak of a wholesale "euphoria of mobility,"[14] particularly for the forced displacements of the early postwar years, we need to recognize the transformative role of different types of displacement and travel for the material and spatial reconstruction of West Germany after World War II.

In retrospect, it is tempting to reconcile the two faces of the 1950s either in a "two-phase model" that would divide the decade into an early period of reconstruction and a later period of transformation and expansion; or one might articulate the link between restoration and modernization by locating the forward-looking dynamism in the economic sphere, as Welsch suggests,[15] and reserving the categories of restoration, normalization, and reconstruction for describing how politics, society, and culture worked to hide the consequences of economic change. Indeed, a version of this argument does underpin my understanding of the Heimat genre and its ideological functioning during the 1950s: undoubtedly, the Heimatfilm served a compensatory function in providing images of settled, rural existence seemingly far removed from the concerns of everyday life. As Eric Rentschler puts it, the Heimatfilm offered an escape from everyday life, into a world where all the coordinates had been reversed: "instead of ruined cities, one contemplated untouched nature; in the midst of widespread homelessness, one reveled in a world where people had roots; and above all, one replaced a presentiment of existential devastation with more comforting notions of timeless and harmonious reality."[16]

This geography of the Heimatfilm is "static" in both the spatial and the temporal sense of the word: everyone has roots, nothing changes. In this German/Austrian landscape composed of a series of remote and archaic places, spectators could heal the wounds of war and take a "holiday from history."[17] We are invited to visit "a balanced, beautiful ambulatory landscape, void of tensions, which offers a kind of preemptive reconciliation of mounting social tensions. One flees from the changing, mobile world into an ostensibly better, idealized past."[18] In this view, well-established among critics of the genre, the Heimatfilm is the false consciousness of the 1950s, illustrating an escape to a stable old world, when everything around is undergoing rapid changes.

However, to trace the "dynamism" and modernizing tendencies of the 1950s only to what Marxist approaches would describe as the "base" fails to account for the complex ways in which the ideological superstructure is regularly forced to address the issues it is designed to hide. The following exemplary reading of one Heimatfilm from the

1950s joins the discussion of the genre's ideological functioning; however, rather than describing the genre exclusively in terms of its escapist, or compensatory function, my interest lies in tracing the often quite intricate negotiations of the postwar present *within* the Heimatfilm. In this view, a number of Heimatfilme reveal not only a conservative or reactionary concern with Heimat as an archaic realm of settled existence, but also a surprising obsession with the various tropes of mobility and displacement that mark the eruption of the present into Heimat as "uncontaminated space."[19] These tropes include particular motifs such as the pervasive presence of *Vertriebene* (expellees) in the space of Heimat, the proliferation of late-model convertibles that traverse the tranquility of Heimat scenery, or the motif of travel more generally; formal devices such as particular editing principles that transport us back and forth between different locales connoted as *Heimat* and *Fremde,* and which permit the relocation of Heimat from the Austrian/German Alps to surprisingly similar mountainous regions in Africa and North America (these edits may take the form of either unmarked cuts or of conspicuous, even self-reflexive dissolves modeled on the transition between the Alps and New York in *Der verlorene Sohn*); recurring plot situations involving border crossings and smugglers; the role of America as a vector for departure and/or return; the increasing prominence of tourist plots over the course of the decade; and the pervasive concern with wandering and itinerancy as the condition of possibility for telling any stories about Heimat in the first place: *Wer nie fortgeht, kommt nie heim.*

While the mere presence of mobility as a motif does not yet tell us anything about its function, the following discussion demonstrates how this motif does tend to threaten the stability of received spatial definitions of Heimat as *locus amoenus,* as a pastoral idyll untouched by modernity. For as the trajectories charted by characters and objects in these films increase to an occasionally frenzied pace of departure, displacement, and return, it becomes difficult to maintain a solipsistic definition of Heimat space as a locale not mediated by distanced relations of time and space. While on the one hand, the Heimatfilm has inherited the presumed traditional Heimat mandate to stem the tide of modernization, the increase in mobility unleashed by the economic and social developments of the postwar era forces a realignment of the coordinates and vectors that define the generic space of Heimat. Taking up the question of geographical and social mobility as an index for modernity, I thus inquire into its function in a generic geography ostensibly centered and at rest in the tranquility of Heimat.

Die Trapp-Familie in Amerika (The Trapp Family in America, 1958, dir. Wolfgang Liebeneiner). (Courtesy Filmmuseum Berlin—Deutsche Kinemathek.)

III

> In der fanatischen Liebe zu den Autos schwingt das Gefühl physischer Obdachlosigkeit mit. Es liegt dem zugrunde, was die Bürger zu Unrecht die Flucht vor sich selbst, vor der inneren Leere zu nennen pflegten. Wer mit will, darf sich nicht unterscheiden.
>
> —Theodor W. Adorno[20]

The opening images of Paul May's *Die Landärztin* (Lady Country Doctor, 1958) must have been a dream come true for the Volkswagen marketing department in Wolfsburg. After the credits have rolled over a picture-perfect Alpine landscape seemingly untouched by civilization, the camera pans as it follows the approach of a young woman on a motor scooter. As she draws closer, her path is suddenly blocked by a car parked in the middle of a country crossing, and the fluid camera movement comes to rest on the latest model of a VW convertible, which now occupies the lower half of the screen.

From the ensuing exchange between Petra (Marianne Koch), and the driver who emerges from the Beetle and boasts of his recent pur-

chase, we soon learn that their acquaintance dates back to medical school. Petra is on her way to take up a position in the nearby village of Kürzlingen as the eponymous country doctor; Dr. Friebe, her colleague and suitor, tries to lure her in for a ride instead, imploring her to return to the city and to the brilliant career that awaits her there. Against his laments that she is jeopardizing her future by taking up a position in a *Kuhdorf* (cow village), she reiterates her reasons for leaving: the country post, she argues, will afford her the opportunity to flee the pressures of specialization and routinization that she would face in the city. Despite the suitor's protests, she insists that he let her pass, for she has work to do.

A film whose mixed reviews all agreed on its generic characterization as a Heimatfilm, *Die Landärztin* begins by showcasing the car as a signifier of modernity. Though private motorization may not top many people's intuitive lists of the basic building blocks of the genre, cars— preferably late-model convertibles—are among the most stable elements of a semantics of the 1950s Heimatfilm from the moment Sonja Ziemann wins the coveted "Ford Taunus Kabriolett" in *Schwarzwald-mädel*. Whether in *Der Förster vom Silberwald* (The Forester from the Silver Forest, 1954, dir. Alfons Stummer) or *Heimatland* (Homeland, 1955, dir. Franz Antel), in *Die Trapp-Familie in Amerika* or *Wenn die Heide blüht* (When the Heath is Blooming, 1960, dir. Hans Deppe), the Heimatfilm appears to engage in a conspicuous motorization of the provinces. The recurring convertibles are not "mere" functional vehicles that bring the urban intruder to the countryside or vice versa. As objects of conspicuous consumption, cars in the Heimatfilm are also invariably signs of the expanding consumer economy, popularly identified as the *Wirtschaftswunder,* engineered by Ludwig Erhard. As the postwar present finds its way into the ostensibly "closed world" of the Heimatfilm, with astonishing regularity it does so by car.

Clearly a tribute to a newly motorized society (not to mention a modern form of product placement), the shiny new VW at the beginning of *Die Landärztin* immediately situates the plot of the film not in some timeless provincial tranquility, but in a marked *Wirtschaftswun-der*-present. More specifically, the conspicuous placement of up-to-date modes of private transportation must be viewed against the background of the so-called *Motorisierungswelle* of the middle to late 1950s, when Germany took to the roads. If only one in eighty citizens owned a car in 1950, this figure had increased almost sevenfold to one in twelve by 1960—not counting the number of motorcycles and scooters, which had peaked at 2.1 million at mid-decade.[21] While similar trends

in other areas—from communication to consumption, from technol-
ogy to economics—contributed to this particular "wave," the increas-
ing and shifting patterns of transportation immediately suggest some
of the consequences of modernity for a human geography of the 1950s.
As the example of *Die Landärztin* demonstrates, those consequences
were most tangible in rural areas that were progressively "deprovin-
cialized" as a result of motorization.[22] With the rapid increase in pri-
vate motorization around 1956, the practice of commuting, too,
became much more common. This led to a redefinition of the bound-
aries of the rural, and to an increasing transformation of non- and sub-
urban communities in line with the pressures of urban lifestyles. Speak-
ing of newly constructed housing developments on the outskirts of
villages and cities, Hannelore Brunhöber points out that traditional
neighborly relations were progressively undermined, while distanced
and often work-related contacts began to replace proximity as a zone
of social exchange.[23] As Arnold Sywottek puts it, "[I]n the long run,
motorization played a key role in the urbanization of rural communi-
ties and in the erosion of marked differences in the lifestyles of the pop-
ulation."[24] This reflects an increased mobility of labor power with
implications similar to those Kristin Ross discerns in France during
these years, where mobility likewise was "the categorical imperative of
the economic order, the mark of rupture with the past."[25] In order to
satisfy the demands of an accelerating economy, individuals had to be
"displaceable in function of the exigencies of the economic order," and
the car was both the sign and the vehicle of that displaceability.
Accordingly, "France-at-the-wheel enacted a revolution in attitudes
toward mobility and displacement. . . . [I]t was a revolution that saw
the dismantling of all earlier spatial arrangements."[26]

Ross's description is particularly apt inasmuch as she highlights the
role of mobility as a spatial and social practice with implications for
historical consciousness: as the sign of a rupture with the past, the new
euphoria of mobility during the second half of the 1950s literally served
to displace not only recent experiences of forced mobility, but also the
expansionist definition of national space and of Heimat that had char-
acterized the Nazi regime. As has often been pointed out since the pub-
lication of *The Inability to Mourn* by Alexander and Margarethe
Mitscherlich, the repressive force that enacted this rupture with the
past found its material expression in the purposeful turn toward recon-
struction and modernization now known as the *Wirtschaftswunder*
(economic miracle).[27] Ross' study of French modernization during the
same time period goes a long way to suggest in what ways mobility

itself played a key role in this process. Generating "available" workers (what Ross calls "l'homme disponible"),[28] changing patterns of transportation and car ownership were literally a driving force in the (re)generation of expanding, flexible labor markets for the growing economy. In this sense, we must think of mobility also in the sense of increased job mobility as the basis for various forms of social mobility—from the forced retraining of expellees according to the demands of their new domestic labor market to the readiness to traverse growing distances between home and work.

Faced with the dynamics of modernization and motorization during the 1950s, the Heimatfilm developed in two distinct directions: while some films took a resolutely antimodern stance that insisted on turning back the clock by offering escapes into premodern idylls untouched by the pressures of economic and social mobilization, others, such as *Die Landärztin,* sought ways to accommodate those pressures within the received iconographic and narrative frameworks of Heimat. While the former variant may be described as escapist in the traditional sense, offering its viewers a simple, mythical alternative to their postwar present, the latter suggests (indeed requires) a more dialectical reading. The escapist variant of the Heimatfilm is "reactionary" in the literal sense defined by Rolf Petri in his overview of German concepts of Heimat during the century leading up to the 1950s: the discourse on Heimat, he writes, is "reactionary in the literal sense of the word, because it represents a reaction to modernity that glorifies the past."[29] Films taking their viewers back to mediaeval Alpine settings such as *Die Martinklause* (1951, dir. Richard Häussler), *Der Klosterjäger* (The Monastery's Hunter, 1953, dir. Harald Reinl), and other Ganghofer adaptations and remakes, but also the famous series of *Sissi* films (1955–57, dir. Ernst Marischka) which glamorized the Hapsburg monarchy of the nineteenth century, fit this mold, as do a number of films whose fictional present is difficult to locate and remains remote from the urban viewer's contemporary life. Scholarship on the Heimatfilm has tended to focus on this aspect of the genre, emphasizing its "escapist" tendency to offer viewers a "holiday from history."

Upon closer inspection, however, the postwar present is hardly always as remote from the diegetic conceits of the Heimatfilm as such views would have us believe. Relatively few *Heimatfilme* are actually situated in an identifiable past in the way of costume dramas à la *Sissi.* Instead of generating an antimodern stance by retreating to a glorified past, many films of the genre seek to integrate aspects of modernization into the space of Heimat, thus suggesting a slightly more compli-

cated—if no less conservative—negotiation of the competing demands of modernity and tradition. While the latter continues to be represented through the constitutive rural spaces, customs, and rhythms of Heimat, the ostensible inertia of provincial tradition is offset by the recurring tropes of mobility that signal the films' engagement with the profound economic and social transformations of postwar (West) Germany.

The plot of *Die Landärztin,* as it develops after the meeting of two motorists in the countryside, provides a case study of the way in which the Heimatfilm combines antimodern traditionalism with the demands of 1950s modernity. At first, it would seem the two vehicles evoke the motorized postwar present only to leave it behind all the more thoroughly, as Petra continues on her way to the *Kuhdorf* of Kürzlingen. Connected to Dr. Friebe and his allegiance to the city, which is in turn the site of specialized, routine—that is, "alienated"—labor, even the shiniest new model cannot entice Petra on her way to a more organic, rooted type of medical practice. By the end of the film, however, we will return to the Volkswagen convertible whose allure the opening images have firmly implanted in the viewer.

For now, the brief encounter between Petra and Dr. Friebe ends with a victory of the scooter over the convertible; more importantly, however, the encounter has established motorization as a key motif, even as it distributes the means of transportation unevenly according to gender. Thus, although Dr. Friebe has been able to reach this remote country crossing before Petra thanks to the new VW, Petra's availability for rural work is tied to her own mobility on the fashionable scooter, which was only just being replaced by the car as the dominant means of private transportation at the time of the film's premiere.

With the single exception of her gender, Petra represents precisely the "new man" whom Kristin Ross discerns in her analysis of the discourses and images of motorization that circulate in France during the same time. Locating the car at the heart of a new economic order built around mobility, Ross describes it as "a key element in the creation of the new and complex image of 'l'homme disponible'—Available Man."[30] It is Petra Jensen's mobility that makes her available for work in the countryside in the first place, and we can already begin to surmise that the exorcism of the car and its connotations will not be as complete as Petra's refusal of a lift back to the city might have suggested.

Themselves conspicuous signs of the contemporary *Motorisierungswelle,* car and scooter serve not only as signifiers of modernization, but

Die Landärztin (Lady Country Doctor, 1958, dir. Paul May). (Courtesy Filmmuseum Berlin—Deutsche Kinemathek.)

also as vehicles for negotiating its meanings within the spaces of Heimat. Locating the function of motorization and mobility in the Heimatfilm, in other words, is not only a matter of determining their semantic presence, but also involves understanding their syntactic relevance. How does the trajectory from the city to the country that initiates this film in a reversal of emerging commuter trends play out in terms of narrative structure?

IV

Upon her arrival in the idyllic rural community of Kürzlingen, Petra learns that she indeed has her work cut out for her. Before she can perform the services for which she was trained in medical school, she has to work hard to overcome the deep-seated mistrust and the reactionary gender politics of the villagers. Shocked to discover that "Dr. Jensen" is a woman, they boycott her office, preferring to travel to the next village or even to be treated by the local veterinarian, Dr. Rinner (Rudolf Prack), instead. Indeed, even Dr. Rinner is dismissive and more than a

little misogynic at first, but when Petra proves her professional skills in an emergency situation, he finally comes around and joins her cause. This clears the path for a wholesale reconciliation between the young newcomer and the villagers, and for the union of country doctor and city doctor in particular. Not surprisingly, this union facilitates Petra's acceptance of the offer she had refused in the opening banter with Dr. Friebe: in the film's closing image, Marianne Koch and Rudolf Prack, the stars of the Heimatfilm, drive off into the Bavarian sunset in the vet's own VW convertible.

As the film's resolutely up-to-date protagonist, Petra labors under a peculiar double burden: on the one hand, she is a highly qualified female professional who simply wants to do her job in a misogynic, rural setting—a basic plot featured two years earlier in Ulrich Erfurth's *Heidemelodie* (Melody of the Heath, 1956), where a young female teacher arrives as the successor to the old *Heideschulmeister* only to encounter the prejudices and distrust of most of the villagers. As is also the case in *Die Lindenwirtin vom Donaustrand* (The Linden-Landlady from the Danube's Shores, 1957, dir. Hans Quest), the young woman has to overcome entrenched expectations about gender, a process that invariably results in a partial restoration of gender norms by the film's end. However, her role as initiatior of the plot leaves its marks on this restoration: while both Petra in *Die Landärztin* and Helga, the successful pediatrician in *Solange noch die Rosen blüh'n* (As Long as the Roses Are Blooming, 1956, dir. Hans Deppe) give up their initial independence by falling for the male lead, neither is forced to give up her medical profession. Maintaining their professional commitment, these women therefore also bear a second, larger burden of functioning as agents of modernization charged with bringing the traditional values and norms of a rural community up to speed with the changing reality in the urban centers. Georg Seeßlen describes this double burden of Heimatfilm femininity as the "myth of the natural woman." Aside from the so-called secretary film of the 1950s, argues Seeßlen, "no other genre describes the role of woman in the Economic Miracle with the same precision, demanding two faces of her, both radiant: one gazing in confirmation on the Fascist man, who wants to remain Fascist, and the other turning an eye on the money, on modernization, corruption, and industrialization."[31]

This double task, which occupies Petra throughout *Die Landärztin,* is repeatedly connected to the function of the scooter, which first carries her from the center to the periphery, from the city to the idyllic countryside, from the metropolis to Heimat. As she rides around a

conspicuously unmotorized Kürzlingen (hers appears to be the only vehicle in the area besides the vet's VW convertible), the scooter marks her as "foreign," even as it functions as the misplaced status symbol of a young urban professional. Gradually, however, Petra earns the trust of a few individuals, who even begin appearing on the scooter's back seat. Though the film stages these scenes for comic effect (the priest looks particularly boyish and undignified as he straddles the saddle of Petra's "rocket," as he calls it), they contribute to the harmonization it fundamentally aims to achieve. As the villagers come to accept a female doctor in their midst, her form of transportation no longer seems as out of place as it did on the day of her arrival. To the degree that Petra and her motor scooter initially represent the "other" to Heimat, it seems important to note that *Die Landärztin* does not redraw the line that would allow the villagers to exorcise the modern (in form of motorization and "emancipation") in order to maintain the integrity of Heimat. Paul May's film significantly does *not* use the initial opposition between the country and the city to prove the superiority of traditional ways of life over the lifestyle and professionalism of the urban intruder. Nor, of course, does it engage in a full-scale attack on Kürzlingen's patriarchal provincialism.[32] Rather, in chronicling Petra's gradual integration into the fabric of the community as well as the community's grudging acceptance of her professional skill, the film asks its audience to entertain the idea of Heimat as a compromise formation, a space in which the urban reaches the local and modernity meets tradition.

While this harmonization has much to do with character development, it can also be seen as a small-scale transformation of provincial space, which has adapted to the effects of motorization. *Die Landärztin* does not block the erosion of differences between urban and rural lifestyles, the beginnings of which cultural historians have traced to the 1950s. Instead, the film negotiates this erosion within the realm of Heimat, both on an iconographic and a narrative level. The happy ending with its heterosexual union of country vet and city doctor neatly illustrates the compromise that this film and the Heimat genre as a whole facilitate. After the requisite marriage, some overly conciliatory speeches, and Petra's public pronouncement that "this is where I belong," the film achieves closure by returning to the vehicle on which it opened. Having transferred her loyalties from the city to the country, Petra can now take the (passenger) seat in a VW convertible that she refused at the outset.

Ross argues that discourse around cars and mobility during the

Die Landärztin (Lady Country Doctor, 1958, dir. Paul May). (Courtesy Filmmuseum Berlin—Deutsche Kinemathek.)

same decade in France is "built around freezing time in the form of reconciling past and future, the old ways and the new . . . past and future are one, *you can change without changing.*"[33] There is hardly a better way to describe the role of the convertible in the Heimatfilm, and in *Die Landärztin* in particular. The undeniable political conservatism of such a film, then, consists not of an uncompromisingly antimodern stance, but of the selective embrace of the modern and of the mythologization of modernization as a process that ultimately does not threaten the underlying sense of continuity and *Gemeinschaft.* In this respect, the Heimatfilm contributes decisively to an image of the 1950s as a decade of "modernization under a conservative guardianship."[34] Paul May's film works, like so many others of the decade, toward a negotiated peace between Petra and the villagers, between the pressures of urban modernity and the ostensible inertia of rural tradition.

In the light of such insights, we need to revise spatial commonplaces that would associate the urban with the modern and the rural with the traditional, drawing sharp dividing lines between the two spheres. For the history of motorization, along with the larger history of modern-

ization in the 1950s, begs the question of where to draw such a line. Although the city is not visually present in *Die Landärztin,* such a film suggests its presence at every turn—not just in the foregrounding of scooters and cars, but also in the decidedly urban and "modern" figure of Petra herself. Moreover, while the clear-cut distinction between *Heimat* and *Fremde* has been a constitutive part of many a definition of Heimat, it is worth bearing in mind that feature films rarely offer lexical definitions, but tell stories instead. In other words, as soon as Heimat becomes a topos in the *process* of narration, the distinction between *Heimat* and *Fremde* is literally set in motion, subject to development, revision, and reversals. As a rule, the Heimatfilm does not, therefore, maintain the rigid definitional distinction between Heimat and its constitutive other as successfully as it might appear. Although it may always invoke that definition as its premise, the ideological function of the Heimatfilm consists precisely of transforming that distinction in the process of narration. These films achieve closure not by exorcising the urban from the rural, the modern from the traditional, but by accomplishing a harmonization between such ostensibly opposed terms. *Die Landärztin* is doubly emblematic of this process by making it explicit in its references to motorization and by depicting it as a task to be performed by a woman.

The "fanatical love" for cars and convertibles, identified by Theodor W. Adorno as an index of homelessness, was only one form of mobility that challenged the discursive stability of Heimat. A closer look at some of the more striking negotiations of displacement in this and other films of the Heimat genre reveals the degree to which Heimat gets swept up in the very processes it seeks to stem: as these films negotiate the competing demands of settlement *and* mobility in the postwar context, Heimat and modernity no longer appear to be mutually exclusive concepts. Adorno's claim that, as part of the culture industry, the Heimatfilm destroys the very image of an authentic place called Heimat—if ever such a place did exist—should thus be given one further dialectical twist. The *Gemütlichkeit* of Heimat is not simply destroyed. However fake, it still plays a role in softening the impact of that force Adorno considers worse than bombs, the great leveler of the incommensurable: capitalist modernization.

In this view, the function of the Heimatfilm is not so much to *compensate* for the effects of modernity, as critics have suggested, but rather to model *compromise* solutions. Negotiating the encroaching demands of modernity within the spaces of Heimat, these films allow their viewers to imagine postwar reconstruction as a process that

embraces *both:* the traditionalism of Heimat and the advances of modernization. Like *Die Landärztin,* these films fail to exorcise the "other" of Heimat entirely—nor is this even their overriding goal. Instead, the films tend to offer compromise solutions that would allow *both* a return to traditional values *and* a (selective) embrace of contemporary change. For this reason, and not because of its promise of escape, the Heimatfilm was predestined to become the favorite genre of the Economic Miracle. Unlike any other fictional format, the Heimatfilm paralleled precisely the decade's double imperative of restoration and modernization, of sedentariness and (imaginary) transport.

Notes

This essay is directly related to the broader investigation of the *Heimatfilm* I undertake in *No Place Like Home: Locations of Heimat in German Cinema* (Berkeley and Los Angeles: University of California Press, 2005).

1. Theodor W. Adorno, "Résümé über Kulturindustrie," *Gesammelte Schriften* (Frankfurt am Main: Suhrkamp 1977), 10:342.

2. Stephen Neale, "Questions of Genre," *Film Genre Reader II,* ed. Barry Keith Grant (Austin: University of Texas Press, 1995), 170. See also Stephen Neale, *Genre and Hollywood* (New York: Routledge, 2000); and Rick Altmann, *Film/Genre* (Bloomington: Indiana University Press, 1999).

3. Johannes von Moltke, "Trapped in America: The Americanization of the Trapp-Familie," *German Studies Review* 19.3 (1996): 455–78.

4. Lutz Niethammer, "'Normalization' in the West: Traces of Memory Leading back into the 1950s," *The Miracle Years: A Cultural History of West Germany, 1949–1968,* ed. Hanna Schissler (Princeton: Princeton University Press, 2001), 237.

5. Frank Stern, "Film in the 1950s: Passing Images of Guilt and Responsibility," Schissler, *The Miracle Years,* 267.

6. Axel Schildt and Arnold Sywottek, "'Reconstruction' and 'Modernization': West German Social History during the 1950s," *West Germany under Construction: Politics, Society, and Culture in the Adenauer Era,* ed. Robert Moeller (Ann Arbor: University of Michigan Press, 1997), 413–43; Schildt and Sywottek, eds., *Modernisierung im Wiederaufbau: Die westdeutsche Gesellschaft der 50er Jahre* (Bonn: Dietz, 1998); and Kaspar Maase, "Freizeit," *Die Bundesrepublik Deutschland: Geschichte in drei Bänden,* ed. Wolfgang Benz (Frankfurt am Main: Fischer, 1983), 2:209–33.

7. Hans Karl Rupp, "'Wo es aufwärts geht, aber nicht vorwärts . . .': Politische Kultur, Staatsapparat, Opposition," *Die fünfziger Jahre: Beiträge zu Politik und Kultur,* ed. Dieter Bänsch (Tübingen: Narr, 1985), 31.

8. In terms of economic growth, Germany led Western European economies and was surpassed only by Japan during the decade; the GNP tripled between 1950 and 1960, and employment increased by 25 percent even as the labor market was forced to accommodate millions of refugees from the East. Indeed, the unbridled dynamism of this multiply coded "wave" of change has evoked comparisons with

"roaring twenties" in the United States and with the the notoriously intense period of modernization in the late nineteenth century, when Germany first made the transition from agrarian to industrial society. See Andreas Schwarz, "Design, Grafik Design, Werbung," Benz, *Die Bundesrepublik Deutschland,* 1:382 and 387f.

9. Hans-Peter Schwarz, *Die Ära Adenauer: Gründerjahre der Republik 1949–1957* (Stuttgart: DVA, 1981), 390.

10. Wolfgang Welsch, "Modernity and Postmodernity in Post-War Germany (1945–1995)," *Culture in the Federal Republic of Germany, 1945–1996,* ed. Reiner Pommerin (Oxford: Berg, 1996), 110.

11. Michael Wildt, "Privater Konsum in Westdeutschland in den 50er Jahren," Schildt and Sywottek, *Modernisierung im Wiederaufbau,* 275–89.

12. Maase, "Freizeit," 212.

13. Indeed, as Kristin Ross suggests, following Michel Aglietta, this double focus on dwelling and mobility may be the signature of a much broader development in consumer capitalism. Fordist consumption, she argues, is "governed by two commodities: the *standardized housing* that is the site of individual consumption; and the *automobile* as the means of transport compatible with the separation of home and workplace." Kristin Ross, *Fast Cars, Clean Bodies: Decolonization and the Reordering of French Culture* (Cambridge: MIT Press, 1995), 4–5.

14. Hermann Glaser, *Kulturgeschichte der Bundesrepublik Deutschland* (Munich: Hanser, 1985), 2:148.

15. Welsch, "Modernity and Postmodernity," 110.

16. Eric Rentschler, *West German Film in the Course of Time* (New York: Redgrave, 1984), 108.

17. Walter Schmieding, *Kunst oder Kasse: Der Ärger mit dem deutschen Film* (Hamburg: Rütten & Loening, 1961), 23.

18. Projektgruppe deutscher Heimatfilm, *Der deutsche Heimatfilm: Bildwelten und Weltbilder* (Tübingen: Tübinger Vereinigung für Volkskunde e.V., 1989), 15.

19. Rentschler, *West German Film,* 105.

20. Qtd. in Schwarz, *Die Ära Adenauer,* 223.

21. Thomas Südbeck, "Motorisierung, Verkehrsentwicklung und Verkehrspolitik in Westdeutschland in den 50er Jahren," Schildt and Sywottek, *Modernisierung im Wiederaufbau,* 171.

22. Südbeck, "Motorisierung," 187.

23. Hannelore Brunhöber, "Wohnen," Benz, *Die Bundesrepublik Deutschland,* 2:183–208.

24. Arnold Sywottek, "From Starvation to Excess? Trends in Consumer Society from the 1940s to the 1970s," Schissler, *The Miracle Years,* 347.

25. Ross, *Fast Cars, Clean Bodies,* 21.

26. Ross, *Fast Cars, Clean Bodies,* 22–23.

27. As Moeller puts it, quoting from the Mitscherlichs, "Leaving behind this difficult history was made possible by a massive self-investment in the 'expansion and modernization of our industrial potential right down to kitchen utensils.'" Robert Moeller, *War Stories: The Search for a Useable Past in the Federal Republic of Germany* (Berkeley and Los Angeles: University of California Press, 2001), 15.

28. Ross, *Fast Cars, Clean Bodies,* 22.

29. Rolf Petri, "Deutsche Heimat 1850–1950," *Comparativ: Leipziger Beiträge zur Universalgeschichte und vergleichenden Gesellschaftsforschung* 11 (2001): 85.

30. Ross, *Fast Cars, Clean Bodies,* 22.

31. Georg Seeßlen, "Der Heimatfilm: Zur Mythologie eines Genres," *Der Sprung im Spiegel: Filmisches Wahrnehmen zwischen Fiktion und Wirklichkeit,* ed. Christa Blümlinger (Vienna: Sonderzahl, 1990), 354.

32. Although the film's gender politics are hardly enlightened, one should note that its implicit critique of the villagers' reactionary misogyny is biting and effective. The open-mouthed silence with which the villagers "greet" the female doctor lasts just long enough to let the spectator experience their gender politics as a profound humiliation of the protagonist with whom we have been aligned from the start.

33. Ross, *Fast Cars, Clean Bodies,* 21–22; emphasis added.

34. Cf. Schildt and Sywottek, *Modernisierung im Wiederaufbau,* 415.

Colorful Worlds

The West German Revue Film of the 1950s

Sabine Hake

On the following pages, you will meet a strange cast of characters: field slaves from Mississippi, steel bands from Trinidad, sheriffs from Puerto Rico, Mexican *campesinos* and *senioritas,* and, of course, the European musical stars who performed these American stereotypes in one of the most disparaged genres of German cinema, the 1950s West German revue film. What you will not find are the real-life American soldiers and businessmen who personified the fundamental economic, social, and cultural transformations referred to as postwar Americanization.[1] In conjuring up this fantastic mixture of ethnic characters, locations, and milieus, I want to draw attention to a group of relatively unknown films that were produced with considerable professional competence and moderate commercial success during the years of the Economic Miracle.[2] Their elaborate production numbers, extensive rehearsal scenes, and highlights from opening nights share an almost compulsive preoccupation with the scenarios of ethnicity that, after 1945, had been banned from high culture and political discourse. The long tradition of stylistic hybridization and cross-cultural fertilization in the revue format and the well-established filmic conventions concerning the representation of music and dance in German cinema provided a convenient framework for the production of performative excess. And through these performative qualities, I argue in the following, the revue genre made possible a highly circumscribed reenactment of racial otherness. Through their fundamental difference from contemporary narratives, the ethnic scenarios allowed postwar audiences simultaneously to reassert and to disavow their own investment in the question of race and nation. This complicated dynamic of self and Other in the restaging of German identity is not only essential for

understanding the processes of projection and incorporation that accompanied the normalization of public life under the conditions of Allied occupation and cultural Americanization. The dependency of postwar definitions of Germanness on an ethnic Other also sheds new light on the function of "America" as a marker of difference in the ongoing reconceptualization both of German cinema as a national/transnational cinema and of Germany as a postnational, multicultural society.

Approaching the revue film on its own terms allows me to examine the contribution of these colorful fantasies to larger developments in postwar West German society without having to equate its formal conventionality with either artistic mediocrity or affirmative ideology.[3] In defining the historical parameters of this examination, three closely related points are worth making at the outset. To begin with, the revue film responded to a second wave of Americanization—and subsequent Germanization of U.S. cultural imports—during the years of the Economic Miracle. This process is most apparent in the selective adaptation of contemporary American styles to popular music and dance forms. However, in contrast to earlier manifestations of the genre, the postwar revue film absorbed these new influences by conjuring up another kind of imaginary "America"—one identified with folk culture, ethnic culture, and the lives of traditional societies and preindustrial communities. Channeled through the perspective of what might be called retroprimitivism—that is, a nostalgic evocation of the primitive as a vessel for decidedly contemporary scenarios of identity—this staged performance of the New World has little in common with the progressive, urban, modern spirit of Weimar Americanism that, in various manifestations and permutations, became an integral part of cultural, social, and economic practices after World War II. And in formal terms, the phantasmagoric effects associated with such retroprimitivism are fundamentally dependent on, but also limited to, the spatial and psychological divisions established by the proscenium arch. The proscenium in the revue films strictly separates the spectacle from the spectators and prevents any direct encounters between the ethnic stereotypes on the stage and the German protagonists in the narrative. Last but not least, this divided mise-en-scène, in which the spectators in the diegesis function as a stand-in for the contemporary audience, produces the binaries of ethnic versus nonethnic through which Germanness—and this is the secret referent in all production numbers—can be articulated outside the taboo categories of race and nation. No longer enlisted in the making of alternately optimistic and

pessimistic visions of German modernity, "America" thus becomes a projection screen for a number of competing fantasies about race, folk, and community and about the relationship between cultural tradition and modernity.

Yet how does the spectacle of ethnicity generate and facilitate these discursive effects? Through the processes of commodification associated with the culture industry or through the elusive strategies of postmodern citation? Should we regard these production numbers as a particularly obvious example of mass-produced kitsch, or are they more adequately described through the aesthetics of camp, including its ironic self-awareness? Can we attribute the irreverent play with stereotypes—or rather fragments of stereotypes—to the emergence of more fluid definitions of identity, including in terms of queer sensibility, or are the artificial settings indicative of a more problematic fixation on the question of ethnicity? In order to address some of these questions, we must pay closer attention to the generic conventions that organize the production and reception of these postwar phantasmagorias of difference. They establish the conditions under which the formal and stylistic legacies of the variety show and the revue theater were enlisted in the survival, or revival, of those ethnic representations banned from the spheres of high culture and official politics. More specifically, the performance of an ethnic Other allowed the members of the entrepreneurial new middle classes—the intended audience in, and of, these colorful stories of individual effort and reward—to proclaim their freedom from all external determinants and to pursue their goals with aggressive determination. Needless to say, the division between world and stage established by the proscenium organizes these two paradigms of identity in fundamentally unequal terms, the all too familiar discourses of alterity (e.g., exoticism, primitivism) that hold together the production numbers and the new discourses of normalization, called the Economic Miracle, that dominate in the narratives. Precisely this inequality, I argue, serves as the generative principle behind the celebration of America as an ethnic Other.

Within these formal constraints, the production numbers provide a seductive mise-en-scène for articulating the difference between those bodies marked as ethnic and those marked as nonethnic: that is, as German. But what kind of ethnic(ized) figures facilitate such fantastic investments? Obviously all are marked as ethnic through their identification with particular costumes, settings, locations, and, most importantly, musical forms and dance styles. In addition to the standard classical, traditional, and modern numbers, the typical revue pro-

gram of the 1950s included North American dance and music styles like
the foxtrot, swing, and rock and roll as well as Latin standards like
rumba, calypso, bossa nova, and cha-cha. With costume and set design
defining the setting and with music establishing the mood, the group
dances were choreographed to express the presumed essence of the eth-
nic body through clichéd references to traditional folk culture and con-
temporary interpretations of these traditions. Responsible for adding
psychological interiority, the songs strengthened the bond between
soloist and ensemble through the musical encoding of temperament,
mentality, and, especially in the plantation numbers, of soul. Aiming at
both a re-essentializing of the body and a remapping of the topogra-
phies of ethnicity, the combination of song and dance consequently
served two equally important functions: to celebrate "America" as a
model of cultural hybridization and, in less obvious ways, to represent
Germanness as an unarticulated, undifferentiated and therefore fully
modern category.[4]

A rather typical approach to the staging of an ethnicized "America"
can be found in the Willy Zeyn-Film production *Tausend Sterne
leuchten* (A Thousand Stars Aglitter, 1959, dir. Harald Philipp). Its
revue program, suggestively called "colorful world," reflects quite self-
consciously on the changing meaning of "America" in postwar culture
by offering compensatory fantasies of German agency and control.
The underlying fascination with a premodern, rather than modern,
America finds expression in several numbers that rely heavily on con-
temporary styles to achieve their anachronistic effects. These include a
raucous "Billy the Kid" Wild West saloon number with cowboys danc-
ing—or, rather, stomping—to rock and roll music, a "Mississippi
Blues" plantation number complete with black slaves carrying bales of
cotton, and a lively song-and-dance number titled "Love on the Island
of Trinidad."[5] Throughout, the number principle of the stage revue
helps to contain the potentially transgressive effects of what I have
called retroprimitivism. Thus in the same way that the "male" adven-
ture of the Western frontier is counterbalanced by the "female"
romance of the antebellum South, the hedonism of the tropics is incor-
porated in a later Dixieland number that translates the foreign musical
elements (e.g., "black" vocal styles) into more familiar "white"
rhythms (i.e., the same melodies but without syncopation). During the
grand finale, these German-American hybrid identities become fully
available to the rituals of cultural consumption once their exotic other-
ness are safely incorporated into the perspectives of mass tourism. As
promised by the agaves, pine trees, and cypresses from the vaguely

Tausend Sterne leuchten (A Thousand Stars Aglitter, 1959, dir. Harald Philipp).
(Courtesy Filmmuseum Berlin—Deutsche Kinemathek.)

Mediterranean set designs, the possibility of wish fulfillment lies within
easy reach to most postwar audiences: namely, in the form of a vaca-
tion trip to Italy or Spain.

The West German revival of the revue film, a genre that had thrived
during World War II, facilitated these kinds of symbolic investments
through generic conventions so different from the classical Hollywood
musical of the 1950s that they warrant a brief comparison between
German and American approaches to the filmic representation of song
and dance. To begin with the all-important question of mise-en-scène,
the classical Hollywood musical seeks to blur the lines between stage
and world through a naturalization of performance.[6] Unlike the UFA
(Universum Film AG) sound film operettas of the early 1930s, the
revue film heightens the same difference by relying on elements of the-
atricality. Where the former simulates the thrill of live performance
through filmic means, including innovative editing and camerawork,
the latter relies on enthusiastic audiences in the diegesis to "prove" the
quality of a stage program. The extensive rehearsal scenes in the musi-
cal aim at a narrativization of performance, while the elaborate pro-
duction numbers in the revue film reduce song and dance to a consum-

able spectacle. Confirming this point, most production numbers are shot frontally, as a theatrical event, and lack the camera movements and shot, countershot patterns that elsewhere help to integrate the performance into the narrative. The high degree of self-reflexivity in the classical Hollywood musical affirms the power of entertainment through the double mechanisms of demystification and remystification. In achieving these effects, most backstage stories focus on a performer's determined pursuit of artistic recognition and success. In the revue film, the stories about troubled productions and struggling theaters are typically told from the perspective of management and its financial or legal problems. Artistic ambitions and concerns clearly play a secondary role; the heavy reliance on clichés and stereotypes is never questioned. Throughout, the divisions established by the proscenium remain firmly in place, even in the open seating arrangement found in the fashionable nightclubs and dinner theaters. As a consequence, the stars perform only on the stage; off the stage, they want nothing more than to be respectable members of the old or new middle classes.

Recognizing the differences between the West German revue film and the Hollywood musical of the 1950s does not necessarily mean accepting the military etymology of the term *revue* and assume an inherent link between aesthetics and politics in the German case. Siegfried Kracauer's reflections on the "mass ornament" have prompted some speculation about the affinities between stage choreography and the militarization of society, especially under National Socialism.[7] However, it is not always productive to equate ossified forms of representation with "ossified forms of perception,"[8] especially when dealing with an "excessive" genre such as the revue film.[9] Greater attention to its performative qualities and the constitutive tension between spectacle and spectatorship suggests more complicated sociopsychological investments that can only be reconstructed through the historical conditions of production and reception. After all, it was the genre's standardized formal and thematic elements that allowed choreographers during the 1950s to abandon the celebration of the collective (e.g., in the chorus line) for the reaffirmation of the individual (e.g., through the emphasis on the soloist). The experiments with serialization and reproducibility found in the theatrical revue format of the 1920s thus gave way to the infinite combinations promised by ethnicity as a proto-postmodern fantasy. Taking advantage of the genre's highly eclectic approach, the directors and producers specializing in the revue film after 1945 were consequently able to utilize its old-fashioned musical and theatrical styles for the demands of a new entertainment and

consumer culture, including its touristy perspectives on an exotized and eroticized Other. The generative principle behind these new symbolic investments resembles the process of appropriation and incorporation that characterized the Americanization of German popular culture and the simultaneous Germanization of American forms, styles, and sensibilities in West German postwar culture as a whole. Of course, in the case of the revue films, the question remains: what was the purpose of such musical hybridization? To simulate and thereby work through the racial theories of the past and replace them with more flexible definitions of culture and identity? Or to use the spectacle of the racialized Other in the reconstruction of West German identity, a process that responded in direct and indirect ways to the Allied Occupation and the cold war?

Answering these questions requires a closer look at the individuals responsible for creating these fantasies of "America" as ethnic Other. A small number of producers dominated the field, including the enterprising Artur Brauner of CCC (Central Cinema Company), who, in more than one film, cast Hubert von Meyerinck as a frantic (and decidedly queer) theater owner or stage manager. Playing his competent secretary and resourceful factotum, Ruth Stephan and Rudolf Platte infused the stories with the kind of forced optimism and frantic activism that, interestingly, also characterized the troubled West German film industry.[10] The lead performers always included a few older UFA stars such as Hungarian Marika Rökk, but the vast majority came from an international group of young recording stars, including French-born Caterina Valente and Silvio Francesco, Swiss Vico Torriani, Austrians Peter Alexander and Freddy Quinn, Swedish Bibi Johns, British Chris Howland, American Bill Ramsey, and, in two famous guest roles, Louis Armstrong in the 1959 productions *La Paloma* (dir. Paul Martin) and *Die Nacht vor der Premiere* (The Night before the Premiere, dir. Georg Jacoby). The appearance of these international stars in a German-language environment was made possible by the widespread practice of dubbing and the creative use of accents, including by German singers and dancers pretending to be foreigners. More often than not, a star's nationality had little to do with his or her screen persona; for instance, Valente and Torriani usually played Italians. Largely because of financial constraints, conventional forms and derivative styles prevailed in the approach to orchestration and choreography. The revue format offered only limited opportunities for talented dancers like Ellen and Alice Kessler and experienced choreographers like Sabine Ress, responsible for many of the colorful Caribbean

numbers. Musical accompaniment was provided by radio orchestras such as the Berlin-based RIAS-Tanzorchester, the orchestra of choice for most CCC productions. Dance ensembles were on loan from state operas, revue theaters, and, beginning in the late 1950s, public television channels (e.g., in the case of Südfunkballett), a fact that, together with a uniquely German approach to mise-en-scène already codified during the silent film era, contributed to the enduring preference for frontal staging and theatrical effects.

The creative personnel of the postwar revue film produced a steady stream of ethnic scenarios that were much too dependent on generic convention and stylistic eclecticism simply to be equated with the ideologies of race and nation—although there exist compelling reasons (perhaps to be examined on another occasion) to speculate about the political function of these colorful, if not outright garish, spectacles of race and ethnicity in the larger context of 1950s popular culture. In theatrical terms, these production numbers may be described to practice a form of "blackface"—of being *braun angemalt* (painted brown), to quote the stage manager from *Ramona* (1961, dir. Paul Martin)—and can thus be connected to the genre's long history of "ethnic drag," to appropriate a phrase from Katrin Sieg.[11] The revue format has always depended on a well-established iconography of the Other, from the orientalist scenarios (e.g., inspired by Persia or China) in the popular variety shows of the 1910s to the erotic fantasies (e.g., surrounding images of blackness) familiar from the spectacular revues of the 1920s. However, the West German revue films of the 1950s stand out through a heightened awareness of, if not compulsive fascination with, the performativity of identity that can only be explained through the contribution of these production numbers to the emergence after 1945 of "America" as an ethnic category.

Since the 1910s, the identification of Americanization with mechanization, homogenization, and standardization (e.g., in the figure of the New Woman) has been accompanied by a complementary fantasy based on the association of America with the kind of primitivism captured most problematically in the figure of the "Negro."[12] In the theater, cinema, and concert hall, the gradual transformation of an ethnic America into the prehistory of a fully Americanized Europe can be seen in the cult status of 1920s revue stars such as Josephine Baker as well as in the enthusiastic reception of Louis Armstrong during the 1950s. In the German case, these strategies of exclusion and incorporation are further complicated by their connection to the National Socialist rhetoric of racial and cultural decadence and their diatribes

against the "niggerization (*Verniggerung*) of music and theater," to cite a slogan from the infamous 1937 Degenerate Art Exhibition.[13] In resisting the coupling of Americanism with modernization, postwar filmmakers (in the West) failed to reconnect to the cultural legacies of Weimar culture and, in ways more familiar from Third Reich cinema (e.g., Detlef Sierck's 1938 Puerto Rico film *La Habanera*), enlisted the antebellum South, the Caribbean, and, less frequently, South America in two equally problematic discursive operations, the normalization of racialized imagery through the association with stage performance and musical entertainment and the reconceptualization of Germanness outside the tainted categories of *Volk* and nation.

Of course, this divided mise-en-scène requires certain prohibitions on representation—namely, that the set designs never resemble actual places, that the ethnic characters never cross over into the main story, and that the German protagonists never become part of the stage fantasy.[14] If they do, more aggressive forms of racial stereotyping have to be mobilized. To give one example, in Geza von Cziffra's *Die Beine von Dolores* (The Legs of Dolores, 1957), a wealthy African American woman, referred to by everyone as the "chocolate lady," saves a struggling revue theater from bankruptcy and, in so doing, allows the entrepreneurial Germans to realize their own dreams of fame and fortune. Yet the assumption of power by the "native" woman in the narrative eventually calls for a compensatory stage fantasy in the form of a nostalgic plantation number set in rural Alabama. Through the cutting back and forth between the "Uncle Tom" figure on the stage and the "chocolate lady" in the audience, the woman is punished for her "transgressions" and reclaimed for the visual spectacle of primitivism. Achieving similar integrative effects, *Der Stern von Santa Clara* (The Star of Santa Clara, 1958, dir. Werner Jacobs) opens with a lively production number that, through the vehicle of traditional Mexican folk culture, thematizes the Americanization of postwar Europe. The two theme songs about the teenagers from "Tampico" and "Tennessee" present two different models of *Volkstümlichkeit* (popularity), the harmonious convergence of ethnic and popular culture identified with traditional Latin culture and the explosive combination of soul, blues, and rock and roll associated with the American South. Ending with a hymn to American youth culture and its leveling effects, the ecstatic staging of a mass-produced popular culture beyond a specific time and place appears blissfully indifferent to the divided reception of postwar Americanization as either liberation or colonization. But again, the perspective of the diegetic spectators in the theater facilitates a supple-

Louis Armstrong during the production of *La Paloma* (1959, dir. Paul Martin). With Wolf Brauner, cinematographer Karl Loeb, and assistant director Jochen Wiedermann. (Courtesy Filmmuseum Berlin—Deutsche Kinemathek.)

mental fantasy in which the association of America with popular culture (i.e., folk culture) makes possible the self-representation of West German postwar society as the full realization of German modernity. Because the performers on the stage remain defined by their (fake) ethnic costumes, the members in the audience can overcome such confining categories in their own lives. Bringing together both sides in this spectatorial relationship, the exemplary stories of effort, failure, and reward acted out by the narrative's enterprising producers and managers implicate the revue film directly in the heroic narratives of the Economic Miracle and its forceful assertion of West German identity as fully modern, which also means: as unmarked by ethnic or national characteristics.

The overdetermined function of the production numbers becomes even more apparent once we move from generic analysis to the larger context of film production and cultural consumption. At a time when many established musical genres (e.g., film operettas, composer films) seemed less and less able to accommodate contemporary tastes and sensibilities, the revue film, too, found itself simultaneously relying on, and attempting to move beyond, the highly standardized modes of production developed to perfection in the old UFA studios. The inevitable crisis of the revue format was acknowledged in the almost compulsive self-thematization necessitated by the growing competition from more fashionable musical forms such as jazz, rock and roll, and the so-called *Schlager* (literally: hit song). Producers responded to the problem of declining mass appeal by taking greater advantage of the close relationship between the film and recording industries by coordinating new releases with a singer's concert tours and media campaigns (e.g., in the case of CCC and Polydor). Similar economic considerations, this time linked to the profitable business of ballroom dancing schools and amateur dance competitions, stood behind the German reception of Hollywood films with a Latin American or Caribbean theme and the widespread fascination with all things Latin in popular music and consumer culture, including women's fashions. With European markets no longer accessible during the war years, Hollywood studios during the 1940s had turned to Latin America in order to cultivate the "other" American markets south of the border. In postwar Germany, this pattern of marketing otherness continued in the enthusiastic postwar reception of American mass culture from the 1940s and 1950s. Thus aside from the enduring fascination with Hollywood versions of Latin America and the Caribbean that fueled the West German success of Carmen Miranda extravaganzas like *Road to Rio* (1947, dir. Norman Z. McLeod) as well as ambitious screen adaptations like *Carmen Jones* (1954, dir. Otto Preminger), musical tastes on both sides of the Atlantic now shifted more and more to Anglo-American cultural topographies. The wholesome lifestyles of the Midwest depicted in rural musicals like *Oklahoma!* (1955, dir. Fred Zinnemann) allowed West German audiences to indulge their nostalgic interest in folk traditions, whereas the culture of the Old South proved susceptive to their own strategies of cultural revisionism, as evidenced by the popular appeal of a classical Broadway production like *Show Boat* (1951, dir. George Sidney) and the screen adaptation of Gershwin's *Porgy and Bess* (1959, dir. Otto Preminger). All of these films had a strong influence on the West German revue film.

The revue film's love affair with Latin music coincided with the gradual assimilation of jazz and blues traditions to mainstream musical tastes, a process that had started in West Germany's artistic and intellectual subcultures. Yet the real challenge to the revue film's continued viability came from the commercialized youth culture that had made possible the phenomenal success of rock and roll both in the original American idioms and in the Germanized versions popularized by youth idols like Buddy Holly look-alike Peter Kraus. Relying on its long tradition of hybridization, the revue film utilized all three musical influences in its desperate efforts at modernization. To give only one example, the inclusion of Latin styles in the standard ballroom repertoire allowed choreographers to blur the boundaries that, until that point, had distinguished folk and popular dance through their different relationship to tradition and modernity. However, such gestures toward contemporary tastes were limited to musical styles and did not extend to the oppositional stance associated with these other musical traditions (e.g., the critique of conservative sexual morality). For that reason, the revue film ultimately proved less successful in attracting new youth audiences than in sustaining the interest of the faithful UFA fan community, an indication of the growing obsolescence of the variety format and its rigid divisions between narrative and spectacle, despite the genre's proto-postmodern visual sensibilities.

Apart from the international orientation in the cast of performers and the choice of musical styles, the modernizing impulses in the genre are most apparent in its own narratives of self-renewal. Two approaches can be found: the call for a radical break with established traditions and the integration of new styles into existing formulas. The possibility of reconciling convention and innovation is addressed in two Marika Rökk vehicles directed by Georg Jacoby and choreographed by Sabine Ress. In the finale of *Sensation in San Remo* (1951), the well-known singer-dancer calls for an opening of German musical culture toward more contemporary styles. Presenting her argument with typical didactic zeal, Rökk reprimands a group of elderly professors for their old-fashioned tastes: "Your views about modern dance are not up-to-date." To make her point, she leads the white-haired scholars through a short history of twentieth-century dance that culminates in an apotheosis of big-city life, complete with black extras. In *Nachts im grünen Kakadu* (At the Green Cockatoo by Night, 1957), Rökk guides her theater audience through a similar tour de force, from a sentimental waltz and wild boogie-woogie to the obligatory Caribbean number with black men, white sails, steel drums, and plenty

Nachts im grünen Kakadu (At the Green Cockatoo by Night, 1957, dir. Georg Jacoby). (Courtesy Filmmuseum Berlin—Deutsche Kinemathek.)

of bananas. Taking a slightly different approach but with the same integrative effects, *La Paloma* presents its argument for a modernization of the genre through the competition between two rival West Berlin revue theaters, the Metropol and the Plaza, both of which are using the eponymous popular Spanish song to put together a more contemporary and, hopefully, commercially more successful program.

The heavy reliance on folk elements in these production numbers also brings into relief another imaginary topography, the validation of enlightened modernity in the staging of European culture (e.g., in the Italian numbers) and the cultivation of folkloristic scenarios through the spectacle of a premodern America. In reassigning the sites of ethnicity along the modern versus traditional, European versus American divide, the postwar revue film was able to draw upon well-established theatrical traditions and, even more important, a long history of musical hybridization in German cinema. After all, the genre had developed out of the variety format prevalent in the early cinema of attractions (e.g., in the Wintergarten of the Skladanowsky brothers), found inspiration in the spectacular revues from the 1920s (e.g., at the Metropol Theater and the Haller Revue), and acquired its filmic credentials by updating the European tradition of song and dance (e.g., the Viennese

operetta) through an infusion of more contemporary American styles (e.g., the ornamental choreography of Busby Berkeley, the tap dancing of Fred Astaire and Ginger Rogers).[15] Early in the sound film period the revue film took full advantage of the various traditions identified with American and central European culture in demonstrating its simultaneous commitment to regional and national, popular and folkloristic, and modern and traditional influences. During the postwar period, it was precisely this amalgamation of German, American, and central European elements that sustained the relationship between two very different mise-en-scènes, the traditional folk cultures evoked in the celebration of an ethnic Other (i.e., the performance on the stage) and the homogeneous, upwardly mobile middle-class society created by the Economic Miracle (i.e., the audience in the theater).

The function of ethnicity in the West German revue film can be further clarified through a brief look at the other musical genres that similarly attempted to reclaim a normalized Germanness through the collective identities conjured up by song-and-dance performances.[16] Old-fashioned film operettas during the period continued to rely on Viennese sentimentality to make the Habsburg monarchy appear as a perfect model of social harmony and cultural refinement (e.g., in the 1962 production of *Die Fledermaus*). The popular *Schlagerfilme* Germanized contemporary American styles like rock and roll in an attempt to incorporate the threat of rebellious youth into the social and cultural rituals of the emerging *Wohlstandsgesellschaft* (e.g., in the Peter Kraus vehicle *Tausend Melodien* [A Thousand Melodies, 1956, dir. Hans Deppe]). Even the *Heimatfilme* provided a musical setting for the affirmation of regional culture in the context of local anniversaries and folk festivals (e.g., in *Am Brunnen vor dem Tore* [At the Well in Front of the Gate, 1952, dir. Hans Wolff]). The revue films differed from these other musical forms in two ways, their resistance to narrative integration and their insistence on visual spectacle. In the *Heimatfilme* and *Schlagerfilme,* song and dance remained an integral part of the narrative—which means that the threat of the Other (e.g., in the form of "alien" musical styles) could be contained through the means of confrontation and, eventually, incorporation. By contrast, the revue films highlighted the fundamental opposition between theater and world and celebrated their different modes of identity and performativity. The lack of narrative integration gave choreographers license to present the Other as pure fantasy, a quality that played a pivotal role in the elevation of "America" to a model of traditional folk culture. Likewise, the sharp distinction between the illusionism of

visual spectacle and the (false) realism of the narrative established a formal structure for the assertion of German normalcy against the staged scenarios of alterity.

Perhaps the strongest case for the overdetermined function of ethnicity in the production numbers can be made through a brief comparison to the East German revue film. All of the films mentioned thus far establish a mise-en-scène for the performance of an ethnic Other; which also means that they facilitate a reenactment of the suppressed discourse of race through the (modified) generic conventions identified with the legacies of UFA. In merging narrative and musical space, DEFA (Deutsche Film-Aktiengesellschaft) productions aim at a very different discursive effect: the thematization of the conditions of production in the new socialist film culture and nationalized film industry. Thus, where the West German films highlight the creative possibilities of the individual in a free market economy, the East German films emphasize the individual's contribution to the building of a truly socialist society. While the spatial divisions established by the proscenium arch allowed West German filmmakers to assert the modernity of the Federal Republic against an ethnic Other identified as American, the unification of narrative and spectacle enabled their East German counterparts to assume a fundamentally different relationship to the process of modernization, namely one inspired by the experience of nationalization and collectivization in the German Democratic Republic.

Open about their didactic intentions, the DEFA revue films narrativize the search for a better relationship between popular and socialist culture by breaking with the genre's problematic reliance on ethnic, racial, and national stereotypes. In developing more relevant topics, settings, and protagonists for their production numbers, the artists and their audiences partake in a larger political project that ultimately aims at the performance of a unified identity beyond class differences. *Silvesterpunsch* (New Year's Eve Punch, 1960, dir. Günter Reisch) and *Revue um Mitternacht* (Midnight Revue, 1962, dir. Gottfried Kolditz) achieve this necessary transition from the stereotypical revue elements to the socialist spectacle of labor and industry in an almost programmatic fashion. In *Silvesterpunsch,* preparations for the New Year's Eve party of a chemical combine occasion a heated debate about the recreational needs of the workers and the responsibility of the entertainers to remain "connected to the people" (*volksverbunden*). After many arguments, a compromise solution is reached under which the traditions of regional folk culture can coexist peacefully with the cult of

technology celebrated in the "Song of Calcium Carbide" number. Working on a new revue show, Manfred Krug in *Revue um Mitternacht* similarly considers a number of popular dance styles, including cancan, waltz, tango, and Charleston, but quickly dismisses all of them as typical expressions of bourgeois individualism. Finally, he and his collaborators find a more appealing model for their emerging society in what, based on their slick "Symphony of the Big City" number, might be called socialist modernism. Typical urban settings like gas stations and traffic intersections are enlisted in a triumphant choreography of modernization that recalls both the cosmopolitanism of *West Side Story* (1961, dir. Jerome Robbins and Robert Wise) and the collectivism propagated by the more politicized Eastern Bloc musicals showcased recently in the postcommunist compilation film *East Side Story* (1997, dir. Dana Ranga).

The surprising similarities in the preoccupation with generic traditions and the very different responses to the problem of staging nation and race bring into relief the competing ideological projects that sustained West and East German cinema during the 1950s, not least in relation to the divergent German-German narratives of mass culture and modernity generated by the Economic Miracle and the cold war. From this perspective, a symptomatic reading of the revue genre allow us to connect the ethnic stereotyping in the production numbers to other, seemingly unrelated postwar phenomena. For instance, how must we interpret the pervasive fascination with ethnicity as an aspect of tourism, consumerism, and mass entertainment in relation to the economic goals of reconstruction and the political goals of *Vergangenheitsbewältigung* (coming to terms with the past)? To what degree is the ethnicized topography of the Other also a function of the Allied Occupation and the cold war with their very different national and transnational fantasies? And in what ways does the revue film contribute to the overlapping binaries of German versus American, and West German versus East German—that is, the binaries that sustained the genre's imaginary topographies in relation to the Economic Miracle in the West and the building of socialism in the East?[17]

To return to the critical terms laid out at the beginning, the fascination with America as the ethnic Other in the West German revue films of the 1950s allowed contemporary audiences simultaneously to address and to suppress the question of ethnicity and race and, in so doing, to set into motion the process of postwar normalization. Within the spatial divisions established by the proscenium, the spectacle of a fixed, stable identity located in the "primitive" American body gave

purpose and meaning to the entrepreneurial, materialist, consumerist, and upwardly mobile new middle classes created by the Economic Miracle. And it is precisely through such aesthetic and discursive investments that a quintessentially "impure" genre such as the revue film opens up new ways of thinking about film genres and musical styles outside the rigid opposition of the national and the transnational. For the production numbers discussed on the previous pages clearly demonstrate that the categories of identity and performance cannot be reduced to the binaries of stage versus world, reality versus fantasy, but must be evaluated through the elusive dynamics of spectacle and spectatorship organized by the proscenium arch and processed through the musical articulation of exoticism, eroticism, and what I have called retroprimitivism. Consequently, the revue film allows us to trace fundamental changes in the articulation of ethnic identities that, from the perspective of German and European unification, marks the beginning of more far-reaching developments associated today with such terms as multiculturalism and cultural hybridity. At the same time, the revue film brings into relief the highly unstable meaning of "America" as a category of self and Other—a characteristic that must be considered of greatest relevance to a better understanding of Americanization as the negative foil of German identity in its various filmic, musical, and performative manifestations.

Notes

I want to thank the participants of the Sixteenth St. Louis Symposium on German Literature and Culture in March 2002 for their helpful comments on an earlier version of this essay; special thanks to Eric Rentschler, Lutz Koepnick, Stephan Schindler, Kathrin Bower, and Hans-Michael Bock.

1. One notable exception can be found in *Paloma* (1959), where three GIs in a restaurant give a folksy rendition of "Tom Dooley," complete with fake American accents; compare the friendly reactions of the other guests to the deep anxieties about cultural colonization thematized in an earlier musical comedy like *Hallo Fräulein!* (Hello, Fraulein!, 1949, dir. Rudolf Jugert).

2. For an introduction to postwar cinema in the Federal Republic, see Claudius Seidl, *Der deutsche Film der fünfziger Jahre* (Munich: Heyne, 1987); Ursula Bessen, *Trümmer und Träume. Nachkriegszeit und fünfziger Jahre auf Zelluloid. Deutsche Spielfilme als Zeugnisse ihrer Zeit. Eine Dokumentation* (Bochum: Studienverlag Dr. N. Brockmeyer, 1989); and Micaela Jary, *Traumfabriken made in Germany: Die Geschichte des deutschen Nachkriegsfilms 1945–1960* (Berlin: Edition Q., 1993).

3. For a typical ideology-critical reading, see Gertrud Koch, "Wir tanzen in den Urlaub. Musikfilm als Betriebsausflug," *Filme* 3 (1980): 24–29.

4. The production numbers drew upon various traditions but relied most heavily on folk and popular styles and their ethnically coded sets, props, and costumes. However, in an effort to avoid all suggestions of authenticity, the spectacle of old-fashioned ethnicity was always presented from the perspective of contemporary styles, from the provocative sensuality of Latin dance to the aggressive sexuality of rock and roll. Other traditions exerted their influence in more indirect ways. The minimalist style of modern choreographers such as Martha Graham or George Balachine remained limited to performances that openly aspired to high-culture status. Similarly, the expressive registers of *Ausdruckstanz* as interpreted by Harald Kreutzberg and Yvonne Georgi played only a minor role in the symbolic investments that implicated popular dance in the discourses of race and nation.

5. The soloist in this number, Kenneth Spenser, also appeared in the 1946 Broadway revival of *Show Boat*.

6. This point has been made by, among others, Jane Feuer, *The Hollywood Musical*, 2nd ed. (Houndmills: Macmillan, 1993), 43.

7. See Karsten Witte, "Gehemmte Schaulust. Momente des deutschen Revuefilms," *Wir tanzen um die Welt: Deutsche Revuefilme 1933–1945*, ed. Helga Belach (Munich: Hanser, 1979), 7–52; and Reinhard Klooss and Thomas Reuter, *Körperbilder: Menschenornamente in Revuetheater und Revuefilm* (Frankfurt am Main: Syndikat, 1980).

8. Klooss and Reuter, *Körperbilder*, 11.

9. The formal similarities between the theatrical and military choreography of the masses, which constitute the basis of such allegorical readings of the (fascist) culture industry, appear only in a few films about girls' "dancing troupes" (*Tanztruppen*). Throughout the 1930s and 1940s, musical forms, dance styles, and staging conventions much more pervasively celebrated the power of the star system, thereby suggesting a greater investment in the question of individual (rather than collective) self-realization. To give only one example, the remarkable continuities in Marika Rökk's career show to what degree the "Merry Widow" rather than the "Tiller Girls" remained the predominant influence in the approach to ethnic and national stereotypes, including in the gendered coding of romance and sentiment.

10. On Brauner, see Claudia Dillmann-Kühn, *Artur Brauner und die CCC: Filmgeschäft, Produktionsalltag, Studiogeschichte 1946–1990* (Frankfurt am Main: Deutsches Filmmuseum, 1990).

11. Katrin Sieg, *Ethnic Drag: Performing Race, Nation, Sexuality in Postwar Germany* (Ann Arbor: University of Michigan Press, 2002).

12. On the discourse of blackness in German culture, see Fatima El-Tayeb, *Schwarze Deutsche: Der Diskurs um Rasse und nationale Identität, 1890–1933* (Frankfurt am Main: Campus Verlag, 2001); and Reinhild Steingroever and Patricia Mazon, eds., *Not So Plain as Black and White: Afro-German History and Culture from 1890–2000* (Binghamton: SUNY Press, 2002).

13. Michael H. Kater, *Different Drummers: Jazz in the Culture of Nazi Germany* (New York: Oxford University Press, 1992).

14. One of the few exceptions occurs in *La Paloma* when Louis Armstrong invites a young blond girl from the prompt box to join him for a lullaby. The

appropriation of jazz and blues is more pronounced in *Schlagerfilme* like *Die große Chance* (The Big Chance, 1957, dir. Hans Quest), where African-American jazz musicians jam with Americanized Germans while Catholic priests teach Negro spirituals to their youthful flock.

15. On Weimar Berlin and the famous stage revues by Eric Charell, Hans Haller, and James Klein, see Wolfgang Jansen, *Glanzrevuen der zwanziger Jahre* (Berlin: Edition Hentrich, 1992). On Berlin nightlife during the 1930s and 1940s, see Knud Wolffram, *Tanzdielen und Vergnügungspaläste: Berliner Nachtleben in den dreißiger und vierziger Jahren* (Berlin: Edition Hentrich, 1992). On the history of music and dance in German cinema, see Katja Uhlenbrok, ed., *MusikSpektakelFilm: Musiktheater und Tanzkultur im deutschen Film* (Munich: Edition Text und Kritik, 1998); and Malte Hagener and Jens Hans, eds., *Als die Filme laufen lernten: Innovation und Tradition im Musikfilm 1928–1938* (Munich: Edition Text und Kritik, 1999).

16. For a brief survey of this hybrid genre, see Tim Bergfelder, "Between Nostalgia and Amnesia. Musical Genres in 1950s German Cinema," *Musicals: Hollywood and Beyond,* ed. Bill Marshall and Robynn Stilwell (Exeter: Intellect Books, 2000), 80–88.

17. For reassessments of postwar culture that focus on the category of gender, see Erica Carter, *How German Is She? Postwar West German Reconstruction and the Consuming Woman* (Ann Arbor: University of Michigan Press, 1997), especially the chapter "Film, Melodrama, and the Consuming Woman" (171–201); and Hanna Schissler, ed., *The Miracle Years: A Cultural History of West Germany, 1949–68* (Princeton: Princeton University Press, 2001), especially Ute Poiger, "A New 'Western' Hero? Reconstructing German Masculinity in the 1950s" (412–27). On the dynamics of gender and race, also see Heide Fehrenbach, "Rehabilitating Fatherland: Race and German Remasculinization," *Signs* 24 (1998): 10–15.

On Location

Das doppelte Lottchen, The Parent Trap, and Geographical Knowledge in the Age of Disney

Joseph Loewenstein and Lynne Tatlock

In the cheerful, enervated manner of contemporary reference, the pan of vestigial forest at the summer camp in Disney's *Parent Trap* of 1998 catches a rustic signpost. One sign shows the way to the "Sportsfield"; the other to "Timbuktu." In what seems a gesture of film-school post-modernity, this second sign points beyond Timbuktu to the English-dubbed version of *Charlie & Louise* (1993), a German sibling of the American film, and points specifically to the geomathematical word problem that a nasty and nastily conventional examining board has devised to stump the unacademic twin, Charlotte.

> EXAMINER: One train is traveling from Hamburg at 60 km an
> hour. Another train is coming from Berlin at 40 km an hour.
> How far apart will the trains be one hour before they meet?
> CHARLIE: One from Hamburg, the other from Berlin—
> EXAMINER: Yes, yes, who cares? They can be traveling from
> Timbuktu to Disneyland if you want.[1]

Charlotte—or Charlie, as she calls herself—can solve the problem because she is not Charlie, but the thoughtful and sober Louise, imper-sonating Charlie. Although she is not thoughtful enough to refuse the premise of trains traveling at speeds that would bring modern Europe to economic collapse, she is sober enough to take the examiner's exas-perated clue, which is that local origins are irrelevant to modern under-standing. Our subject here is that lapse of confidence in local distinc-tion suggested by this story problem. We will trace in a series of remakes a microhistory of forgotten place.

Hamburg and Berlin were not always reducible to Disneyland and

Timbuktu. If we follow the commemorative direction of the sign from
Nancy Meyer's remade *Parent Trap* (1998) to Joseph Vilsmaier's *Char-
lie & Louise,* and thence, earlier, to David Swift's *Parent Trap* (1961),
and finally to *Das doppelte Lottchen*—both Josef von Baky's 1950 film
and Erich Kästner's 1949 children's novel—we arrive at an original
question about our knowledge of place, "Kennt ihr eigentlich See-
bühl?" (Do you know Seebühl?). And the gentle examiner of *Das dop-
pelte Lottchen* goes on to assert a gap in that knowledge: "Keiner, den
man fragt, kennt Seebühl!" (No one you ask knows Seebühl!). Yet
place, as everyone once knew, is a primary determinant of character—
thus the novel's introduction of the first of its two heroines, "ein kleines
neunjähriges Mädchen, das den Kopf voller Locken und Einfälle hat
und Luise heißt, Luise Palfy. Aus Wien" (163; a little, nine-year-old girl
with a head full of curls and bright ideas, who goes by the name of
Louise Palfy—from Vienna); thus, too, the rendering of the approach
of plot, in the clamorous form of a busload of other little girls—from
south Germany (164); and thus, the emergence of the crucial One from
among them: Lotte Körner—from Munich (166).

Do we know Seebühl? Is geography more than a narrative conve-
nience in this work, more than a simple explanation for the fact that
the twins have not met before? As Kästner reframes the question—
"Das Gebirgsdorf Seebühl?" (163; The mountain village, Seebühl?)—
he offers a first answer by adumbrating the snow-capped panorama
that follows: geography makes a generic affiliation, to the *Heimatfilm*
and to its local nostalgias. But if geography is more than a narrative
convenience, is it more than a space of memory and its lapses? Kästner
and von Baky would have it so: in *Das doppelte Lottchen* geography
turns out in fact to be the essential figure of knowledge. "Jede entdeckt
einen anderen, einen neuen Kontinent. Das, was bis jetzt von ihrem
Kinderhimmel umspannt wurde, war . . . nur die eine Hälfte ihrer
Welt" (180; Each girl discovered another continent, a new one. What
their little universe had encompassed before was now only half of their
world). Space is a thick medium here, and when the twins decide to
impersonate each other, they seize on spatial knowledge as one of the
two primary constituents—the other is food—from which the alter ego
is fabricated. Each must master the other's likes and dislikes, must also
memorize the unknown parent's preferences, but the film registers
preference as an urban spatial habitus: not simply that the carnivorous
Lotte must develop an appetite for *Palatschinken,* but that she must eat
them at the Imperial Restaurant; not merely that Luise must remember

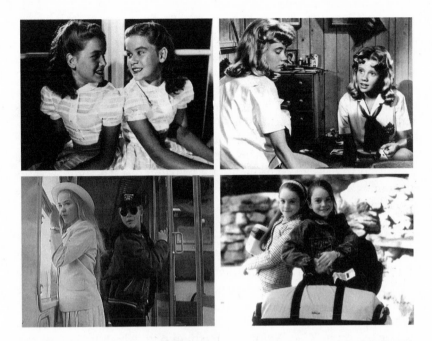

Four times *Das doppelte Lottchen* (clockwise, starting with upper left: *Das doppelte Lottchen* [1950, dir. Josef von Baky], *The Parent Trap* [1961, dir. David Swift], *The Parent Trap* [1998, dir. Nancy Meyers], *Charlie & Louise* [1993, dir. Joseph Vilsmaier]). (Courtesy Filmmuseum Berlin—Deutsche Kinemathek.)

that her mother likes noodle soup with beef, but that one buys the beef from a shop at the corner of Max Emanuel and Prince Eugen (184).

The inattentive Luise—for in *Das doppelte Lottchen* Luise is the undisciplined child of an artistic father, whereas in *Charlie & Louise* Louise is the meticulous *Hausmütterchen*—the Luise of the film is ill-equipped for spatial adaptation and will find herself lost in her mother's kitchen. Later, she will have to trick a classmate into steering her through her "own" Munich neighborhood to Frau Wagenthaler's grocery store; Lotte, on the other hand, will find her way alone across Vienna to pay a monitory visit to a Fräulein Gerlach, who has set her cap at the twins' father. The child's presumptuous invasion of the haute-bourgeois sphere of the Gerlachs may be an essentially social adventure, yet the film insists on rendering it as a spatial one.

Lotte's mastery of a spatial world and Luise's disorientation provide more than a contrast between the children. Space means differ-

ently in Lotte's native Munich than in Luise's Vienna. Munich presents
a trial to the impersonating Luise, and its baffling configuration is
complemented by a release into the pure pastoral idyll of the moun-
tains around Garmisch, where Luise and her mother spend an almost
boundless weekend. Viennese space, on the other hand, presents the
perspicacious Lotte with no mysteries; rather it is simply frustratingly
zoned, particularly so because of the distance that opened, long ago,
between the father's apartment and his studio. For Lotte, the spatial
problem specific to Vienna reduces to whether the aestheticized and
sexualized studio can be brought into proximity to the home, with its
economies, obligations, and redundancies. But the spatial problem is
also a mnemonic one—not surprising, given the initial affiliation with
the *Heimatfilm:* space and memory are mutually entailed.

Does this mutual entailment persist in the tradition that issues from
Das doppelte Lottchen? In their doubled doubling of twins, the German
and American iterations of *Das doppelte Lottchen* reminisce over the
local, the regional, and the national, even as they find themselves borne
forward by a film industry irresistibly global in tendency. Because of
their sustained concern with geography, whether as a medium of social
knowledge (as in Kästner) or as a medium onto which fictions of cul-
ture may be blithely or doggedly projected (as they are in the remakes),
we propose the four film versions of Kästner's children's novel as an
especially revealing instance of German-American film relations, rela-
tions in which cultural locality is placed under palpable stress.

Of all the vectors of Hollywoodization—Wilder, say, or Dietrich—
Disney is the most cornucopian: one can speak of "Disney" not only as
a historical figure, but as an industry and a mode.[2] Disney's
transfiguration of German *Kulturgut* as first American and then global
products can be read not only in the appropriations of particular
imports—Snow White, Neuschwanstein, Bambi—but in the force by
which these particularities are rebranded, so that whole modalities of
culture—the fairy tale, fantasy, childhood, even color, the "Wonderful
World of Color" to which Disney laid claim in the 1960s—are made
merchantable.[3] Although the Disney remakes credit Kästner, neither
the trailer for the German-dubbed version (released in West Germany
on October 5, 1962) nor current advertisements on video for the Ger-
man-dubbed version of 1998 alert German audiences that Disney is
telling them a story they might already know, because it was once
theirs.[4]

Goods subjected to remanufacture, rebranding, and export, these
films might be discussed as political allegories, their twinnings shown

somehow to reflect on neocolonial practice, and in Germany, on national division, and in America, on international polarization. We are more interested in a differently distinguishing feature of the American iterations, in the fact—to take one example—that in the American versions twinning is not a matter of biology, but of movie magic. Such movie magic is hardly a *simple* reflex of the cold war, or of the latest capitalism for that matter, since twinning reiterates some of the earliest of cinematic visual effects: in a ceremony in which the cultural colonizer markets the colony's own transformed commodity, *The Parent Trap* refines and returns the raw material of such early German films as *Der Student von Prag* (The Student of Prague, 1913, dir. Stellan Rye and Paul Wegener) with its technically virtuosic twinning. Indeed, the Disney films have been marketed in Germany as benign fables of such a circuit of goods, the German-dubbed version of the first *Parent Trap* having been proffered in its commercial trailer as a story of reunion and reconciliation that "alle Wünsche erfüllt" (fulfills every wish), the German-dubbed video of the second *Parent Trap* similarly promising that viewers will "immer wieder was Neues erleben" (encounter something new at every turn). The opening sequence of the latter film confirms its participation in a repeatable cycle of stimulation and fulfillment when it includes a close-up of a wine label, a close-up whose brevity renders the label illegible; only near the end of the film are we able to decipher the words "Where Dreams Have No End," and thus to see the label for what it is, a Disney branding of the remake, as one site in an endless dream cycle of longing, fulfillment, and renewable desire.[5]

To advertise the coupling of innovation with endlessly recirculated desire for narrative is to assert the very mode and signature of the remake. As Leo Braudy would have it,

> in even the most debased version, [the remake] is a meditation on the continuing historical relevance (economic, cultural, psychological) of a particular narrative. A remake is thus always concerned with . . . unfinished cultural business, unrefinable and perhaps finally unassimilable material that remains part of the cultural dialogue—not until it is finally given definitive form, but until it is no longer compelling or interesting.[6]

The commitment to remake, Braudy observes, must be founded on "a basic intuition that . . . the underlying fable is still compelling."[7] Kästner's story apparently remains compelling enough to have elicited

a Hindi version in 2001, *Kuch Khatti Kuch Meethi.*[8] Allegorical inter-
pretation may be useful here, enabling us to construe the mechanical
reproduction of Hayley Mills, both as figure and promise of childhood
and as a commercial resource continually and unnaturally renewable.

We began by asserting the primacy of geographical indices in *Das
doppelte Lottchen,* but the geographical reconfigures itself in subse-
quent remakes until local difference becomes both obtrusive and egre-
giously simulacral. In 1950 acceleration marks the urgency of reunion:
when Luiselotte Körner offers to take the first train to Vienna, her ex-
husband tells her to take a plane instead. In the mythos of twinning
under scrutiny here, accelerating transportation asserts precisely the
insignificance of place: with gleefully empty sagacity, the Californian
Hallie asks at the denouement of the second *Parent Trap,* "Did you
know that if you take the Concorde you can get here in half the time?"
If the collapse of distance before acceleration makes a myth of the
power of narrative ellipsis and editorial splicing, it also makes a myth
of the collapse of cultural differences: the Londonish daughter and the
Californian are effortlessly interchangeable, are never lost, are virtu-
ally identical. In the Wonderful World of Color, space and location
make no abiding difference.

Yet if the American films mount a weak protest against the
processes of geographical indifference, a sturdier resistance on the Ger-
man side of the divide snubs the pedant when he protests, "Who cares?
They can be traveling from Timbuktu to Disneyland if you want." *Das
doppelte Lottchen* firmly links locale to sociology, and hardly at all to
local ethnology. If Kästner's imagination is occasionally *heimatlich,*
his Munich and Vienna are only lightly specialized. (When the twins in
the first film concoct their plot in the inn yard at Seebühl, they move
out of earshot from a curious figure of hackneyed regionalism—hilari-
ously, the old guy appears to have been played by Kästner, decked out
in the "native garb" of the Bavarian mountains.) Kästner's Munich
and Vienna serve primarily to apply differentiated locality to probings
of the social, and not the regional, determination of identity. As others
have pointed out, this early film shows us the economic consequences
of divorce: the mother must work and can barely make ends meet,
while the father lives in relative luxury and enjoys a successful career.[9]
Clinging unconvincingly to sociology, its German remake, *Charlie &
Louise,* indulges in an almost thoughtless inversion intended as a sign
of progress: the mother has become a successful advertising account
manager—and a conspicuously bad parent—and the father, an unsuc-
cessful composer of musicals—and a conspicuously bad parent.[10]

In both German versions, and as a visible result of social milieu, one twin has become a conscientious, highly domesticated copy of her mother, and the other has taken on the insouciant cheek of her father. The diegesis of the first of the two films devotes itself to demonstrating the difficulty of switching social roles, while such physical markers as voice, gesture, and appearance present no problem. The second German film continues to make overtures toward the sociology that informs the first one, acknowledging the importance of nurture in shaping the twins by having each parent say to the impersonating twin that she is just like the missing and highly annoying ex-spouse, both of whom have gravitated to the milieu in which they feel most comfortable. Yet, as we shall elaborate below, in its articulation of space *Charlie & Louise* loosens its ties to Kästner's fable, opening itself instead to influences deriving specifically from Hollywood, that is, to settings not located in mimetic geographical space but in the imaginary of film. The very title of the film, for example, alludes to the American film *Thelma & Louise* (1991), an allusion apparently intended to resonate in Charlie and Louise's flight to Scotland when their parents threaten their plan to stay together always. This Scotland provides only a bit of scenery— a lighthouse, some thoroughfare-clogging sheep, a boarding-school setting for English language instruction, and a steam locomotive traveling, one suspects, at about 60 km per hour—but, with nothing more to offer in the way of local culture, it remains for the twins an empty elsewhere. During their first train trip to Scotland—and in lieu of looking out the window; that is, in place of place—the children look at black-and-white photos of American film stars, including Arnold Schwarzenegger, an Austrian who has "gone Hollywood."[11]

Even if they make nodding gestures toward that sociology of locale—or, rather, the localization of the sociological—which shapes *Das doppelte Lottchen,* the two remakes on the American side of the divide offer a different take on the story of twins who long to be together. In weak deference to Kästner's geographically organized sociology, growing up with a father (or a mother) as opposed to a mother (or a father) is supposed to have left conspicuous marks on each twin; Boston and Monterey, London and the Napa Valley have likewise imprinted themselves upon them. Both Disney films seem more interested in regional and national variation than does the first German film, yet it must be said that Disney's locations and genderings are shallow and schematic, more a matter of style than of character. In both Disney films as well as in the second German film (which surely takes its cue from Disney), the physical difference between the twins

will be erased not by the brushing of unruly curls into tight braids by
the domesticated twin, which the latter firmly notes is a matter of char-
acter-building, but by the boyish twin's cutting the feminine twin's hair
to bring her up to date. The 1950s Germans engage in mutual educa-
tion; the later Americans, in styling.[12]

Charlie & Louise rejects Kästner's indexical geography for the
schematic regionalisms that Disney produced in 1961. Vilsmaier's film
recurs to a century-old notion of Hamburg as the haven of a snobbish
haute bourgeoisie that looks to England for its style—indeed, one of
the children on the train proclaims that Louise looks like "Lady Di."
Berlin, on the other hand, is imagined as the habitat of a German
bohème.[13] Charlie has something of the notorious Berlin lip, while
Louise, who expects a private room when she arrives at language
camp, initially reads as the pampered daughter of the Hamburg haute
bourgeoisie. But even these geographical coordinates are remapped by
Hollywood: Louise shows up for the train to Scotland wearing a hat
and dress that recall those worn by Hayley Mills's Bostonian; the very
choice of Hamburg and Berlin is not so much a northern displacement
of Kästner's Munich and Vienna as a translation of Disney's Boston
and Monterey, counterfeitable prim and easily affected mellow.

The simple opposition between training and styling codes the chief
opposition between German and American diegetics in this cycle of
twins, the opposition between the sociological and the sexological, but
it also codes distinctive commemorative projects. The twins of the ur-
narrative undertake their dual imposture, above all, as staunch oppo-
nents of forgetting. In Lotte's dream the twins insist on the need not to
forget one another just as their double bed is sawn in half:

LUISE: Wir schreiben uns! (We'll write!)
LOTTE: Postlagernd! Vergissmeinnicht 18! (203; General Delivery!
 Forget-me-not, 18!)

And when Lotte fails to write, the clerk at the General Delivery win-
dow gently teases her waiting correspondent: "Vielleicht ist aus dem
Vergissmeinnicht ein 'Vergissmich' geworden?" (230; Perhaps the for-
get-me-not has turned into a forget-me?). The reduction of the code
name is apt. The fragility of the dislocated blossom reiterates the ear-
lier genial and acquiescent rue over the forgetting of place: No one you
ask knows Seebühl.

The wiser, more emotionally disabused Lotte has in fact already
guessed the forget-me that threatens to bloom from the fragile
heimatliche forget-me-not. As the two twins depart for the "new conti-

Charlie & Louise (1993, dir. Joseph Vilsmaier). (Video stills.)

nent" of their recovered parental homes, Lotte worries that Luise may forget to give their mother a goodnight kiss, but Luise assures her that she couldn't possibly. Yet however deep *her* confidence, however secure *her* memory of the responsibilities of intergenerational affection, it turns out that her parents have forgotten: the German half of the cycle is distinguished by plots that remind the parents to love their children.

In *Das doppelte Lottchen,* Frau Körner and Herr Palfy remarry because they finally remember their obligation to house their children in a shared space, and not because they remember their desire for each other: in fact, the German films conspicuously repress and displace the erotic. In *Das doppelte Lottchen* the de-eroticization is most conspicuous in the remarital studio. Gone now is the nude that the divorcé had once displayed (and hidden when Lotte entered to confer with him); an old picture of the mother now occupies the spot on the piano where Fräulein Gerlach had once draped herself. Although the camera suggests sexual intimacy by playfully closing the door on this newly configured private space, it then undermines our expectation by cutting to the couple within the space chatting about their newfound happiness, conversing but not touching. We learn that the four of them will be happy next door together, that the father will be happy in his new studio alone.

Less conspicuous, but perhaps even more interesting is the way the film chastens Plato's great equation of desire and memory. In Lotte's dream, the myth of the hermaphrodite receives very specific rehearsal: not the parents, but the twins are a unity cleft in two, and it is their specular longing to be reunited that moves both film and novel. By celebrating the twins' birthday as the pivotal occasion for the insistence that the parents make good on their ancient marriage vows, the film narrative again foregrounds the Platonic twins', not the parents', lost desire for one another. And if, for its part, the novel concludes with the hope for future sets of twins, it is the twins and not the parents who must muster that hope. Plato's myth of the hermaphrodite is charged with explaining sexual appetite; Kästner's myth serves only to explain sibling affection.

The chilliness of Corinna Harfouch's performance in *Charlie & Louise* forty-three years later makes it similarly difficult to imagine that the parents have rediscovered an old attraction, and the very fact that Harfouch's character plans to marry a stuffy older man, a man without sexual allure who seems the embodiment of reproach, only underlines the sturdy obliviousness to sexuality in the plotting. The script steadily avoids the narrative possibilities of rivalry between the fiancé and the estranged spouse—a part that Heiner Lauterbach plays so delightfully in Doris Dörrie's *Männer* (Men, 1985)—and an element that figures so broadly in the Disney remakes as rivalry between women. Like the first set of German parents, these newly reconciled parents barely touch one another and never kiss. The mother stands to one side while the father embraces the twins in the closing sequence. Posterotic, husband and wife, the parents, long only to be good parents.

The Platonic mission repressed in *Das doppelte Lottchen* returns in *The Parent Trap:* for the sociological, the sexological. Where the German twins long to restore parental responsibilities, the twins of the American films desire their parents' desire. Annette Funicello and Tommy Sands give the crucial advice in the title song to the 1961 film: "If their love's on skids / Treat your folks like kids." This places *The Parent Trap* in the genre that Stanley Cavell calls the comedy of remarriage, a version of romance plotting in which marital therapy is achieved by means of regression.[14] The genre takes the Disney stamp, of course, for Sharon and Susan become a rejuvenation industry, but pressure from Kästner gives the genre a distinctively Platonic character, so that the twins summarize their mission as nothing less than "recollection and memory." Funicello and Sands are less terse: "To set the bait / Recreate the date / The first time Cupid shot 'em / Get 'em under

the moon / Play their favorite tune /—'John,' 'Marsha'—/ 'Ya got 'em.'"[15]

In trying to rekindle their parents' romance, the twins stand in as puckish engineers of regression. When their attempt to re-create their parents' first date ends in failure, they refuse to identify themselves until after their parents have gone on a camping trip with them. The twins and their American adaptors have clearly watched a lot of American movies; they believe that if they can transport an estranged couple into the pastoral space usually called—at least in the Hollywood movies of the 1930s and 1940s—Connecticut, the estranged spouses will remember their desire for one another and be reconciled. Indeed, Maureen O'Hara's antics in her ex-husband's bathrobe—antics performed to discomfit her husband, irritate his fiancée and her mother, and shock the minister—recall Irene Dunne's performances for an exasperated Cary Grant in two classic comedies of remarriage, *My Favorite Wife* (1940, dir. Garson Kanin) and *The Awful Truth* (1937, dir. Leo McCarey).[16]

Like Hayley Mills's twins, Lindsay Lohan's set out to engineer a reconciliation by means of regression therapy: re-create the first date, relocate the parents into a pastoral setting. But the parents prove resistant, and the film wrests responsibility for their rapprochement out of the youngsters' hands. It's the wine that will do it, an intoxicating nostalgia adulterated with acquisitiveness—for Nick owns every extant bottle of "Where Dreams Have No End." When the parents are finally reconciled in London, the camera lingers over their remarital embrace, while it refuses to admit both twins to the same frame for the entire sequence. And although the twins rejoice in the reunion, it is the father's determination to live happily ever after that makes the denouement possible. In a return of the repressed, sex all but triumphs over family values.

Even as these four films rehearse the "unfinished cultural business" of the struggle between desire and the family, sexology and sociology, their very obsession with twinning forces one to confront the dialectic of the remake, "the clash between principles of continuity and principles of innovation in film history." The uncanny encounter with the double that is not merely frozen in a photograph but mobile and menacing marks cinema, particularly German cinema, from its inception, and this encounter has variously depended upon innovation in film technology. As we have already recalled, the special effects of Stellan Rye's *Der Student von Prag* allow the mirror image, with whom the eponymous hero has practiced his fencing, to emerge from the frame to

wreak havoc; Disney's most recent *Parent Trap* exploits the capabilities of digitization to place its celluloid twins in the same frame after an extravagant swashbuckling fencing match between doubles that evokes early German cinema, even if the evocation will remain illegible to most audiences.

We have already described the twin as a curious figure of iterable cultural production. Twice, in 1961 and 1998, American film relies on special effects to display artificial twins, once to produce a vehicle for a new international film star of British origin and once to produce twins who constitute an appreciative homage to the earlier version—a reduplication wittily recalled when, as Hallie takes in the sights of London, the sound track offers up L. A. Maver's lyrics, "There she goes, there she goes again."[17] Twice, in 1950 and 1993, German film displays twins who were discovered after exhaustive casting searches for real twins who could carry off the roles.[18] The two sets of German twins, in their blond blandness, bear a remarkable resemblance to one another.

In 1961, Disney's split screen and doubles manufacture an utterly credible screen set of twins, amusingly figured in the popsicle that Susan eats while the twins hatch their plan to reconcile the parents. Aural reproduction is not as successful, however, for although Mills tries to reproduce two ways of talking, her poorly disguised English accent marks her as neither Bostonian nor Californian. Of course few girls watching *The Parent Trap* in America in 1961 were disturbed by Mills's inauthentic American accents. Her fans knew she was English, and her mild and approachable foreignness was part of her complex charm. Twenty-seven years later, in a nostalgic tribute to Hayley Mills and America's fascination with the England of the 1960s, the home of Lohan's Annie, the more cultivated twin, is relocated from Boston to Mills's London. To American ears, Lohan's accent is convincing; to British ears it may be no more convincing than was Mills's when she attempts to reproduce the cadences of a 1960s California girl. But Germans watching the dubbed version of *The Parent Trap* of 1998, on the other hand, can only be mystified by the film's premise that these are two different girls, for in this version they are not only played by the same actress, but they sound exactly alike.[19] As in the joke about the Berlin cabaret singer ineptly trying to give voice to American sheet music, "You like tomahto, and I like tomahto."[20]

What should relocated doubles sound like? Writing of the transition from silent films to talkies in Germany, Elliott Shore notes, "Sound rocked the international market for foreign films, threatening to make the national film industries just that: national again, not able to compete in other markets because of the inability to cross the sound bar-

rier."[21] Shore's observation reminds us that the iterations of *Das doppelte Lottchen* have crossed sound barriers with varying success. Unlike Kästner's novel, which was translated into English the same year it was first published in German, the very first film version of *Das doppelte Lottchen* did not, as it were, cross language barriers; correspondingly, the first celluloid iteration of our cycle of twins, winner of the first Federal Film Prize and at one time called "der beste deutsche Nachkriegsfilm" (the best German postwar film),[22] remains in tone, in style, and in message a strikingly nostalgic local product, this, despite its arguably universal theme.[23] Relentlessly local: the Günther twins would go on to ride the 1950s *Heimatfilm* wave; their careers collapsed in 1958 shortly before the taste for local nostalgia had played itself out.

A train sets out from Seebühl to Disneyland, a journey from fictive locale to nowhere in particular. It meets the second *Parent Trap,* which begins and ends at sea and leaves in its wake the turbulent work of local memory, the biological actuality of twins, a faith in cultural difference, and an allegiance to sociological knowledge. Here, somewhere in the wide, uncharted world of color, this flotsam of particular loss drowns in the solvent of the iterable, the endlessly sexual, the unfixed. And before the credits roll, a little girl, mechanically reproduced, rolls her eyes heavenward and bites her lip, just like Hayley Mills. "We actually did it!" she squeaks and sinks out of sight.

Notes

1. The English translators offered "Timbuktu" as a substitute for the "Pusemuckel" of the original German version, and "Disneyland" for Wanne-Eickel. The German could have also been translated as "from Podunk Junction to Waukegan," Pusemuckel doubly coded as a faraway place and the sleepiest of German villages, and Wanne-Eickel—a real German town—coding a pocket of provincial industrial drear. As it happens, the so-called Filmpark, an amusement park that has taken some cues from Disneyland, is located near Wanne-Eickel and must have suggested the alternative translation. The choice of "Timbuktu to Disneyland" translates the dominant local connotation of the original on behalf of a global market.

2. This framing of "Disney" is intended to recall Foucault's description of Radcliffe, Freud, and Marx as "founders of discursivity." Michel Foucault, "What Is An Author?" *Textual Strategies,* ed. Josue V. Harari (Ithaca: Cornell University Press, 1979), 153–56.

3. The second *Parent Trap* appears to be quite self-conscious about its place in this culture industry, for its title sequence, a vignette of the parents' shipboard marriage, concludes with fireworks that recall those featured in the title sequence of the popular weekly television series *Walt Disney's Wonderful World of Color.* The claim apparently bears repetition. In a TV commercial that began airing late in 2001, a delighted little girl, to the embarrassment of her mother, inadvertently

discloses to strangers in an elevator that her infant sibling is the product of recreation on board one of the rollicking ships of Disney's cruise line.

4. The credits for all of these movies acknowledge Kästner's novel; those for *Charlie & Louise* actually show a picture of the book, proposing it as a "tie-in."

5. The wine label is one of several gestures of affiliation with the first *Parent Trap*, which ends in the twins' dream of familial wish-fulfillment.

6. Leo Braudy, afterword, *Play It Again, Sam: Retakes on Remakes*, ed. Andrew Horton and Stuart Y. McDougal (Berkeley and Los Angeles: University of California Press, 1998), 331.

7. Braudy, afterword, 328.

8. The global dissemination of the fable may argue for a universality of plot that would complicate, if not thwart Braudy's argument for the cultural-historical specificities of remaking, although the dissemination might equally argue what one might (ruefully) designate a globalization of cultural specificities. We count something on the order of seven film versions. For a filmography up to 1998, see Ingo Tornow, *Erich Kästner und der Film* (Munich: DTV, 1998), 68–70. Tornow lists neither such distant derivatives as *The Patty Duke Show* (1963–66) nor the more closely derivative *It Takes Two* (1995), which, although it rehearses the economic differences found in Kästner's children's novels, is farther removed from *Lottchen* in its basic premise. The twins of this film are not biological ones, although Ashley and Mary-Kate Olsen, who play them, are, and they must bring together not estranged parents but caregivers.

9. Elisabeth Lutz-Kopp, *"Nur wer Kind bleibt . . ." Erich Kästner-Verfilmungen* (Frankfurt am Main: Bundesverband Jugend und Film e.V., 1993), 88; Tornow, *Erich Kästner und der Film,* 58–59.

10. At their reunion, during a late-night chat, the parents appreciatively remark on the other's fine child-rearing, but the gesture is plainly intended to signify a nostalgic erotic appreciation. The flirtation is as unconvincing as it is clichéd, as empty as is the sociological assessment: the parents have been selfish, and only fitfully attentive to their children.

11. Evidence of Louise's more decorous version of this absorption in American celluloid appears later when we are shown the walls of her Hamburg bedroom adorned with large figures of Donald Duck and Mickey Mouse.

12. Disney will further underline the new style represented by California when the twins perform for their parents. Bostonian Sharon begins with the opening chords of Beethoven's Fifth Symphony, only to have a well-rehearsed Susan ask, "Hey, what's all this noise?" In compromise, to the joint accompaniment of piano and guitar, the twins perform a pop duet, "Let's get together, yeah, yeah, yeah."

13. Theodor Fontane's *Frau Jenny Treibel* (1892) offers perhaps the *locus classicus* of a confrontation between "Das Hamburgische" and upstart Berlin.

14. To his very slight discredit, Stanley Cavell pays no attention to the dire sexual politics of this genre, which trivializes marital tensions by proposing that alleviating them is child's play. Stanley Cavell, *Pursuits of Happiness: The Hollywood Comedy of Remarriage* (Cambridge: Harvard University Press, 1981).

15. Remarriage will mean that the twins can stay together, but unlike the German twins, their desire for one another seems secondary in the end—and compul-

sory at the outset. In both German films, the girls isolate themselves when they discover that they are twins: Vilsmaier shows them riding along the loch on identical horses and transforming the Scottish lighthouse into their own secret space; Baky's twins take refuge in the garden of an inn and flee to another table when another guest (apparently, as we have already noticed, Kästner in *Lederhosen*) intrudes on their space. In the Disney versions, the "isolation table" and "isolation cabin" are punishments, albeit punishments eventually embraced.

16. The 1998 Disney remake punctuates the film narrative with several sequences that signal to film-literate audiences that this is a so-called comedy of remarriage. The opening and closing credits frame the narrative with scrapbooks—the first rendered in fluidly moving pictures; the second, in stills—of the shipboard marriage and the shipboard remarriage. The generic affinity signaled by the credits is underlined within the film with easily recognizable quotations from *My Favorite Wife* and Michael Gordon's *Move Over Darling* (1963).

17. The special inflection of the genre of remarriage by the American "tradition" of parental entrapment is also marked in the recourse to body doubles for the originally newlywed parents in the opening credits, a technical device crucial to the production of the first *Parent Trap* and all but gratuitous in the second. *The Parent Trap*s make remarriage into a narrative expression of a technology that overwhelms diegesis.

18. Lutz-Kopp, *"Nur wer Kind bleibt,"* 92 and 114.

19. Similarly, the British English–dubbed version of *Charlie & Louise,* marketed by Good Housekeeping, elides difference by making no distinction in the voices of real twins, even though these twins have grown up in two different places.

20. George and Ira Gershwin, "Let's Call the Whole Thing Off" (1937).

21. Elliott Shore, "Gained in Translation: Hollywood Films, German Publics," *The German-American Encounter: Conflict and Cooperation between Two Cultures, 1800–2000,* ed. Frank Trommler and Elliott Shore (New York: Berghahn Books, 2001), 228.

22. "Tageblatt," Heidelberg, 6 April 1951, qtd. Lutz-Kopp, *"Nur wer Kind bleibt,"* 100.

23. Although the twins' accents bear no trace of regional upbringing, the film takes pains to mark Vienna, by means of accent, as Other. On the other hand, despite the shots of the Frauenkirche and other street scenes that situate the film in a specific geography, Munich occasionally feels surprisingly "Prussian." This is particularly noticeable in the juxtaposition of Viennese-sounding teachers in Vienna and a nasty, High German–speaking teacher in Munich. In thus coding Munich as both Bavarian city and as stand-in for Germany as a whole, Baky lightly registers the postwar reestablishment of the German-Austrian border. For his part, Vilsmaier makes little effort to differentiate Hamburg and Berlin by means of dialect or accent. The twins sound remarkably alike, and only characters with cameo appearances exhibit traces of local speech habits. The accent of the father's Turkish friend, however, serves to mark the Berlin neighborhood Kreuzberg.

PART 2

Reworking the National

The Mourning of Labor

Work in German Film in the Wake of
the Really Existing Economic Miracle

John E. Davidson

I

This chapter is concerned with cinematic treatments of labor in the increasingly global environment of the 1960s and beyond in East, West, and reunified Germany. Labor is an aspect of contemporary life that transcends local restriction: needing to market one's labor power as commodity is as near a universal condition as there is under globalized capital. But because labor is performed in a specific locality and manner, the working body is always at a nexus between the local and the global, which is simultaneously a nexus of two senses of labor: concrete and abstract. This places the working body in a position structurally analogous to the process of labor itself and the commodity it produces. Developing vital descriptions from Karl Marx's *Grundrisse,* Moishe Postone has shown that labor has a dual character in commodity-determined society: "On the one hand, it is a specific sort of labor that produces particular goods for others, yet, on the other hand, labor, independent of its specific content, serves the producer as the means by which the goods of others are acquired."[1] The former sort is left to concrete labor, the "intentional activity that transforms material in a determinate fashion" that creates use value. The latter sort is the domain of abstract labor, which "expresses a particular, unique social function of labor," namely the general determination of social mediation through value.[2] Postone goes on to indicate how abstract labor girds a structural totality by allowing labor to ground "its own social character in capitalism by virtue of its historically specific function as a socially mediating activity. In that sense, *labor in capitalism becomes its own social ground.*"[3] This grounding means that abstract labor has the function of constructing value not only in exchange but in the identities

95

produced in the interplay of the concrete and abstract, particular and general, local and global.

Postone argues convincingly that it is domination *through* the value produced by abstract labor more than the domination *of* concrete labor that provides the structural key to capitalism. Accordingly, traditional criticism of capitalism (including that espoused by most Marxists) has often fallen short by failing to recognize that not just the conditions of concrete labor but also the role of abstract labor must be understood as historically contingent and specific to capitalism: that is, critics have assumed "labor" to be a transhistorical constant. This underlying assumption remains invested in the abstract labor specific to capitalism and reproduces its ideology of labor, and thus generates a critique only from the standpoint of (concrete) labor rather than one aimed at the historically specific position of labor under capital. That limited critique focuses only on the distribution of wealth rather than its (post-) industrial production and thus fails to attack capitalism's inherent structural contradiction between real and abstracted labor and its consequences. Hence, as Postone surmises but does not pursue explicitly, the differences between the West and "real existing socialism" may well have been of degree and not of kind since the mode of industrial production was common to both and unquestioned as the vehicle for progress toward a self-projected image of arrival. Seen in this way, the juxtaposition of ahistorical principles—value for capitalism and planning for socialism—elides the extent to which developing and keeping to the "plan" rely upon the ideology of labor itself. Even in a state-capitalist form, such industrial production is the most essential aspect, rather than distribution or consumption. Indeed, despite the disparity in the official approaches to the globalization of concrete and abstract labor, the ideology of labor was structured for a similar deployment in Germany on either side of the Iron Curtain, and it remains integral to the ideological legitimation of Germany after reunification.

In what follows I examine closely three films that suggest that a trenchant critique of domination through labor can be generated by attending to filmic forms embedded between the local and the global. These texts provide forceful depictions of the concrete, local contexts out of which they arise, but are structured in such a fashion as to allow the abstract, global function of labor as a structural determinate to become visible. By following the consequences of the aesthetic representation of work in Frank Beyer's superb *Spur der Steine,* we will see that labor does "become its own social ground" in real existing social-

ism. The virtual absence of concrete labor as anything other than attempts to work on the socialist subject makes abstract labor in this context palpable. The filmmaker seems to imply that concrete labor, relieved of the pressures brought to bear by irrational distribution and ideological constraint, is the natural and constant means of generating the value of (socialist) labor, and hence reasserts a transhistorical view of it. However, as we shall see, the film itself goes further than this limited criticism from the point of view of labor, illuminating the similitude of the ideology of labor in East and West Germany through its formal structures and helping to ground a critique of the function of abstract labor more generally. A glance at the seminal West German "workers' films" of the late 1960s and early 1970s will reinforce this finding in a Western setting, allowing us then to examine the collective project *Deutschland im Herbst,* where traditional leftist views on terrorism, labor, and historical mourning converge in considering the horrors of the German Autumn of 1977. Here we concentrate on the way aesthetic form exposes the ideological function of "labor" in structuring this society plagued by violence, but also how it poses the question of a broader and more emancipatory conception of labor that links it with social, bodily practices that inhere to the underside of globalization under capital. Finally, Hellmuth Costard's *Der Aufstand der Dinge* (The Uprising of Things, 1994) revisits labor in reunified Germany and puts its global aspects in a farcical, interstellar light by returning the focus to the relative autonomy of the commodity, which by its nature both masks labor in its concrete form and gestures to it in its abstract form. As we reach for the stars at the end of that film, we are reminded of something beyond the bounds of the ideology of labor.

In the GDR labor was always both an ideological precept and a concrete reality, and DEFA (Deutsche Film-Aktiengesellschaft) films reflect these cultural priorities amply. But no connection to the global world was made that exceeded the nods to the East bloc allies and to the *Klassenfeind,* and in most cases the *Internationale* was far more local than global. Ironically, not until the erection of the Berlin Wall allowed a self-critical filmmaking to arise regarding the local context did DEFA directors meld this consideration of personal happiness and a criticism of concrete labor into really powerful statements. Notably, Konrad Wolf's version of Christa Wolf's *Der geteilte Himmel,* as well as *Das Kaninchen bin ich* (I Am the Rabbit, 1965, dir. Kurt Maetzig) and *Karla,* carry this investigation of personal happiness in the development of a socialist identity for women further than any previous works. However, for the purposes of this essay, which hopes to distill a

critique of abstract labor as a determinate absence, another banned film offers the most fertile thematic and aesthetic approach to this meld: Beyer's *Spur der Steine*.[4] Borrowing from Louis Althusser's analysis of mirrors and windows, the human face, and the visual "weight" of great vertical lines in his famous essay of 1966 defending Leonardo Cremonini,[5] I show that Beyer's film depicts the determinate absence of relations *of production* in the lives of citizens interested in contributing to the project of building a just socialist society. By this I mean that *Spur der Steine* makes structures that are only apparent in the effects they produce visible on screen, and this depiction exceeds the direct ideological project of socialist *Selbstkritik* in which Beyer engages.[6]

II

For a film that depicts the developments, intrigues, advances, and set-backs at a massive construction site at the start of the GDR's second decade of existence, *Spur der Steine* is markedly devoid of images of the physical work of construction. Workers abound, of course, and the mise-en-scène often contains the unfinished results of unseen labor: spars thrust upward out of bulldozed spaces, indicating that the process of building up real existing socialism is well under way. We see the construction workers mainly in their off hours, in bars, sleeping quarters, or going to and from their shifts. In the few cases in which we see workmen on the sites, they are engaging in work stoppages, steal-ing materials from other squadrons, or, most often, sparring with the engineers and managers from the planning offices, most of whom are party members. These figures, on the other hand, are constantly at work calculating ways to improve production, negotiating with the central committees in Berlin, and convincing the workers to go along with the increased rationalization of the new three-shift system. And yet the planners' constant duty seems to leave them enough time for an illicit affair and subsequent transgressions of the SED's moral code, as well as numerous instances of public "Selbstkritik." Certainly these depictions of nonproductive workers and less than exemplary party members contributed to the banning of Beyer's film after the Eleventh Plenum. But to understand its critique of real existing socialism more fully than the party functionaries did, the formal dimension of the film and its reconnection with its historical moment must be explored, and to facilitate that I turn to a contemporary discussion of one artist's work that had been disparaged by a Stalinist party: Althusser's "Cre-monini, Painter of the Abstract."

Spur der Steine (Traces of Stones, 1965, dir. Frank Beyer). (Courtesy Filmmuseum Berlin—Deutsche Kinemathek.)

Leonardo Cremonini began his career with images that refute the progressive narrative of natural history evoked by the notion of the "descent of man," images of individual, human-esque figures surreally melded with their surroundings. Regarding these first pieces, Althusser refers to figures that still have "the *form* of their things. Men . . . fashioned from the material of their objects . . . caught and defined once and for all . . . in a parody of human time reduced to the eternity of matter."[7] Cremonini first moves beyond this eternity to engage with human history, that is, with the "*relations* between men,"[8] when old mirrors begin to appear in his work, and here the eternity of matter begins to take on more contoured shape. People "look at themselves: no, they *are* looked at"[9] in these mirrors, and what is seen is marred, elongated, muted in tone, and vaguely defined. In Cremonini's most recent images, Althusser continues, the mirrors have been replaced by windows that see the subjects that should themselves be seeing. These reflective glasses provide them with an image of themselves, but one that would appear normal in the real world only through the lens of ideology that hides alienation. The appearance of normality does not

materialize in Cremonini's work, for the figures are disproportionate, at times even ghoulish, but never naturalistic; and yet his work involves a realism belied at first glance by its apparently unrealistic form.

Althusser is defending the work of an Italian artist from the "charge" of being "expressionist," and in doing so produces a veiled critique of the French Communist Party, whose hacks passed that judgment at a glance. He links the PFC's aesthetics of consumption to precisely the bourgeois ideology of artistic creation that socialist realism aims to overcome, showing that they both assume their own ideological self-recognition as the basis of aesthetic judgment. The human face has served as the visual assurance of individuality and subjectivity in this self-recognition when it has been the object of Western art. Althusser's claim is that, rather than indulging in decadence, Cremonini's expressionistic figures entail a resistance to the ideological work performed by the face. His faces are subjects of de-formation, that is, of the determinate absence of form. The visual "weight" of Cremonini's vertical lines reminds us of that which is not structured in the circle of ideological reflection. In capturing the "real *abstract*" of structural causality,[10] Cremonini paints relations determinate in their absence, visible only in the effects they produce.

Though the possibilities available to a narrative filmmaker are quite different than those of a "painter of the abstract," the language of the GDR's official and "unofficial" criticism leveled at *Spur der Steine* supports the comparison to Althusser's Cremonini that I am making, for it claimed to see a "verzerrtes Bild" (distorted image) of reality in which it could not recognize itself ("uns erkennen"). Hence, this criticism misapprehends the film in a parallel manner by applying the consumerist point of view that Althusser exposes.[11] More importantly, the massive image of Manfred Krug's visage initially used to promote the film indicates that something of a reconsideration of the subject's face could well be at work in *Spur der Steine.* An analysis of the shot compositions and visual weight of verticality in Beyer's mise-en-scène, which are more telling than the appearance of party hacks, spies, or repressive militiamen at Schkona, will show this indeed to be the case. The film evokes a potential toward freedom in the upright spars of the construction site and in the prominent vertical lines in private spaces, providing visual reminders of that which is outside the ideological "work" of socialist subjects on themselves. Yet even in the film's opening moments that verticality is traversed by the horizontal motion of the functionaries' cars, and horizontal lines become the marker of objectified dreams here. *Spur der Steine* makes "visible" the determin-

ing ideology of fulfillment through industrialized labor that is sup-
posed to be the expression of a higher human subjectivity in the social-
ist-realist hero, which has its necessary counterpart in a private notion
of individual fulfillment, both of which are touchstones of desire for
the director. The absence of the face of the primary female protagonist
will provide the final evocation of social and personal fulfillment with
which we must grapple in viewing this film today.[12]

Vertical lines weigh heavily in shaping our apprehension of that face
throughout the film. In one sequence at Christmas, Werner Horrath
has brought Kati Klee a dress that he wants her to try on hurriedly
before he has to catch his train to return home to his family. She stum-
bles in pain as she does so and gives the audience (and her landlady,
Frau Schikedanz) the first indication of her pregnancy. In this scene
there are three striking moments when the compositions seem remark-
ably akin to those of Cremonini. First, Klee views herself in a mirror,
while vertical lines separate her from Horrath (who sits off screen).
Second, she is in the bathroom after feeling ill, her face separated from
Frau Schickedanz's by the vertical line of the door. Third, she returns
to the room to stand next to the door frame and turn her back on Hor-
rath. In the shot containing the mirror, Klee's image as a subject seeing
herself is unformed in the presence of the vertical lines, which bear the
weight of the possibility of personal happiness in a context in which it
cannot exist. She leaves the room to keep herself from being seen, but
in the next compositions we sense the failure of that attempt. Though
Klee is hidden from the older woman's sight, the compositional bal-
ance between her and Frau Schikedanz around the line of the bath-
room door locks her back into the ideology of private life for the
viewer. When she returns to Horrath, she turns away from him, but
this too only increases her unhappiness, as it denies even the promise of
personal fulfillment in heterosexual coupling. Though Klee knows that
promise to be an illusion, she turns quickly back to face him in a circle
of privacy.

A similar dynamic of seeing and being seen underlies the presenta-
tion of socialist identity in *Spur der Steine*'s theme and content. The
"Ansehen der Partei" (image of the party) is always at stake for the
organs of power. The phrase "Siehst du das nicht?" (Don't you see
that?) occurs over and over again as the characters try to align them-
selves and each other with what is right or what the dominate powers
demand. The mise-en-scène often harbors a presence, and watchers are
always at hand as the hierarchy at the *Baustelle* tries to manage its
affairs. At times that presence is merely a horizontal trace in place of

the party insignia, as we see it on the wall behind Bleibtreu in the "trial" framing the film, but the most frequent observer is Lenin, whose ossified face locks the socialist "subjects" in a circle of vision in which their only image is one provided by ideological labor.[13] Once the key to enlightenment, self-critique in this ocular circle becomes an instrument that frustrates maturation and insists on conformity: "um die eigenen Fehler *einzusehen.*" Here the graphic coupling of the window and the portrait of Lenin suggest the basic similitude of seeing and being seen. As in Cremonini's last works, the mirror of ideological circularity can be replaced by windows behind which nothing awaits except the presence that looking provides. The finished windows in Schkona depict the possibility of freedom trapped in ideological form through the application of modern industrial labor.

It is important at this point to remember the film's temporal structure, which looks back from the "present" investigation into Horrath's failings as a public and private citizen onto the main narrative of the lover's triangle and the task of modernizing the chaotic and unsuccessful construction site. Beyer deems flashback structures to be cinematically weak and claims that he employed them here only as a means of focusing on these specific strains from Neutsch's novel that seemed most compelling. He retroactively notes that this device allowed both strands of the story to expand each other, and this is clearly one of the elements that make the film so rich.[14] But the temporal structure *elides* something as vital as that which it adds, because it erases the actual concrete labor that completes the building and contains the possibility of freedom in the form of ideological reflection. The absence of physical work maintains industry in idealized form and gestures to the determinate structural absence of the *ideology* of labor.

Seen in light of material practice, the use of time here maintains the utopian encoding of the potentials of labor by keeping production out of sight in the film. Thus, unbeknownst to Beyer, progressivist ideology returns and recoups the concrete labor that is never possible in this film into the abstract "work on ourselves" visible through the public windows of the GDR. Of course, "real productive work" arises near the end as the new possibility, with Horrath and Hannes Balla facing it as they walk away from the camera; that, however, is merely the circular return to an absent image of industrial labor as if it were not historically determined. To adapt Postone's description of the traditional Marxist interpretation of capitalism, Beyer's project faults real existing socialism from the position of transhistorical labor rather than through an immanent critique of labor within that social formation.

I want both to underscore and yet to supplement the assessment that the successful union of Balla and Horrath, of the people and the party, comes only through the sacrifice and exclusion of Klee. One of the shortcomings of *Spur der Steine* clearly involves its inability to conceive of the private realm outside of traditional gender roles in a heterosexual paradigm; however, Beyer's insistence on an artificial, ultimately "bourgeois" distinction between public and private becomes the self-evident (i.e., ideological) moment of *Selbstkritik* subject to deformation through the absence of Klee's face in the final sequence. To see this requires than we first return to the visual construction of the mise-en-scène in the "private" areas of the film. The verticals in the private realm take on more than just visual weight at two points where the burden of trying to embody personal happiness literally pulls down first Horrath and then Klee: the vehicle is a pair of pajamas with prominent vertical stripes. In the first instance, about halfway through the film, Horrath has returned to his wife, Marianne, in Rostock and prepares for bed. Much later, after Klee and Horrath have split up, she and Balla have gone to Berlin for a conference, and the romance that has been submerged in their relationship has a chance to surface. In both sequences the visual lines go from vertical to diagonal to horizontal: fulfillment in the private world, too, takes on the shape of a thing, and here we see, as Althusser saw in Cremonini, "humans in the form of their things."

The lines on the pajamas seem strikingly busy when compared with the rest of the scenery, but they are most intense when set against the two human partners, Marianne and Balla, both of whom wear white (night) shirts. The crew chief is particularly interesting in this regard: here for the first time he slips fully into the public/private ideology that is fostered by the film as its point of both criticism of, and coincidence with, socialist realism. Indeed, contrary to the rhetoric in the film, and to most interpretations of it, we can see that Balla is not "won over" to socialism, but rather to two "new" ideas: modern industrial labor practice (embodied here in centralized, scientific management) and the private (quasi-bourgeois) subject marked by restraint. He learns here to renounce personal happiness in the sphere that is supposed to be defined by it. Although he has waited so long for the moment in which he would sleep with Klee, he now refrains. His shockingly white shirt contrasts with the lines of the room and doorway, as well as those on Klee, which again become the reminder of difference, of that which is outside of the ideology structuring the private. His acceptance of subjectivity in this circle is simultaneously subject to deformation, and his

shirt provides a parallel to what Althusser calls the determinate absence of form precisely at the moment in which he takes on the role of the proper subject.

The shot, reverse-shot editing used in the hotel scene is common to depicting such moments of intimacy. Here it has the interesting consequence of realigning the pajama stripes: when looking from Balla's vantage, they become vertical in the screen composition; whereas the establishing two-shot that punctuates the scene shows them as horizontal lines that exhibit Klee's abjection. As in the hearing scene where Horrath interrogates Klee about the paternity of her child (though he knows he is the father), this is a moment when cinematic form simultaneously creates the "inter-face" of subjectivity *and* emphasizes cuts to show the incomplete nature of such sutured unity. These faces cannot bear the weight of the look that is implied, and the cuts gesture to an excess, a reminder of difference that will be "relocated" in Klee's role at the film's end.

Throughout the day of the frame story—the trial of Horrath—Klee consistently refuses to show her face publicly in the ideological sense. Klee has ceased to be a subject in dynamic tension with the state, and, when sought privately at the film's end, she is nowhere to be seen. Significantly, she has left both the public and the private arenas of the movie, and is repositioned for us neither discursively nor visually. We know neither where she has gone nor what she will do. We do not know if she has gone to the West or someplace else in the GDR—she simply is not there. Kati Klee is in neither a public nor a private realm as she speaks: in her disembodiment she has become the trace of difference from the circular reflection of public and private, of fulfillment defined by reified production and objectified subjectivity.[15]

Of course Klee's disappearance is a by-product of Beyer's problematic gendering of the public and private realms, with their reconciliation being made possible only through the exile of a woman. But, while fully aware of how careful we should be about taking Althusser's advice on questions of gender, I feel that we need to see a different potential in the film's final seconds in light of the way the relationship of the face to ideological subjectivity has structured *Spur der Steine.* Her words speak of happiness, and her voice reminds us of what is outside our vision. This gesture to excess in the GDR's realist aesthetic shows us that, just as capitalist and "real" socialist societies are built on the same transhistorical conception of labor, so too are bourgeois and socialist realisms aligned in grounding individual and social fulfillment in self-evident self-recognition. The aim of both, as Christa Wolf once said of nineteenth-century literary realism, is to allow people to recog-

nize themselves, "[um] als Zitat zu leben" (to live as a citation).[16] The placement of Klee's body outside the diegetic world connects her, and with her the very local context of the GDR, to global requirements to abstract value from the working body in the form of a self that is already prefabricated and equalized; and yet her voiced disappearance pushes us to a place where we wish for something different between the local and the global.

III

The self-evident place to look for a similar commitment to the plight of labor in West Germany would be the spate of films referred to collectively as *Arbeiterfilme* (workers' films), which had their heyday between 1969 and 1978. One of the most important of these, *Rote Fahnen sieht man besser,* lends us images that might fit our title well: it documents the demise of the Phrix plant in the northern FRG, where the workers laid off in increasing numbers drape the building in black flags to mourn their "redundancy." Through its presentation of the events both as they are and as a missed opportunity, the film wants to suggest that this mourning by laborers was actually misplaced and ultimately deterred the workers from bettering their lot, since it prevented them from radicalizing their struggle. Although stated in the film merely as a physiological fact, the greater visibility of "red flags" of course gestures to the international plight of workers and the organizations dedicated to furthering their cause globally. The workers in *Rote Fahnen,* however, seem fully aware of the effects of globalization on their very local struggles, at least to the extent that they realize what depressed wages and relaxed regulations in other parts of the world mean.[17] This is an awareness that pervades other important *Arbeiterfilme.*[18]

These filmmakers hoped to use the traditions of realistic proletarian cinema brought down from the Weimar era to recapture an audience by depicting the Blochian contradictions of everyday life.[19] Even though their subject matter and naturalistic, documentary style tended to leave mainstream and critical film audiences cold, they make a vital contribution to recording the domination of labor under capitalism. However, their critical project, like Beyer's realistically socialist work, maintains the transhistorical notion of labor that shapes the incapacity of personal fulfillment, in either the public or private realms artificially separated as a social principle, to (re-) produce the possibility of accumulation.[20] So while very much aware of the worldwide and regional aspects of concrete labor and laborers, the global aspects of abstract labor remain unchallenged in these works.

Complicating this still further is the fact that the "local" in

post–World War II Germany has always also been a temporal coordinate relating to recent German history. We turn now to a film in which the local situation of the German past and present is explored without losing sight of the interpenetration of the global into the everyday at the point of both concrete and abstract labor. *Deutschland im Herbst* has long stood as a *Paradebeispiel* for the New German Cinema's location in specifically German circumstances.[21] No doubt, whether ironic, heartfelt, pathos-laden, farcical, or oedipal (and it is all of these at different times),[22] *Deutschland im Herbst* is about "Deutschland, Deutschland, über Alles . . ." But by uniting two aspects of mourning and labor through aesthetic form, *Deutschland im Herbst* expressly situates the mourning of labor between the local and the global.

Death and labor clearly predominate in the film, with two funerals providing the opening and closing poles: that of Hanns Martin Schleyer and that of Andreas Baader, Gudrun Ensslin, and Jan Karl Raspe. Between the frame of the two funerals, work is constantly evoked. These evocations seem very conscious of class relations, and in some cases the type of work performed is itself class conscious, as in the two vignettes showing the preparation for funeral dinners, the one for the guests of the state and the other for the Ensslin family. Interesting for us is that ethnicity is used to show that the local is inflected with the global precisely in the realm of work. An unemployed Turk with a rifle appears in a Stuttgart square not far from the funeral, ostensibly looking for pigeons for food. During Schleyer's funeral we witness the stoppage of work so that the imported laborers (Kluge's voice tells us that the vast majority are *Gastarbeiter*) inside the auto plant can observe three minutes of silence commemorating his death. The ironic distinction between this work stoppage and those generated by organized labor seems completely clear as the perfunctory mourning ceases when the conveyor belts reengage. But other moments in the film seem to be more concerned with forms of labor that could appropriately be termed cultural work, and are firmly rooted with the intellectuals in this society. Palpable, too, is the gulf that separates those who perform manual labor and those who claim to be driving toward a revolution in their name, as Max Frisch puts it in his speech to the Sozialdemokratische Partei Deutschlands (SPD) with the fictitious history teacher, Gabi Teichert, recording the session.

In the segment following the initial shots at Schleyer's burial, Fassbinder returns to his apartment from a trip to Paris where he has been working and, in the course of the next few minutes, is shown dictating the shooting directions for *Berlin Alexanderplatz* and being inter-

viewed about his ideas on film. Fassbinder yells that his blue-collar lover, Armin, does not understand the importance of his work and how tragic it is that he now cannot work. Later, in the prime example of this troubled cultural labor, we see the famous sequence by Böll and Schlöndorff in which various disclaimers about *Antigone* are trotted out for the television bureaucrats, who feel that the themes of the classical tragedy are too "aktuell" to be safely shown. Upon the objection that DM 800,000 in production costs have been invested, the decision is made to complete the film but put it "on ice" until more sanguine times: the work defused by dint of being a finished work. There is an impulse here to lay bare the problematic intertwining of cultural work with the powers of the state (television), especially as the government has been linked to major capital concerns through the association of the West German flag with the banners of Daimler Benz and Esso: in this sense the national is very much aligned with the global. The omnibus structure of the film allows these contradictions to come to the surface but lays them to rest neither with false resolution nor narrative contouring.

In the previous section of this chapter I read the aesthetic construction of *Spur der Steine* to generate from within a critique of Beyer's critical assessment of real existing socialism, exposing the reliance on an ideology of labor under socialism as well as capitalism. In considering *Deutschland im Herbst* I want to extend that critique by examining the manner in which this film's concern with labor, coupled with its omnibus structure, unpacks the overdetermined notion of "work" both as a social idea(l) and as a reference to the finished film as an artistic product. The segmented production and assembly of parts in this work revitalize the notion of *montage* to carry it beyond the kind of associative device that directs, or even prefabricates the meaning of images for the viewer.[23] It exposes roots in the notion of modern industrial construction without simply reproducing the images of revolution championed by Soviet montage filmmakers of various stripes. One of the film's recurrent strains in particular reframes the notion of montage, because, like the unconscious critique in *Spur der Steine,* it highlights the impossibility of fulfillment in the public or private sphere as conceived of in the bourgeois division of labor.

Franziska Busch appears throughout the film, a young woman who wants to improve things. She has read much of what Horst Mahler has written and seeks "clarification" when her media team interviews him in prison. She listens to Wolf Biermann as he sings about Ulrike Meinhof, whom she in some ways resembles, and asks, "What will become

of our dreams?" She is in a relationship with a media executive and seems to be employed by his department, but is also involved with a political group that hopes to make revolutionary films. Franziska Busch, too, wants to make a film, but neither her husband nor her comrades see the potential in it, for they are interested only in self-evident ideological work. Kluge's voice describes her not-yet-made film as we watch takes from it on the screen:

> Two workers stand on a balcony, then they go inside;
> A woman shakes out her blankets in the early morning;
> A sparrow flies 60 cm higher to the next branch.

This seemingly nonsequential set of three images gives us the key to a different understanding of the film and its desires, for Franziska Busch's dream is the filmic equivalent of a haiku, that specifically Japanese poetic form that has become so international that it is used in classrooms for young children across the globe.

The haiku traces itself back to the opening verse (*hokku*) of the *haikai* poems of the Tokugawa period (1600–1868), the epoch in which capitalism developed, mass education started, and print culture expanded. It corresponds to the existence of capitalism but results neither directly from the progress of industry nor the wider dissemination of books, because it began as a popular, communally structured example of collective art that was not (yet) subject to the pressures of the industry. Haiku is often thought of as a form relating to the natural world, making it a formally different take on one of the most longstanding themes in post-Enlightenment philosophy in the West: the relation of the human to the natural. This is a moment of convergence that evokes the global in a manner not often recognized in today's debates, one to which we will return as we begin to unravel our visual poem.

First we must note that, although the pictures are accompanied by spoken words, it is in the images themselves that the parallel to the haiku arises. The standard three lines are spoken here, but the rhythmic syllabic structure of 5–7–5 does not fit (nor do the standard variations on it); the montage, however, does provide such a rhythm, as the first and last takes are roughly equal to each other and slightly shorter than the second in duration. In addition to a particular rhythm, haiku requires a temporal component, offered here in visual references to time (early morning turning out the beds) and season (the fall of leaves, bare branches). The last element in the standard poem is the "cutting word," which divides the verse into its two conflicting parts: the majes-

tic and the mundane, the grand sweep and the minute detail, the universal and the particular.[24] Franziska's imaginary film is sliced between the human and the natural, not just between the world of big buildings and of small branches but along a cut traditionally defined by labor.

Her dream is, or would be, a mourning of labor, for labor is the fault line of the cut of her haiku: those called *Arbeiter* stand in a private space but do not work, while the physical exertion of the woman (housekeeping) and the bird (natural and undirected activities) have not traditionally been considered as labor, as they take place in private or in nature. How to spark something that unites them in their commonality, to fuse them with the "aspects of labor power which *escape* determination by the economic"?[25] That would be the question posed by her film, which would manifest personal fulfillment in a realm in which the artificial divisions derived from abstract labor under capital ceased to exist. The fact that she cannot get it made keeps it a dream, but a powerful one: it would only be hers until externalized—after that, it would be a part of the world of that work which alienates. Juxtaposed against the film her political group makes to link up with the revolutionary traditions of Soviet films from the 1920s, Franziska Busch's film would show us that all they depict is a flag waving in smoke. There is a lack of workers, no movement, nobody on the street during a work stoppage, even though we see the film crew standing around outside the image. The smoke and their flag blend with the older tradition in the Soviet-montage sequence, but this only points to what has become of one dream because it refused space to so many others. One of the things film has to "work through," *Deutschland im Herbst* suggests, is the lack of workers involved at this point, and the trauma that such a lack should cause to "the movement."

The dream here is not of the kind that offers the key to a personal past when interpreted, opening up the stunted progression to individual normality and fulfillment. In the impossible moment set up by the rhetorical structure of Kluge's segment, Franziska Busch's haiku interweaves with the fairy-tale moments stressed so often in the film. The poems, parables, and "cave drawings" seem to have nothing to do with the immediate, local story of Germany and its terrorism in the 1970s, but they have everything to do with a global dreamwork on ourselves that avoids the self-evident commodification resulting from concrete labor *and* abstract labor under modern industrial production. Reading the other vignettes through this lens shows that *Trauerarbeit* in the psychologized sense has become part of that process and throws into relief the impossibility of fulfillment through labor under the public/private

distinction of capitalism. In doing so it materializes the alienation of labor in images and uncovers the importance of the ideology of labor to those trying to provide their contribution to the cause through cultural texts. By focusing on the labor of concrete mourning and on the need to mourn the abstraction and absence of labor, *Deutschland im Herbst* becomes a film very much about the way the Federal Republic and other contemporary societies are working themselves to death, and have been for hundreds of years.

IV

We have been casting our eyes back to 1977, a move paralleled by Germany's recent TV and film output. If we were looking at British culture, we might be talking about the punk explosion and the Brixton uprisings; in the United States it might be the first installment of the *Star Wars* franchise; in German history, 1977 has become synonymous with the apex of the Rote Armee Fraktion (RAF) violence and related criminal actions in the disastrous German Autumn. Terrorism, Schleyer, "Landshut," Mogadischu, GSG 9, Stammheim: these have come to stand for Germany 1977. But our reading of *Deutschland im Herbst* shows that remembrance of these very (West) German events should not lose sight of labor as both a concrete and an abstract determinate for the conjuncture that gave them rise. The visual track of the crowds of mourners in the streets after the burial of the Baader, Ensslin, and Raspe are a reminder of the dream to which people can aspire, even as the soundtrack seems to shroud them under the hagiographic paean to Sacco and Vanzetti: seen retroactively through the 1980s, this is indeed the death of another moment of possibility. In 1993 Hellmuth Costard, one of the senior figures of alternative cinema in the Federal Republic, finds that *Konsumterror, Konzernterror,* and *Entfremdung* are revisited upon postwall Germany, submerged beneath a new wave of commodified dreams. *Der Aufstand der Dinge* is a story of revolution that lampoons everything from German reunification to the renewed arms race to ecological blindness, taking up the strategy of linking form and critique employed by Fassbinder, Kluge, and company in viewing Germany 1977. Costard, however, points our attention beyond the crucial difference between cultural work and the labor of dreams, stressing fundamentally material moments in the contemporary culture of transition. In shifting his concern back to the world of material itself, Costard is able to evoke ideas that are often instrumentalized, and hence forgotten, in the postwall world: individual freedom and fulfillment chief among them.

Already the title, *Der Aufstand der Dinge,* makes us aware of the shift from media to material by punning on the title of Wim Wenders' exploration of the difficulties facing the committed film artist in a world dominated by Hollywood and big business, *Der Stand der Dinge.* Costard has always used jokes to make a point and sought to use the technical apparatus available to his very modest means in order to structure his punch lines. The core conceit of this film, that "things" have become autonomous, allows him to employ relatively simple special effects to help initiate the fun. Here he uses them to make a film about fetishization itself and the problems inherent in the progressivist notion that accelerated fetishization under capitalism will inevitably lead to a utopian state of things. Those seeking social change have been alienated from revolution, which has been taken over by things: the youth movement of oppositional entrepreneurship furthers *Abstand* rather than *Aufstand* (distance rather than rebellion). Costard explores this redoubled alienation by eschewing state-of-the-art film effects for the childlike images of stop-action animation, a process that makes the presence of labor in the film's production evident in the jerky visual track that arises from *not* showing it. The gags here are made sharper by the intentional display of outdated machine-parts and tools on the screen, for they resist the blinding fascination that can accompany the visions of new technology. Even these outdated things, which are the objectified dreams of those who made them, have more volition than humans because they labor to realize dreams of their own

The convoluted plot of *Aufstand der Dinge* is peppered with bad puns and extensive dialogue sampled from Shakespeare and Büchner, among others. It opens with a prehistory in voice-over of how two "lurkers" from outer space once crashed on earth when their light-driven ship (*Getriebe*) was damaged in an interstellar collision. The aliens have spent millennia shifting into different bodies, for they have no material presence and thus possess no motive force themselves: they are "without will, but not without goals." Replacing reflexivity with self-deprecating comedy from the outset, they find themselves in a "cheap film" in which the main characters are "stupidity," "error," and "greed" under the direction of "things, as always." Costard's cheap film tells of the last phase of the aliens' attempt to return to space. For this they are able to make use of a group of ex-GDR twenty- to thirtysomethings, who are trying both to make it as entrepreneurs from the "neuen Ländern" and to help combat environmental problems. Their invention, the inspiration for which was planted by the "lurkers" in a dream, uses empty beer cans to support wafers of shining metal that

concentrate sunlight on a collection cell: infinite power, zero pollution. The viewer soon suspects that the process leading to this *Dosentechnik* is more than just the pursuit of the ultimate form of recycling: it shows the process of self-objectification in labor as the false means to transcendence, calcifying human dreams of self-determination and self-fulfillment.

For example, in a stop-action sequence of just over a minute in duration, we watch tin cans forming and labeling themselves, and then marching out the door. The voice-over speaks of the philosophical essence of the can: more than just the garbage of tomorrow, the can embodies a space of pure will formed by others. But in the visual track, there are no others laboring to manifest this space of will, or rather, they are visible only in their effects and can be traced in the shuddering "descent of the can" into life and out into the world. The "will" that is connected to the potential of bodily labor is neutralized in the empty space within the commodity form. The abstract labor that creates its own ground in capitalism is here shown to be doing precisely that work, and it is the erased, concrete labor of humans in the aesthetic form of the film that brings this to the fore. As will and representation, the world of commodities already inscribes those who, like these entrepreneurs, seek "eine lose Symbiose mit der Dose" (a loosely symbiotic relationship with the can).

That, of course, is just what the two lurkers are hoping for. With the help of the *Dosentechnik* they position their reconstructed ship and return to space. Before doing so they have to reassure themselves that the humans will not follow them, but a quick series of questions reveals that all those involved have already forgotten anything of the original idea. Though the aliens have taken the plans for the pollution-free energy source with them, they have nonetheless left an explanation about the "state of things" that might be worth remembering. We learn that the things we watch moving independently—from ladders and bicycles to money and furniture—are nothing but the dreams and desires of people objectified through the processes of work that have arrested them in commodified form. To overcome the alienation, the *Abstand der Dinge,* we have to get our desires back because under the direction of things the work of greed, idiocy, and error takes its course, and the humans are ultimately to be completely left behind.

V

Costard manages to get the audience thinking about the interconnectedness of major contemporary issues, from reunification to the envi-

Der Aufstand der Dinge (The Uprising of Things, 1994, dir. Hellmuth Costard).
(Courtesy Filmmuseum Berlin—Deutsche Kinemathek.)

ronment to the post–cold war spiraling of the arms race. He does this,
however, by evoking representations that, much like the technology he
uses and depicts, belong to our archaic image-banks of the cold war:
the military-industrial-scientific complex; the basis of new production
in material consumption (of beer!); tools that belong to the second
rather than final third of the twentieth century. And yet perhaps these
are not so archaic after all. They remind the viewer of the unevenness
of development across the globe, even as Costard employs them to dis-
place the myth of infinite development and freedom from material
want, which is so vital to Germany after reunification. The component
of this myth located in Germany does indeed take us back to the future
of the 1950s, where the dream of individual fulfillment and social
renewal through hard work was continually reproduced by the dream
factory that is capitalism. Abstract labor functions as the invisible
structural determinate for that factory producing the real existing Eco-
nomic Miracle, then and now.

Once itself known as the *Traumfabrik,* film has become an archaic,
although not yet redundant, site for the reproduction of that myth
within the larger structures of social mediation. Other forms have

begun to offer more palpable means of generating self-evident self-recognition. But the cinematic affinity to modern industrial processes that are still doing the hidden labor of producing and reproducing its conditions of existence means that it maintains a special potential for sparking an immanent critique. In viewing the aesthetic form of these three films we have seen film gesture to the determinate structural absence of abstract labor behind the dream of public and private fulfillment. At times this nod has happened despite the intentions of the filmmaker, as in *Spur der Steine*. In order to actuate this critique, *Deutschland im Herbst* and *Der Aufstand der Dinge* realienate film form by setting it against, on the one hand, a nearly global artistic tradition in a different form and, on the other, the acts of concrete labor that work in the information and cultural age is supposed to transcend. If there is a progression here, it is not to be found in the sophistication of the film work, but in the disappearance of the specified location of labor. Between the local and the global, reunified Germany itself becomes the dream factory in *Der Aufstand der Dinge,* at least until the end. Costard's final image, in which we ostensibly watch the alien ship rise through the heavens, shifts to a computer animation that provides the illusion of seamlessness that has been refused by the rest of the film. The final disappearance of human forms here, accompanied by the move to "effortless" visualization that erases all residual traces of labor, makes a joke of the dream of freedom from alienation. This is a gallows humor that reminds us of the dream on which we sadly have to work.

Notes

1. Moishe Postone, *Time, Labor, and Social Domination: A Reinterpretation of Marx's Critical Theory* (Cambridge: Cambridge University Press, 1993), 149.

2. Postone, *Time, Labor, and Social Domination,* 150.

3. Postone, *Time, Labor, and Social Domination,* 151.

4. Banned in the wake of the repressive cultural decrees emerging from the Second Bitterfeld Conference and the Eleventh Plenum of the SED (Sozialistische Einheitspartei Deutschlands), *Spur der Steine* was adapted from Erich Neutsch's monumental novel, which had quickly become a popular and official favorite after its publication in 1963–64. Erich Neutsch, *Spur der Steine* (Leipzig: Faber & Faber, 1996).

5. Louis Althusser, "Cremonini, Painter of the Abstract," *"Lenin and Philosophy" and Other Essays,* trans. Ben Brewster (London: New Left Books, 1971), 209–20.

6. As J. H. Reid points out, there is indeed nothing anti-GDR about the film, and its dialogue is often much less provocative than that of Heiner Müller's *Der*

Bau or even Neutsch's novel; Reid, however, fails to take any of the visual struc-
ture of the film (beside the carpenter's dress) into account and thus cannot see that
it inadvertently shows the ideological coincidence of real existing socialism and
that which it was supposed to have overcome. J. H. Reid, "Erich Neutsch's *Spur
der Steine:* The Book, the Play, the Film," *Geist und Macht: Writers and the State
in the GDR,* ed. Axel Goodbody and Dennis Tate (Amsterdam, Rodopi, 1991),
58–67.

7. Althusser, "Cremonini," 211.

8. Althusser, "Cremonini," 213–14.

9. Althusser, "Cremonini," 211.

10. Althusser, "Cremonini," 210.

11. See "Die gedruckte ND-Kritik" and "Werktätigen gegen *Spur der Steine,*"
both in the "Dokumente" section of *Regie: Frank Beyer,* ed. Ralf Schenk (Berlin:
Hentrich, 1995), 106–51.

12. This analysis will help us deepen our understanding of what Karen Ruoff
Kramer has rightly identified as the vital determinations in the film: "work,
women, and the West" ("Representations of Work in the Forbidden DEFA Films
of 1965," *DEFA: East German Cinema 1946–1992,* ed. Sean Allen and. John San-
ford [New York: Berghahn, 1999], 136). Kramer frames her discussion of the *Kan-
ninchenfilme* with the metaphor of the "window" of self-examination that opened
briefly after the wall was erected. She seeks to retrospectively "wash that window
clean" to afford us the best understanding from the postwall context of the project
of self-critique involved in order to most "productively" engage in the "retarded
reception" (134) of these works. My project of aesthetic analysis shows that "clean
windows" do not always provide the best view to understanding the "real abstract"
of ideological structures.

13. Such watchers are not specific to communism, and they leave traces even
when they are no longer physically present, as we see in Kati Klee's new apart-
ment, decorated with Frau Schickedanz' faces from the previous periods of Ger-
man history. The spaces where the pictures were continue to hover over her after
she has the old faces removed.

14. Beyer expounds on this issue in regard to *Spur der Steine* in his autobiogra-
phy, *Wenn der Wind sich dreht. Meine Filme, mein Leben* (Munich: Ullstein, 2001),
129ff. Aside from the mammoth scope of the novel, the film also treats its setting
differently. The dirt of the early Schkona presented by Beyer is the dust of the
"Western" town under the feet of the not-so-magnificent seven, but it becomes
clean; Neutsch's Schkona is dirty because of the industry, and, interestingly
enough, windows and vision are used immediately to show the effects of the pollu-
tion from the factories.

15. While I am aware that scholars such as Kaja Silverman (*The Acoustic Mir-
ror: The Female Voice in Psychoanalysis and Cinema* [Bloomington: Indiana Uni-
versity Press, 1988]) have shown that problems adhere to use of the woman's voice-
over, I feel that we should not conclude that nothing further happens with it.
Indeed, here the powerful disembodiment is made even more interesting if we
remember that the voice we hear is not even that of the actress who has been visu-
ally available to us through most of the film. Of course, diegetically this is Kati

Klee's voice, but even as Jutta Hoffmann speaks the words, the visual trace of Krystyna Stypulkowska is entirely absent.

16. Christa Wolf, "Lesen und Schreiben," *Lesen und Schreiben* (Berlin: Luchterhand, 1980), 29.

17. Richard Collins and Vincent Porter, *WDR and the Arbeiterfilm: Fassbinder, Ziewer, and Others* (London: British Film Institute, 1981).

18. Christian Ziewer's *Liebe Mutter, mir geht es gut* (Dear Mother, I'm Doing Well, 1972); Klaus Wildenhahn's *Emden geht nach USA* (Emden goes to the USA, 1976); Christian Ziewer's *Der aufrechte Gang* (Walking Upright, 1976).

19. Fareed Armaly, "Interview with Peter Märthesheimer," http://www.haus site.net/haus.0/SCRIPT/txt1999/11/Marthes2.html, accessed 7 June 2006.

20. The most successful example of the *Arbeiterfilme*, Fassbinder's *Acht Stunden sind kein Tag* (1972), may be an exception to this general estimation because as a miniseries that did manage to occupy the generic ground of the family melodrama for TV viewers, it is formally able to direct its energies elsewhere. Since this chapter is most concerned with feature films, consideration of this important work must be left to another time.

21. Rightly so, since many of the leading alternative filmmakers of the day worked on this omnibus piece that treats the "German Autumn" in light of Germany's very unique Nazi past. German political and cultural figures, symbols, and actions pervade the film, which is shaped by Alexander Kluge and editor Beate Mainka-Jellinghaus to make a contribution to the oppositional public sphere that has had its most powerful expression in Kluge's works coauthored with Oskar Negt. See Oskar Negt and Alexander Kluge, *Öffentlichkeit und Erfahrung: Zur Organisationsanalyse von bürgerlicher und proletarischer Öffentlichkeit* (Frankfurt am Main: Suhrkamp, 1972); *Geschichte und Eigensinn* (Frankfurt am Main: Zweitausendeins, 1981); and *Maßverhältnisse des Politischen: 15 Vorschläge zum Unterscheidungsvermögen* (Frankfurt am Main: Fischer, 1992).

22. Thomas Elsaesser, *New German Cinema: A History* (New Brunswick, NJ: Rutgers University Press, 1989).

23. Kluge, of course, has often averred that light, music, and rhythm interest him most in film and that the images often get in the way (see, for example, the interview with Edgar Reitz, *Bilder in Bewegung: Essays, Gespräche zum Kino* [Reinbek bei Hamburg: Rowohlt, 1995], 75).

24. The cut of the haiku is more thematic than formal, and so it does not necessarily correspond to the cut of the film. However, its conception is very much akin to the notion of montage, as filmmakers from Eisenstein on down have noted: the art of interpretation is in the attempt to understand the link of the two sections. See Haruo Shirane, "Writing Haikai," http://www.columbia.edu/itc/eacp/asiasite/topics/index.html (accessed November 18, 2003).

25. "Christoper Pavsek, "History and Obstinacy: Negt and Kluge's Redemption of Labor," *New German Critique* 68 (Spring–Summer 1996): 137–63.

Drums along the Amazon

The Rhythm of the Iron System in
Werner Herzog's *Fitzcarraldo*

Lilian Friedberg and Sara Hall

> Even the aesthetic activities of political opposites are one in their enthusiastic
> obedience to the rhythm of the iron system.
>
> —Theodor W. Adorno, "The Culture Industry:
> Enlightenment as Mass Deception"[1]

I

Werner Herzog's 1982 production of *Fitzcarraldo* has been lauded as a
spectacular tribute to the power of dreams—in one reviewer's words,
"uplifting and melancholic, praising artists and giving failed artists the
courage to fulfill their dreams, however grandiose and impractical they
may be."[2] The film received the Cannes Director's Prize and Ger-
many's Federal Film Prize in 1982. But even during its troubling five-
year production period, doubts were raised about the film's impact on
the indigenous populations involved and the environmental damage
the crew wrought on one of the world's last remaining outposts of pris-
tine rainforest in the Amazon regions of Peru. Nor were the perils of
production restricted to the bodies and homelands of "savage Indians"
(as Herzog describes the thousand-plus indigenous extras hired in the
film's making).[3] In the preliminary stages of filming, the production
camp was attacked and burned down by oppositional Natives
(Agaruna). A plane crash later took several lives. One crew member
amputated his own foot with a chainsaw after he was bitten by a ven-
omous snake. Eight-hour emergency surgical procedures were needed
to save the lives of other cast members injured by live arrow fire. On-
site anesthesia supplies were depleted during the surgery, so when cam-
eraman Thomas Mauch split open his hand shooting a scene in the

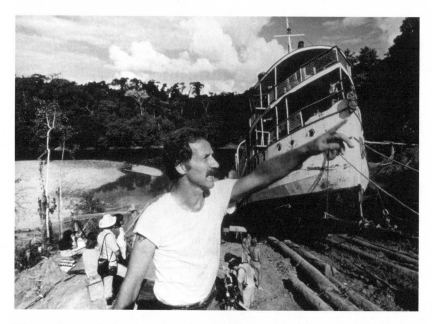

Werner Herzog during the production of *Fitzcarraldo* (1982). (Courtesy Filmmuseum Berlin—Deutsche Kinemathek.)

rapids, a two-hour procedure had to be performed without painkillers. Activists expressed concerns about the conditions of apartheid imposed on cast and crew, and finances depleted as investors cast a pall of skepticism over a project that seemed fated for disaster from the start.

It is not simply shock value that lends prominence to these events. Critics argue that they serve as evidence of the neocolonialist dimensions of Herzog's cinematic project and that the physical violence involved in the film's production reenacts the invasive practices the film presumably critiques. In *Burden of Dreams* his documentary about the making of *Fitzcarraldo,* Les Blank recounts objections raised against Herzog for his treatment of both the land and the people of South America, providing a sense of the measures taken by the director and of his justification for those measures. Throughout the early 1980s, critics and the public confronted Herzog with complaints about his colonial fantasies and practices, and these objections found visual expression in Nina Gladitz's 1984 documentary *Land of Bitterness and Pride.*[4] Then and now, those discussing and writing about the film have

gone beyond considering the experiences of the individuals involved and begun exploring the larger significance of a production process that engenders trauma and sacrifice. Recent critical scholarship has elaborated on the fact that the neocolonialist elements of Herzog's filmmaking are textual as well as physical. The films themselves, through their codes of signification, impose anew on indigenous cultures the very colonialist narratives they ostensibly seek to critique. The reinscription of a neocolonialist narrative is particularly insidious in this case because it does not stop at the "symbolic" level of cinematic extermination, but rather, in its unrelenting pursuit of "ethnographic authenticity," actually participates in the contemporary reenactment of the colonialist drama *in situ* in the rainforests of Brazil and Peru.

Most of the critical work demonstrating Herzog's neocolonialist impulses focuses on visual elements of the film and their relationship to the role that visual practices and tropes have played historically in the execution and representation of colonialist violence. To date little has been written about the way the soundtrack of *Fitzcarraldo* similarly employs *audible* forms of exploitation in its representation of colonialist practices. And yet Herzog's aural representations involve the same forms of cultural colonialism that have characterized the cinematic stereotyping of indigenous Others throughout the history of recording media. This is not to say that the audible elements of Herzog's work have not been taken into account in general, for they have. As William Van Wert writes: "Music is perhaps the strongest organizing principle in Herzog's films. On a conscious level, the spectator may well marvel at 'haunting' visuals in Herzog's terms, but, I contend, the music that accompanies those visuals is what charges them, providing the 'haunting' as much as the camera or editing."[5] Herzog himself said in a public discussion with Roger Ebert: "On most occasions it is the sound that determines the outcome of the battle."[6] While emphasizing sound and music, these two quotations alone begin to hint at the problematic status these representational elements assume in our examination of Herzog's films in the context of a neocolonial enterprise. What we hear is: Music is a structuring factor that "haunts" the characters and the spectators. Sound is a driving force in the violent conflict at hand. These quotations are part of a larger discourse that is militaristic and exoticist, and, as we shall demonstrate, derisively primitivist.

Since the Western operatic tradition stands at the center of the narrative, European music has been the primary focus of what little writing has been done on the element of sound in this film. The traditional indigenous music on the soundtrack has been effectively marginalized

not only by the film text, but also by scholarship. In fact, in these con-
texts the function of indigenous music—drumming in particular—has
thus far not even been afforded the distinction of being classified as
"music" but treated, rather, by the filmmaker and his critics alike
merely as "sound" or "noise." A closer consideration of the function of
indigenous music on the soundtrack raises the question of the degree to
which the presence of non-Western music in the film serves Herzog's
purported critique of colonialism and the degree to which it reinscribes
and reenacts colonialist practice. In an attempt to confront that ques-
tion, this essay outlines the way aural appropriations in *Fitzcarraldo*
underscore stereotypical perceptions of indigenous populations as
"savage," "sinister," and "menacing" based on distorted representa-
tions of their musical traditions in the film.

II

In *Deterritorializing the New German Cinema,* John E. Davidson
injects critical reflection into the popular notion of New German Cin-
ema (NGC) as a revolutionary cinematic movement characterized by
the oppositional visions and utopian designs of German filmmakers
who viewed themselves as a marginalized minority struggling to estab-
lish a new German (cinematic) identity against the juggernaut of Hol-
lywood. He describes the way NGC films center on a rhetoric of "Ger-
man difference with Western sameness" and assume in their logic
contradictions already in place in the late nineteeth century, when var-
ious imperialist powers were vying for colonialist control of non-West-
ernized territories.[7] Davidson sets out to examine the "contradictory
results of cultural opposition" and reminds us that in the 1960s NGC
emerged from a neocolonialist global context in which Western politi-
cal powers sought to maintain cultural, sociopolitical, and economic
supremacy in territories over which they had once exerted physical
domination. By placing NGC in this neocolonialist framework, David-
son demonstrates the way the creation of an "othered" German iden-
tity became an integral component of Germany's sustained effort to
assume a respectable position among other Western nations as a major
player on the international political landscape. By sending their pre-
sumably critical, culturally resistant high-art films onto the interna-
tional festival and distribution circuit, representatives of the NGC
were assuring Germany the status of a civilized, culturally evolved
nation in the international public eye. Taking this into account, David-
son calls into question the putative "anti-imperialist" potential of
NGC and points to the way this "false othering" identifies NGC as a
site of neocolonial knowledge production.[8]

Davidson discusses the way NGC's quest for "sameness with a difference" recalls the nineteenth-century rhetoric of an inherent European right to empire. Herzog's neocolonial incursion into the Amazon then functions as a German right/rite of passage into the international imperialist regime of the New World Order. According to Davidson's analysis, NGC emerged in the 1970s and 1980s to position German national cinema as a minor discourse in the dominant arena of Western filmmaking,[9] and *Fitzcarraldo* represents the pursuit of this aim in the effort to inaugurate a rebirth of legitimate film culture in Germany. The film that sets out to provide a critical perspective on the role of cultural production as an ideological pillar of colonialism ironically perpetuates the very tradition it aims to challenge. While Davidson does draw a parallel between Fitzcarraldo's grandiose dreams of bringing opera to the South American Natives to Herzog's own attempt to film a *Gesamtkunstwerk* in the jungle, he does not go into detail about the significance of the protagonist's love of opera as the motivating force behind his momentous endeavor. If we explore more deeply the relationship between colonialism and musical culture, we will see that Fitzcarraldo's beloved opera exists in a dialectic relationship with a marginalized Native musical culture that continues to be defined, objectified, and reductively codified according to colonialist representational standards.

A portion of the dialogue in the film's opening sequence substantiates Davidson's claim, while at the same time pointing to the centrality of music in the cultural struggle that lies at the heart of both the colonial project and the aspirations of the NGC. Fitzcarraldo and his girlfriend Molly have made a grueling river journey to attend the Caruso performance at the opera house in Manaus. When stopped at the door by an usher (who is Black), Molly pleads that they should be let in, saying of Fitzcarraldo, "He may not have a ticket, but he has a right." The protagonist may not have the technological power of others around him and he may not have built the first large opera himself, but his love of culture and his desire to build the second great opera house in Peru should be impressive enough to gain him entry into the performance. The usher lets him in and joins him, revealing that he too would love to hear the performance. Though he is not a colonizer of the highest order, Fitzcarraldo thus becomes both a consumer and an agent of the practices of cultural intervention that are part of the colonialist project—he, a European white man, is viewed as blessing a Black member of the servant class with the "privilege" of partaking in a high European art form.

By association, then, while the character Fitzcarraldo may not have

a ticket to participate in the "colonialist drama" that forms the narrative framework of the "Western" world in which NGC (and with it, German national identity) attempts to secure a place for itself, he does have a *right*. *Fitzcarraldo* hence emerges as an expression of the desire to participate in the European colonialist drama, but in an oblique and uniquely German fashion. In the subsequent action, Herzog points to the hubris and folly of measures taken by Europeans in the name of economic and territorial development in South America, but at the same time he shows the protagonist's case to be different by virtue of its motivation, thus implying the superiority and even excusability of measures taken in the name of culture. It is implied by extension that German colonial and neocolonial endeavors are similarly superior and excusable, for Germany as a neocolonial power is cast as participating not in outright slaughter but in a process of cultural colonization. It is a nation catching up with colonialism, but catching up gently.

Lutz Koepnick similarly addresses the way Herzog's "Amazon films" "stage colonial enterprises destined to fail due to the heroes' inability to escape their Western imagination, to relate to the semantic multiplicity of the jungle, and to demarcate the kind of boundaries that provide for personal and collective identities in the first place" only to participate in the same colonial spectacle that is the object of its criticism.[10] Drawing on the sylvan imagery in both films and on semiotic associations of the jungle/forest with savagery as opposed to the "civilized" space of the "clearing," Koepnick states that, through the imperial gazes of their main protagonists, "Herzog's Amazon films not only expose colonial practices by mapping the visual and tactile strategies that are employed when Western civilization meets the jungle, but also depict colonialism as an inadequate system of representation and understanding, one that systematically leads astray when used to navigate action amidst the erotic spectacle of nature."[11] Like Davidson, Koepnick identifies the paradoxical disjuncture inherent in Herzog's comprehension of the "shortsightedness of the colonial gaze," juxtaposed against his own participation in the same logic of his colonialist hero in his role as auteur.[12]

Koepnick's analysis of "sylvan politics" is aptly applied to the way inhabitants of the forest are placed at the same phenomenological level as the trees in *Fitzcarraldo,* thereby reinforcing the notion of "savage Indians." *Savage* and *sylvan* are derived from the Latin *silvaticus,* meaning "woodland, wild," and this perception of the Native inhabitants of forested areas has been enlisted in the extermination of these

very populations for centuries. Much of the film's cinematography draws on this exterminationist logic for its effect. For example, in the opening sequence, the camera pans the "sylvan" landscape from an aerial view and zooms in for a long take on a dying tree whose outline assumes a conspicuously human form. This association of human life forms with the (dying) life forms of the forest is repeated in the central sequence in which the Molly Aida is about to be "swallowed" by the forest: as the ship pulls into the forest, four Native Indians appear in a *tableau vivant*. Their lifeless vertical position at the center of the frame is juxtaposed against the horizontal image of two felled trees beside them. They are frozen in time and framed by the forward-moving colonialist gaze of the camera. Once the ship has embarked on its ominous adventure and left the tableau Indians behind, our first glimpse of the Natives comes in an extreme long shot, filmed from the moving ship. The Natives are at first barely distinguishable from the canopy of trees behind them. As the camera slowly moves in on them and they come into view, they are perfectly aligned with the trees. It is only at the point in which the colonial gaze of the camera has "closed in" on them that the humans become distinguishable from the trees.

The visual alignment of the Native inhabitants with the forest imagery recalls the same logic by which "depopulation" is placed on a par with "deforestation" in the Western hegemonic project of the New World. Native humans beings are seen in this context as belonging to the same stock of "natural resources" that are there for the white man's taking. According to this paradigm, the human inhabitants of the forest are expendable and exploitable resources, as are the trees. Hence, the "cultural deforestation" or "depopulation" of the New World does not involve a human tragedy, and participants in the process can be exculpated from the crimes they commit in the name of "progress" and "development." What is more, the Natives are thus eulogistically framed as having always already been dead or dying, and the inevitability of the Western telos of progress is confirmed—whoever stands in the way of the clearing's creation will either be left behind or bulldozed. The visual language of this scene demonstrates this deadly logic.

III

Koepnick points to the way Caruso's voice is positioned in the storyline to represent the marvels of Western high culture.[13] Similarly, the image of the iron steamship *Molly Aida* inching up the mountain on its own steam recalls the phantasmagoric trope of technology as a self-

propelled, self-procreating, autonomous subject with a will and logic of its own. Drawing analogies to Adorno's assessment of Wagnerian compositional techniques that seek to imbue technology with self-producing autonomy, Koepnick concludes that Fitzcarraldo's (and Herzog's) endeavor is equally phantasmagoric inasmuch as it seeks to displace nature by assembling in the rainforest an autonomous technological construct that may be admired, but not controlled. While Koepnick astutely recognizes the significance of the tropical rainforest's "polyphonic complexity,"[14] his analysis seems inordinately fixated on the visual aspects of the film, and much of what he argues regarding the film's visual operations and their relationship to the instrumental modes of vision operative in colonialism can be extended to a discussion of the audible aspects of *Fitzcarraldo.* In their displacement into the rainforest, Caruso and Verdi represent a "sophisticated" musical culture in contrast to the "savage" strains of indigenous music, as drum sounds are captured and tamed in the service of Herzog's higher codes of cinematic signification. Russell Berman (as cited by Koepnick) argues that Herzog's films unfold as purely visual spectacles, that they render language secondary and thus solicit mute, inactive modes of spectatorship rather than critical acts of reception. In Berman's words, "The viewer is produced as the passive observer of images, not as an active reader of communicative symbols. . . . A noncomprehending fixation on the image is set as a privileged mode of experience, allegedly providing access to a more authentic perception than could a rational-discursive penetration."[15] A new auditory reading of *Fitzcarraldo* stands to challenge many basic assumptions about Herzog's work, such as those reflected in Berman's discussion of instrumental vision in Herzog's Amazon films. Our goal is to challenge what is indeed an aesthetic of visual plentitude that immerses rather than engages the spectator by insisting that we all listen to, as well as watch, Herzog's film. The soundtrack contains communicative symbols that yield a troubling message of their own, which in turn leads to a more critical reception of the film in both its visual and audio dimensions. One aspect of the film that must be studied in order to comprehend the extent of *Fitzcarraldo*'s neocolonialist implications is the use of Native music and the way this lends further credence to the indictment of cultural extermination in the film.

Even Les Blank fails to point to the problematic misrepresentations of indigenous music in *Fitzcarraldo* in his documentary *Burden of Dreams.* This failure is surprising for a filmmaker whose professional reputation rests primarily on portrayals of ethnic musicians and musi-

cal traditions in such films as *The Blues Accordin' to Lightnin' Hopkins* (1970), *Spend It All* (1972), and *Sprout Wings and Fly* (1983). According to one reviewer, Les Blank "loves ethnic music," "hopes to find better people somewhere than the ones he grew up with in an upper-middle class white family," and "finds the ethnicity of other peoples more satisfying than the ethnicity he got."[16] Blank's omission is emblematic of a broader trend that has impacted not just the reception of Herzog's work, but film studies in general, and the scant critical attention directed toward the politics of musical representation in *Fitzcarraldo* may be partially attributed to the visual bias of Western culture as it is reproduced in the discipline.[17] As Koepnick points out in "Consuming the Other: Identity, Alterity, and Contemporary German Cinema," this cultural bias is particularly relevant to the construction of identities in the West because "[d]ominant Western conceptions of identity are inextricably bound up with the modern privileging of sight as the primary locus of experience and knowledge."[18] In the historical legacy of classical film theory, discussions about the soundtrack and its narrative function have been largely restricted to the music's relation to the visual image.[19] The aural aspect of film has traditionally been subordinated to the visual and placed in a dependent relationship that can either be viewed as "parallel" or "contrapuntal" to the images on the screen. More recent theoretical approaches have, however, come to recognize the function of music as a filmic process, and a growing body of scholarship has begun treating the significances of sound in film from any number of perspectives. As Kathryn Kalinak writes in her 1992 study, *Settling the Score,* "Narrative is not constructed by visual means alone. . . . [M]usic works as part of the process that transmits narrative information to the spectator, . . . it functions as a narrative agent"[20] Music and other aural elements signify in their own right, so scholars such as Koepnick, Claudia Gorbman, Caryl Flinn, Royal S. Brown, Anahid Kassabian, Rick Altman, Richard Abel, James Lastra, Eric Ames, and others have begun treating sound culture as primary, even offering examples where image supports or counters the sound in a reversal of earlier assumptions that the image was the primary bearer of significance. In some cases—and the case of the drums along the Amazon in *Fitzcarraldo* is exemplary in this regard—the soundtrack alone bears sufficient cultural and semiotic weight to be treated in its own right.

Music is central to our dominant notions of what characterizes sound in a film text. As Gorbman points out in her introduction to *Unheard Melodies: Narrative Film Music,* "Any music bears cultural

associations and most of these associations have been further codified and exploited by the music industry."²¹ The use of music by the film industry compounds such codification. In her introductory statements to *Hearing Film: Tracking Identifications in Contemporary Hollywood Film Music,* Kassabian stresses the significance of the soundtrack and the way it "conditions identification processes, the encounters between film texts and filmgoers' psyches."²² This process can be considered on a cognitive or perceptual level as Kassabian implies, but it is also a matter of cultural conventions and expectations. Three main fields of musical signification are at issue in *Fitzcarraldo:* Western music (opera in particular), Native music (drumming in particular), and the postmodern cultural synthesis represented by the music of Popol Vuh (as a simulated, mediated representation of Native music). Separately and in relation to one another these types of music lend meaning to the places and the people represented in the film, and to Germany as well, when taken as an extension of the NGC film project and its director.

In his study of sound as it functions in German cinema between Hitler and Hollywood, *The Dark Mirror,* Koepnick notes that music has long played a primary role in defining German national and cultural identity. As far back 1800, German intellectuals saw in music an expression of the common ground shared by a culture increasingly fragmented by disparate political and regional interests. In his 1878 essay "What Is German?" Richard Wagner declared that the essence of German national identity was located in music, despite the apparent difficulty that one might initially have identifying what music qualified as German and what did not. Indeed, as Koepnick reminds us, the connections between the French and Italian traditions and the work of Bach, Handel, and the Austrians Haydn and Mozart were strong. Wagner's rhetorical solution to the dilemma was to describe German composers as having an exceptional ability to rework foreign sources and to add aesthetic value to them. Wagner wrote, "[H]is [the German's] is no mere idle gaping at the Foreign, as such, as purely foreign; he wills to understand it 'Germanly.' . . . [H]e strips the Foreign of its accidental, its externals, of all that to him is unintelligible, and makes good the loss by adding just so much of his own externals and accidentals as it needs to set the foreign object plain and undefaced before him."²³ Koepnick demonstrates that Nazi musicologists followed this reasoning in creating their own definition of the essence of German music, a definition that was echoed in the film music of Nazi cinema.

Herzog's Fitzcarraldo, as he freely admits, is no great fan of Wagner; his heart belongs to Caruso and the music of Verdi. For him, Ital-

ian opera represents everything that the dominant colonials cannot appreciate with any depth. In their instrumental concern for profit and expansion, they scoff at his dream of bringing Caruso to sing Verdi live in the depths of the jungle. Implicit in Herzog's choice of the Italian is a critique of the political instrumentalization of Wagnerian music and operatic spectacle by Goebbels and the Nazi Party.[24] But this critique does not supersede the fact that by including Italian opera in his own masterpiece in the Peruvian jungle, Herzog was himself engaging in a Wagnerian enterprise. Following Davidson's thesis in *Deterritorializing New German Cinema*, we can conclude that Fitzcarraldo's love of Italian opera provides international legitimation for Herzog's contribution to the NGC. In other words the Italian music serves to give the film the "German difference with a Western sameness."

The "Western sameness" becomes most apparent when we consider the unmarked presence of non-Western musical forms in the nondiegetic dimension of the soundtrack. At first listen, no "Native" music is discernible (especially not in contrast to the prevalence of pan flute music in Herzog's other Amazon film, *Aguirre*). Aside from the opera elements integrated into the diegesis, the soundtrack is filled with original compositions by the musical trio Popol Vuh, headed by the late Florian Fricke.[25] The group was formed in 1969 and has been working with Herzog since 1972. Their compositions figure prominently not only in *Fitzcarraldo*, but also *Aguirre* (1972), *Herz aus Glas* (Heart of Glass, 1976), *Nosferatu* (1979), and *Cobra Verde* (1987). Fricke, inspired by the music he heard on his travels to Tibet, India, Nepal, and to various African and South American countries, began composing ethereal pieces for the Moog synthesizer that have been described by one student of avant-garde organ music as an "absorbing, highly eclectic blend of German post-romanticism, electronic music, ethnic dreams and rhythms, minimalist static movement, psychedelic reverie."[26] Popol Vuh's multicultural blending grows out of a multiplicity of Western and non-Western traditions, serving the narratives of both *Fitzcarraldo* and *Aguirre* well because, as Chris Blackford writes, its "introspective synth somehow conjures an ambivalent atmosphere of colonial grandeur and exploitation."[27] One might argue that the music celebrates an attempt to preserve regional musical traditions and casts a critical light on the erasure of culture. Yet at the same time, as a mere simulation of musical traditions in which indigenous musicians remain actively participant, it engages in that very erasure.

Ella Shohat and Robert Stam have discussed the cultural associations that have been codified and exploited by the music and film

industries to reinforce stereotypical images of non-Western peoples through aural stimuli. The authors describe the way that the "native" environment is not only seen through the lens of the colonial gaze, but is also filtered through the sonic limitations of the colonial ear: "when we as spectators accompany the settlers' gaze over landscapes from which emerge the sounds of native drums, the drum sounds are usually presented as libidinous or threatening. . . . African polyrhythms become aural signifiers of encircling savagery, acoustic shorthand for the racial paranoia implicit in the phrase 'the natives are restless.' "[28] Often non-Western music has been codified as so utterly "other" from Western musical traditions that it is not even considered "music" and is reduced instead to the level of an "aural signifier" exploited to reinforce commonly held stereotypes of indigenous peoples as sinister or oversexed savages.

If, following Koepnick in his article "Sylvan Politics," the steamship *Molly Aida* represents the phantasmagoria of technological autonomy, it can also be seen to represent the intrusion of the "rhythm of the iron system" on territories and peoples whose tastes and affinities had previously remained unforged by and uncharted on the ferrous grid of the culture industry register. Focusing our attention on the musical score of Popol Vuh, we hear simulations of their music playing harmoniously in association with the river journeys taken on the protagonist's operatic endeavor, and eventually with the *Molly Aida* exclusively. Their orchestrations first play as Fitzcarraldo and Molly row toward the opera house where Caruso sings in Manaus. They come in again when the two approach and begin examining the ship. Popol Vuh can be heard when the hired workers repair and prepare the vessel for the journey, and again the music swells soulfully as the ship sales into the mission at Saramiritza. From outside the narrative, the music of Popol Vuh achieves what opera achieves within the narrative, a function Fitzcarraldo describes when he insists on bringing his phonograph to the meeting with the rubber barons: "It gives expression to our greatest feelings"—but at the cost of Native rhythms.

IV

The phonograph playing Caruso's music stands for an unspoken drive behind Fitzcarraldo's grand scheme to enlighten the colonizers and to bring pleasure to the Natives, and so to "soothe the savage beast." This taming process is underscored by sounds and silences in the film as these speak within the terse codifications the culture industry has established and disseminated for non-Western music. When Fitzcar-

Fitzcarraldo (1982, dir. Werner Herzog). (Courtesy Filmmuseum Berlin—Deutsche Kinemathek.)

raldo and the crew of the *Molly Aida* enter the dangerous territory of the Jivaros and head toward the deadly rapids, Fitzcarraldo plays Caruso into the trees in a seemingly gentle gesture that provides a direct contrast to the way that his ship's mechanic tried to "have a conversation with our invisible friends" by igniting explosives in the river. The sound of Caruso does indeed quiet the drums and cries that had been emanating from the tangle of the sylvan riverbanks.

In a move rather baffling for a director obsessed with problematic notions of cinematic authenticity, Herzog employs here an aural bricolage that can only function within the parameters of hegemonic Western codes for understanding indigenous peoples and their musical traditions. As the ship is about to be swallowed by the jungle landscape in a long take filmed with a steady, slightly mobile camera, "Native" drum music sets in—softly, barely perceptible at first, then rising to crescendo when it coincides with a frame of the *Molly Aida*'s billowing black smokestack. The "sound effects" in this scene are deliberately deceptive: when the smokestack fills the frame, the sinister sound of the savage drums seems almost to emanate from the ship's engine. The source of this seemingly diegetic sound effect is invisible: its rhythms can be heard, but its origin is not seen. While it renders the illusion of

coming from the forest, it has actually been edited in, both technically and culturally/geographically. What the film's audience hears is a recording of the drummers of the central African country of Burundi, enlisted here to signify the sinister presence of Native South American Indians. Herzog is well aware of this cultural dislocation. As he states in the director's commentary, "There is a certain danger, a certain menace . . . in this music, and I really don't worry about doing such a thing. An anthropologist may come and say, 'Well, this sounds like African drumming,' and I say, 'Yes, so what?' It's wonderful for the film here, and I don't really worry whether the music is in fact African music." In his global film project, musical differences are elided for the sake of cinematic effect.

As Eric Ames reminds us in his study "The Sound of Evolution," since their earliest instantiations, mass culture and technology have promised to bring distant places and populations closer, but this closeness is a double-edged sword when it comes to cultural preservation.[29] Even the earliest musicologists studying non-European traditions were sensitive to the threat of "annihilation," "homogenization," and "modernization" that late-nineteenth-century global contact and circulation entailed. Focusing specifically on the work of the founder and director of the Berlin Phonogram Archive, Carl Stumpf and on Erich Mortiz von Hornbostel respectively, Ames writes, "They consistently emphasized two interrelated forces of transformation, namely colonialism and circulation."[30] In the mind of these two pioneers in German and Austrian comparative musicology (the disciplinary forebearer of ethnomusicology), the wide-scale collection of non-European music (at first via transcription and then by means of mechanical recording) was necessary in case colonialism drove Native populations and their cultures to extinction. The problem was not simply that the musical forms of non-Western regions would fall out of ritual use, but also that European musical forms would take their place, thus accelerating the disappearance of the music beyond any threatened rate of human extinction. Ames cites a quip made by Hornbostel in a 1905 address to the International Society for Musicology in Vienna to sum up this sentiment: "We must rescue what there is left to rescue, before the airship reaches the automobile and the electric speed-train, before we hear Ta-Ra-Ra-Boom-Der-É in all of Africa and The Beautiful Song of Little Cohn in the South Seas."[31]

Ames convincingly offers other significant cases in which early comparative musicologists connected the proliferation of technological forms, and technologies of transportation in particular, with the

exchanges and erasures occurring in the cultural realm. As an example, he cites a letter from Albert Schweitzer to Stumpf in 1914, in which Schweitzer describes a scene from Gabon, Africa: "Motorboats are increasingly replacing rowboats, as the foreign trading posts prefer them. In the foreseeable future there will no longer be any day-long journeys by rowboat, with twenty men in a canoe standing one behind the other, singing in order to keep time in their rowing, i.e. end of the rowing song."[32] According to Ames's reading of the letter, Schweitzer saw that the mechanized forms of modernity were overpowering the very rhythms of daily life, which in turn utterly transformed the rhythms of musical expression in the Native context. The example of *Fitzcarraldo* demonstrates that this musical colonialism extends well beyond the early context studied by Hornbostel, Stumpf, and Schweitzer.

In the drumming scene described above, Herzog follows this self-same pattern when he makes one machine of the phonograph and the ship. The amplification of "his master's voice" from the deck of the *Molly Aida* masks and eventually silences the "savage" sounds of the Natives, enacting a neocolonialist assault not on one, but two separate indigenous populations and their musical traditions—the Native peoples of Peru (acting as stand-ins for indigenous populations throughout the world) and the drummers of Burundi whose drum music is used to signify these peoples acoustically in the film. In *Fitzcarraldo,* Native music signifies (and announces) the sinister, menacing presence of hostile "savages" lurking in the wilds. Herzog exploits the culture industry's codes of signification for non-Western music to advance the narrative. In the process, Native music—and by association, Native people—are demonized, denigrated, infantilized, and distorted beyond recognition. The film thus reinforces the atavistic racial paranoia undergirding the colonialist project and solidifies those unilaterally presumed racial animosities that continue to act as barriers to the development of mutually beneficial cultural exchanges between the worlds of the "West" and the "Rest."

The sonic design of *Fitzcarraldo* entails an attempt to inscribe European musical schemes on the native soundscape. The drumming is present, but it is engineered into the soundtrack as an effect rather than explored in its original representational context. Italian opera, on the other hand, functions as a mode of expression somewhere between the demonic alterity and the alienated and instrumentalized experience of colonialism, a culture that, like the version of American movie culture against which NGC defines itself, can produce nothing better than the

flat strains of bad prose. Similar to the way the opera in the diegetic soundtrack becomes part of the common Western text of the NGC film, the nondiegetic African music is swept into the soundtrack simply for effect, and in a manner that blatantly disregards its cultural specificity and thus effaces its value. It does not take an anthropologist to discern the cultural displacement employed here—it is clearly recognizable to any viewer with a relatively firm grip on the worldwide ethnomusicological landscape. The travesty is that this music, in its indigenous context, is neither created nor perceived by Native listeners as threatening or menacing, but rather as sacred and celebratory. What we read on the WOMAD (World of Music, Arts, and Dance) website about the drum recording Herzog employs here stands in stark contrast to the way it is used to signify the sinister in the film:

> The Drummers of Burundi descend from an old tradition. They learned their skills from their ancestors who have been drummers for many centuries. Their drums are connected to their royalty and are sacred. The word for drum is *ingoma* that means drum as well as King—linking both powers together through sacred performance. The power of *ingoma* insures fertility, regeneration, prosperity and good fortune to the kingdom and its inhabitants. Originally the Drummers of Burundi accompanied the king on his travels. Today, they play at local festivals and national events. It is a great privilege to become one of these drummers as the skills have been passed down father to son for generations. Their fellow countrymen consider them as the most important representatives of their country's musical tradition.[33]

This is hardly the picture of "menace" the music is intended to signify in the film, and it is only in the disjuncture between the perceived threat conveyed by the sound of the drum and the actual "message" transmitted by a culture (or cultural collective) using the drum as medium that these codifications can inscribe meaning for the film spectator. The drum sounds sinister to the spectator because it has been constructed so—in fact, in fiction and in film. The putative validity of this signification is accented in *Fitzcarraldo* by the response on the part of the "friendly" Natives—namely, taking up arms and ultimately jumping ship in fear. But, in its indigenous context, the drum is a sacred object reserved for ceremonial use in celebrating the cycles of lives and of seasons.

In this act of musical displacement at the service of *Kulturkritik,*

colonial attitudes toward South America are expressed through the presence of African drums. An all-too-easy evocation of the "dark continent" is thus imposed on the Amazonian landscape. The soundtrack of *Fitzcarraldo* taps into what Koepnick has described as universal fantasy of Africa that is located outside of real history, geography, and culture, a "fetishized African alterity."[34] The Africa evoked by the drumming is a timeless cultural repository of difference—at once a temptation, a relief, and a threat. Again, although Herzog seems intent on criticizing colonial practices and their ties to the racist media machinery of the Third Reich, his film is driven by the same ideological engine. The protagonist of Herzog's film, along with Herzog himself, seems impressed and moved by the Native drumming, but both choose to channel their impulses into a passion for a more moderate cultural form, one that is both soulful *and* civilized. Whether in Peru or Africa, in the nineteenth or the twentieth century, the German *Seele* prevails in the wilderness.

Herzog engages here in what in the context of contemporary German cinema Koepnick has called a "Third Worldism" that reinforces the colonial past, an attitude that ultimately harnesses rather than decenters German identity.[35] While challenging the hegemonic role of American popular culture and engaging in the postcolonial discourses of other Western nations in the 1970s and 1980s, Herzog does not provide a direct critique of Germany's own colonial history. While it might be argued that musical displacement does explode existent borders between cultures, borders that service the "us" versus "them" mentality perpetuated in colonialist ideology, in *Fitzcarraldo* this borrowing across national and geographic borders does not challenge existent cultural stereotypes—neither when Fitzcarraldo brings Verdi to the jungle nor when Herzog brings the drums of Burundi and Popul Vuh's simulations of Native music to this South American riverbank. Both projects of musical displacement domesticate alterity according to a Western paradigm centered in German notions of culture. The soundtrack of *Fitzcarraldo* thus scaffolds the film as it carries on a cinematic colonial legacy that began with early ethnographic film,[36] became distorted and instrumentalized in the Nazi colonial film, and can still be detected in some of the contemporary postcolonial films to come out of the united Germany.

V

Emerging Third Cinema artists have focused increasingly on the differences that exist between indigenous and Western ways of "compos-

ing for the films." In an article dealing with the use of music by such African filmmakers as Djibril Diop Mambety, Souleymane Cisse, and Sembene Ousmene, Olivier Barlet observes that these filmmakers employ music not as a way of adding "exotic colour," but "to make a collective statement on behalf of the people which thus becomes a key character in the film."[37] Third Cinema's efforts to develop filmic strategies that capture the significant role played by "orality" in indigenous culture often translate into the innovative application of "aural" devices. Against the backdrop of an emerging awareness of music's role in film in general, we can also see why a careful examination of the representation of African and other non-Western musical cultures in films produced by the West for the West might help us recognize colonial constructs produced and reinforced at an aural level.

The question Barlet poses in his discussion of the use of music in Third Cinema is hence equally applicable to any consideration of the same in NGC and in Hollywood: it is a question of whether we know how to listen to the music of Africa in order to hear the difference it expresses.[38] The fact is, most of us don't, or, as Connel and Gibson have stated, "All too often music from developing countries seemed no more than strange sounds and obscure structures that . . . were too challenging for Western audiences."[39] So Western audiences have been forced to rely on misconceptions propagated by cultures of hegemony and fallen prey to many of the same misconstrued notions of what traditional music is, what it signifies in the cultures of origin or what it is intended to convey at a symbolic level in film.

In the imperial cinematic idiom—as evident in the use of the drum in classical Hollywood narrative, road movies, documentaries, and the gamut of aural arenas for cultural extermination—the Native drum signifies menace, danger, fear: the Unknown. It signifies the quintessential Other, and above all, the perceived *threat* of the Other. If this cinematic coding wasn't already apparent to the Western viewer of *Fitzcarraldo,* the point is driven home by the "friendly Natives" who respond to the sound of the drums by taking up arms in a series of shots that reinforce the association of drums with military threat from a perspective of "native informancy." Fitzcarraldo is aided in his monumental mountain-moving expedition by assimilated Natives who get on board with him, man his ship, and accompany him on his journey. But these "visible friends" commit mutiny when the presence of "invisible" friends is signaled by the sound of "savage" drums.

While Herzog anticipated criticism from those who would point out the geographic discrepancies at issue here, he neglected to consider the

implications of the cultural discrepancies involved and the way these relate to historical realities. A disjuncture exists between the way this music is perceived in its Native context and the meanings that have been affixed to it in the imperial imagination, which has led to deadly consequences for Native peoples throughout the world. Native histories are replete with reports of the way this perception of the Native drum has led to harrowing outcomes for real people playing real drums in real lives. In the Native American Ojibwe tradition, for example, a drum created around 1860 in order to "establish intertribal peace and brotherhood"[40] was incorrectly assumed by the settler population to be an instrument of war, and its playing resulted in an incident that went down in history as "The Wisconsin Scare."[41] Hundreds of people lost their lives as a result of this fundamental misperception of the drum's function in Native culture and the utterly false association of drum music with martial intent and military threat. In the United States, throughout the period of slavery, prohibitions were enforced against African drumming under severe penalty because the drums were viewed as expressions of insurgent designs among the enslaved peoples. Since the very beginning of colonial conquest in South America, indigenous people have been forced to foreswear traditional art forms and to burn their musical instruments.[42] And only within the imagined imperial community that is the intended audience for this NGC production does the use of indigenous drums to signify the sinister produce the desired result. In alternatively informed communities, this use of music may serve to confuse rather than to clarify meaning and may in fact lead some to produce unintended or resistant readings.

Today, over twenty years since the film was produced, the manufacture and distribution of Native African and Native American cultural products (i.e., CDs, film, video, written materials) and services (live performances, musical instruction) has expanded to the point where a higher percentage of potential viewers and listeners will be informed enough to inscribe Native music with a more discerning reading or audition. With the dissolution of cold war allegiances and restrictions combined with increased possibilities for transnational cooperation at every level of culture, artists from throughout Africa have developed a visible—and audible—cultural presence in Europe. Today, in cities and towns throughout Europe, classes in African and South American drumming are offered by qualified professionals from the countries of origin and their European students and collaborators. Books have been written, in French, German, and English, by Native practitioners and conscientious ethnomusicologists who deconstruct the myth of the

menacing drum. A substantial "subculture" has been established and generated an audience of discerning listeners who might be confused not only by the geographical disjuncture between the drummers of Burundi and the Araguna supposedly lurking in the sinister folds of the forest, but also by the use of Native music to signify the sinister. At the same time, these developments subject the cultures and cultural products at issue here to the rigors of the "culture industry," and the commercialization of these art forms presents a certain "danger" or "menace" for the purveyors of the tradition.[43]

It would be difficult if not impossible to pinpoint the exact moment in human history in which drums—particularly in the hands of "Others"—came to be associated with martial threat and hence to signify the sinister, menacing presence of presumably hostile "savages." In recent years, several pseudoscholarly, pop-cultural studies have appeared that attempt to clarify the drum's origins in ancient cultures. Layne Redmond attributes changing attitudes toward the drum to the rise of patriarchal cultures and religions.[44] In *Planet Drum,* Mickey Hart (former drummer for the Grateful Dead) provides on the other hand no explanation for the fact that, as he states, "Drums were the driving force behind the percussive din that characterized the ancient art of war."[45] He uncritically places the martial function of the drum beside its more harmonious functions as the accompaniment to dance and work and as a medium for communication. Nor does Hart clarify what he means by "ancient" or how in the world "war" comes to be considered an *art* form! In his picture-book history of drums, Hart has, however, compiled interesting illustrations that, when subjected to further research, might reveal insights into the ways in which drums, Natives, and the threat of war may have come to form this unholy trinity in the Western imagination.

Were the history of colonist/colonized relations not so fraught with the devastating consequences that cultural misperceptions/misrepresentations have had for the real people and cultures "signified" by hegemonistic assignments, one might think it a minor infringement to employ the music of a given culture in an entirely altered context. However, because the Native drum has been construed to signify the sinister again and again in the history of Western civilization, and because the ensuing political response to this basic "translation" error has resulted in the death, suppression, and repression of millions, this type of manipulation for cinematic purposes can be seen as nothing less than irresponsible—especially in the context of a cinematic tradition that pretends to challenge Western hegemony and the imperialist project.

Notes

1. Theodor W. Adorno, "The Culture Industry: Enlightenment as Mass Deception," *Dialectic of Enlightenment,* by Theodor W. Adorno and Max Horkheimer, trans. John Cumming (New York: Continuum, 1995), 120.

2. Paul Brenner, "Online Review: *Fitzcarraldo,*" http://www.mediascreen .com/ef/fitzcarraldo_dvd.htm (accessed September 1, 2003).

3. Werner Herzog, cited in *Burden of Dreams* (1982, dir. Les Blank).

4. Andrea Rosta, ed., *Werner Herzog in Bamberg* (Bamberg: Universität Bamberg, 1986).

5. Cited in Ming-Che Lai, "Birth, Death, and In Between, Ritual," http://www.icaen.uiowa.edu/~mclai/p6.pdf, 68 (accessed September 1, 2003).

6. Cited in Lai, "Birth, Death," 29.

7. John E. Davidson, *Deterritorializing the New German Cinema* (Minneapolis: University of Minnesota Press, 1999), 7.

8. Davidson, *Deterritorializing,* 33.

9. John Davidson, "As Others Put Plays upon the Stage: Aguirre, Neocolonialism, and the New German Cinema," *New German Critique* 60 (1993): 102.

10. Lutz Koepnick, "Colonial Forestry: Sylvan Politics in Werner Herzog's *Aguirre* and *Fitzcarraldo,*" *New German Critique* 60 (1993): 135.

11. Koepnick, "Colonial Forestry," 136.

12. Koepnick, "Colonial Forestry," 137.

13. Koepnick, "Colonial Forestry," 152.

14. Koepnick, "Colonial Forestry," 156.

15. Russell A. Berman, "'The Recipient as Spectator': West German Film and Poetry of the Seventies," *German Quarterly* 55.4 (1982): 504.

16. Les Blank and James Bogan, eds., *Burden of Dreams: Screenplay, Journals, Reviews, Photographs* (Berkeley: North Atlantic Books, 1984), 117.

17. Kathryn Kalinak, *Settling the Score: Music and the Classical Hollywood Film* (Madison: University of Wisconsin Press, 1992), 20.

18. Lutz Koepnick, "Consuming the Other: Identity, Alterity, and Contemporary German Cinema," *Camera Obscura* 15.2 (2000): 41.

19. Kalinak, *Settling the Score,* 24.

20. Kalinak, *Settling the Score,* 30.

21. Claudia Gorbman, *Unheard Melodies: Narrative Film Music* (Bloomington: Indiana University Press, 1987), 3.

22. Anahid Kassabian, *Hearing Film: Tracking Identifications in Contemporary Hollywood Film Music* (London: Routledge, 2001), 1.

23. Qtd. in Lutz Koepnick, *The Dark Mirror: German Cinema between Hitler and Hollywood* (Berkeley and Los Angeles: University of California Press, 2002), 42.

24. Herzog will later use a Wagnerian soundtrack to accompany the scenes of military imperialism in Kuwait in his film *Lektionen in Finsternis* (1992, Lessons of Darkness).

25. The group's name derives from the title of the Mayan book of the dead, likely formulated prior to A.D. 250 and written by the Quiché people after the Spanish Conquest of A.D. 1594. The Quiché were a great independent nation in the

highlands of Guatamala before the Conquest. The use of these words involves the group in a discourse over the legacy of colonialism and cultural imperialism in the Americas. See Lai, "Birth, Death."

26. Chris Blackford, "Pipe Dreams: A Century of Innovative Organ Works. Part 5: Popol Vuh and Florian Fricke (1944–2001)," http:www.btinternet.com/~rubberneck/avantorgan5.html (accessed July 2003).

27. Blackford, "Pipe Dreams."

28. Ella Shohat and Robert Stam, *Unthinking Eurocentrism: Multiculturalism and the Media* (New York: Routledge, 1994), 209.

29. Eric Ames, "The Sound of Evolution," *Modernisim/Modernity* 10.2 (2003): 308.

30. Ames, "The Sound of Evolution," 309.

31. Qtd. in Ames, "The Sound of Evolution," 310.

32. Ames, "The Sound of Evolution," 309.

33. WOMAD, "Drums of Burundi," http://www.arts.auckland.ac.nz/womad/africa.html (accessed September 1, 2003).

34. Koepnick, "Consuming the Other," 47.

35. Koepnick, "Consuming the Other," 67.

36. Assenka Oksiloff, *Picturing the Primitive: Visual Culture, Ethnography, and Early German Cinema* (New York: Palgrave, 2001).

37. Olivier Barlet, "If Your Song Is No Improvement on Silence, Keep Quiet!" *African Cinemas: Decolonizing the Gaze,* ed. Chris Turner (London: Zed Books, 1996), 186.

38. Barlet, "If Your Song," 183.

39. John Connell and Chris Gibson, *Sound Tracks: Popular Music, Identity, and Place* (London: Routledge, 2003), 146. Eric Ames recounts the dialogue that took place among early German and Austrian comparative musicologists over the "legibility" of non-European musical forms, a discussion that centered on a questionable distinction between European "art music" (*Tonkunst*) and non-European "natural music" (*natürliche Musik*), which had been postulated by Eduard Hanslick in 1854. See Ames, "The Sound of Evolution," 306.

40. Thomas Vennum, *The Ojibway Dance Drum: Its History and Construction* (Washington, DC: Smithsonian Institution, 1982), 70.

41. Mickey Hart, *Drumming at the Edge of Magic* (San Francisco: HarperCollins, 1990); Winona LaDuke, *Last Standing Woman* (Stillwater, MN: Voyageur Press, 1997).

42. Max Peter Baumann, "'Listening to the voices of indigenous peoples . . .' On traditional music as policy in intercultural encounters," *Echo der Vielfalt/Echoes of Diversity/Traditionelle Musik von Minderheiten/ethniscchen Gruppen/Traditional Music of Ethnic Groups/Minorities,* ed. Ursula Hemeteik (Vienna: Böhlau, 1996), 32.

43. For more on some of the issues involved in this commercialization process, see also Lilian Friedberg, "Drumming for Dollars: The Bottom Line Between Appropriation and Appreciation," *Bearing Witness: Reading Lives: Imagination, Creativity and Cultural Change,* ed. Gloria Anzaldua and AnaLouise Keating (forthcoming); this essay, together with a paper presented in February 2003 at the University of Tennessee–Knoxville's conference "Cultures in Motion: The Africa Connection"

("'Manger Malade': 'Eating Disorders' and the North American Drum Community") is available online at http://www.chidjembe.com/lilianwritings.html (accessed 7 June 2006).

44. Layne Redmond, *When the Drummers Were Women: A Spiritual History of Rhythm* (New York: Three Rivers, 1997).

45. Mickey Hart, *Planet Drum: A Celebration of Percussion and Rhythm* (San Francisco: HarperCollins, 1991), 57.

Somebody's Garbage

Depictions of Turkish Residents in 1990s German Film

Caryl Flinn

> The Germans can't stand themselves or their country. They hate with head and body. That's why they need distance between themselves and others. A kind of buffer zone. . . . A hygienic zone that keeps Germans from crossing over.
>
> —Zafer Senocak[1]

> We only notice rubbish when it is in the wrong place. Something which has been discarded, but never threatens to intrude, does not worry us at all.
>
> —Michael Thompson[2]

> Dirt is matter in the wrong place.
>
> —Sigmund Freud[3]

I

Trash has always been critical to nation-formation. The process is constantly marked by valences of belonging and exclusion, the pure and the sullied, usually culminating in the "foreign" element being expelled or excreted out of the nation-body. That dyadic structure of debris/cleanliness has had particular resonance in Germany, informing juridical, political, social, and ideological conceptions of its land, bloodlines, citizenship laws, policies on foreign workers, and most horrifically, the Holocaust. For some critics, it is rooted in Germany's very state structure, constructing as it does of *Inländer* and *Ausländer*. Others maintain that the dirty dualism goes back centuries, to the country's early modern encounters with Jews and other nonwhite, non-Christian ethnic populations.

Obviously, this kind of two-sided coin is produced by an elaborate network of institutions, forces, policies, and representations, none of which is fully separable from the other—consider the conflation of land, body, and political policy in the concept of *jus sanguinus.* Yet what helps sustain the myth of the abjected, dirty foreigner is the extent to which cleanliness and tidiness are associated with Germanness "itself," a stereotypic notion that finds contemporary expression in the cultural, political, and economic arenas of tourism, the military, and cleaning industries. Moreover, representational institutions like the cinema abet these primarily sociological ones. It is scarcely surprising, for instance, that films seldom depict white Germans cleaning for people of color. When they are so depicted, as in Percy Adlon's *Bagdad Café* (1988), you have less a role reversal than a colonialist imposition of order on the purportedly chaotic, messy space of a geographically, nationally, and racialized other. Jasmin Munchgstetter is the white Bavarian tourist who cleans up the home and business of African American Brenda. Her white European hands must "fix" Brenda's black café before it can be transformed into the shiny, magical, pseudofeminist, and multicultural fantasy that the film tries to establish.[4]

Trash and debris thus always open up the questions of whose trash it is, who cleans it up, under what conditions and what *for.* As an index of nation and ethnicity, it involves much more than the simple principles of exclusion and inclusion, although this is not to suggest that that bipartite system is not still entrenched. Perhaps one reason why that system persists so intensely is because of the falseness and the impossibility of its premise: what it wants to deny is the fact that trash and devaluation, like alterity, reside in and alongside the "nation-body," not outside of it. Garbage, and the refuse/d alterity with which it is tied, is thus fully imbricated in systems of value essential to the maintenance of these very nation-bodies. In short, trash is the waste necessary to sustain the nation, even if it is most "properly" kept invisible, as both by-product and process. In the following analysis of post-Wende German film, I pay special attention to moments when trash and the intertwined processes of "making trash" and establishing value are *not* hidden from sight. I want to ask what happens when trash and the bodies linked to it through economic, political, and ideological racism emerge from their "invisible" place. Certain cinematic strategies begin to suggest, however preliminarily, ways that we might reconceptualize standard notions of value, notions that are imprinted onto bodies with the same force as ethnicity, class, and sexuality.

II

If trash and detritus have a special place in German nation-formation, they have also played a substantial role in the history of its national cinema. The *Trümmerfilm* (the "rubble film" that appeared after World War II) may well be the world's only genre dependent upon garbage. Trash and ruins were equally pervasive in the New German Cinema. Even apart from the deliberately trashy camp and kitsch aesthetics of gay directors like Werner Schroeter, Ulrike Ottinger, and Rainer Werner Fassbinder,[5] trash, in its more literal representations, was often used to allegorize a nation or national identity in ruins. At once trace and by-product, it was a signifier of crisis, and behind it was often a lamentation for some prelapsarian order or lost hope, good, or productivity. That signifying value was surprisingly fixed, standing in for something that had been lost in Germany, or even for Germany itself. In this way, garbage and ruins were the perfect visual trope for a cinematic movement obsessed with its country's ruinous recent history. One finds it in films like Helma Sanders-Brahms's *Deutschland bleiche Mutter* (Germany Pale Mother, 1980), which borrows from the *Trümmerfilm,* and in Hans-Jürgen Syberberg's *Hitler—ein Film aus Deutschland* (Our Hitler, 1977), whose sets are immersed in the debris of German history and culture. For Alexander Kluge, leftovers and remains were the effective bookends of his entire filmmaking career: his first, the short *Brutalität in Stein* (Brutality in Stone, 1959) examined architectural ruins as witnesses to the horrors of Nazism; his cinematic swansong, *Der Angriff der Gegenwart auf die übrige Zeit* (The Blind Director, 1985) offers an extended meditation on a postfilmic cultural economy of recycling, in which he ponders the value of scrap metal, film, and other products of bygone modes of production.

Kluge's work resolutely distinguishes ruins from garbage. For him, ruins were failed forms of previous greatness, taking the form of statues, buildings, and so forth. Not incidentally, Kluge treated them as immodest physical monuments, something akin to the atrocities left in the wake of history that Benjamin famously described in his analysis of Klee's "Angelus Novus." Waste and trash, on the other hand, were different. Both Kluge and Benjamin ascribe a great deal of potential political and use value in discarded, unused, or overlooked artifacts—for them, they provide evidence of alternative histories and the different forms such histories might take. Even the most mundane remnant could offer insight and help with the task of rebuilding or refiguring "nation." Kluge tried to put this belief into practice—with mixed

results—by having the remains of a dead Wehrmacht officer narrate his 1979 film, *Die Patriotin.* For as much as I share their interest in reassessing the value and debris, Kluge's and Benjamin's essentially modernist understanding of trash differs from the one I examine here. Benjamin's conception of allegory invokes a sort of semantic recycling center, to be sure, but it is important to stress that both he and Kluge activated their recycled readings from within a monocultural perspective, from within a framework of national singularity. Although their understanding of Germany is marked by tensions, omissions, and difference, ultimately they reread it according to the shifts and fissures of the country's "own" capital and history. Such possessed national autonomy was obviously never anything more than a fantasy. Still, Kluge and Benjamin redirected this vestige of nineteenth-century discourses on nation formation, to address the destruction and waste produced by twentieth-century German fascism. One could argue that in a transnational, multicultural context, that self-sufficient notion of nation is even more difficult to sustain, even as a fantasy.

By the time the Berlin Wall came down in 1989, "Germany the film" had become a decidedly more hybrid phenomenon than it had been in the 1970s for the New German Cinema. In spite of the notorious political claim that "we are not a country of immigrants," the public construction of Germany was now just that. Generational boundaries helped reshape "Germany" as much as geographical ones. Turkish residents—often the descendants of first-generation *Gastarbeiter*—were telling their own stories and histories as Germans.

One of these was Jakob Arjouni's novel on which Doris Dörrie's 1993 film *Happy Birthday, Türke!* was based. (Arjouni was not happy with her adaptation.) *Happy Birthday, Türke!* might be called an interethnic film noir, a point to which I will return. For now, it is worth observing that it is a film stuffed with garbage: cigarette stubs, broken bottles, crumpled papers. Characters fall on roadsides strewn with litter; they place garbage upon one another (for instance, a white cop sticks his chewed gum onto the Turkish protagonist's lapel); they "waste" one another, turning them into corpses; and the lifeless blood of slain Turkish men runs throughout. Trash is also transmitted aurally. In addition to calling protagonist Kemal Kayankaya "shit," white characters call him a goat-fucker, and comment that he "bleeds like a pig" after a vicious assault. Given that Turkish and other foreign workers—even two generations after the first wave of *Gastarbeiter*—are still relegated to cleaning up after white Germany, such images may hardly be surprising. Even more, for all this cleaning these workers do,

it is *they* that xenophobic culture wants to align with dirt and impropriety. And while Dörrie's film is hardly the only one that depicts garbage and the nonwhite workers having to clean it, its representations are particularly overt and provide the base of much of my discussion.

What interests me here is less the sociological accuracy of the reflection of Turkish Germans working in cleaning industries than their discursive construction. Psychoanalysis theorizes abjection as a way to "make shit of the other," and *Happy Birthday, Türke!*'s copious references to shit, stench, and animals make racism's debt to that formulation clear. In such a context, it is hardly surprising that garbage and alterity are so intertwined with attitudes about race, ethnicity, and nation. Along with metaphors of contagion and contamination, trash has given racist discourse over the years a colorful way to drive out or devalue the ostensible "other." For trash always invokes something from which it was taken or expelled and immediately puts the issue of production, consumption and waste—along with the question of *whose* waste—center stage. It shows the unsteady relationships between the body and the economy, the local and the global, and Germany's position within ever-shifting social, economic, and cultural landscapes. And just as garbage points to waste, the by-product of consumption, it also points to used-up goods.

How are waste and by-products racialized in a "united" Germany that is in turn marked by so many contradictions? The new, postwall Germany is neither autonomous nor subsumed by the European Union; its trash is its own (consider laws on recyclable packaging) but also part of the global circulation of goods and services, trash and cleanup. Films like Dörrie's *Happy Birthday, Türke!* that focus on ethnic differences within Germany begin to expose not just the whiteness behind the fantasy that would always trash the other, but question the sustainability of "othering" in a transnational economic context to begin with. Other films looking at ethnic difference with trash or cleaning as central motifs include Kutlag Ataman's *Lola und Bilidikid* (1999) and Angelina Maccarone's *Alles wird gut* (Everything Will Be Fine, 1998); I select Dörrie's film—the only one of the three made by a white German—for its intense drive to visualize and revalorize trash, and for the limitations as well as the achievements of the director's neoliberal vision. This is not to suggest that her film is the most important or even the most interesting of the three, but rather that its liberalism is interesting for replicating some of the very contradictions and fissures of the value system it critiques.

Happy Birthday, Türke! was financed solely by German sources, Dörrie's Munich-based production company, Cobra Film, and television channel ZDF. It was released in 1993, that is, after the Historians' Debate, after the wall, during the heat of the firebombings in Mölln and Solingen, and as the idea of a European economic union was being discussed and before German citizenship laws were modified. These kinds of historical markers are evident in the text. We see a copious number of wounded Turkish men, whose bleeding seems not only a displaced reference to the victims of the firebombings, but a visual shaming of Germany's blood-based citizenship laws. The ubiquitous presence of garbage and waste certainly suggests the sense of something leftover, of something not quite being admitted into the present. Perhaps a comment on the Historians' Debate, all this trash intimates not a country lying in ruins, as it had in the *Trümmerfilm* or in the navel-gazing New German Cinema, but rather that the concept of nation is itself in tatters. The film, as I will develop below, certainly forces the "purity" of Germany to go underground, bringing its seamy racist "dangers" to the surface.

Taking place on and around the birthday of Kemal Kayankaya, a second-generation Turkish German, the film immediately invokes the issue of birthright and one's positionality as a social, legal citizen. Kayankaya is a self-employed private detective who is drawn into the drama of the Ergun family, three generations of Turkish residents whose son-in-law Ahmed has gone missing, and whose patriarch, Vasif, was killed in a mysterious, unresolved car accident. Over the course of the film, we learn that Ahmed, who is murdered during the investigation, dealt drugs, and that Vasif had kept a white mistress who, like his own daughter, becomes a drug addict. The city police are racist, misogynist, and corrupt as can be. Not only do they turn out to be responsible for Vasif's fatal car accident (and they kill a young girl who had the misfortune of witnessing it), but they viciously assault Kayankaya in his bathtub (trying to clean himself), and they deal drugs or force Turkish residents like Vasif to deal for them. By the end of *Happy Birthday, Türke!*, we learn that Yilmaz, the brother of Ilter, murdered Ahmed for the sake of the family he wants to head.[6] Kayankaya, who enjoyed a brief erotic relationship with Ilter, pins the murder on the exposed police. The last scene is weirdly lighthearted, with the private eye driving off with a trunkful of daisies (marguerites) to woo a white woman (Margareth), a sex worker who seems to have taken a fancy to him.

Happy Birthday, Türke! borrows heavily from American film noir,

Happy Birthday, Türke! (1993, dir. Doris Dörrie). (Courtesy Filmmuseum Berlin—Deutsche Kinemathek.)

with specific winks to Howard Hawks's *The Big Sleep* (1946). The male detective falls for the beautiful woman who reports a missing husband, whom she doesn't really seem to miss. Their affair becomes unsustainable; she is too encumbered by family and tells half-truths to protect it; he must remain the lone wolf. On their first meeting Kemal tells Ilter, "I get two hundred a day, plus expenses" and for her, money is no object (her gold bracelets and the watches of other characters form a leitmotiv I discuss below). Other noir details include scenes in which Kayankaya is warned off the case by police thugs who beat him in his bath.

The violence in the film is heavily gendered. The bleeding Turkish bodies alluded to above include Ahmed, the son-in-law who is knifed, Kayankaya, in the above-mentioned scene, and police photographs of the bodies of Vasif the father. Women's bodies, more docile and domestic, are healthier, cleaner, and significantly, are shown *cleaning.* Ilter is constantly picking up for Kayankaya when she visits his filthy apartment—it is as if she were on automatic pilot. Even the corpses trade in gendered difference. In contrast to the bloody depictions of Vasif and Ahmed's deaths, the fractured skull of the young girl who witnessed Vasif's death is shown via an antiseptic, bloodless x-ray.

Made by an internationally known director known for her liberal efforts to portray multicultural, contemporary Germany, *Happy Birthday, Türke!* is criss-crossed with signs of "Germanness," not the least of which is its exclusively German backing. The immediately recognizable music of Peer Raben gives the film an after-the-fact imprimatur of the New German Cinema along with its search for a less sullied Germany.[7] *Happy Birthday, Türke!* is thus positioned unsteadily among the local, the national, and the global and among different cinematic historical traditions. Based on a Turkish-German novel, it is a white German film noir, a U.S. genre named by French critics. It is at once German and not German, "popular" and "art." Even its Turkish figures—that site onto which non-Germmanness is obsessively cast—are transnationalized, occupying several positions at once: Yilmaz, Vasif's son/Ilter's brother, works in a cafeteria where he masquerades as an Italian, urging Kayankaya to try the pork of the day. This masquerade, to which I return below, illuminates not just the historical cycles of different nationals entering Germany as *Gastarbeiter,* but the rotating nature of German xenophobia and racism itself. In 1993, perhaps a Turk would rather be an Italian, whereas in Werner Schroeter's 1980 *Palermo oder Wolfsburg,* being an Italian working for Volkswagen is misery itself.

Happy Birthday, Türke! takes place in Frankfurt. Of course, as Germany's financial center, this is where fortunes are made and gold produced. But the film withholds the clean city streets and its towers of lucre that glitter in the ironic opening of Kluge's *Die Macht der Gefühle* (The Power of Emotion, 1983). Here, wealth is not revealed through production, but through excessive and corrupt consumption and its by-product, debris. The very first shot of *Happy Birthday, Türke!* is of a cigarette stub on the floor. Kayankaya's racist white neighbor outlines it and draws a long line that connects it to the name card on Kayankaya's apartment door. It looks like the kind of chalk lines police make around fallen victims, death being the ultimate signifier of bodily waste—abjection par excellence. The interior of Kayankaya's apartment at this point is cluttered with the debris of the night before: booze bottles, food, sex establish the place of slovenly consumption. When Kayankaya steps into the hall, the neighbor who had drawn the lines rails: "Imagine me, cleaning up after a Turk. You're shit, that's what you are to me."[8] (When Kayankaya responds by calling him an asshole, we have an indication of who's really produced the shit.) In just a few minutes, with just a few words and images, the film establishes its thematics of trash.

Garbage is strewn everywhere, both in interior and exterior spaces. We see huge waste management facilities, we ride with Kayankaya behind garbage trucks, we see the mess in people's homes and cars. We see garbage tossed around, we hear references to dog piss, stench, and shit. And if racism tries to lay waste to others, its trashy talk is also omnipresent. Kayankaya is dogged by insults to himself and Turks in general: Turkish taffy, Aladdin, camel, goat-fucker. He is urged to go home to Turkey, and we are told that Turkish crime victims "count less" in the police office and elsewhere. Even compliments drip with prejudice, as when a white upper-middle-class jogger tells him that Kayankaya "speaks German very well." ("So do you," he replies.)

While these things may appear as so many small representational details, Stuart Hall reminds us there is no such thing as pure discourse without social, economic impact or information.[9] In this vein it is important to note how the "shitty" minoritarian cultures are those that to a great extent produce the gold for transnational circulation and that lines the coffers of white businessmen in Germany and elsewhere.[10] Garbage, in all of its stench, thus keeps the spotless machinery of capital in motion. The same thing goes for the people whose work capital profits from the most, and in return treats as so much garbage.

III

In order to challenge the racism it exposes, *Happy Birthday, Türke!* resorts to a form of reverse "othering." Aligning white Germans with waste, and Turkish Germans as the folks who are constantly cleaning it up (interestingly, Dörrie does not do much to distinguish the Turkish workers from working-class whites), the film makes it emphatically clear that garbage is produced by the filth of German racism and consumerism. The point is telegraphed in scenes where men—usually police officials but including working-class white men and Kayankaya—are constantly eating, drinking, reading, watching sex shows, or preparing for sex. Nothing is actually produced in this realm except the proof of consumption itself (at one point police officers invite Kayankaya to join them for a round of grappe and stiff him with the bill). By contrast, women of different ethnic and class backgrounds are shown neither as producers nor as consumers, but as the guardians of the interior spaces they are so often tidying. Such a gendering of space and cleaning not only reproduces aspects of material and social realities, but it also recalls their depictions in movies ranging from Fassbinder's *Angst essen Seele auf* (Fear Eats the Soul, 1974) to Tevfik Baser's *40 qm Deutschland* (Forty Square Meters of Germany, 1986).

In a 1992 interview, Doris Dörrie said that she used the film's art design to comment on German racism. Depicting Frankfurt as lifeless, she used washed-out blues and dusty neutral colors to mark most of the scenes (Ilta, by contrast, is associated with a very bright blue). Vibrant reds and oranges are reserved for two things: Sex shows (a point the director does not acknowledge) and Turkish residents (which she does). The most conspicuous of the latter include orange-clad garbage workers; the scene of Kayankaya and Ilta having sex, which bursts into an orange-red; and the blood of men like Ahmed, which suggests lost life and vitality. Although this vitality and vibrancy are absent in white Germany, it is important to acknowledge that, despite her good intentions, Dörrie is simply reversing the tables by giving positive value to the Turks and abjecting white Germans or showing us how "washed out" they are. In other words, her film seems to preserve the simple binaries of good and evil, value and waste. Moreover, her choice of colors is intriguing. Why red, and when is it used? Its clichéd symbolism of passion is in evidence in nearly all of its appearances. Thus while it may be reversing ethnic privilege by enlivening the people who are normally devalued, it also reproduces extremely conventional representations of love, romance, and reproductive sex—not to mention notions of the hot-blooded "other."[11] Again, and despite Dörrie's good intentions and the film's red-hearted celebration of heterosexual passion (which *Lola und Bilidikid*—another film that uses red as a marker for difference—makes problematic and Tom Tykwer's *Lola rennt* [Run Lola Run, 1998] does not), she is not immune to what Paul Willemen has called "ventriloquism," that which allows "the monopolist-imperialist . . . to remain an authoritarian monopolist while masquerading in the clothes of 'the oppressed.'"[12] True, Dörrie insists on a multicultural Germany (e.g., *Keiner liebt mich* [Nobody Loves Me, 1994]) and is sensitive to Germany's construction of Mediterranean or Asian cultures as escapist venues (Spain in *¿Bin ich schön?* [Am I Beautiful? 1998]; Japan in *Erleuchtung garantiert* [Enlightenment Guaranteed, 2000]). Nevertheless, it is hard to shake the sense that these non-German cultures are offered as cultural alternatives for primarily white consumers, who can actually opt to buy into them, whether psychically or economically.

A more outrageous example of this can be found in Percy Adlon. Discussing his pleasurable experience working with African Americans in *Bagdad Café,* he stated that the affinity he felt for them could be explained by the fact that he was a Bavarian. "Black actors have many wonderful theatrical and comic gifts which have a lot in common with

our Bavarian culture and theater. . . . We're very earthy and instinc-
tual—they call us the German Africans. You see lots of connections—
our yodels are like African drums. And our folk dancing and tradi-
tional costumes are much like the ones you see in Africa."[13] According
to him, that is why everyone got along so well making *Bagdad Café*.

More interesting than the separation or similarities between the cul-
tures of black and nonblack Germany are the representational and
economic forces that intermesh them and produce them as something
more than a set of opposing terms. Regarding *Alles wird gut,* her film
that featured Afro-German lesbian protagonists, screenwriter Fatima
El-Tayeb stressed how important it was for her to "represent a group
of people who all belonged to minorities . . . and show them interacting
with each other, not in relation to the 'majority.'"[14] She did not want
to reduce characters to being black, being gay, being victims, with only
one experience of difference. To be sure, Dörrie's film seems to follow
this line of thought, not reducing Turkishness to one set of characteris-
tics. In fact theorists could easily find in her film examples of the mas-
querade of gendered, national, and ethnic identity. There is Yilmaz as
"Guiseppe," or the fact that Kayankaya is played by Hansa Czypri-
onka, a German of Polish descent. His character's "too-fluent" Ger-
man is a constant source of commentary—perhaps a violation of the
stereotype of the silent or jabbering Turkish *Gastarbeiter.* At one point
Kayankaya tells someone that the only thing Turkish about him is "his
face and his name," thus in the racist logic of reading ethnicity, every-
thing. To obtain information about Vasif's death from the police
department, he masquerades as a stammering immigrant who is a
"friend of the family" and later as a Turkish ambassador who suggests
Vasif died at the hands of Turkish terrorists. One of Ilter's children
gives Kayankaya a mustache "to make him look more Turkish." He
glues it on, peels it off, and the white woman who sells him coffee every
day notices it. He carries around and eventually wears a scarf Ilter left
at his office. It would be tempting to read Kayankaya's donning and
shedding of mustaches, veils, and identities as a performative mas-
querade of postcolonial male subjectivity. The character certainly
plays around with what he is supposed to look or act like. Graffiti on
his office door changes his first name, Kemal, which he says means
"absolute perfection," to the less-than-perfect Kamel. Yet what ciga-
rettes does he smoke? American Camels. By playing with some of the
deleterious clichés of Turkishness, Kayankaya operates within the
unstable boundaries of disidentification, which queer theorists and the-
orists of color have discussed as a deliberate misfit, an ironic appropri-

Happy Birthday, Türke! (1993, dir. Doris Dörrie). (Courtesy Filmmuseum Berlin—Deutsche Kinemathek.)

ation of the shittier aspects of the alterity usually inscribed upon their bodies. As El-Tayeb states, "Both lesbians and people of color are experts, out of necessity, in getting something positive out of negative, stereotyped images."[15]

Perhaps it is these images, these visual signifiers that provide the real trash of the film. Two women (white and Turkish) tell Kayankaya that he only "sees with his eyes" and that appearances guarantee nothing. This is played out in a brief homage to Michelangelo Antonioni's *Blowup* (1966) when, near the Ergun residence, Kayankaya observes some children at play. A passing bus interrupts his view of a boy on a scooter, and after it goes by, the boy is implausibly gone.[16] This warning against placing too much stock in visible evidence oddly occurs in the same text that emphatically "color codes" ethnic difference and heterosexuality, suggesting some contradictions that it is unable to resolve.

With all its scooters, buses, cars, and car accidents, it is impossible to ignore the significance of movement as a trope in the film. Numerous scenes are shot from moving vehicles, usually Kayankaya's car. Windows, sides of bridges or highway ramps, electrical towers, or

highway signs all obscure what we (or Kayankaya) might see, reinforcing Dörrie's point on vision's unreliability. That constant movement makes it impossible for points of view to be nailed down and turns them into something unsteady—not an unusual device given the detective genre with which the film plays, but significant nonetheless. (*Lola und Bilidikid,* by contrast, emphatically stresses place: its opening sequence is a romantic rendering of the Brandenburg Gate, to let you know exactly where you are.)

In one regard, the emphasis on movement in *Happy Birthday, Türke!* reinforces the idea of Kayankaya masquerading, since he travels outside of seemingly fixed locations and origins. Constantly on the move, Kayankaya traverses largely segregated Turkish and white German spaces and is able to negotiate—or fake his way—in each. He also seems to cross gender boundaries just as easily, penetrating the feminized, veiled spaces of Turkish family (again, reminiscent of the space in *40 qm Deutschland*) or donning the woman's scarf at the end of the film. For some theorists, Kayankaya's ability to function in such rigidly demarcated spaces ("Turkishness," "whiteness," "femininity," even queerness) might suggest an alluring liminality. But that reading is not altogether convincing, especially given that so many films depicting Turkish-German life (again I think of *Lola und Bilidikid*) show how cultural crossings and interethnic and cross-gendered masquerades often provoke bashing and murder, not freedom of movement. And in fact, the Turkish men that are killed diegetically in *Happy Birthday, Türke!* are all on the road moving, usually in vehicles. As Caren Kaplan has observed in another context, postmodern critical theorists have tended to romanticize terms like *nomadism* and *displacement,* using them without much historical or cultural sensitivity. Silvia Kratzer-Juilfs has noted that in Muslim contexts, these terms (she concentrates on *homecomings*), in contrast to Western understandings, "are always in flux" because of their historical and political contingency, not due to their theoretical expediency.[17]

Place and location have been key concerns in studies of immigration, transnationalism, and diasporic cultures. They inform academic debates in addition to political and legal definitions of nomads, migrants, seasonal workers, guest workers, refugees, immigrants, residents, aliens, and invaders. At this point one sees how the differences of ethnicity, gender, sexuality, class, and nation can be and have been relentlessly interwoven with Freud's remark that "dirt is misplaced matter."[18] Consider how Turkish residents in Germany are repeatedly constructed as out of place in three senses of the phrase: First they are

misplaced (i.e., in the wrong place), displaced (initial generations having been forced, for economic and other reasons, to leave Turkey), or they are literally "out of places," with no place left to go. There is nothing romantic about that strand of wandering movement, nor about Germany's historical responses to other nomadic groups, such as Gypsies and "wandering Jews." But what happens with the fact that Turks occupy a very large "place" in contemporary Germany and cannot be wished away? That very visibility and sense of placedness, I believe, disrupts traditional, conservative economies of waste that inform racist accounts. As Michael Thompson writes, "That which we discard, shun, abhor, wash our hands of, or flush away, we are consigning to the rubbish category."[19] Normally, these economies would have waste be all that is undesired, discarded, and abject, and kept emphatically out of sight.

IV

Rather than view Kayankaya's ability to roam in white, Turkish, feminized, masculinized, and even queer worlds[20] as a matter of postmodern masquerade or nomadism, I want to suggest that he inhabits the unsettling space of "rubbish" that Thompson theorizes. For Thompson, rubbish is less *de*valued than an object occupying a liminal space *without* value. And while this space is potentially upsetting for its liminality (and invisibility), it does not make itself available to romanticization or celebration in the way that Kaplan and others have similarly critiqued nomadism and hybridity.[21] Rubbish is the great social unseen, noticeable only when, as Thompson's opening remarks attest, it "threatens to intrude." In this way it is not merely the "danger" to the "purity" of a national or racial category, for instead of operating in the dyadic system of insider and outsider, he argues, it provides a third term between two principle social/economic categories that determine value (of goods, people, etc.): the durable and the transient. Although Thompson doesn't acknowledge the work of Veblen and other social economists before him, he follows aspects of their work in maintaining that nothing inheres in the materials themselves—furniture, houses, books, or people—to determine their function and value as either durable or transient. That is achieved by their social function. Take luxury goods, for example. Animal fur provides apparel for wealthy Manhattan dwellers as well as for impoverished Inuits, and even within one location, like a large industrialized municipality, its value differs since fur is not always a cherished durable good, but the deliberate wasting of life to which privilege is often oblivious.

Rubbish is thus not what's simply been discarded (or "misplaced," like trash or immigrants), but operates as a ghost category that makes possible exchanges between durable goods and transient ones. For example, in order for a sofa to move from "used furniture" to "antique"—a movement from the transient category of falling worth into the durable category of increased value—it must first pass through the neutral, value-free category of rubbish. Despite its pejorative connotations, then, for Thompson rubbish is a neutral, unofficial category whose objects are not recognized as valuable. It is an underground, "off the record" category—as in the time it takes an old piece of furniture to move from "secondhand" to "antique." It's at this moment that you won't find sales documented at Sotheby's, for instance.

Because the categories of the durable and transient are so arbitrary and culturally contingent, it is in the interest of the powerful to control and contain them as tightly as possible, especially when it comes to keeping the durable durable. Since rubbish is the status a durable good (like a used fur coat) must pass through before it becomes transient (unsellable at used clothing stores), and vice versa, it is the category in which the "pure and the dangerous" meet and switch functions. For that reason alone Thompson believes rubbish is important. To summarize: the value of rubbish is in its nonvalue, its phantom participation within an economy that otherwise separates society's *good* from the *bad.*

Thompson's scheme enables us to revisit the masquerades and movement in *Happy Birthday, Türke!* Rather than have Kayankaya occupy the position of either transient/devalued/Turk *or* durable/valuable/white, the construction of Kayankaya simply shows how unstable and arbitrary the categories of "durable" and "transient" are, along with the values they contain. The character's seeming ability to go everywhere, along with the constant display of rubbish, suggests that the film makes visible that usually stealth category in order to disrupt conventional, racialized economies of waste.

V

In his correspondence with Wilhelm Fliess, Sigmund Freud wrote of turning shit into gold, an alchemy he would develop in *The Interpretation of Dreams* (1900). Freud weaves a complex web among filth, shit, anality, greed, money/gold, Jewishness, and the body in *The Interpretation of Dreams.*[22] His 1908 article "Character and Anal Eroticism" pushed the point even further. Basically, Freud argues for a continuum rather than an antagonism between gold and shit, as in the term *black*

gold. Freud proposed that the developing child's fascination with feces becomes, upon reaching adulthood, an obsession with wealth. "Holding on" turns into selfish avarice, keeping one's shit to oneself, while casting its aggression outwards.

Dörrie's film is as full of references to gold as it is to shit, not the least of which is the precious golden, orange hue in which she bathes the "undervalued" Turkish workers and lovers. The color scheme suggests they are not only "worth" something, but that they are highly precious—and visible. One cop revealingly tells Kayankaya, "We Germans have an expression: money isn't everything," to which Kayankaya responds, "There's one in Turkish: it *is.*" Another cop hides gold bricks in his TV set, keeping it from view in a commodity made *to be watched.* The film is constantly providing close-ups of Ilta's gold bracelets and of people's wristwatches. Here, Dörrie seems to follow Freud's view, showing how shit can be made into gold as she transforms Turkish bodies into visible explosions of precious golds and reds. At one point the white cops joke among themselves: "Things would be dreadful here without the foreigners; we'd die of our own bullshit." Again, this is part of the film's liberal project of establishing that the truly abject body, the piece of shit, is racist Germany. In this view, all the shit that the Turkish immigrants have to clean up has enabled a number of them to profit off of it: Kayankaya's father made his small fortune in the garbage industry. (The "filthy rich," by contrast, are the racist white cops on the make.) The alchemy of turning shit into gold is treated humorously in one scene toward the end of the film as Kayankaya waits in the luxury apartment of the corrupt German police officer to "unearth" his filthy involvement in drugs and murder. After the cop returns and viciously insults his wife, she breaks the gigantic screen of their TV to reveal the hidden gold bricks. Shimmering, ironic (TV as Fort Knox; kicked in, in contrast to its role in *Angst essen Seele auf,* where Fassbinder resents the human loneliness it feeds upon), here the gold shrine is concealed, too unclean and cruel (anality) to "fit" into the role of an openly durable good. It is valuable and shitty all at once.

If the Turkish residents represented by the film are usually deemed transient—both in Thompson's sense of the term and in the sociological and political sense of being temporary residents or "guests"— *Happy Birthday, Türke!* transforms that alterity into something durable and precious, even in its color design. Inverting the racism that would quite literally, "trash" them, the film ultimately posits white Germans as dirty, corrupt, wasteful. But Thompson's economy of rub-

bish enables us to observe that rather than simply reversing these categories of value as Dörrie seems to do, it is the racialized *categories themselves* that are unstable. "Rubbish" intimates a constant oscillation between these categories of value, along with the goods and people to which they are compared.

In this light a collective feminist response to the United States' reaction to the events of September 11, 2001, is worth mentioning. Noting the apathy of the U.S. government toward conditions for women under the Taliban prior to that date, the authors wrote that the "stakes change when the 'abject, backward and male-oppressed people' are brought out of the sphere of 'developing' nation and into a nation that 'developed' as a strangely nondifferentiated Euro-American 'nation.'"[23] As films like *Happy Birthday, Türke!* show, Turkish residents in Germany are not backward, not premodernist, not low-tech, not feminized victim, abject, dirt, or trash. Instead, they are positioned across a more complex set of social, cultural and political positions, positions more numerous than racist and nationalist discourse allows, more complex than Dörrie's scheme of reversed value.

I am not out to "trash" this film, however. For its multicultural setting, its emphasis on movement and trash, imply, if not represent overtly, an economic structure in which shit and money are not so diametrically opposed, nor Turkish/whiteness so easily contrasted. Instead it produces a collision of sorts as the durable and the transient, the white man and "other," *Inländer* and *Ausländer* no longer operate in pure, fantasmatic opposition. Like Thompson's work, the film suggests a covert economic structure in which gold is a source of shame, in which shit and money are not so diametrically opposed, and in which the ethnic groups aligned with these categories/value systems occupy positions that are as culturally, politically, and economically contingent as the categories themselves.

Notes

 1. Zafer Senocak, "Dialogue About the Third Language: Germans, Turks and Their Future," *Atlas of a Tropical Germany: Essays on Politics and Culture 1990–1998,* trans. and ed. Leslie Adelson (Lincoln: University of Nebraska Press, 2000), 33.

 2. Michael Thompson, *Rubbish Theory: The Creation and Destruction of Value* (Oxford: Oxford University Press, 1979), 91–92.

 3. Sigmund Freud, "Character and Anal Eroticism," *Collected Works,* ed. James Strachey (London: Hogarth Press, 1959), 9:172–73.

 4. See Barbara Mennel and Amy Ongiri, "In a Desert Somewhere between Disney and Las Vegas: The Fantasy of Interracial Harmony and American Multi-

culturalism in Percy Adlon's *Bagdad Café," Camera Obscura* 44 (2000): 150–75; and Catrin Gersdorf, "Globalization and Cultural Ecology: Race, Space, and the American Desert," Ph.D. diss., University of Leipzig, 2002.

5. For a discussion of Werner Schroeter's aesthetic of trash and kitsch, see Caryl Flinn, "Embracing Kitsch: Werner Schroeter, Music and *The Bomber Pilot," Film Music: Critical Approaches,* ed. Kevin Donnelly (Edinburgh: Edinburgh University Press, 2001), 129–51.

6. The theme is repeated in *Lola und Bilidikid,* which links fratricide more explicitly still to heterosexual anxiety.

7. This same effect is produced by Claus Bantzer's award-winning score for Baser's *40 qm Deutschland.* Interestingly, the first time we hear Turkish music is when Turna opens her windows and catches a glimpse of her German surroundings. Otherwise, Bantzer's score dominates.

8. A very similar scene is depicted in Ngozi Ongurah's 1988 *Coffee-Coloured Children,* her semiautobiographical short about growing up as a racially mixed child in Britain. The film opens with a skinhead scooping up dog excrement and smearing it on their apartment door.

9. Hall argues that representation does not reflect reality or "real" social relations but is constitutive of them. "My own view is that events, relations, structures do have conditions of existence and real effects, outside the sphere of the discursive; but that it is only within the discursive, and subject to its specific conditions, limits and modalities, do they have or can they be constructed within meaning. Thus, while not wanting to expand the territorial claims of the discursive infinitely, how things are represented and the 'machineries' and regimes of representation in a culture do play a *constitutive,* and not merely a reflexive, after-the-event, role. This gives questions of culture and ideology, and the scenarios of representation— subjectivity, identity, politics—a formative, not merely an expressive, place in the constitution of social and political life." Stuart Hall, "New Ethnicities," *Critical Dialogues in Cultural Studies,* ed. David Morley and Kuan-Hsing Chen (London: Routledge, 1996), 443.

10. It is also important to note how expendable and transient these workers are, i.e., not just in terms of labor value nor in the economics of the workplace but in their social settings. Consider the deaths of women working in maquiladoras at the U.S./Mexican border; violence in Africa over precious minerals, etc.

11. That color scheme is used to isolate the passion between lovers in two big films of the late 1990s: Tom Tykwer's *Lola rennt* (Run Lola Run, 1998) (the scenes in bed between Lola and Manni), and more pointedly, *Lola und Bilidikid,* where gay Turkish lovers "Lola" and "Bili" (Gandi Mukli and Erdal Yildiz) are connected through the many red artifacts that appear in Bili's bedroom, along with Lola's bright red wig.

12. Paul Willemen, "The National," *Fields of Vision: Essays in Film Studies, Visual Anthropology, and Photography,* ed. Leslie Devereaux and Roger Hillman (Berkeley and Los Angeles: University of California Press, 1995), 29.

13. Quoted in Mennel and Ongiri, "In a Desert," 168.

14. Barbara Kosta, *"Everything Will Be Fine:* An Interview with Fatima El-Tayeb," *Women In German Yearbook* 18 (2002): 34.

15. Kosta, "Everything Will Be Fine," 41.

16. At the end of the film another boy appears on a scooter; its psychic weight is heightened by the fact that the one souvenir Kayankaya has of his biological parents depicts him on a scooter.

17. Silvia Kratzer-Juilfs, "Return, Transference, and the Constructedness of Experience in German/Turkish Documentary Film," *Feminism and Documentary,* ed. D. Waldman and J. Walker (Minneapolis: University of Minnesota Press, 1999), 189.

18. The work of Karl Marx, for his part, is (perhaps predictably) filled with references to shit and waste, and warrants further study. His letters are riddled with fecal imagery to refer to "lumpenproletariat" that identified with Louis Bonaparte; by maintaining their allegiances, they displaced themselves from their "proper" class position and interests, again suggesting being out of place. Marx referred to these working-class supporters as "the scum, offal and refuse of all [other] classes"—a non class for its purported removal from the realm of production." Karl Marx, *The Eighteenth Brumaire of Louis Bonaparte* (New York: International Publishers, 1963), 75.

19. Thompson, *Rubbish Theory,* 91–92.

20. There are scenes in which the private investigator responds to the sexual overtures of some men who espy him shaving in the car. After they ogle him, he smiles back and lowers his visor, on which his phone number is written.

21. Caren Kaplan, *Questions of Travel: Postmodern Discourses of Displacement* (Durham: Duke University Press, 1996).

22. Sigmund Freud, *The Interpretation of Dreams,* 3rd ed. (New York: Avon, 1998), 233 and 439.

23. Paola Baccetta, Tina Campt, Grewal Inderpal, Caren Kaplan, Minoo Moallem, and Jenneifer Terry, "Transnational Practices Against the War," October 2001, from FEMLIST, received at the University of Arizona, October 19, 2001.

From Riefenstahl to Riemann

Revisiting the Question of Women's Cinema
in the German Context

Hester Baer

At least since Siegfried Kracauer's reading of Weimar film as a
reflection of the collective German psyche, German cinema has occu-
pied a privileged place in discussions of national cinema.[1] From
Metropolis to the films of Leni Riefenstahl, from the *Heimatfilme* of
the Adenauer era to the *Frauenfilme* of the 1970s, from Doris Dörrie's
1985 *Männer* (Men) to the postwall comedies it generated, German cin-
ema of the twentieth century appeared to reflect or interrogate a col-
lective national identity more strongly than the film productions of
many other nation-states. Indeed, the impulse to understand German
cinema(s) as uniquely national (and sometimes nationalist) establishes
a moment of continuity within a film historiography that has otherwise
often defined the history of German film around a series of historical
ruptures and Oedipal rejections.

In this chapter, I would like to argue, polemically, for a second
moment of continuity in German film history. I suggest that many of
the most significant German films and film genres of the twentieth cen-
tury—such as those enumerated above—can also be considered
women's cinema. Harnessing the indeterminacy of the term *women's
cinema,* I argue that its slippages allow for a productive reading of
women's cinema as a primary genre of German national cinema.
Focusing on historical and thematic continuities across German film
history, I will briefly examine the vicissitudes of women's cinema and
its popular and critical reception with recourse to two paradigmatic
examples: *Das blaue Licht* (The Blue Light, 1932), whose director and
star, Leni Riefenstahl, has proved consistently vexing for both German
film studies and feminist film theory; and the sleeper hit *Abgeschminkt!*

(Makin' Up, 1992), directed by Katja von Garnier, and featuring, in a career-making role, Katja Riemann, the consummate star of 1990s German cinema.

Women's cinema has always proved a notoriously indeterminate concept. Critics have argued over and invoked the term's multiple definitions as cinema by women, cinema for women, or cinema about women.[2] Film scholars have further sought to distinguish women's cinema from women's film and from "the woman's film," semantic distinctions that have sometimes created more confusion than clarity. In German, the term *Frauenfilm* has, if anything, proved even more indeterminate than its English-language equivalents.[3] Referring originally to movies produced for a female viewing audience, the *Frauenfilm* was redefined in the 1970s to refer to the feminist auteur films of that era. Since the late 1980s, the term has again been invoked in reference to mainstream films that appeal to female viewers. Some of these are directed by women, and some, like their precursors from earlier eras, are directed by men but seek explicitly to thematize "women's issues" and questions of female subjectivity.

As studies of national cinema, emigration, postcolonialism, cultural transfers, and transnational fusions have come to dominate German film studies, the old debates about "women's cinema" have receded into the background of disciplinary prominence, if not lost their relevance entirely. In its 1970s and 1980s incarnation, the German *Frauenfilm* was poised at the forefront of an international movement that sought to conceptualize a filmic language adequate to convey female subjective experience. Associated with filmmakers such as Helke Sander, Helma Sanders-Brahms, and Jutta Brückner, that *Frauenfilm* garnered excitement about and provoked interest in German film among feminists worldwide. Unsurprisingly, the eclipse of feminist filmmaking practice by an explicitly un- (if not anti-) feminist commercial cinema in Germany has diminished international interest in German cinema on the part of feminists (and others) and has signaled a turn toward different theoretical approaches among those who remain interested in and committed to the study of German film.

Certainly it is not only in the realm of German film studies that feminist film theory, criticism, and, indeed, practice have diminished in influence and been replaced by other models. The publication in 1999 of B. Ruby Rich's autobiographical anthology *Chick Flicks* both named and signaled an emergent phenomenon whereby "film feminism" was relegated to the past—more a relic of film history than a current of film theory.[4] Rich attributes the end of film feminism pri-

marily to its institutionalization in the academy. Patrice Petro suggests a different reading in a more recent essay that situates Rich's book within a wider trend of nostalgia for a lost theoretical and political moment.[5] As Petro remarks, it is not only feminist film theory, but "1970s film theory"—with its psychoanalytically informed paradigms—that has been discounted within recent film studies. According to Petro, new movements in the discipline have left many "first generation" feminist film theorists feeling marginalized and above all nostalgic for an earlier era of feminist theorizing and feminist activism.

As Petro's analysis recalls, feminist film theory emerged at a historical moment when feminist politics fueled both academic discourse and aesthetic practice. Like feminist politics, feminist theorizing about film proved remarkably multivocal and contentious, and never more so than when it addressed the question of "women's cinema." Not only did definitions of women's cinema (by, for, or about women) generate debate, but so did questions of aesthetic strategy and audience appeal: Should a cinema that aims to represent female subjectivity do so in an avant-garde or popular mode, via a new visual language or through a revision of standard entertainment genres? How have avant-garde and popular films appealed to (or failed to appeal to) female spectators, and how do we account for the responses of actual female viewers to these films? Clearly, such questions, originally formulated as a critique of dominant cinema in general and classical Hollywood cinema in particular, have *not* lost their relevance at a moment when mainstream cinematic practices have again become dominant, and not least so in Germany. Indeed, it is a mistake to relegate obsolete these central questions and the feminist film theoretical apparati that have emerged in response to them, for cinema *always* takes among its primary subjects gender, sexuality, and the construction of male and female subjectivity.

What is truly at stake in the so-called end of film feminism appears to be the loss of a moment of unity between theory and practice, between the personal and the political, and among feminist criticism, feminist filmmaking, and feminist activism. As the space between the feminist subject and the object of study has increased, then, feminist work on cinema has markedly decreased. At the same time, feminist film theory (unlike feminist work in other disciplines) has failed for the most part to address sociohistorical and political developments that have shifted the attention of much film theory toward topographies of nation, particularly in studies of film outside the American or Hollywood context. The now canonical paradigms of feminist film theory, among them the concept of women's cinema, merit a look back, par-

ticularly when it comes to the question of national cinema and how national cinemas define their nationality within an ever more transnational economy of mediated images and sounds.

For if feminist film theory has become mired in nostalgia and has failed to address the sociohistorical and political changes in film production and reception since the 1970s, scholarship focusing on a theorization of "national cinema" has been slow to assimilate the insights of feminist film theory. Surprisingly, work on national cinema has often neglected the intersections of questions of gender—whether in relation to authorship, audience, genre, discourse, or textuality—with those of nation, race, ethnicity, and even sexuality. It is my aim in this essay, then, to think elements of the two together—to revisit the question of women's cinema in the context of German national cinema—in order to approach the central questions posed by this volume, namely "What is German cinema?" and "What's German about German cinema?" within a global context.

What all women's cinema shares, whether it is explicitly feminist or not, is an attempt to appeal specifically to female viewers; as such, the multiple genres of women's cinema together constitute a "genre for female spectators."[6] This is accomplished on formal, visual, and narrative levels within a given film, as well as through stars, advertising, and other discourses that surround the film. Women's cinema generally engages questions of female subjectivity and addresses themes that are defined as "female," often through the figure of a female protagonist who, in Mary Ann Doane's words, "is granted significant access to point of view structures and the enunciative level of the filmic discourse."[7] Women's cinema is concerned, at narrative and formal levels, with the image of woman, with public and private space, with structures of the gaze, and with the idea of visual pleasure. While mainstream women's cinema often seeks to call attention to these elements by explicitly foregrounding them for the spectator, feminist women's cinema may attempt to deconstruct them, as Teresa de Lauretis puts it, "by addressing the spectator *as* female."[8]

At various junctures in German history, German filmmakers have explicitly sought to address female viewers, for demographic, social, economic, or political reasons. In the 1920s and early 1930s, for example, the proverbial "little shopgirls" were a primary constituency of the cinema, and the upheaval in gender roles during this period provided an additional impetus to the film industry to address women's issues on both narrative and formal levels.[9] In the late 1940s and early 1950s, the gender disproportion in the population after World War II meant that

70 percent of cinema audiences were female, a fact reflected in genre and star choices, as well as in the formal structures, of films from that period.[10] In its representation of female subjectivity and its political and aesthetic address to the feminist spectator, the *Frauenfilm* of the 1970s and 1980s clearly sought to engage and revise the dominant cinematic codes of the women's cinema of the Nazi and Adenauer eras.[11]

A resurgence of female-oriented genres also characterized the post-unification cinema of the 1990s. Among the most popular films of the decade were comedies such as von Garnier's *Abgeschminkt!*, Sönke Wortmann's *Der bewegte Mann* (Maybe . . . Maybe Not, 1994), Doris Dörrie's *Keiner liebt mich* (Nobody Loves Me, 1994), and Rainer Kaufmann's *Stadtgespräch* (Talk of the Town, 1995). These films featured female protagonists (more often than not played by Katja Riemann) in narratives about contemporary social dilemmas—gender roles, family constructs, class differences, as well as issues of race and sexuality. Such "neo-*Heimatfilme*" shared common strategies with noncomedic films—action films like Tom Tykwer's *Lola rennt* (Run Lola Run, 1998), dramas like Wolfgang Becker's *Das Leben ist eine Baustelle* (Life under Construction, 1996), and historical melodramas like Max Färberböck's *Aimee und Jaguar* (Aimee and Jaguar, 1998)—combining narratives about space and place that unfold against the backdrop of a particular, familiar German landscape or cityscape, with stars and genre conventions calculated to appeal to female viewers. Many postwall films foregrounded questions of gender identity and sexuality, and featured plots that revolved around cross-dressing and inverted gender roles. Though these films included explicitly gay and lesbian characters and sometimes bore the traces of feminism, they were hardly more nuanced in their representation of gay issues or women's issues than were their precursors, the *Heimatfilme* of the 1950s.[12]

The significance of women's genres for postwall cinema suggests the repetition of another commonplace of German cinema from earlier eras. In periods of national turmoil throughout the twentieth century, Germany witnessed an upsurge in popular filmmaking. German films were able successfully to compete on the domestic market during these periods in part because German audiences sought representations of Germanness on screen. Yet it is striking that the films themselves generally failed to address questions of national identity or historical events of national import explicitly. Instead, as in the case of both early postwar and postwall cinema, they often combined a distinct address to female viewers with a strong thematization of gender roles, family constructions, and sexuality.

One explanation of this tendency focuses on the role of genre in addressing collective national experiences. As critics of women's cinema have repeatedly suggested, in contrast to other cinematic genres, women's genres are much more able to accommodate complex social and political themes within a popular, entertainment-oriented framework. Furthermore, women's genres—in particular melodrama— often incorporate irresolvable dilemmas and irreconcilable conflicts that are encoded and made representable through certain generic conventions. Both of these qualities of women's genres have made them especially suitable for German cinema during periods of national upheaval. The "unspeakable" aspects of German national identity were sublimated into conflicts surrounding gender identity; what was "suspect" about Germanness was transmuted into comedic or melodramatic narratives about cross-dressing, inverted gender roles, and ambivalent sexualities. For viewers—female and male—filmic representations of gender-related conflicts were perhaps more palatable than narratives dealing explicitly with national identity, but they were no less relevant in periods of upheaval that generally also witnessed major conflicts in conceptions of masculinity, femininity, sexuality, and family dynamics. At times when the question of the day was the always troublesome refrain "What does it mean to be German?" films sublimated the question of national identity into the seemingly more harmless questions of gender and sexual identity.

Filmed during two transitional moments in German history, Leni Riefenstahl's directorial debut *Das blaue Licht* and Katja von Garnier's final student film project *Abgeschminkt!* are paradigmatic examples of women's cinema. While *Das blaue Licht* is a mountain film and *Abgeschminkt!* is a comedy, both films are directed by women, feature female protagonists, and exhibit dramas of "female subjectivity." *Das blaue Licht* narrates the tale of Junta, an athletic Gypsy girl who possesses a keen knowledge of the natural mountain landscape that has eluded the men of the village nearby. While Junta is able to climb neatly up to the crystal cavern high atop the mountain's peak, many village men have fallen to their deaths while attempting to scale the peak and reach the mysterious blue light that emanates from the crystal cavern when the moon is full. The artist Vigo arrives in the village, attracted by the legend of the blue light, and, after painting Junta and then falling in love with her, he observes her secret path up to the peak. Subsequently, Vigo reveals Junta's secret to the villagers, who proceed to destroy the cavern and mine its crystals. Attempting to scale the mountain peak in the wake of the cavern's decimation—now without

Das blaue Licht (The Blue Light, 1932, dir. Leni Riefenstahl). (Courtesy Filmmuseum Berlin—Deutsche Kinemathek.)

the aid of the blue light the crystals had provided—Junta falls or perhaps jumps to her death. She is later anointed by the villagers in a popular legend that credits the town's newfound wealth (based on the crystals as well as on tourism surrounding the legend) to Junta's sacrifice, as we learn from the frame story that takes place many decades after Junta's death.

While the narrative of *Das blaue Licht* casts Junta as the classically dichotomous woman, perceived by Vigo as a virgin-saint, and by the villagers as a whore-witch, *Abgeschminkt!* splits her in two. *Abgeschminkt!* presents a vignette in the lives of two best friends. The cartoonist Frenzy is a workaholic tomboy who resists her parents' insistence that she grow up and act her age; her friend Maischa is a frivolous and deceptive sexpot who wears tiny dresses, lies to her

boyfriend, and is constantly on the prowl for men. Representing opposite poles in terms of dominantly constructed femininity, Frenzy and Maischa are unhappy with both themselves and their lives; it is only Frenzy's cartoon character, *Rubi die Moskitofrau,* in whom their discrete traits are synthesized. After a degrading sexual experience with another man, Maischa ultimately decides to dump her boring boyfriend and go it alone, but only after Frenzy finds a new boyfriend. After repeatedly imagining Maischa and Frenzy together—including one eroticized scene with the two in bed—the film in the end forecloses the logical narrative progression that would have seen them begin a relationship with one another.

While *Das blaue Licht* and *Abgeschminkt!* are superficially very different sorts of films, they share many elements. Both films stage narratives about female desire, which is insistently contained or channeled in the films through visual and narrative devices. The films' protagonists, Junta (played by Riefenstahl) and Frenzy (played by Riemann) are strongly desexualized: each character occupies a space outside the dominant social order that allows her to avoid or refuse maturation into adult sexuality. This element of each character is furthered by the extradiegetic star qualities associated with Riefenstahl (androgynous athleticism) and Riemann (whom one critic has called a "glamour tomboy").[13] In both films, female desire is also closely linked to questions of representation and perception, questions that are foregrounded through the figure of the artist and the spectator in each film.

Furthermore, both films follow the model I have outlined above in couching questions of national identity within narratives that focus on gender identity—without entirely dispensing with the traces of a displaced national conflict. *Das blaue Licht* takes place in the Dolomites, and its story involves a shifting set of conflicts between various insiders and outsiders: the Italian villagers, who possess a strong regional identity; the Gypsy girl Junta, a social outcast living on the outskirts of town; and an intervening character, the Viennese artist Vigo, who speaks a different language and fails to understand both the natural and the social codes of the region. In *Abgeschminkt!* the intervening male character is similarly constructed as a foreigner: Frenzy's love interest Mark is a tourist in Munich, a half-American on leave from the American army in Frankfurt. Like Vigo in *Das blaue Licht,* Mark repeatedly infringes on natural and social codes. Both Mark and Vigo are figured as mediators of a sort between the dominant social order and the women they fall in love with. In both cases, their attempt to contain female desire is unsuccessful at the level of the immediate nar-

rative, but successful in its ramifications at the level of representation.

In *Das blaue Licht,* Junta refuses the advances of the artist Vigo, who attempts to kiss her while painting her one day. It is only after her refusal that Vigo betrays Junta's secrets to the villagers, a betrayal that leads to the symbolic rape of the crystal cavern and to Junta's eventual death. Ultimately, it is only Vigo's paintings of Junta that remain, paintings that continue to focus the gaze and generate desire years later. Significantly, the plot of *Das blaue Licht* is set in motion by the gaze of a woman at Junta's image. The woman—a tourist in the town where she has come on her honeymoon (dressed exactly like her groom in pants, duster, and goggles after an automobile journey)—finds herself surrounded by images of the legendary Junta, and asks about her, thus triggering the flashback that comprises the film's main narrative.

Abgeschminkt! is also motivated by the female gaze and structured around a framing device that foregrounds questions of representation and perception. At the outset of *Abgeschminkt!* Frenzy fills in the speech bubbles of her cartoon with one-liners gleaned from a conversation with Maischa. Here and throughout the film, Frenzy and Maischa are doubled, and their mutual desire is synthesized in the figure of the *Moskitofrau.* Over the course of the film, Frenzy argues with her editor, who wants her to make the cartoon sexier; in the end, she succeeds in fulfilling—and even exceeding—his demands: as he remarks, the cartoon is almost pornographic art now. While the narrative suggests that Frenzy has achieved editorial approval by channeling her newfound desire for her love interest Mark into her cartoon, it is the cartoon representation—and not the film itself—that clearly references this desire. For in the ambivalent ending of the film, we do not see Frenzy happily united with Mark in the proverbial normative heterosexual relationship we have been led to expect. Instead the ending again imagines Frenzy and Maischa together, this time in a tree, and the film breaks out of its formal code to allow the two characters to address the (female) audience directly, in the second person. In a parody of a late-night television dating service advertisement, the two women nominally deconstruct the film's comedic "message," ending with the same ambivalently delivered line that began the film: "sehr witzig" (very funny).

In both *Das blaue Licht* and *Abgeschminkt!* the insistent framing of representations of the female body and the explicit address to the female viewer are pushed to the point of self-consciousness. Yet in the end, each film steps away from the critical message it almost deploys. Both films' narratives oscillate wildly between articulating a critical

Abgeschminkt! (Makin' Up, 1992, dir. Katja von Garnier). (Courtesy Filmmuseum
Berlin—Deutsche Kinemathek.)

position vis-à-vis questions of gender and sexuality and foreclosing or
recuperating that critical position entirely. That these films ultimately
opt for the status quo is attributable not only to their conformity to
dominant cinematic codes or patriarchal social structures. In bearing
the traces of national turmoil, these films also parlay the sublimated
dilemmas of German identity into ambivalent resolutions in the realm
of gender identity.

In conclusion, the rhetorical gesture of my essay's title, "From
Riefenstahl to Riemann" suggests not only some remarkable continu-
ities in women's cinema in the sixty years and several political regimes
separating *Das blaue Licht* and *Abgeschminkt!* It also, of course, sug-
gests a dialogue with the Kracauer-inspired tendencies of German film
history that regard German cinema not only as a reflection of the col-
lective national psyche, but also situate much popular filmmaking in
the German tradition within a narrative trajectory of "male subjectiv-
ity in defeat." By arguing for the notion of women's cinema as a cate-
gory that can accommodate the many ruptures, breaks, and rejections
of German film history, I by no means wish to propose women's cin-
ema as a "good object" within that history. On the contrary, the
women's cinema to which I refer (with the partial exception of the fem-

inist *Frauenfilm* of the 1970s and 1980s) comprises a generally ambivalent and often conservative set of films. Yet the notion of women's cinema provides one means of moving beyond some of the static dichotomies (critical vs. popular, auteur cinema vs. commercial film, art cinema vs. genre cinema) that have often structured our understanding of German film history and that have persisted in shaping analyses of postwall cinema.

As young women directors enter the marketplace of popular German cinema in ever increasing numbers, and as directors of both sexes continue to make films that address issues of gender and sexuality in ways that shape and are shaped by dominant discourses, it is more important than ever for scholars to insist on a critical apprehension of both these films and these discourses. Precisely now, when feminism as a politics and as a basis for cultural praxis is on the wane, we must insist on a renewed theorization of feminism that can provide an impetus for its return.

Notes

1. Siegfried Kracauer, *From Caligari to Hitler: A Psychological History of the German Film* (Princeton: Princeton University Press, 1947). For more recent discussions of the contested category of national cinema in the German context, see Anton Kaes, "German Cultural History and the Study of Film: Ten Theses and a Postscript," *New German Critique* 65 (1995): 47–58; Marc Silberman, "What is German in the German Cinema?" *Film History* 8 (1996): 297–315; Eric Rentschler, "From New German Cinema to the Post-Wall Cinema of Consensus," *Cinema and Nation,* ed. Mette Hjort and Scott Mackenzie (London: Routledge, 2000), 260–77; Sabine Hake, *German National Cinema* (London: Routledge, 2002); and numerous contributions in *The German Cinema Book,* ed. Tim Bergfelder, Erica Carter, and Deniz Göktürk (London: British Film Institute, 2002).

2. See, for example, Alison Butler, *Women's Cinema: The Contested Screen* (London: Wallflower, 2002); Teresa de Lauretis, "Rethinking Women's Cinema: Aesthetic and Feminist Theory," *Issues in Feminist Film Criticism,* ed. Patricia Erens (Bloomington: Indiana University Press, 1990), 140–61; Mary Ann Doane, *The Desire to Desire: The Woman's Film of the 1940s* (Bloomington: Indiana University Press, 1987); Claire Johnston, "Women's Cinema as Counter Cinema," *Movies and Methods I,* ed. Bill Nichols (Berkeley and Los Angeles: University of California Press, 1976), 208–17; E. Ann Kaplan, *Women and Film: Both Sides of the Camera* (New York: Methuen, 1983); Annette Kuhn, *Women's Pictures: Feminism and Cinema,* 2nd ed. (London: Verso, 1994); Laura Mulvey, *Visual and Other Pleasures* (Bloomington: Indiana University Press, 1989); and Constance Penley, *Feminism and Film Theory* (New York: Routledge, 1988).

3. On the indeterminacy of the term *Frauenfilm,* see Christiane Rieke, *Feministische Filmtheorie in der Bundesrepublik Deutschland* (Frankfurt am Main: Peter

Lang, 1998); and Temby Caprio, "Women's Cinema in the Nineties: *Abgeschminkt!* and *Happy Ends?*" *Seminar* 33.4 (1997): 374–86.

4. B. Ruby Rich, *Chick Flicks: Theories and Memories of the Feminist Film Movement* (Durham: Duke University Press, 1998). The book anthologizes Rich's essays from the 1970s and 1980s. Each original essay is accompanied by a contemporary prologue that seeks to situate the essay within the personal and political context out of which it emerged.

5. Patrice Petro, "Film Feminism and Nostalgia for the Seventies," *Aftershocks of the New: Feminism and Film History* (New Brunswick, NJ: Rutgers University Press, 2002), 157–73.

6. This is Mary Ann Doane's definition of "the woman's film" in *The Desire to Desire,* 1–5.

7. Doane, *The Desire to Desire,* 3.

8. de Lauretis, "Rethinking Women's Cinema," 148.

9. See, of course, Siegfried Kracauer, "Die kleinen Ladenmädchen gehen ins Kino," *Das Ornament der Masse* (Frankfurt am Main: Suhrkamp, 1963); and Patrice Petro, *Joyless Streets: Women and Melodramatic Representation in Weimar Germany* (Princeton: Princeton University Press, 1989).

10. I make this argument in my book manuscript, currently in progress, *Dismantling the Dream Factory: Gender, German Cinema, and the Postwar Quest for a New Film Language.*

11. See, for example, the essays collected in *Gender and German Cinema: Feminist Interventions,* ed. Sandra Frieden et al. (Providence, RI: Berg, 1993).

12. On the representation of homosexuality in German films from the 1990s, see Randall Halle, "'Happy Ends' to Crises of Heterosexual Desire: Toward a Social Psychology of Recent German Comedies," *Camera Obscura* 44 (2000): 1–40.

13. See Caprio, "Women's Cinema."

Afterimages of the Holocaust: A German Affair?

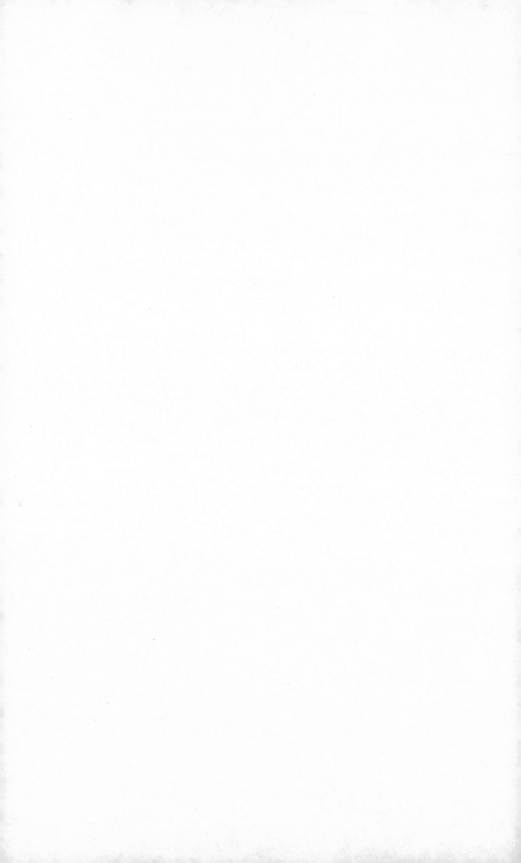

Judgment in the Twilight

German and American Courtroom Dramas and the Holocaust

Hanno Loewy

I

In 1961 Rod Serling, producer, director, and scriptwriter of the popular American TV series *The Twilight Zone* surprised his audience with an episode "visiting" an infamous German site that had not yet begun to attract American tourists and Holocaust pilgrims. Oscar Beregi plays SS officer Lutze, who, living safe in South America, pays tribute to feelings of nostalgia, and travels to Dachau. In the deserted blocks of the camp Captain Lutze experiences one of those uncanny encounters that were *Twilight Zone* standard. Alfred Becker, a former prisoner of the camp and one of Lutze's victims, is waiting for him in the camp, a ghost of the past. The gate of the camp is closed by an invisible hand, and Becker leads Lutze into Compound 6, to stand trial. The jury—the ghosts of the prisoners—pronounce their sentence: life spent in madness, suffering the pain of his victims.

Just two years had passed since *The Diary of Anne Frank* when *Death's Head Revisited* was aired on TV. This movie, directed by George Stevens, had presented Otto Frank, the family's sole survivor, as a man of reconciliation, offering his daughter's message to the world: "In spite of everything, I still believe that people are really good at heart." Could anything express more radically that something must have changed between 1959 and 1961 than the casting in those films? It is the same Joseph Schildkraut playing Otto Frank and Alfred Becker, the utterly unreconciled ghost of the victim who asks for justice.

When the 1950s came to an end, Senator McCarthy's repressive postwar consensus had become fragile. The self-image of the United States as a model for democracy and peaceful integration of minorities, and the consequences of the war, again became subject for scrutiny.

The Nuremberg trials were examined anew: first on TV, then on the big screen. The survivors became witnesses and had to expose their experiences publicly. They became symbols of ambivalence, characters transmitting their traumas into the present, figurations of unpredictability—even social misfits—invisibly connected with the perpetrators. Fantasies portraying the survivors as possible avengers spread. New trials had begun in Germany in 1958, and in 1959 preparations began for the huge Auschwitz trial in Frankfurt, which would remain in session from 1963 to 1965. Worldwide attention, however, came through media coverage of Eichmann's abduction from Argentina and his subsequent trial in Jerusalem. This made the Holocaust a crime to be considered separately, and thus a subject of distinct courtroom narrative for the first time. In contrast to Nuremberg, it was now particularly the murder of the European Jews that informed the prosecution, and it was the survivors whose testimonies formed the major part of the trial performance.

During the Nuremberg trials, no courtroom dramas—neither fiction nor docudrama—appeared on the screen, while the documentaries of the Allies played a certain role in the courtroom. Wolfgang Staudte's film *Die Mörder sind unter uns* (The Murderers Are among Us, 1946) was planned to center on a courtroom narrative. Returned to postwar Berlin, a German soldier takes revenge for the massacre of Jewish civilians his officer was responsible for, kills the perpetrator, and stands trial for murder. But the script was altered because of the Soviet authorities, and the revenge plot was not executed to its very end, thus deleting the whole courtroom scene. One finds hardly any fictional feature film centered on the question of justice or revenge that made reference to the camps, too. Eugen York's *Morituri,* produced by Artur Brauner in Berlin, came to German cinemas in 1948, and was received by its audience (what little audience there was) with open hostility. It was the only attempt in postwar Germany to show a fictional reality of concentration camps as one of the main sets of a feature film.

Even the subject of selection in the camp is touched upon, although it is done without any direct reference to the persecution and annihilation of Jews. The community of prisoners is carefully presented as an international body of average people who manage to organize an escape into the woods and join Polish partisans. The Holocaust nonetheless informs the most dramatic sequence of the film: its central narrative, and a courtroom drama of a certain kind. The fugitives, hiding in a secret camp in the woods, capture a German soldier—a young

and seemingly innocent boy—and start to discuss whether they should kill him. The "prosecutor," whose rage turns into the form of an indictment, is in fact a Yiddish-speaking Jew from the East. His portrayal links him with one of the most prominent icons of German postwar self-imagery: the image of the German war veterans and POWs returning from Russia with a lost arm or leg. But this veteran comes from the ghetto, and he has no family to receive him. The wood dissolves into an imaginary courtroom, turning trees into a gothic window, when another Jew, a former lawyer from Germany, starts to defend the soldier, asking for justice and reconciliation. The soldier is sentenced to a poor life, to deserve love anew as a part of a new world. But this was certainly not the kind of reconciliation for which the postwar German audience was looking.

Only at the end of the 1950s did trials become a public issue again, specifically in a CBS teledrama, Abby Mann's *Judgment at Nuremberg,* in 1959. Maximilian Schell plays Hans Rolfe, a fictitious attorney defending Nazi jurists in one of Nuremberg's American military tribunals. In December 1961 Stanley Kramer's feature film version premiered in Berlin on the very day Adolf Eichmann was sentenced in Jerusalem, in the midst of the crisis following the erection of the wall.

"Historical discourse follows the structure of trial narratives,"[1] Dan Diner writes in an essay on strategies of historical understanding. The attempt to reconstruct historical events appears as a hearing not only in a metaphorically juridical sense, in particular when it comes to the discussion on the responsibility for historical crimes. In consequence Dan Diner interprets the debates on history—polarized by the "intentionalists" and "functionalists"—as the competition between different claims: a claim for recognizing historical behavior and taking action as a matter of guilt, or an "interpretation of negligence—a kind of guiltless guilt." "Guiltless guilt" is more than just a paradigm of negligence or a combination of thoughtlessness and chance, however. It is also a paradigm of "fate," the dilemma of making an impossible decision, a choice between impossible alternatives. That is: it is exactly the narrative structure we call a "tragedy." And we will see that it is exactly the claim *for* a tragic story that informs so many German attempts to come to terms with the past as a "fateful entangling." Maybe this is the *tertium datur* behind the polarity described by Dan Diner.

Whatever kind of guilt we discuss in the imaginary courtroom of historical discourse, it seems that no other historical crime could be better fitted for a genre that chooses the mechanisms producing histor-

ical narratives as its main subject: the courtroom drama. By 1964, Susan Sontag was speaking about the relation between trial and drama. "The trial is preeminently a theatrical form. . . . And as the trial is preeminently a theatrical form, the theater is a courtroom."[2] The conflict between protagonist and antagonist comes to a conclusion, a closure equivalent to a sentence. "The function of the trial was like that of the tragic drama: above and beyond Judgment and punishment, catharsis." The trial Sontag has in mind is that of Eichmann in Jerusalem, which she sees as "one of the most interesting and moving works of art of the past ten years."[3]

She identifies a fatal flaw in that work of art, however. It suffers from a contradiction, which is in fact due to the difference between a trial (and a historiographical discourse) and a tragic narrative driven by fate. But this is also true for another plot structure; the politics of the Eichmann trial were about the adventure of spiritual survival, from which the state of Israel should draw its legitimacy as the heir of the Jewish Diaspora.

> The trial is a dramatic form which imparts to events a certain provisional neutrality: the outcome remains to be decided; the very word "defendant" implies that a defense is possible. In this sense, though Eichmann, as everyone expected, was condemned to death, the form of the trial favored Eichmann. Perhaps this is why many feel, in retrospect, that the trial was a frustrating experience, an anticlimax.[4]

In contrast to drama, the courtroom lives by the fact that the characters on stage are responsible for their actions, that they are not only agents of fate (as in a tragedy), or of an unfolding teleological history (as in a romance). Tragedy is just *one* possible self-image of the protagonists and hence, in most cases a self-image of perpetrators.

But the social space, established by the law, depends on the competition of different narratives possessing an equivalence of potential legitimacy. They can be fragmented and synthesized, doubted and sustained. Only the decision of the jury or the judges reconstructs the narrative and evaluates its meaning in the sentence. James Boyd White sees the law basically as a narrative form, as a poesis, "a way of creating versions of experience in cooperation or competition with others. . . . It ends in story too, with a decision by a court or jury, an agreement between the parties, about what happened and what it means."[5] As Robert Hariman puts it: "The trial required that people of vastly different perspectives recognize a common forum, while allowing them to

keep and project their own voices."[6] Truth in this perspective is something that can only be established through communication, through discourse, as a social construction, performed as a drama.

This is true for the law as much as for its performance, as "the law is in structure multivocal, always inviting new and contrastive accounts and languages."[7] "In the micro-world of the courtroom," Kathy Laster writes, "stories are told, tested and resolved in a controlled environment."[8] But as much as the trial may be, following White, "the most powerful method of cultural criticism American society has had,"[9] the courtroom drama is at the same time a pathetic affirmation of the legal system's rules and decorum—a cultural criticism of its vulnerability as it is subjected to the powers of society, and a celebration of its strength. Part of that ambiguity of affirmation and criticism is the widely accepted consensus about the rules of the game: "These include," according to Hariman, "the adversarial format, use of official symbols, the necessity of decision, and the theme of judging character."[10] If you examine the reality of the courtroom, you will not necessarily find a real battle for truth, but a competition for the best and most convincing story.

Sontag's observation, that the trial as drama violates the narrative plot structure of tragedy, that openness of discourse does not allow fate and tragic closure to direct the process, does not necessarily preclude the transformation of trial into a narrative genre in its own right. To define this genre one has to focus on a structure of hybrid story-telling as a means of creating a suspenseful discourse that proceeds on the crossroads of different basic genres—those that can be found in Northrop Frye's archetypes of comedy, satire, romance, and tragedy. The outcome of the courtroom drama should be as open as the outcome of a trial performed in "due process."

In Germany you will hardly find such pathos of the law as public discourse or the trial as a narrative creating event. Saying that the courtroom drama is originally a very American genre should not conceal the fact that it is not unfamiliar to the German screen, and we will see what variations of it evolve in the German cinema. In part this is due to the differences between German and American law and trial procedure, the most salient being the existence of cross-examination in the American courtroom, or the importance of the jury and the different role of the judges. Yet these differences can also be interpreted the other way around: as an expression of a different culture of public discourse as a whole.

Given the close affinities between historical discourse and the trial,

and given the fact that it was indeed public trials that put the Holo-
caust on the public agenda again around 1960, it seems quite natural
that the courtroom drama would be one of the favorite genres of pop-
ular cinema to adopt this particular subject. Looking at the courtroom
drama as a genre, one finds, quite astonishingly, very few studies and
books—and those written mostly from a juridical point of view.[11] It is
quite obvious that the courtroom drama very often appears as a
hybrid, adopting elements from the "whodunit," the thriller, the social
problem drama, or other genres or formulas. Thus any study of the
Holocaust courtroom drama has to begin from the beginning. I have
identified about twenty-five movies that I would consider to be either
courtroom dramas proper, or films that contain courtroom scenes
crucial, if not central, to the narrative—including feature films, tele-
dramas, and episodes of TV series. Fourteen of these films were
produced in the United States (among these is an Italian-American co-
production), one in Israel and one in Great Britain. Significantly, there
are ten productions from Germany: four from the GDR and six from
the Federal Republic. This list is, of course, incomplete, but I think it is
quite representative.

As much as the courtroom drama seems to be an almost natural set-
ting for films exploring the history of the Holocaust (and particularly
its impact on life after it), Susan Sontag's observation of the Eichmann
trial becomes significant too: how do directors and scriptwriters apply
the subject of the Holocaust to a genre that demands a certain open-
ness of plot? Five different answers to that demand may be distin-
guished:

1. The defendants, prosecutors, witnesses, and judges are not as dif-
 ferent from one another as we would like them to be.
2. The courtroom is only a stage for a show, which conceals the real
 interaction of power behind the scenes.
3. The trial is only a stage for meaningless public rituals. The real
 drama takes place in the world of families and generations.
4. The identity of the defendant is unclear.
5. The defendant is not a Nazi, but a former victim who tries to find
 justice outside the realm of the law.

II

The first of these strategies dramatically calls into doubt the moral
fiction that constitutes the pathos of the law in performance, and it
opens the stage for the possibility of a pathetic moral-cosmos-restoring

confession. At least four of the films play with this variation, among them *Judgment at Nuremberg*. This film presents as its major defendant a fictitious Ernst Janning, former Nazi minister of justice played by Burt Lancaster. There is much to say about the film, which according to Judith Doneson, served several functions and made

> a number of, at times contradictory, points. It finds the Germans guilty of war crimes yet claims we are all guilty. It weakens the image of the Jew without having a single Jewish character in the film. In attempting to show the uniqueness of the Holocaust to the Jews, it instead universalizes the event by portraying the Jews as victims among victims. *Judgment* also becomes a metaphor for all injustice, especially in America in the 1960s.[12]

Alan Mintz follows her in describing the persistence of references the film makes to American issues and contemporary struggles, up to subtle visual markers such as "the look on the face of the black soldier when hangings are mentioned."[13] The film produces an uncertainty of outcome, not only through the political pressure under which the judges have to conclude the trial but also through the fact that defendant Rolfe (Maximilian Schell) is indeed capable of raising doubts of the moral superiority of the United States. The camera pans around and circles the courtroom, catching the defendants, judges, spectators, and guards as they react to what is said, and in doing so it identifies the viewer with the competition about truth as a competition about the hegemony of physical space.[14]

At the same time the film presents a generational drama. While the two "sons," defender Rolfe and prosecutor Lawson (Richard Widmark), engage themselves in a wild verbal battle, the two fathers (Burt Lancaster as defendant Ernst Jannings and Spencer Tracy as Judge Haywood) communicate on a more profound level, leading to the cathartic moment of Jannings's confession, which reveals him as a tragic figure. More precisely, he is revealed as a figure who claims to be tragic: he had been trapped in the illusion of being able to "prevent worse" by going along with the Nazis. Jannings claims Rolfe is "going to do this again," expressing his contempt for the defense attorney's tendency to stage a revival of the crime itself, the persecution of a victim who is giving testimony, by trying to save the honor of his "fatherland." *Judgment* does not end with the pathos of Jannings's confession, nor with Kramer's political statement that the independence of justice should not be biased by political powers. It ends in the prison, where

Judgment at Nuremberg (1961, dir. Stanley Kramer). (Courtesy Filmmuseum Berlin—Deutsche Kinemathek.)

Jannings tries to achieve Haywood's consent to his own tragic self-image. He hands over to Haywood a stack of papers, his notes from the trial, expressing a deep feeling of trust, and says that he is guilty of having done wrong, but that he did not really know where his wrongdoing would lead. Haywood stands firm. Jannings's seductive tragism does not take him from the track: "It came to that the very first time you sentenced to death a man you knew to be innocent."

Only a year later, in Vittorio de Sica's film version of Jean-Paul Sartre's play *The Condemned of Altona,* an American-Italian co-production, Maximilian Schell again played the main character, and Abby Mann, the author of *Judgment,* wrote the script. The trial in this film is only a fantasy. Franz Gerlach, son of a powerful industrialist and Nazi supporter, himself obviously a war criminal, lives in hiding in his family's villa in Altona, and imagines himself as the defendant of his tragic century in a trial in 3059, with a jury of crawfish—after mankind's self-annihilation. His guilt and his reason for being in hiding is highly

ambivalent, and it is only slice by slice that this hiding entails his insanity as much as his withdrawal into a concealed room.

He surfaces briefly after 1945 to help his sister fend off an American soldier attempting to rape her. But this only removes him further from reality, because he does not want to give up his image of a devastated Germany, doomed and annihilated by its victorious enemies. His sister feeds him with false "reports" from the newspapers, because he would not stand to learn the truth about Germany's recovery and Economic Miracle. Or is it that he simply vanishes, because he is a war criminal? His criminal career begins, paradoxically, with an attempt to save a "Polish Rabbi" who had escaped from the concentration camp in which his own father was involved—an attempt that fails because of loyalty to his father. And it ends, as far as the audience can tell, with the torture and killing of Russian civilians near Smolensk. Gerlach expresses, in the truthful manner of the insane, how he interpreted *his* "tragic," choice-less choice: "All ways are blocked, even the one of the minor evil. There is only one way left, which is never blocked, because it is impossible to go there: the one of the greatest evil. We will go this way." In the end Franz and his father commit suicide together, reuniting in death.

Such "tragism" also establishes the starting point of Roland Suso Richter's 1999 film *Nichts als die Wahrheit* (After the Truth). Josef Mengele (Götz George) is not dead, according to the plot, but presents himself before the court in Germany to tell *his* story. The film begins with an ostensibly demonical inversion of the Eichmann trial. Abducing lawyer Peter Rohm *to* Argentina with the help of a neo-Nazi organization, Mengele seduces Rohm to act as his attorney. He has chosen him because Rohm had already done extensive research on Mengele, in an attempt to try to understand *why* Mengele did what he did. The way Rohm (and Richter) poses this question is quite problematic, but its function in the narrative will soon be understood. In defending Mengele, Rohm starts to resemble Hans Rolfe in more than one way. After attacking a survivor on the stand, he cools his face with water in the men's room, and returns to the courtroom with wet and confused hair, looking like Rolfe in his rage in the courtroom of *Judgment at Nuremberg*. Rohm tries in a similar way to show that euthanasia is not only a phenomenon of the Nazi past; he does this not so much to defend his "client," but to demonstrate how seducible we are all, how close the step to evil seems to tread. But this "closeness," this hollow moralistic universalization, is exposed as, and motivated by, a generational drama of family traditions, of a German longing for continuity. The

formal trial is itself only a stage for political correctness and false morale. The camera, which in *Judgment* dramatizes the discourse, pans around in Richter's film without purpose. Showing "moved" faces by slowly hovering toward them, it creates nothing but an impression of emotional people, evoking cheap tears.

III

In the films produced by East Germany's DEFA (Deutsche Film-Aktiengesellschaft), the image of the trial as a superficial discourse covering up the "real" struggles in the society becomes explicitly political. In Kurt Maetzig's 1950 film *Der Rat der Götter* (The Council of Gods), the IG-Farben trial in Nuremberg is presented as a trial staged to conceal the real interests of the United States, which has betrayed the morale of the war against the Nazis by rearming Germany against the Soviet-led world peace camp. Yet it would be misleading to find such ideological *Lehrstücke* and political satires as the only mode of expression in the GDR. Jo Hasler's 1964 film *Chronik eines Mordes* (Chronicle of a Murder) is far from being that simple. Angelica Domroese, in her first leading part as Jewish survivor Ruth Bodenheim, kills Zwischenzahl, the newly elected mayor of a West German city and murderer of her family. In the end she finds her defender in state prosecutor Hoffmann (Jiri Vrštala), who changes sides and abandons the state apparatus that is just a cover-up for conspiracy of powerful ex-Nazis and new democrats. Domroese's and Vrštala's introverted, shy performances make Ruth Bodenheim's story and both personalities much more complex and meaningful than the plot, which plays with stereotypes, as it allows some of the characters a more ambivalent appearance. Still, in *Chronik eines Mordes* the educational gesture is obvious and dominant.

This is less the case in the West German teledrama *Mord in Frankfurt* (Murder in Frankfurt, 1968) by Rolf Hädrich. A Polish witness in a trial against an SS doctor who had been active in Auschwitz visits Frankfurt to give his testimony. A parallel plot manifests itself with the murder of a cab driver provoking demonstrations in favor of death penalty. The two plots meet only on the stage of the Frankfurt theater, where rehearsals of Peter Weiss's play *Die Ermittlung* are taking place. The play involves a young actor who has a sexual relationship with a stewardess. She is a witness too—in the cab murder case, or, more precisely, the one who had seen the murderer taking the cab she had just left. But memory is not her strong suit; she is not even able to identify him when confronted with suspects at the police station a few days

later. The documentary style of a loose portrait of different citizens and their stories, evolving simultaneously in the city of Frankfurt, culminates in the appearance of the Polish witness in the courtroom. The trial is fictitious, but it is drawn from a clearly identifiable interrogation in the well-known Auschwitz trial of defendant Capesius, an SS doctor. Jost Vacano's camera, panning around the head of witness Markowski, almost produces a reverse variation of the camera movement in *Judgment.* Instead of representing the struggle for spatial hegemony of the speaker it encloses the witness, who is trapped between the defender and the prosecutor, both of whom are using his story only as an instrument in their quarrel and disregarding its existential meaning for the survivor. In the end Markowski collapses, and leaves Frankfurt as soon as he can.

Konrad Petzold's DEFA 1963 film *Jetzt und in der Stunde meines Todes* (Now and in the Hour of My Death) plays on an actual trial by beginning with Eichmann in Jerusalem, seen on a television screen in the office of a newspaper in Frankfurt. Ella Conradi, a journalist, is sent to Jerusalem to cover the trial, but she flees back to Germany, unable to stand the horror of the proceedings. Moshe,[15] a charming Jewish-American communist, tries without success to convince her to stay. This is a romance that does not take off, as Conradi is incapable of looking behind the horror and into the face of its "causes." Conradi's boss, the Jewish editor of a newspaper, sends her to a courtroom in Frankfurt to cover two ordinary killings. We soon learn that these murders are the result of a well-known conspiracy of old Nazis, new democrats, and capitalists who are both. This is a conspiracy that in all these GDR productions is put into function on a basically identical set, a seductive night or dance bar with an obscene female dancer or singer, with few clothes and sometimes dark skin, either black or Latino. Conspiracy, obscenity, and the exploitation of the "exotic" female body merge as a simple metaphor for power and decadence in "Western" commodity culture—a metaphor (as the DEFA well knew) most fascinating to the citizens of the GDR.

The first murder examined in this Western "courtroom" is in fact committed only to cover up the motives for the second. Importantly, these facts will never be revealed in the courtroom itself. Powerful industrial bosses kill an old comrade who they fear might become nervous watching Eichmann in Jerusalem and start revealing names himself . . . their names. What happens in the courtroom is only a farce, a stage for a grotesque competition of vanities between prosecutor and defender, and—in a satirical scene occurring after the case has been

settled and while the audience is out of the courtroom—for a rehearsal of the prosecutor's plea, coached by the defender. Ella Conradi finally learns about that conspiracy of power, but being bound in her individualism, she is incapable of acting and so must die. Before that, her father-like but weak Jewish editor had thrown her out of business because he had been put under pressure by local elites to do so. In the beginning of the film it was he who mocked Eichmann on the screen: "Something like that made people tremble." But there is one who understands his lesson in the end: Detective Hendricks, who is starting to fight for the truth. Interestingly enough, his courage is obviously connected to a certain status. He is not bound by marriage and has a strong relationship with his mother while his real father is replaced by a stepfather he does not like.

IV

Family and generational drama play an even more prominent role, albeit in a different way, in Richter's *Nichts als die Wahrheit.* Defendant Rohm has a wife: a journalist and companion in his political and historical interests. She becomes pregnant, though, and can no longer understand her husband's obsessions. Rohm almost loses her during the trial, first because she leaves their home, then again when she starts to investigate Mengele's case and affiliations herself. The neo-Nazi organization murders one of her informants with an explosive device, almost killing her in the process. Rohm has strong support, as well: his mother joins him. There is no father in this film either, but there is a father-like figure in his antagonist, state prosecutor Vogt. Vogt is a cynical guard of political correctness, who is, himself, obviously planning a show trial against Mengele. Rohm has to go his own way. This leads him—informed and provoked by Mengele—to the story of his own mother, who participated as a nurse in the euthanasia crimes and concealed it from her family for more than fifty years. She confesses what Mengele is incapable of confessing; this gives Rohm the strength to surprise Mengele and the court by demanding life imprisonment for his client. Before his mother uses the courtroom to tell her son the truth, though, the survivors from Auschwitz regain their voice. And while listening to them in the courtroom, we suddenly hear a music that we know all too well: the most sentimental motif from the soundtrack of Steven Spielberg's *Schindler's List* (1993). This does not support the dignity of the survivors, but instead the dignity of Rohm's mother. When she decides to confess her "guilt," the *Schindler's List* motif returns, now transferring the moral status of the survivors as witnesses to the Rohm family.

Nichts als die Wahrheit (After the Truth, 1999, dir. Roland Suso Richter). (Courtesy Filmmuseum Berlin—Deutsche Kinemathek.)

Bernhard Sinkel's film about IG-Farben, *Väter und Söhne. Eine deutsche Tragödie* (Fathers and Sons: A German Tragedy, 1986), not only takes the tragic paradigm to its kitschy climax, but also concludes with the IG-Farben trial in Nuremberg. In the very last shot, Georg Deutz leads his mother back into their villa, where he just checked to see if his old childhood toys are still there. "Come home, Mama. There are no Americans in the house anymore." That Georg, the last heir of the great industrialist's family, who did not become a chemist but a movie director, has the last word in the film is significant enough. Sinkel himself is the nephew of Fritz ter Meer, one of the IG-Farben managers who received one of the strongest punishments in Nuremberg. That the trial is betrayed by politics, as in *Rat der Götter,* here leads not to revolution but to a German reconciliation with itself. Sinkel's film differs from *Rat der Götter,* however, in that it does not concentrate on the victorious and innocent working class, but on the tragically entangled old elites.

Constantin Costa-Gavras proves that it is possible to play on the generational drama in another way with his film *Music Box* (1989), featuring Armin Müller-Stahl as an old Hungarian fascist living as a U.S. citizen in Chicago, and Jessica Lange as his daughter. Being a lawyer, she defends her father in court against the immigration office, which wants to expel him from the States. After a long battle in the court-

room over his real identity and over the credibility of witnesses and scientific expertise, she wins because she is able to raise doubts in the minds of some of the survivors taking the stand. Claiming that their testimonies were forged by communist intelligence, she follows the path her ex-father-in-law, a well-established old warrior of the cold war, has opened to her. But this is not the close of the film. In the end she realizes that her father is indeed the person he is accused of being. In a music box she finds photographs showing her father killing Jews in Budapest. She sends the new information to her opponent in the courtroom and cuts the ties between her son and his beloved grandpa. This is possible because it affirms her identity as American and constitutes a new American family: she and her son. Again, a father had to be aborted to accomplish that nucleus of a newborn innocence, the primal couple.

V

Music Box develops its plot not only as a generational drama, but also as a drama of identity. Who is the man on trial? *The Man in the Glass Booth* (1975, dir. Arthur Hiller) poses this question, identifying the Jewish businessman Arthur Goldman from New York as a Nazi war criminal, Adolf Karl Dorff, who is kidnapped by the Mossad to stand trial in Jerusalem. In the end he is revealed to be indeed the self-hating Jew Goldman, who, as a kind of capo in the camp, survived because of the privileges the real Dorff gave him. The presiding judge says to Goldman: "I understand . . . your need to put a German in the dock— a true German Nazi who would say what it is necessary to say . . . say what no German has ever said in the dock. I understand that."[16] But Goldman leaves no doubt that the judge has understood nothing. "I'm seeking for humility,"[17] he says, and he finishes the trial with an outburst of insanity.

Seemingly more fantastic, this contamination of identities is presented by a 1993 episode of the science fiction series *Star Trek: Deep Space Nine,* named "Duet." Playing in the twenty-fourth century, its plot is centered around the Cardassian data-administrator Marritza, a typical bureaucrat who is accused of having been a member of the guards of a Cardassian death camp on the planet Bajor, which had been occupied by the Cardassians for more than fifty years. The allusions *Star Trek* makes to the Nazis and their victims in this episode are obvious. Kyra Nerys soon realizes that Marritza is lying, only to be mocked by him: "If this is the case, I make my lies more mysterious." The stranger is identified during the examination as being the infamous

camp commander Gul Darhe'el himself, butcher of thousands of innocent victims. Gul Darhe'el is proud of his deeds. "You call it Holocaust. I call it my daily work." In a second plot twist, he turns out to be just the man he seemed to be in the beginning: a self-hating Cardassian pretending to be Gul Darhe'el—even to the extent of undergoing plastic surgery—in order to make possible a public trial that would allow the Cardassians to come to terms with their criminal past and to reconcile with the Bajorans. His prosecutor on Deep Space Nine, a far outpost of the Federation, is Kira Nerys, who is herself Bajoran. She decides to release him in the end, but in the last scene he is killed by another Bajoran, an avenger who is unwilling to reconcile even with an innocent Cardassian. So Kira Nerys can address her plea for individual and lawful justice instead of revenge only to the dying Marritza and to us. It is not only the twisted plot of this episode that is surprising, but also the obvious impact it had on Roland Suso Richter's film on Mengele. Not only does Götz George's performance of Mengele resemble Marritza, but his futuristic high-security prison cell is almost a carbon copy of the respective location on Deep Space Nine.

VI

The revenge of a victim, or the fantasies of revenge others project into the minds of survivors, forms the plot of no less than seven of the films discussed here. Reginald Rose's "The Avenger," an episode of the lawyer and courtroom series *The Defenders* from 1962, presents a survivor as the murderer of a former SS commandant who was responsible for the death of his wife in a Nazi camp. The jury and the defenders are confronted with the complete and blank confession of the defendant, without any repentance—and with the (indeed unconvincing) attempts of the American widow of the killed Nazi doctor to present her husband as a good man trying to do the best for the prisoners under impossible circumstances. Without solving the dilemma of how to judge such an act, the episode ends with the jury deadlocking with a vote of 6 to 6. As a result, an emphasis is put on the seriousness of both the trial and the jury in charge of finding a sentence: "We need more time." The plot centers not so much on the motives of the Jewish perpetrator of the crime, but on the insistent attempt of his lawyers—Prestons senior and junior—to try to reestablish in their reluctant client a sense of faith in the law and the values of society. The climax of the episode is in the first smile on the face of defendant Mayer Löb, after a last exchange of arguments with his defenders: "The law depends ultimately on human beings. We use it." Preston senior answers, "That is

its weakness, but also its strength. And it continues to improve." And this in spite of all critical examination. The faith in the potential of justice must not be broken.

In *Chronik eines Mordes* there is no faith in justice at all, but rather in the truth that might emerge from an act of rebellion against a corrupt legal system. Ruth Bodenheim had desperately asked German officials to put Zwischenzahl on trial, but was confronted with ignorance and suppression. Now she wants to be sentenced; she wants *her* trial, in order to explore the truth about her "victim," who once led the Gestapo squad that deported the Jews from this German town. Ruth and her little brother remained, miraculously, in the synagogue that served as the assembly point, only to end up in camps and in a German army brothel in Poland. Hoffmann's superior, conspiring with the old Nazi elites who have returned to power in West Germany, wants to preclude the exposure of the past a trial would permit, and is even willing to let her escape. But in the end Ruth Bodenheim will break the silence because prosecutor Hoffmann takes her side, thus terminating his employment as a state servant.

Taking sides is also Liv Ullmann's task in Fons Rademaker's 1990 film *Der Rosengarten* (The Rose Garden, 1990). Ullman plays the lawyer Gabriele Schlüter-Freund who, together with her daughter, witnesses a puzzling incident at an airport involving two old men, one pursuing and attacking the other. The assailant is caught and turns out to be a Jewish survivor (played by Maximilian Schell) who is reluctant to speak. Again the plot is about conspiracy behind the scenes of a trial, without any pathos of "due process" or even any trust in the possibility that a trial could establish the truth. The old man who was attacked was the commander of the camp in Hamburg, in which the sister of the old Jewish man was killed just a few days before the camp's liberation that enabled his escape. The old camp commander, Arnold Krenn, still has powerful allies, among them friends and colleagues of the lawyer's ex-husband, played by Peter Fonda, another ex-husband, and her new friend, a medical doctor who provides Krenn with medical expertise that saves him from prosecution. Gabriele Schlüter-Freund takes sides, defending the old man in court and trying to understand his attack. This, as we learn in the end, is motivated not by revenge, but by Aaron Reichenbach's desire to learn the fate of his sister and to stop Krenn from escaping to South America.

Before this happens we witness an orgy of reconciliation: a family melodrama that outdoes the trial and its process. The trial itself is identified as completely meaningless by an insert at the end of the film

that tells the viewer that the camp commander after whom Krenn was modeled was never sentenced because of the particularities of German criminal law. The judges considered his deathly acts as only following orders without particular personal cruelty or participation. He is merely an accomplice, and not a perpetrator. But this criticism of the German criminal law in regard to Nazi criminals is only a dry post-script following an emotional climax.

Back in the courtroom, Aaron's sister Ruthi (played by Gila Almagor) suddenly appears—still very much alive—and she and her brother melt into a sea of tears. This reunion is made possible, the films suggests, by virtue of a memorial site, erected in the former school building that hosted a camp extension of Neuengamme at the end of the war. Aaron and his sister Ruthi had both left, one shortly after the other, their comments in the visitor's diary. But it took some time for Gabriele Schlüter-Freund to identify this coincidence. Her investigation requires her to leave her daughter home alone, while neo-Nazi supporters of Krenn attack their apartment, precipitating another dramatic climax in which her ex-husband finally gets the chance to care for his daughter and therefore for his ex-family again. Reconciliation and reunion of the survivors and of the German family, then, is staged by the site, by inviting the different parties into the ritual of commemoration and, in so doing, reconciling the site with its own history.

VII

In turning what is first presented as a possible tragedy into the reconciliation of families, the German courtroom drama of the 1990s ends as comedy. Even if these films are in no way funny or comical, their closure brings together what "belongs together." As Willy Brandt commented on the falling wall in 1989: "Jetzt wächst zusammen, was zusammen gehört" (That which belongs together will now grow together), thus moving German history as such from the self-image of a tragic narrative into the realm of comedy.

Rod Serling's vision of Dachau ends with a statement: the camp's grounds must never be cleaned up. We must always remember. This cleaning up is exactly what happened, though, only a few years later: in order to remember, in order to replace the veritable blocks of the camp by symbols and to focus on religious attempts to create meaning dominated by a Catholic chapel. But Rod Serling had already done so when he portrayed the prisoners' ghosts with a partial view of their wooden bunks on their shoulders, as if they carried crosses. Serling's presentation of the camp site as a haunted mansion populated by the souls of

martyrs introduced the courtroom into a narrative of adventure and romance, as a site of spiritual survival and transition. Even earlier there was *Morituri*'s depiction of the prisoner's escape into the woods as an escape thriller, as an adventure of a soul endangered by the longing for revenge. A soul that can survive this temptation is initiated into a new world of hope. This is true on another plane as well for *Judgment at Nuremberg,* which follows Spencer Tracy on his journey to the limits of morality, into the wilderness of the Nuremberg ruins (which he explores in the beginning of the film). In the end the film follows him out again, out of the prison cell in which he leaves Jannings, whose confessions and tragism remain behind as a seductive aberration, a "test" of Spencer Tracy's integrity. Even *Music Box* does not end merely in reconciliation, but in a new beginning, a new birth, as we see mother and son in the end by the shore of Lake Michigan.

The American courtroom could be portrayed realistically or fantastically, on board a space station at the limits of the universe or on earth in the twentieth or twenty-fourth century. It remains a stage, however, where rules of discourse are taken serious. The German courtroom as it is depicted by the courtroom drama remains a fake throughout. No libido is invested in the insignia, the decorum, and the "due process" of democracy and the social, dramatic creation of reality and truth, that is, the story. The courtroom is not the site of the drama of public discourse or the center of the society. It is just plain theater, "only" illusion, as Richter in his film *Nichts als die Wahrheit* puts it blankly by staging the courtroom in the former theater at Gendarmenmarkt in Berlin. The site itself is an impostor of tragedy—or comedy. The English translation of the film's title is quite revealing: instead of "Nothing but the Truth," it was turned into *After the Truth.*

Notes

1. Dan Diner, "Über Schulddiskurse und andere Narrative. Epistemologisches zum Holocaust," *Bruchlinien: Tendenzen der Holocaustforschung,* ed. Gertrud Koch (Cologne: Böhlau, 1999), 70.

2. Susan Sontag, "Reflections on *The Deputy,*" *Against Interpretation and Other Essays* (New York: Dell, 1967), 126.

3. Sontag, "Reflections on *The Deputy,*" 125.

4. Sontag, "Reflections on *The Deputy,*" 127.

5. James Boyd White, "Telling Stories in the Law and in Ordinary Life: The *Oresteia* and 'Noon Wine,'" *Heracles' Bow: Essays on the Rhetoric and Poetics of the Law* (Madison: University of Wisconsin Press, 1985), 168. Like Sontag, White stresses the significance of Aeschulus's *Oresteia* as a prototype for the paradigm of law as a drama and drama as a trial.

6. Robert Hariman, "Performing the Laws: Popular Trials and Social Knowledge," *Popular Trials: Rhetoric, Mass Media, and the Law,* ed. Robert Hariman (Tuscaloosa: University of Alabama Press, 1990), 21.

7. James Boyd White, "Is Cultural Criticism Possible?" *Michigan Law Review* 84 (1986): 1373.

8. Kathy Laster with Krista Breckweg and John King, *The Drama of the Courtroom* (Sidney: Federation Press, 2000), 9.

9. White, "Is Cultural Criticism Possible?" 1373.

10. Hariman, "Performing the Laws," 26.

11. See Laster; *Drama of the Courtroom;* and Paul Bergman and Michael Astimow, *Reel Justice: The Courtroom Goes to the Movies* (Kansas City: Andrews and McKeel, 1997). Bergman and Astimow summarize sixty-nine film narratives and present them together with a juridical comment, without further aesthetic analysis.

12. Judith Doneson, *The Holocaust in American Film* (Philadelphia: Jewish Publication Society, 1987), 106.

13. Alan Mintz, *Popular Culture and the Shaping of Holocaust Memory in America* (Seattle: University of Washington Press, 2000), 101.

14. See Thomas Harris, *Courtroom's Finest Hour in American Cinema* (Metuchen, NJ: Scarecrow Press, 1987), 144.

15. Played by Gerry Wolff, a Jewish actor who had returned from British exile after the war and was well known to the audience in the GDR, having just played Herbert Bochow, the head of the communist resistance at Buchenwald, in Frank Beyer's *Nackt unter Wölfen* (Naked among Wolves) in 1962.

16. Robert Shaw, *The Man in the Glass Booth* (New York: Harcourt Brace, 1967), 176.

17. Shaw, *Man in Glass Booth,* 178.

Displaced Images

The Holocaust in German Film

Stephan K. Schindler

April 1945 in the small Swabian village Nesselbühl: The camera follows Anna, leader of the local Bund deutscher Mädel (BDM) group, as she is pulling a cart full of food to the railway station where three cattle wagons hide their mysterious load. In a medium close-up shot we see the blond girl, played by German TV star Karoline Eichhorn, opening the door of one of the wagons, her face displaying a sense of nervous anticipation. As the door gives way to reveal the inside of the wagon— the wretched figures of concentration camp prisoners—the camera moves back to Anna as she, in shock, vehemently vomits on the bread she intended to deliver. In order to protect her, the villagers standing by, and the film's audience from the traumatic display of horror, the door of the cattle wagon is immediately shut again, before the prisoners receive water and bread or any visual attention of the camera's eye. The overdetermined mise-en-scène not only plays heavily on contrasts by juxtaposing bread and half-digested food, the girl's beauty and the prisoners' tormented bodies, but it also reverses the historic configuration of perpetrator and victim. The girl's physical reaction, her discomfort, relocates the victims' suffering on the perpetrator's body, a displacement of trauma that is then literally blamed on the victims of Nazi atrocities: the wagon's door is shut. Unable to demonstrate any successful action of empathy, even the villagers become "victims" beleaguered by the never-ending screams of the starving prisoners in agony. In a strange reenactment of one aspect of the "final solution," the villagers get rid of their problem by pushing the cattle wagons with the dying prisoners down the hill to the next village.

These disturbing elements of plot and narrative in Oliver Storz's 1994 TV production *Drei Tage im April* (Three Days in April) seem to

be symptomatic for so many well-intended but ill-conceived attempts of German filmmakers to represent the Holocaust against the backdrop of an ever-more global economy of images (re-)writing German history. Storz's choice to tell the history of the Holocaust as an anecdotal melodrama of the regional bystander—obviously a lingering effect of Edgar Reitz's attempt to imagine "that *Heimat* must overcome *Holocaust*"[1]—manifests displacement on so many levels that the film ultimately fails to incorporate the victims' stories in Germany's atrocious history. Throughout the film the prisoners are identified only by their concentration camp uniforms; we never know whether they are Jews, Gypsies, Poles, or Russian POWs. Their utterances remain largely untranslated, and no long takes reveal individual features in the empty physiognomies of horror. The camera does not dare to explore the inside of the cattle wagon, leaving the audience in a guessing game about life in prison. With the doors shut, the victims are even disembodied, reduced to hands sticking out of the wagon's openings or to their haunting off-screen screams. In short, the film's representation of the victim repeats on an aesthetic level exactly those aspects of dehumanization with which the Nazis stripped prisoners of their individuality and subjectivity. While the film intends to illustrate the historical guilt of the bystander-turned-perpetrator, its imagery manifests its own fault by reproducing the abstract and thus forgettable image of the victim without identity. This depersonalized image had already been established in Nazi documentation about the deportations or the ghettos and even in some liberation movies. The film might even be considered dangerously manipulative, because it forces the spectator to adopt the bystander's point of view to the extent that he or she might feel relieved when the haunting screams of unidentified victims finally stop. The sole function the victims of Nazi atrocities obtain here is to serve as an object through which the bystanders and perpetrators redefine their relationships among each other in face of the historic power shift in Germany at the end of the war. The screams of starving prisoners transform the ideologically blinded Nazi youth Anna into a naive woman who "really" wants to help, but they also spark the villagers' hatred, this eccentric emotion so deeply grounded in the provincial German approach to the Other.

What James E. Young has called "the dilemma Germany faces whenever it attempts to formalize the self-inflicted void as its center—the void of its lost and murdered Jews"[2] becomes painfully obvious when one investigates the representation of the Holocaust in German feature films. Similar to postwar German literary works that "fash-

ioned many languages of silence to cope with the knowledge and the legacy of the atrocities committed,"[3] the aesthetic transfiguration of the genocide in German film is marked by a complex scenario of absence, repression, and displacement.[4] While representing the Holocaust in cinematographic images has become an international enterprise in which national film industries, for example in Poland (*Korczak,* 1990, dir. Andrzej Wajda), Italy (*La Vita è Bella,* 1997, dir. Roberto Benigni), or Romania (*Train de Vie,* 1998, dir. Radu Mihaileanu), display their interpretation of Germany's gruesome history in compelling and provocative stories, German filmmakers seem to have a uniquely "German" problem with the subject. Early postwar German cinema participated in the collective amnesia of the *Stunde Null* (zero hour) when political, economic, and social "realities" demanded a departure from the criminal past in order to create a new beginning that did not locate the Holocaust at the center of national identity and history. Instead of addressing the crimes that have come to be symbolized in the name Auschwitz, films of the late 1940s and early 1950s such as Helmut Käutner's *In jenen Tagen* (Seven Journeys, 1947), focused on historic German-Jewish and Nazi-Jewish relations before the deportations and mass killings, because "Jewish issues are part of a German discourse to reach a reconciliation with the past."[5] But the repressed historical void—the expulsion of Jewish life from Germany and the murder of the European Jewry—returned in the lapses of the New German Cinema, be it the second and third generation's phantasmatic fascination with Fascism or their stereotypical and at times anti-Semitic stylization of Jewish characters.[6] The same year the NBC miniseries *Holocaust* (1978) presented the events of the Shoah for a mass audience by utilizing classical Hollywood narrative strategies, Hans-Jürgen Syberberg's *Hitler—ein Film aus Deutschland* (Our Hitler, 1978) signaled the coming of the postmodern "rejection of narrativity, the specularization of history, the proliferation of perspectives, and the affirmation of nostalgia."[7] Embracing the abstract apocalyptic pessimism of the *post-histoire,* German films of the 1980s continued to steer clear of working through the very factual realities of the Nazi genocide. Neither the political scandal of Reagan's and Kohl's visit to the SS cemetery in Bitburg nor the attempt to "normalize" German history in the so-called *Historikerstreit* (Historians' Debate) initiated a counterdiscourse in film. Change seemed to come about when the cinema of unified Germany embarked on a postmemory exploration of German-Jewish cultural history in what Lutz Koepnick has coined "heritage films."[8] It is significant, however, that most of these films,

such as *Comedian Harmonists* (1997, dir. Joseph Vilsmaier), *Aimée & Jaguar* (1999, dir. Max Färberböck), *Viehjud Levi* (Jew-Boy Levi, 1999, dir. Didi Danquart), or *Klemperer—Ein Leben in Deutschland* (Klemperer: A Life in Germany, 1999, dir. Andreas Kleinert and Kai Wessel), project the renegotiation of Germany's troubled past into a melancholic yearning for a German-Jewish symbiosis that evades the ruptures of history and replaces historic trauma with retrospective imaginings. Such obvious quandaries, misplacements, and omissions of German filmmaking in the (re-)writing of post-Holocaust history, its entanglement in specifically German forms of collective amnesia and mechanisms of repression, raise the question, how could or should "a nation of former perpetrators mourn its victims"?[9] Even if we assume that German filmmakers have been and are capable of depicting the atrocities of their own people or of mourning their victims through the aesthetic and ethical reconstruction of the victims' unrepresentable trauma, it is the German history of the medium itself that causes an almost insurmountable obstacle.

Already in 1940, the Holocaust was presented to German moviegoers in narrative form as a kind of fantastic and phantasmatic entertainment with the construction and destruction of "the 'Jew' as Nazism's constitutive social fantasy" of the Other.[10] Veit Harlan's monstrous *Jud Süß* (Jew Süss, 1940) not only prepared the audience for the deportation and extermination of the European Jewry, but also cast a haunting shadow on any future attempt to represent the Holocaust in melodramatic form, utilizing the medium's deceiving narrative and formal properties.[11] How can one avoid replicating the scopophilic fascination with anti-Semitic, repulsive images displayed, for example, in Fritz Hippler's *Der ewige Jude* (The Eternal Jew, 1940) when one attempts to portray the catastrophic conditions in cattle wagons, ghettos, or concentration camps? The complex tensions between history, memory, and visual narration are deeply grounded in the fact that the iconographic kit of our own memory is shaped by the political aesthetics of the Nazis. Consider, for example, the function of the yellow star as a racist marker that bestows public shame and humiliation on its Jewish bearer or the striped concentration camp uniform as the counterimage of the German uniformed masses. Filmmakers are confronted with the task of integrating these historical elements of mis-en-scène without reproducing their dehumanizing effect and without allowing the camera to denigrate the Jewish prisoner from a perpetrator's or bystander's point of view. The Nazis also established the staging of "documentaries" as visual reaffirmation of their anti-Semitic

ideology or as a distortion of the murderous realities they had created. Films like *Der Führer schenkt den Juden eine Stadt* (The Fuhrer Gives a Village to the Jews, 1944) carefully orchestrated an idyllic scenario of the camp Theresienstadt in order to deceive the national and international observer with staged humanity of Nazi Germany toward prisoners. On the other hand, edited materials for anti-Semitic films about the Warsaw or Lodz ghetto pretended to record "objectively" what the Nazis had in fact constructed: "the subhuman status of the Jews."[12] Any film that wants to pay tribute to the historical and moral imperative of authenticity faces the challenge that photographic or filmic images do not just record actual and factual events, but also construct their realities and their perception. As part of their reeducation, many Germans learned about the Holocaust through the liberators' documentaries. The intention of these films was to give visual proof of the atrocities of the Nazi regime, to establish a feeling of collective guilt, and to simultaneously offer some kind of political redemption for the German audience through identification with the liberator. American, British, and Soviet recordings of the liberation of concentration camps reveal unsettling similarities: most of them are staged reenactments of the actual arrival of the liberating troops, and they are despicably self-referential. They keep the victims at a distance in groups behind barbed wires, leave them in speechless anonymity, focus on the victims' damaged physical appearance, and even let the viewer glimpse their nudity. While the perpetrators have individual features and even names, the camps' inmates are represented as abstract images of horror, functionalized to give proof of the heroic actions and the emotional stress of the individual liberators.[13]

These significant complexities of agency in the visual foreshadowing and reconstruction of the Holocaust have to some extent informed the discourses on the *Bilderverbot* (prohibition of images). Adorno's famous dictum, "To write poetry after Auschwitz is barbaric," not only informed the German critical rejection of the NBC series *Holocaust* or Steven Spielberg's *Schindler's List* (1993),[14] but might also have motivated German filmmakers to avoid the Shoah in their films and to seek refuge in the moral imperative: there should be no images of the unimaginable. With a few exceptions such as Frank Beyer's *Jakob der Lügner* (Jacob the Liar, 1974), Peter Lilienthal's *David* (1978), or the German co-productions of Agnieszka Holland's films *Bittere Ernte* (Angry Harvest, 1984) and *Hitlerjunge Salomon* (Europa, Europa, 1990), German cinema, be it old or new, from the west or east, has generally failed to create a substantial counterproduct to the Fas-

cist control of Holocaust imagery or to the conventional narratives à la Hollywood.[15] For every film that dares to present to hostile viewers, who do not want to be reminded, the spaces, lives, and experiences of now absent Jewish subjects, there are dozens of movies that engage in a desperate effort—as Lutz Koepnick has argued—to undo Germany's bad history by presenting good stories about German subjects as victims, seduced but innocent bystanders, or even heroes of the resistance.[16] Some films are obsessed with even asking the impossible question: "How could this have happened?" This psychological inquiry into the fascist mind creates scenes of departure from the Holocaust, scenes in which the Jewish victim is victimized again, and even scenes of adoration of the victimizer. Consider, for example, Heinz Schirk's docudrama *Wannsee Conference* (1984) in which the bureaucratization and cold abstraction of the Nazi mass murder of the European Jewry is restaged. In this infamous meeting for the implementation of the "Final Solution," high-ranking representatives of the Nazi regime reduce the victims to numbers of industrialized killing or to material for grotesque anecdotes about the deportation in progress: complaints come from the *Reichsbahn* (national railway) that the Jews are ruining wooden seats when they are frozen to them. In the foreground, however, the film displays the stylish coldness of the Nazi officials, their cheerful attitude, their flirts with the secretaries, and their superhuman self-control when discussing the murder of millions of Jews as a logistic enterprise. These aesthetics of the barbaric created by the mise-en-scène open the venue for an emotional response: the cold-hearted but stylish murderers could all too easily become an object of identification for neo-Nazis who wish to improve their poor public appearance. Indeed, as many scholars have concluded,[17] the last fifty years of German cinema have manifested the cinematographic blunders of the work of mourning, the disavowal of the irreconcilable differences between German and Jewish trauma, and the displacement of the victims' histories in the construction of a post-Holocaust German identity. I would like to concentrate on this last point, namely, the various strategies of displacement in narrative films by having a closer look at three critically acclaimed German feature films.

Traditional historiographies of the German mass-murder of six million Jews have been criticized that if they rely heavily on the Nazi's documentation of the genocide, then they victimize the victims again by denying them agency in the course of history and reducing them to abstract figures that cannot capture the differences of individual experiences. Imaginative narrative forms, however, such as memoirs,

biographies, fiction, and film tend to focus on the individual subject's story vis-à-vis the overarching constrains of history. While post-Holocaust German, Jewish, Israeli, or American identities share the effects of the Holocaust's *longue durée,* their cultural construction differ tremendously according to geopolitical origin. And that is where the problems start for German filmmakers who did not accept the myth of an ahistorical new beginning, *Stunde Null,* but attempted to construct a new German identity against the backdrop of already being defined by the negative history of German crimes. In other words, almost every German film that addresses the Shoah has to renegotiate the relationships between self and other, German and Jew, perpetrator/bystander and victim; respect the rules of historical authenticity; and yet tell a new story that differs from the already known history. It is at this potential gap between individual story and collective history that the strategy of historical displacement enters narrative films.

One of the first postwar feature films, Wolfgang Staudte's *Die Mörder sind unter uns* (The Murderers Are among Us, 1946), can be seen as the blueprint for displacing the history of the Holocaust in a German story about the war by reversing the historical perpetrator-victim relationship. The concentration camp survivor Susanne Wallner, played by Hildegard Knef, adopts all too easily to the harsh living conditions in bombed-out Berlin; she fills the role of housewife and partner for the former army officer and physician Dr. Mertens, because it is he who needs "love and care." The viewer does not learn much about Susanne's camp experiences or about other victims, who are mentioned but not identified in a newspaper headline: "2,000,000 People Gassed." Instead, the film devotes much attention to Dr. Mertens's wartime trauma that causes his mysterious behavior, his suicidal mood swings, his excessive alcohol consumption, and his aggression against a wealthy businessman who turned out to be his former army commander. In a flashback toward the film's end the curtain is lifted: Dr. Mertens suffers from guilt because his halfhearted attempt to change his superior's orders did not stop a mass execution of civilians in Poland. Here is where the Holocaust enters the film's narrative through a peculiar use of overconnotated objects. The scene in discussion opens with a medium shot of German officers in front of a Christmas tree, singing a carol. The camera cuts to a close-up of a crucifix that is decorated with a soldier's helmet and a gun as a prelude to the next image: the shooting of the silent and faceless civilians seen through a distorted and foggy camera lens. The victims are only identified in terms of gender and age by a cut to the captain's report

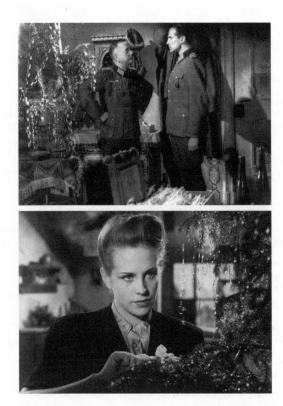

Die Mörder sind unter uns (The Murderers Are among Us, 1946, dir. Wolfgang Staudte). (Courtesy Filmmuseum Berlin—Deutsche Kinemathek.)

that states the successful operation in terms of body and shell count—thirty-six men, fifty-four women, thirty-one children, 347 machine gun cases. Then the camera focuses on Dr. Mertens's hand as he is crumbling what appears to be a paper star. The narrative of this scene suggests silent disobedience. Dr. Mertens was supposed to make a star for the captain's Christmas tree, but the plot offers quite different allusions. Cross-cutting between the scenes, the star could be seen as a symbolic comment for the execution, because in size and shape it resembles the Star of David and thus functions as a displaced marker of the victims' possible Jewish identity. In addition, the shooting of the civilians is framed by the display of two religious symbols, and syntagmatically the star can be read as the Star of David in opposition to the crucifix. The film's intended antifascist and anticapitalistic message shatters in this scene because the "good German" forced to do evil is an

accomplice who failed to prevent atrocities and symbolically reenacts them by crushing the star. When the film ultimately "offers redemption to its troubled male subject, the potential of domestic happiness to the long-suffering woman, and a promise of . . . moral order restored to a confused community,"[18] then a historic reversal of victim and perpetrator has occurred. As in *Drei Tage im April,* the fate of the (Jewish) victims in Poland serves only one purpose: to address the different degrees of guilt among the Germans themselves as they renegotiate their postwar relationships with each other.

The self-referential displacement of the Holocaust in German film as a means to differentiate between good and bad Germans continues in the second generation of German filmmakers. Even representatives of the progressive New German Cinema were unable to find an appropriate language that would fill the void left by their fathers. Instead, an even stranger appropriation of Germany's history took place. The perpetrators' children either identified with the Jewish victims in order to break away from the paternal inheritance of guilt or "invoked the horrors of the Holocaust to strengthen their case for sexual liberation."[19] In Michael Verhoeven's *Das schreckliche Mädchen* (The Nasty Girl, 1990), the protagonist, Sonja Wegmus, describes her journey through archives and oral histories in order to find the truth about her town's Nazi past. Little do we learn about the Jewish victims, like the department store owner Hirsch, or the businessman Nathan Krakauer, who was killed because he sold two priests over a hundred pairs of underwear. The film refuses to give any visual attention to Jewish life in Germany and oscillates between a misplaced shot of a marble plate with Hebrew letters and Sonja naming her children Sarah and Rebecca. What is at stake, then, is the redefinition of German identities through revealing the town's repressed past: "the fate of the Jewish merchant, for instance, comes only up in connection to the townspeople's guilt."[20] With Sonja becoming the victim of the town's neo-Nazis, the Holocaust is made absent and has only one visual signifier in the entire film. We are with Sonja in a petit bourgeois kitchen listening to Sonja's grandmother describing the town's concentration camp. As she explains how she endangered herself by feeding the Jewish inmates, who are mentioned only in a strange comparison to "animals in a zoo," a cut inserts the master icon of the Holocaust: the barbed wire of the camp. The space of German atrocities is populated again, this time by marching young men, dressed in black, one of the film's allusions to the rise of Germany's neo-Nazi movement. But this short take reiterates the film's message: the legacy of Fascism has created a new victim-per-

petrator configuration in which young Germans occupy the place of the dead Jews because they inherited their grandparents' courage of resistance. With the expulsion and murder of the Jews in Germany, they also have lost the cinematographic representation of their voices and faces. Instead, their stories are told only by German witnesses, while the film's subtext focuses on the sexual awakening of the female protagonist. In the end, this displacement is the director's choice, especially in a film that pays much attention to the photographic display of memory.

In my last example, Didi Danquart's *Viehjud Levi,* based on Thomas Strittmatter's prize-winning play, the narrative follows the transformation of the Jewish cattle trader Levi from accepted outsider to outcast in a small southern German community. The reason for the dramatic change is the arrival of railway workers under the supervision of a Nazi engineer, who start repairing the damaged railway system, but also bring dramatic technological and ideological innovations to the village in the Black Forest. The railway workers introduce anti-Semitism as a device to reshape personal and professional relationships in the village's traditional economic exchange system, of which Levi is an integral part. At the film's end Levi is expelled from the community, whose members redefine their collective identity beyond the boundaries of *Heimat* as non-Jewish Germans. Portraying the villagers' racist aggression, the film reveals the fascist breeding ground of the idyllic southern landscape and thus can be read as an *Anti-Heimatfilm;* its imagery, however, displays a problematic foreshadowing of the Holocaust. The character Levi is "socially, gesturally, linguistically and especially by his fastidious clothing" overidentified as a stereotypical "(Eastern European) Jew"[21] who has only one companion or friend, a rabbit, with whom he shares his thoughts, feelings, and experiences. The casting of animals in this movie—rats signifying the destroyed railways; the "golden" calf as object of contention between Levi, the Nazis, and the farmers; the engineer's white rabbit as a failing prop for his magic—assigns a troubling symbolic meaning to Levi's pet when the film reenacts specific stages of the Holocaust. Levi loses his business to the Nazis; he is increasingly identified as being Jewish; his property is damaged by the railway workers; the Nazi engineer declares that he is a "nothing." Levi's progressive degradation and exclusion from the community peaks in an overdetermined scene: the camera follows him as he discovers a bloody sack hanging from his truck. When he opens the sack the camera cuts to a point-of-view shot and the viewer sees with him the sack's gruesome content: the dead rabbit with its

Viehjud Levi (Jew-Boy Levi, 1999, dir. Didi Danquart). (Courtesy Filmmuseum Berlin—Deutsche Kinemathek.)

head cut off. The camera moves back to a more neutral perspective showing in a medium frontal shot how the shocked Levi tries desperately to put the rabbit's head back onto its body. After several failed attempts Levi has stained his white shirt with blood and begins to mourn his loss by singing a song. A close-up of his crying face concludes the sequence. The film's open ending—the backlights of Levi's cart fading into the dark—finds anticipating closure in this scene, because the rabbit's brutal death displaces onto the animal's body what the film conceals: Levi's potential fate as a Jew in Nazi Germany. Almost as a response to Hollywood's drastic realism in *Schindler's List,* Danquart chooses not to show what German anti-Semitic violence did to millions of human Jewish bodies. The allegorical allusion to Nazi violence (the dead rabbit, the blood stains) reallocates the depiction of the Holocaust from representation to interpretation and thus off the screen into the viewer's imagination. Not knowing Levi's future but yet anticipating it through the fate of his companion, the rabbit, the viewer remains at a safe distance from the "unrepresentable" atrocities of the Holocaust.

The representation of the Holocaust in German film is marked by

absence, displaced presence, and a specific kind of "mourning work as parapraxis"[22] that echoes those faux pas that have been associated with the failed performances of public commemoration in the Federal Republic. Some German films, however, employ the reversed strategy when they perform failure or "parapraxis as mourning work."[23] In his film *Das letzte Loch* (The Last Hole, 1981), the *enfant terrible* of Germany's avant-garde, Herbert Achternbusch, creates melodramatic "moments of absurdity, black humor, and grotesque embarrassment"[24] in his pseudonarcissistic identification with victims of the Nazi regime. Achternbusch plays the private detective, waitress lover, murderer of his fiancée, and professional beer drinker Nil, who commits suicide in order to belong to the mountain of dead victims rather than to the self-righteous Germans. Throughout the film Nil attacks the long legacy of collective German anti-Semitism ("everyone was against the Jews, and still today they are against them"), calls the Germans a "people of murderers," considers himself to be "too stupid to be a Jew," but does not count himself among the Germans. Achternbusch supplements the traumatic absence of realistic representation of the Holocaust in German feature films with absurd exaggerations of verbal references to the genocide. His specific strategies of irritation (linguistic slips, lyrical associations, overconnotive metaphors, surreal image-sound montage, provocative nonsense, etc.) stage the programmatic failure of coming to terms with a past that haunts the children of the perpetrators. Throughout the film the Holocaust has almost no visual signifier but a skull and is reduced to a language game of the number six million, as Nil proclaims: "I live in the last hole with my six million and hopefully I will not dream again about six million dead Jews." The film dedicates much time to Nil's therapy to forget: the disappearance of dead Jews is equated with the quantity of alcohol intake. Nil calculates that he has to drink half a liter of beer in order to forget five hundred thousand dead Jews, but his therapy fails, and at night the dead Jews return according to his beer consumption. What follows is a lengthy discussion with his doctor, who finally prescribes 200 centiliters of schnapps for every dead Jew of the Holocaust. While the two men get lost in their respective equations, the viewer is left alone with a display of the provocative insensitivity to the victims of Nazi horror that marks the problematic representation of Jews in German film after Auschwitz.

When Nil drinks schnapps out of a bottle with the label "150 Jews" or when he digs up a Jewish skeleton with tennis racquets at the foothills of Mount Stromboli, the limits of representation are seriously probed. *Das letzte Loch* oscillates between impossible identification

with the Holocaust victims and acceptance of perpetrators' guilt in the second generation. When Nil commits suicide, he proposes another infeasible act of "reparation," or coming to terms with Germany's brutal history, but in its satirical self-reflexivity the film addresses the impossibilities of historical forgetting, of recreating a (negative) German-Jewish symbiosis, and of representing the absent victim.

While in *Drei Tage im April* the victims could at least be heard as a reminder of their agony and while their screams question the stereotype of the victim's passivity, Achternbusch's or Verhoeven's films—like so many other German films—have disembodied the Jews, reduced them to historical but empty signs without reference, signs that continue to characterize German films as specifically German.

Notes

1. Eric Santner, *Stranded Objects: Mourning, Memory, and Film in Postwar Germany* (Ithaca, NY: Cornell University Press, 1990), 101.

2. James E. Young, *At Memory's Edge: After-Images of the Holocaust in Contemporary Art and Architecture* (New Haven: Yale University Press, 2000), 155.

3. Ernestine Schlant, *The Language of Silence: West German Literature and the Holocaust* (New York: Routledge, 1999), 243–44.

4. See Thomas Elsaesser, "Die Gegenwärtigkeit des Holocausts im Neuen Deutschen Film—am Beispiel Alexander Kluge," *Die Vergangenheit in der Gegenwart: Konfrontationen mit den Folgen des Holocaust im deutschen Nachkriegsfilm,* ed. Deutsches Filminstitut (Munich: Edition Text und Kritik, 2001), 54–67.

5. Frank Stern, "Jewish Images in German Films since 1945," *SICSA Report,* no. 10 (summer 1994), available at http://sicsa.huji.ac.il/nl10.html (accessed August 22, 2006).

6. See Stern, "Jewish Images"; and Gertrud Koch, *Die Einstellung ist die Einstellung: Visuelle Konstruktionen des Holocaust* (Frankfurt am Main: Suhrkamp, 1992), 234–59.

7. Anton Kaes, "Holocaust and the End of History: Postmodern Historiography in Cinema," *Probing the Limits of Representation,* ed. Saul Friedlander (Cambridge: Harvard University Press, 1992), 209.

8. Lutz Koepnick, "Reframing the Past: Heritage Cinema and Holocaust in the 1990s," *New German Critique* 87 (2002): 47–82. For summaries of recent German films dealing with the Holocaust, see Annette Insdorf, *Indelible Shadows: Film and the Holocaust,* 3rd ed. (Cambridge: Cambridge University Press, 2003), 329–34.

9. Young, *At Memory's Edge,* 184.

10. Linda Schulte-Sasse, *Entertaining the Third Reich: Illusions of Wholeness in Nazi Cinema* (Durham: Duke University Press, 1996), 48.

11. See Eric Rentschler, *The Ministry of Illusion: Nazi Cinema and Its Afterlife* (Cambridge: Harvard University Press, 1996), 149–69; and Schulte-Sasse, *Entertaining the Third Reich,* 47–91.

12. Slavoj Žižek, *Did Somebody Say Totalitarianism* (New York: Verso, 2001), 63. See also the analysis of the photos from the ghetto in Lodz by Koch, *Die Einstellung,* 170–84. Some Nazi documentary clips about the deportation and ghettoization are quoted in Alain Resnais's *Nuit et brouillard* (Night and Fog, 1955).

13. See, for example, *Memory of the Camps* (also known as "F3080," produced by British Ministry of Information, Sidney Bernstein, and the Imperial War Museum between 1945 and 1952, released on PBS's *Frontline,* 1985).

14. See Martina Thiele, "Publizistische Kontroversen über den Holocaust im Film," Ph.D. diss., University of Göttingen, 2000; and Klaus L. Berghahn, Jürgen Fohrmann, and Helmut J. Schneider, eds., *Kulturelle Repräsentationen des Holocaust in Deutschland und den Vereinigten Staaten* (New York: Peter Lang, 2002).

15. See Deutsches Filminstitut, *Die Vergangenheit in der Gegenwart,* 1. For a comprehensive analysis of Holocaust representations in East German films and their idiosyncrasies within a state-supporting antifascist paradigm, see Thomas C. Fox, *Stated Memory: East Germany and the Holocaust* (Rochester: Camden House, 1999), 97–144.

16. Koepnick, "Reframing the Past," 72–73.

17. See Koch, *Die Einstellung;* Koepnick, "Reframing the Past"; Elsaesser, "Die Gegenwärtigkeit des Holocausts;" and Deutsches Filminstitut, *Die Vergangenheit in der Gegenwart.*

18. Robert R. Shandley, "Rubble Canyons: *Die Mörder sind unter uns* and the Western," *German Quarterly* 74.2 (2001): 146.

19. Dagmar Herzog, "'Pleasure, Sex, and Politics Belong Together': Post-Holocaust Memory and the Sexual Revolution in West Germany," *Critical Inquiry* 24 (Winter 1998): 442.

20. Caroline Wiedmer, *The Claims of Memory: Representations of the Holocaust in Contemporary Germany and France* (Ithaca, NY: Cornell University Press, 1999), 101.

21. Johannes von Moltke, "*Heimat* and History: *Viehjud Levi,*" *New German Critique* 87 (Fall 2002): 94–95.

22. Elsaesser, "Die Gegenwärtigkeit des Holocausts," 56.

23. Elsaesser, "Die Gegenwärtigkeit des Holocausts," 57.

24. Thomas Elsaesser, "Tarnformen der Trauer: Hebrert Achternbuschs *Das letzte Loch,*" *Lachen über Hitler: Auschwitz-Gelächter? Filmkomödie, Satire und Holocaust,* ed. Margrit Frölich, Hanno Loewy, and Heinz Steinert (Munich: Edition Text und Kritik, 2003), 157.

An Icon between the Fronts

Vilsmaier's Recast Marlene

Eric Rentschler

In his documentary portrait of 1984, director Maximilian Schell asked Marlene Dietrich about her return to Berlin during her famous German concert tour of 1960. It was awful, she replies, "people went and put bombs in the theater." They stood on the street with signs proclaiming, "Marlene go home." "They didn't want me. They were angry with me. . . . They said, 'She left us. She didn't want us.' They loved me and hated me at the same time." She speaks fondly of a meeting with Willy Brandt and then recalls another encounter. "And then there was this woman, a real Berliner, and she said to me, 'Well, can't we be friends again?' [Na, wollen wir uns wieder vertragen?]." In the midst of all the outrage emerges a conciliatory voice. Do we want to get along again? the old woman asks. Let us, she proposes, put aside the bad memories and the different histories that divide us and recognize what we have in common: a city, a homeland, a culture. To be sure, Marlene is quick to add, many Germans did not share these sentiments: "There were a lot of others who wouldn't forgive me." Marlene Dietrich's place in Germany and her relationship with Germans were contested then and remained embattled when she died in 1992. Forty years after the meeting in Berlin, Joseph Vilsmaier's biographical feature of 2000, *Marlene,* reiterates the old woman's question. How it does so, as we shall see, reveals much about the conflicting historical energies at work in the life and afterlife of this controversial performer.

I

For us to accept a portrayal of a well-known historical figure, Jean-Luc Comolli noted, the film actor must perform so convincingly that spectators, at least to a sufficient degree, can suspend their disbelief.

Famous personages, after all, "have a past, they have a history before the film began"; indeed, they have been dealt with by historians, perhaps even by other scriptwriters and directors.[1] In the recent German biopic *Marlene,* Joseph Vilsmaier cast the young actress Katja Flint[2] as the legendary diva Dietrich. The director faced a considerable creative challenge given the profusion of images and stories, "the already mediated and abbreviated versions" of a legendary career.[3] A historical figure who appears in a historical film, Comolli points out, possesses at least two bodies. In the case of *Marlene,* for instance, the first abides in preexisting images and recollections of the star, the second in the actress who stands in for her. These two bodies compete with each other, and that means potentially a body too many. If Katja Flint posed before Vilmaier's camera, then we know that the figure we see onscreen cannot be the famous film star. Viewers of a historical film know that they are seeing a simulation. Historical films therefore "usually try to ensure that the actor's body is forgotten, to cancel it, to keep it hidden, at least, beneath the supposedly known and intendedly preeminent body of the historical character to be represented." The spectacle does not just fool the spectator, argues Comolli. The spectator has to be a participant in the fooling.[4] Indeed, she needs to "believe in the reality of the image"[5] if the film is to be convincing and pleasurable.

Joseph Vilsmaier's *Marlene* constituted one of the most expensive postwar German productions with costs of almost eighteen million marks, with extravagant sets by Oscar winner Rolf Zehetbauer, costume design by Ute Hofinger (who had worked on Vilsmaier's 1997 *Comedian Harmonists*), a script based on the best-selling biography by Dietrich's daughter,[6] and elaborate commercial tie-ins. The director invested much time and great ambition. Vilsmaier, wrote the film's press agent (the former film critic of *Tip,* Alfred Holighaus), is a man of goodwill, with a strong respect for both the immensity and the gravity of this undertaking. He "is a craftsman of emotionality. He transforms written scripts into authentic feelings. Anything he puts his hands on is stirred, not shaken. For that reason he does not shy away from political controversy. And it may well be that one or another historical scene [in *Marlene*] will not stand up to closer political analysis; no matter, it will in any event not seem false or untruthful. And that counts for something in a medium that shapes feelings and is shaped by feelings."[7] Just how authentic or moving this film's display of feelings actually turned out to be remains a question to which I will return. *Marlene* depicts historical scenes, no doubt, and these scenes ordered as a narrative constitute a history lesson, one that will surely stand up

to political analysis, even if that analysis might lead us to conclusions that go beyond the director's claim to authenticity and his high regard for feelings. Just how much truth or untruth is at issue here remains to be seen. Taking my cue from Simon Frith, I will examine not only how truthfully the film recounts Marlene's biography, but also "how it sets up the idea of 'truth' in the first place" and for what reasons and with which consequences.[8]

II

In his lavish narrative feature of 128 minutes, *Marlene,* Vilsmaier turned to the biography of (after Hitler) Germany's greatest film star of the twentieth century.[9] The story picks up in 1975 with fireworks bursting over the sky of Manhattan and the star's triumphant taking of leave in Carnegie Hall, before flashing back to a procession of tableaux from 1929 to 1945: the discovery of the actress by Josef von Sternberg, the big breakthrough after the premiere of *Der blaue Engel,* Dietrich's arrival in Hollywood and the subsequent path to international stardom, the ongoing tension between personal ambition and domestic responsibility as wife and mother, a secret love amid a series of romantic partners, the fluctuations in her career, her enlistment in the war effort, and the return to Germany after the Allied victory.

Immodest and hyberbolic announcements preceded the film's opening. Press releases promised an unknown Marlene, a glimpse behind the scenes at the real person and the truth behind the mask. In the end the production could not meet the expectations raised by the advance billing. Vilsmaier's makeover of the famous actress failed to convince or compel German viewers. Despite the director's sincere desire to rouse feelings, popular audiences were neither stirred nor shaken. Rarely, in fact, has a domestic production been so roundly and viciously panned by the nation's critics, individuals who are not exactly reluctant to express their displeasure with German commercial features, especially ones that involve large amounts of public subsidy funding.[10] In an editorial, an outraged Alfred Holighaus attacked journalists for transforming the film's noble ambitions into "the greatest fall from grace" in the recent history of Germany cinema.[11] Above all, three major concerns fueled press responses.

The film, claimed reviewers, failed miserably in its attempts to capture Marlene's magic and fascination. For all the effort put into makeup, costume design, and lighting, and even though Katja Flint had mastered Dietrich's vacant look with a perfect Valium gaze, the actress on screen remains limpid and lifeless.[12] The director takes great

pains to show us the construction of a face and the making of a star, maintained H. G. Pflaum, but Vilsmaier never manages to probe beneath the surface. There is a protracted sequence in which von Sternberg molds and makes over his star. The only thing he does not do himself is to extract her wisdom teeth. For Pflaum, the film is most persuasive at its beginning and end: here Marlene appears as a pure icon, without commentary, powdered and silent. But the minute Flint begins to sing, she becomes a karaoke diva.[13] Even if she at times uncannily resembles Dietrich, Flint does not succeed in sounding like a Berliner.

This biopic lacked a trajectory and a telos, protested critics. The narrative has a hectic and episodic structure; the mise-en-scène is wooden and one-dimensional; dialogues more often than not sound trite or flat. No doubt, the film is very busy. The pyrotechnic opening sequence, with its elaborate fireworks, displays considerable production values, quite literally showing the money in an exhibit of glamour and allure with glitzy choreography, grand-scale décor, and extravagant set and costume design. The passage sets the stage for the film's unrelenting celebration of surfaces and also intimates the decided discrepancy between production cost and aesthetic sensibility. The story line is constantly on the move, at times even harried. We begin in Carnegie Hall, then flash back to the past in the kitchen of a Berlin apartment; afterward the film races from station to station, from 1929 to 1945. We see a lot of fluid traveling shots, but that does not mean that the story has a clear sense of direction. Repeatedly, scenes seem to move with great velocity toward a dramatic payoff, only to reach a feeble conclusion. Vilsmaier, in Peter Körte's judgment, "has described himself as a person 'who does not constantly second-guess himself intellectually.'" Be that as it may: a look at a classical Hollywood biopic and its care for plot structure might have made for a more user-friendly experience.[14]

The movie, argued Georg Sesslen and a host of critics, resembled a harlequin romance in its transformation of a life and a career into a grandiose kitsch spectacle. Marlene cherishes men, women, her husband and her child, and Berlin and Germany. Above all, she adores Prussian officer Carl Seydlitz, who becomes a magnificent obsession. They meet cutely on the streets of Berlin, trade barbs in a bohemian night club, ride horses through the verdant Brandenburg countryside (with lyrical touches straight out of Veit Harlan), share romantic interludes (including a nude sex scene on an Austrian hillside) before a dramatic final wartime encounter behind the lines in the Ardennes where, in the meantime, Carl has joined the French Resistance.[15] (So that

there is no doubt about his change of allegiance, he is seen wearing a Basque beret.) Focusing their dismay particularly on this contrivance, German critics complained vehemently about the liberties that *Marlene* took with history.

III

The dream lover was, unlike the film's heroine, not a body too many, but rather a bold addition, a fictional figure without a historical referent. In some regards, Carl looks like a German stand-in for Jean Gabin, a romantic partner who participated in the French Resistance, the great romantic passion of Marlene's life whom she in the end could not have.[16] The figure likewise reflects the actress's high regard for soldiers (especially officers)[17] as well as her own anti-Nazi initiative. Despite her shift of citizenship and her commitment to the American war effort, it was well known that Dietrich remained at heart the product of a rigorous Prussian upbringing, a controlled person whose foremost virtues were loyalty, work, duty, and discipline. "Changing your nationality," she once said, "is not an easy step to take, even when you despise the beliefs and actions your country has taken. Whatever you tell yourself to the contrary, denying what you were brought up to cherish makes you feel disloyal. The love and respect for the country that is taking you in has nothing to do with it."[18] If Marlene embodies a better Germany, so too does Carl, who will die a hero. I am "no Nazi," he tells Marlene. "I am a German officer. And I was one long before Hitler became the Reich chancellor." He is a Prussian soldier and a man of cultivation. A veritable *Zitatenschatz,* he is conversant with the poetic canon from Hölderlin to Heine, and able to recite long passages at a moment's notice from authors as diverse as Erich Kästner and Ferdinand Freiligrath. The high-low merger between a *Bildungsbürger* and a movie star represents the screenplay's greatest indulgence; the anti-Nazi exile/activist and the anti-Hitler resistance fighter become a good German dream team, the revisionist's ultimate fantasy couple.

Particularly during her encounters with Carl, Marlene has strong and conflicted feelings. Were it not for him, suggests the scenario, she could easily pursue her career in Hollywood and not be so heavily burdened by her love for the fatherland, specifically the venerable Prussian heritage and the better Germany embodied by her soulmate. He alone, avers Marlene, allows her to escape a life of playacting and become authentic, to feel comfortable and safe, "accepted as the person she really is." "When you're with me," Carl assures her, "you don't need to

act. The actress Marlene Dietrich is of no interest to me." Von Stern-
berg, in contrast, unsettles her, so much so that she exclaims to the
director soon after meeting him, "I don't know anymore who I really
am." Flint portrays a more contained Marlene who has the opportu-
nity to become what the film would have us believe is her true self, a
person who is direct and loath to put on pretense. She becomes, in
effect, the opposite of Frank Wedekind's narcissistic Lulu and von
Sternberg's cold-blooded Lola Lola.[19]

The narrative distinguishes between Carl, who allows Marlene to be
true to herself, and von Sternberg, who spirits her away from her
homeland and fashions her into something larger than life. The direc-
tor introduces her to a world of luxury; he guides her through a lavishly
furnished Beverly Hills mansion, in which she finds the script to
Morocco. He tells her she is fat and that she needs to exercise. He works
over her eyelids and hair, applies just the right amount of makeup,
sculpts her figure with light, teaches her how to pose and how to speak.
The choice between von Sternberg and Carl involves an overdeter-
mined tension between artifice and authenticity, between Hollywood
illusionism and Prussian substance. This construction echoes the
rhetoric of Nazi pamphleteers who contrasted the calculated falsehood
of images made by Jews with the honest German respect for honest
and truthful representations.[20]

Clearly, Vilsmaier's construction of a Marlene who wishes to cease
acting and become authentic is at odds with the studied lack of fixity
and the highly self-conscious performativity that constituted the cen-
tral aspects of her persona. Here, as James Naremore observes, "visible
artifice becomes the sign of authenticity" for "a star who *acted* star-
dom."[21] Dietrich's image negotiated seemingly contrary properties:
cruel woman and devoted lover, sexual being and maternal presence,
Hollywood luminary and Prussian *Hausfrau,* exotic beauty and Amer-
ican patriot, object of a fetishistic gaze and yet an agent with an active
look. She was a cross-dresser, romantic partner of both men and
women, playful and inexorable, ironic and earnest, striking and yet
ever elusive. A resolutely liminal entity, Marlene crossed lines, tra-
versed borders, and stood between fronts, both on the screen and in
her life.

Long before Madonna, Dietrich strategically choreographed the
on- and offscreen dimensions of her public presence. In performing for
the USO, for instance, she nimbly mobilized "her association with
illicit sexuality, Germany, cross-dressing, and spectacle."[22] The image
of a nightclub singer who is also a Nazi is essential to her roles in *A*

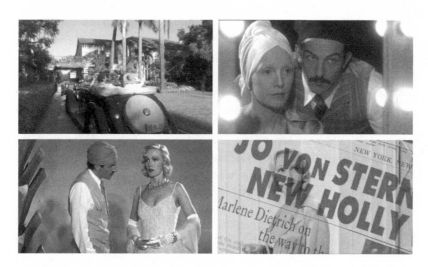

Marlene (2000, dir. Joseph Vilsmaier). (Video stills.)

Foreign Affair (1948, dir. Billy Wilder) and *Witness for the Prosecution* (1957, dir. Billy Wilder), where the exemplary "icon of seduction"[23] becomes associated with the seduction of the Nazis themselves. The Lola Lola of *Der blaue Engel* (The Blue Angel, 1930, dir. Joseph von Sternberg) would later become linked on the screen with Nazi perversion in Luchino Visconti's *The Damned* (1969) and Liliana Cavani's *The Night Porter* (1974). Reprising her German persona in American films, Dietrich simultaneously inflected it with the attributes of forces that she had despised and combated. In *Judgment at Nuremberg* (1961, dir. Stanley Kramer), she appears as a former collaborator who avers after the war that the Germans knew nothing of the Holocaust. In these roles Marlene functioned as a Hollywood double agent, at once "an icon of fascism *and* an antidote to it."[24]

Onstage before the troops, she stepped out in the garb of a U.S. Army officer's uniform before changing into elegant slippers and a sequined dress, thus deploying, as Andrea Slane describes, her two most famous styles, "her penchant for menswear and fabulous evening gowns and her history as a Weimar era German performer." It is, Slane notes, "the fabulous sequined gown that anchors her femininity, her obvious love for men that mitigates her occasional lesbian affairs, and her rousing American patriotism that dispels any negative aura around her German origins." Seen from this perspective, the mobilized Marlene served to make ambiguity safe for Allied democracy.[25] By intro-

ducing the dream lover and revealing a previously unseen Marlene, Vilsmaier sought to divest the Hollywood celebrity of both her illicit allure and her overwhelming indeterminacy, to make a woman widely perceived as a turncoat acceptable for German audiences, to transform a source of reproach and shame into a symbol of *Wiedergutmachung.*

IV

"I am not," proclaimed Josef von Sternberg, "an archeologist who finds some buried bones with a pelvis that indicates a female. I am a teacher who took a beautiful woman, instructed her, presented her carefully, edited her charms, disguised her imperfections and led her to crystallize a pictorial aphrodisiac. She was a perfect medium, who with intelligence absorbed my direction, and despite her own misgivings responded to my conception of a female archetype."[26] Vilsmaier, many decades later, likewise sought to shape Dietrich into his own medium. He took a star sign who had lent herself to many different meanings and appealed to a diversity of viewerships, and had been historically problematic for German audiences. Marlene, he believed, needed to appear less defiant and more reassuring if his film was to be commercially viable. How, though, was one to make over the transgressive international star into an affirmative national symbol of reconciliation that she had never been?

This dilemma was hardly novel. Managing the intractable performer had caused Joseph Goebbels and his minions great difficulties. After her move to Hollywood and well into the 1930s, Dietrich maintained a large and growing appeal at the German box office. *Scarlet Empress* (1934, dir. Josef von Sternberg), *The Devil Is a Woman* (1935, dir. Josef von Sternberg), and *Desire* (1936, dir. Frank Borzage) all ran for at least four weeks in the Reich's cinemas. Indeed, the world premiere of *Desire* took place in Berlin, even though it was no secret that its producer, Ernst Lubitsch, was Jewish.[27] Goebbels's representatives wooed her with great care, believing that she offered a unique and much desired blend of German distinctiveness and international flair. The minister of propaganda would order the press to desist from all negative comments about Dietrich; even as late as November 1937, Goebbels harbored the belief that she stood "steadfast with Germany" and would return within the near future.[28]

Managing Dietrich proved to be a serious problem for Nazi pundits. As Erica Carter argues, Marlene's penchant for artifice and masquerade posed a large challenge to the Reich's anti-individual and ensemble production aesthetic.[29] Commentators blamed Josef von Sternberg for

abducting the star and distorting her appearance. In doing so, they readily took recourse to anti-Semitic constructions of Jews as master manipulators of the image. Von Sternberg, claimed Ewald von Demandowsky, "has led Marlene Dietrich down the path that, in keeping with Hollywood notions, will create the world champion of seductive depravity."[30] German reviewers sought to neutralize her excessive performativity by stressing its larger aesthetic function within narrative economies. Likewise, they countered the international circulation of her image by cultivating the fantasy that she soon would be returning home.

Vilsmaier, likewise, worked over an unruly image. His *Marlene* shows us in great detail the construction of a face and the fabrication of a persona. We see Sternberg literally remake a woman so that she appears as a star before Hollywood cameras and American audiences. In contrast to the onscreen director, Vilsmaier aimed to go beyond surface values. He wanted to imbue the figure with depth and emotion, to present Marlene as a person dominated by her love for and obligation to others. The film acknowledges that she had many romantic partners, even that she was bisexual, but it tones down the rampant promiscuity and emphasizes her maternal instincts and domestic aptitudes. Vilsmaier's Marlene is not so much vampish as what critics deemed trustworthy and well behaved ("brav und bieder"). Even the actress Katja Flint expressed her surprise at how resolutely Vilsmaier had underemphasized Marlene's erotic dimension.[31] The director, for instance, cut out shots in which the diva takes off her clothes and joins GIs in the shower. He also deleted a protracted and explicit bedroom scene with Marlene and Mercedes de Acosta.[32]

The film all but disregards Dietrich's postwar status in West Germany as a persona non grata. We only get a brief written reference in the closing credits, but no visual evidence, no glimpses of her return to Berlin in 1960 with the bomb scares, smear campaigns, and angry protesters. Goebbels, eager to lure German stars back to the Reich, had issued directives prohibiting negative words about Dietrich. Vilsmaier, in his own way eager to bring Marlene home, sought to replace signs of discord with prospects of a more harmonious relationship. We hear few overt expressions of her well-known enmity toward fascist Germany; in truth, none of the anti-Nazi comments she utters are political. What she dislikes most about Hitler's Reich, the narrative stresses, is the fact that its critics badmouth her films (which, as we know, is at best a partial truth). The historical Dietrich rejected the Nazis' offer to become the "queen of UFA" and instead greeted German Jewish emi-

grants in Hollywood. The vituperative welcome that she received upon her return to Berlin took place because people believed that she had abandoned them and become a traitor, "a star who had pledged allegiance to the Stars and Stripes and come back to Germany in an American uniform."[33]

A recent German documentary produced by Guido Knopp[34] (and screened in the United States on the History Channel) at one point shows Marlene, the sole female in the image, literally bathing in a wave of American soldiers, a tableau that recalls the evil Maria of *Metropolis* (1927, dir. Fritz Lang) and her lascivious overtures to male masses. The voice-over narrator suggests, in a rhetorical question, that Marlene not only enjoyed, but also enthusiastically returned, the amorous attention of many GIs—thus confirming (both visually and by innuendo) the popular notion of a failed love affair between a performer and a national audience. Having been betrayed, Marlene's German public would, to quote Hellmuth Karasek's confirming phrase, remain forever unreconciled. And it is precisely these harsh feelings that Vilsmaier's *Marlene* works so hard to dispel. In the compensatory fiction of a great love, the Prussian soul mate militates against disturbing memories of Marlene's foreign affair with Hollywood, America, and its GIs. Vilsmaier revives the star's myth and infuses it with new meanings, prosthetically enhancing the image of the icon by airbrushing the troubled memories that attend it.

V

In Schell's *Marlene,* we recall, the actress described how an old *Berlinerin* came up to her during the postwar German tour and asked, "Na, wollen wir uns jetzt wieder vertragen?" Let us look at Vilsmaier's scenario and the manner in which it restates that question.

It is October 1944 and Marlene is performing for American troops in the Ardennes. She jokes around with some GIs and then requests to see the wounded German prisoners.[35] A pan reflects her point of view as she beholds signs of pain and suffering; her gaze indicates both distress and sorrow. Walking forward, she is surprised when one of the invalids calls out her name. "You recognize me." "*Blue Angel,*" responds the perhaps twenty-year-old.[36] She strolls over to him, kneels, and takes his hand. "Na, dann wollen wir uns wieder vertragen, was?" she asks, "Well, now let's be friends again, okay?" Hans, she learns, is from Berlin, "just like me" (which she says in the local dialect). The war is coming to an end, she assures him, and, anyway, he's much too young for this nonsense. "No one asked me," he replies. She strokes his fore-

head tenderly; countershots alternate between increasingly close-up views of the dying soldier and the angel-nurse-mother Marlene. After he expires, her hands close his eyes and another sustained close-up registers her anguish.

With its solemn and saccharine background music, this tableau recalls the "kitsch of death" privileged by Nazi aesthetics. It also provides a striking, indeed stunning role reversal. Marlene is now the one who takes the initiative and proposes that she and the bleeding German youth get along again. She makes the conciliatory gesture, as if she, the conqueror and the survivor, had wronged the wounded party. The reiteration of the well-known turn of phrase fosters a tableau of reconciliation between warring partners, both of whom come from Berlin. In its fantasy restatement, Marlene is recast in a pietà that provides a family portrait and a national allegory. The prodigal daughter becomes the nurturing mother who offers the wounded son of Germany solace in his moment of need. She asks Hans where he comes from ("Wo kommst du her?"), a commonplace, no doubt, but also a phrase that recalls a well-known moment in *Triumph des Willens* (Triumph of the Will, 1935, dir. Leni Riefenstahl). As in Riefenstahl's Labor Service Rally, a commanding figure musters the troops in order to heal a wounded Germany, just as we see Hitler's redemptive gaze put together the separate pieces of a fragmented nation.

In Vilsmaier's metamorphosis, the outspoken enemy of Hitler and champion of the Allies transmutes into, when all is said and done, a German patriot. The narrative seeks to neutralize more disturbing images of the Dietrich who insisted all Germans were guilty for the war, the Dietrich who returned to Berlin in the uniform of an American officer, much less the Dietrich who visited Bergen-Belsen with Allied troops and felt intense horror and chagrin at the cruelty and crimes of a nation. Marlene appears in this revisionist scenario as the contrite party, as if she, having turned her back on her homeland, were somehow guilty for innocent ("No one asked me") German suffering. The offer of reconciliation is made to what appears to be a randomly chosen soldier, who just happens to come from Berlin, who (implausibly, given his age and Nazi censorship) recalls having seen *Der blaue Engel.* In asking for normalized relations, Marlene in effect asks to be forgiven. She at once assumes the role of the conqueror and yet renounces the claims of the victor, sympathizing with and taking responsibility for the other party, indeed becoming once again a part of that party.

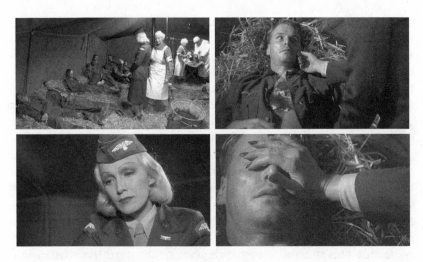

Marlene (2000, dir. Joseph Vilsmaier). (Video stills.)

VI

Upon its release, *Marlene* realized its protagonist's worst nightmare: box office poison (*Kassengift*). That the film failed is a matter of fact; why it failed warrants some final reflections.

The Marlene fashioned by Vilsmaier was an overly literal and, precisely for that reason, an utterly unconvincing simulation. To see Dietrich's unique and legendary pictorial beauty imitated by a relatively unknown actress and shackled in a contrived narrative of a tragic love affair gave rise to a sense of "one body too many." This tamed corpus was a stillborn entity, defetishized and domesticated, divested of vibrancy and robbed of Marlene's very essence, namely, her powers of mystery, ambiguity, and contradiction. In various regards Vilsmaier's film is a formal antipode to Maximilian Schell's portrait, *Marlene,* in which we partake of a voice without a body.[37] Schell signed a contract to make a film with an unruly actress who refused to stand before his camera. Insisting that she had been photographed to death, she would only agree to speak offscreen. In sum, the problem for Schell was less that of a body too many than one of a body too few. The filmmaker rose to the challenge and transformed this serious constraint into an aesthetic advantage. Faced with Marlene's visual proscription, he decided to scrutinize and study a body of recollections, images, and perfor-

mances, including the presence of an aged voice that speaks "in a baritone that itself seems to scoff at her mezzo-soprano days"[38] and provides a retrospective view of her experiences that is alternately obstinate, humorous, warm, and willful. The ultimate body in question, the film leads us to conclude, remains out of reach, auratic and enigmatic, far away no matter how close it seemed to be, an imaginary signifier that possessed a magic presence and yet never really was all there, an invention of mass culture and the cinema—"und sonst gar nichts."[39]

In its endeavor to repatriate Marlene, Vilsmaier's film focused on the actress's self-imposed exile from Hitler's Germany and, in so doing, replicated parameters of Nazi attempts to domesticate the wayward star. Indeed, the mission of luminaries from the Ministry of Propaganda depicted by Vilsmaier offers an unwitting mirror image of his own project. It is not just a body too many that is the problem, but rather the film's recourse to the rhetoric of the narrative's ostensible historical adversary. The presentation of von Sternberg at times recalls anti-Semitic stereotypes in which the Jew is the master manipulator of the image, the highwayman who abducts a healthy German woman, leads her astray, and renders her homeless. Carl, the educated Prussian officer, is portrayed unquestionably as the more appropriate object choice. The ultimate tragedy that the narrative presents and resolves is that of an interrupted great love between Marlene and a better Germany.

The closing sequence spirits us back to Carnegie Hall, where we see the aging diva begin to sing "Ich bin vom Kopf bis Fuß auf Liebe eingestellt," which, as we recall, was the song that made her famous as well as the film's point of departure. She stops abruptly, protesting that this is utter nonsense, in effect repudiating this role and the memories of Weimar decadence and erotic appetite that attend it. (One might also note that the song she now mocks as "Quatsch" was written by the German Jew and fellow exile in Hollywood, Friedrich Holländer.) As a replacement, she decides to sing something for a fallen soldier (thirty years later, Carl is still on her mind) and proceeds to do a German rendering of "Where Have All the Flowers Gone?" This flamboyant gesture both negates and mutates crucial aspects of the star sign. It provides the parting shot in a film that desexualizes the transgressive icon, transforming her into the grieving lover of a soldier and his nation, and, in the process, translating Pete Seeger's pacifist folk tune into a German work of mourning.[40]

Vilsmaier wanted to reclaim Dietrich, to refurbish her myth in the form of a conciliatory popular feature. Like the German emissaries in

his film who visit Marlene in Salzburg, the director sought to bring the errant star, if not *Heim ins Reich,* then back to Germany, to recast her as the centerpiece in a fantasy of conciliation with the appeal of a Hollywood blockbuster. Alas, it proved far less difficult for a unified Germany to rehabilitate UFA and even to honor Leni Riefenstahl. When Dietrich died in 1992, the prospect of a final resting place in the city of her birth prompted renewed controversy. For many she abided as a symbol of German self-hatred and, for that reason, remained a source of bitter feelings, for her life offered incontrovertible proof "that there were indeed Germans capable of mustering the courage to object to Hitler's totalitarian regime."[41]

After a decade of further debate, the éclat subsided and postwall Germany finally came to terms with Marlene. The star's vast estate of photographs, letters, press clippings, documents, costumes, and props was brought back to Germany and is now on display in the Film Museum Berlin. There is a Marlene-Dietrich-Square near Potsdamer Platz as well as a bistro called "Dietrich's" and a bar named "Marlene."[42] The figure that the New Berlin embraced was an international star, not just a prodigal German daughter, in keeping with the unified nation's simultaneous desire to think globally and to be mindful of a better German past.[43] Perhaps we might view this development positively, not as a cynical and belated gesture of reconciliation, but rather as an act of what Andreas Huyssen terms "productive remembering." If contemporary German (but not only German) commemoration culture produces and confronts a surfeit of memory, he submits, it is crucial that people "make the effort to distinguish usable pasts from disposable pasts. Discrimination and productive remembering are called for, and mass culture and the virtual media are not inherently irreconcilable with that purpose."[44] By the year 2000 Marlene had already been brought home and accepted by the Berlin Republic, by and large on her own terms. Fashioned by the director to be a triumph of good will, Vilsmaier's *Marlene* constituted a serious miscalculation, a redemptive reclamation that was both belated and misguided, a history lesson out of the past and off the mark.

Notes

1. Jean-Luc Comolli, "Historical Fiction: A Body Too Much," *Screen* 19.2 (Spring 1978): 43.

2. See Heiko R. Blum and Katharina Blum, *Gesichter des neuen deutschen Films* (Berlin: Parthas, 1997), 128: "At the latest since Dominik Graf's *Die Sieger*

(*The Invincibles*), Katja Flint has become an important presence in the German film landscape."

3. George F. Custen, *Bio/Pics: How Hollywood Constructed Public History* (New Brunswick, NJ: Rutgers University Press, 1992), 179.

4. Comolli, "Historical Fiction," 49.

5. Philip Rosen, *Change Mummified: Cinema, Historicity, Theory* (Minneapolis: University of Minnesota Press, 2001), 180.

6. Maria Riva, *Marlene Dietrich by Her Daughter* (New York: Knopf, 1992).

7. Alfred Holighaus, "Normal ist, wenn es verrückt ist," *Marlene. Der Film,* by Christian Pfannenschmidt and Joseph Vilsmaier (Hamburg: Europa, 2000), 158.

8. Simon Frith, "Towards an Aesthetics of Popular Music," *Music and Society: The Politics of Composition, Performance, and Reception,* ed. Richard Leppert and Susan McClary (New York: Cambridge University Press, 1987), 137.

9. Vilsmaier had also planned to release a director's cut of 160 minutes for Dietrich's one hundredth birthday, but this did not come to pass (*Filmboard News* 4 [2000]).

10. Commentators described the film as the worst blunder in recent memory by the German film subsidy system. At a panel discussion in the Filmmuseum Potsdam on 9 September 2000, Vilsmaier complained vehemently about the mistreatment of *Marlene* by the German press. "I have memorized the names of the film's five harshest critics and as long as I'm around, I'll do everything within my powers to make their lives hell."

11. Alfred Holighaus, "Die Kritiker jammern meckern höhnen," *Tip,* 21 June 2001.

12. Rainer Fellmann, "*Marlene:* Der laue Engel," *Spiegel,* 7 March 2000.

13. "Melodrama dama," *Süddeutsche Zeitung,* 8 March 2000.

14. "Fernsehens Schwester," *Frankfurter Rundschau,* 8 March 2000.

15. Cf. the entry "Ardennes," in *Marlene Dietrich's ABC* (Garden City, NY: Doubleday, 1961), 18. Among her memories, it is not a fond one. "I acquired my worst war wounds there. I froze my hands and feet during the winter of 1944."

16. Marlene's relationship with Gabin, claims biographer Steven Bach, was stormy and "unique. It combined an outlet for her mothering instincts with the high romantic excitement of a volatile sexy man . . . who would tell her what to do, whether she actually did it or not. No one doubted she was madly in love with him" (*Marlene Dietrich: Life and Legend* [New York: Da Capo, 1992], 317–18).

17. Cf. the entry "Army" in *Marlene Dietrich's ABC,* 19–20.

18. *Marlene Dietrich's ABC,* 120.

19. Cf. Andrea Slane, *A Not So Foreign Affair: Fascism, Sexuality, and the Cultural Rhetoric* (Durham: Duke University Press, 2001), 219–21.

20. See Carl Neumann, Curt Belling, and Hans-Walther Betz, *Film-"Kunst," Film-Kohn, Film-Korruption* (Berlin: Scherping, 1937).

21. James Naremore, *Acting in the Cinema* (Berkeley and Los Angeles: University of California Press, 1988), 131, 132.

22. Slane, *Not So Foreign Affair,* 231.

23. The phrase is taken from Elisabeth Bronfen, "Zwei deutsche Stars," *Filmmuseum Berlin,* ed. Wolfgang Jacobsen et al. (Berlin: Nicolai, 2000), 170.

24. Slane, *Not So Foreign Affair*, 218.

25. Slane, *Not So Foreign Affair*, 231–32.

26. *The Blue Angel: The Novel by Heinrich Mann. The Film by Josef von Sternberg* (New York: Ungar, 1979), 260.

27. "Dietrich Pictures Bows Ahead of New York," *Variety*, 13 March 1936.

28. See Markus Spieker, *Hollywood unterm Hakenkreuz. Der amerikanische Spielfilm im Dritten Reich* (Trier: Wissenschaftlicher Verlag, 1999), 233–35.

29. Erica Carter, "Marlene Dietrich—The Prodigal Daughter," *The German Cinema Book*, ed. Tim Bergfelder, Erica Carter, and Deniz Göktürk (London: British Film Institute, 2002), 73.

30. See von Demandowsky's review of *The Devil Is a Woman*, "Die spanische Tänzerin," *Völkischer Beobachter*, 30 June 1935 (quoted in Spieker, *Hollywood unterm Hakenkreuz*, 138). He notes: "A person of healthy sensibilities would be tempted to make certain that such a woman receive a thorough dunking in the River Spree."

31. Ulrich Lössl, "Katja Flint: Vom Kopf bis Fuß auf Marlene eingestellt," *Der Spiegel*, 6 March 2000.

32. In various interviews and discussions after the film's disastrous reception, Vilsmaier maintained that he had been put under legal pressure by Maria Riva to delete any scenes that suggested sexual license or excess on the part of Marlene.

33. Gertrud Koch, "Exorcised: Marlene Dietrich and German Nationalism," *Women and Film: A Sight and Sound Reader*, ed. Pam Cooke and Philip Dodd (Philadelphia: Temple University Press, 1993), 11.

34. *Marlene Dietrich: Die Gegnerin*, a forty-five-minute portrait, appeared in the series *Hitlers Frauen* (2001). See also the accompanying book, Guido Knopp, *Hitlers Frauen und Marlene* (Munich: Bertelsmann, 2001).

35. Frank Noack points out that Marlene had spoken to Leo Lerman, a journalist for *Vogue*, about an encounter in 1944 with wounded members of the Wehrmacht ("Rückkehr der Zeitzeugen," *Filmforum* 30 [2001]: 34). Whether this meeting actually transpired remains, however, uncertain.

36. That the soldier appears to know Marlene from *Der blaue Engel* is highly implausible, given that the film had not been screened in Germany since 1933.

37. The opening sequence in fact foregrounds this aesthetics of reduction by showing a close-up of a reel of tape unwinding on a recording machine from which Marlene's reproduced voice emanates.

38. Stanley Kauffmann, "Long Twilights," *New Republic*, 8 December 1986, 29.

39. In David Thomson's assessment, Schell's documentary "is a magisterial maintaining of the legend, to such an extent that she managed not to appear. She was radio, and in charge" (*The New Biographical Dictionary of Film* [New York: Morrow, 2002], 238).

40. Dietrich's initial performances of the song were in French ("Qui peut dire vont les fleurs?"), first at a UNICEF concert in Paris held in 1962 and then on a Pathé record issued in May of that year. In September 1963, she sang the tune in English before an enthusiastic Washington, DC audience.

41. Bronfen, "Zwei deutsche Stars," 172.

42. See Ulrike Wiebrecht, *Blauer Engel aus Berlin: Marlene Dietrich* (Berlin:

be.bra, 2001), 146. A restaurant in the Gotenstrasse near her Schöneberg birthplace is called "Der blaue Engel." It displays pictures of the star and serves dishes prepared according to Marlene's original recipes.

43. David Riva's documentary portrait, *Marlene Dietrich—Her Own Song,* might be best understood as a response to and a refutation of Vilsmaier's problematic initiative. The production of 2001 documents the biography of his grandmother and in the process discloses the irresolvable tension between the star's German past and her international career. The portrait is, no doubt, in crucial regards touched up. Dietrich's family members, the moving forces behind the production, studiously stifle the more transgressive aspects of Marlene's star sign.

44. Andreas Huyssen, *Present Pasts: Urban Palimpsests and the Politics of Memory* (Stanford: Stanford University Press, 2003), 28.

German Cinema and the
Global Imaginary Today

Catholic Pictorialism

Religion as Style in the Films of
Lars von Trier and Tom Tykwer

Gertrud Koch

I

It is no secret that postwar German film history generated neither a noteworthy popular film industry nor a widely noticed independent film movement. The most successful oppositional strategy came in the form of the so-called New German Cinema, which began to boom in the ghost towns of the old studios. It strongly emphasized the principle of the film auteur and was committed to the values of individual responsibility on all levels of film production and circulation—political, aesthetic, and economic. New German Cinema situated the author as producer, as Bertolt Brecht's magic formula once read. Accordingly, the new filmmakers wanted to do everything themselves: they oversaw a film's script development, its directing, and its production; some of them even appeared as actors and sought to do the camera work themselves.

Furthermore, it is also no secret that New German Cinema's stress on radical auteurism skidded with full force into a crisis caused by the rise of postmodernism. On the one hand, auteurism found itself confronted with the proclamation of the death of the author, while on the other it faced the effects of a neoanarchistic economy of success. The diverse challenges that consequently ensued from this situation led a younger generation of filmmakers to seek success on the popular market and become involved with questions of genre and audience rather than with discourses about images and narrative fragmentation.

If crises call for simple solutions, simple solutions often produce additional crises. This statement applies not only to cinema culture in unified Germany, it also describes larger global patterns. Film directors today, similar to the role of new multimedia companies, increas-

ingly move on global terrain rather than work locally or nationally. It is interesting to observe how more and more directors, in the wake of the globalization of film production, are in fact becoming global stars, global players. The thesis of this essay is that the deceased author is being resurrected in the wake of global developments—as the creator of a style bearing his or her name, like a fashion designer.

In the following I discuss a number of cinematic motifs central to the work of both Lars von Trier and Tom Tykwer. What particularly interests me about their work is how it engages religious imagery concerned with issues such as miracles, victims, and fate. However, I am not referring to these motifs as manifestations of a new kind of religiosity or devoutness. Rather, I understand them as part of a response to the aesthetic crisis in European cinema around 2000, a crisis that marks not only the films of Polish directors such as Krzysztof Kieslowski, but also more recent French films such as *Amélie* (Jean-Pierre Jeunet, 2001) and the Swedish-French co-production *Chocolat* (Lasse Hallström, 2000)—films that have gained enormous popularity across Europe and elsewhere. What I would like to ask is whether the stories Tykwer and von Trier tell are simply stories about people whose strong mystical convictions somehow come true. Or whether these stories, in all their novel strangeness, are designed to strengthen our belief in cinema itself, our belief in this magical, wonderful machine and its ability to recharge our belief in the world.

Following the lead of André Bazin, French philosopher Gilles Deleuze has not been the first to make a connection between cinema and Catholicism and identify both of them as special ways of believing in the world, of seeing the world as a creation of which we are a part. In the second volume of his book on cinema, Gilles Deleuze writes: "It is clear from the outset that cinema had a special relationship with belief," and that "there is a Catholic quality to cinema." Though good directors do not need to be good Catholics, cinema's Catholicism has posed and continues to pose specific challenge to non-Catholics as it situates the viewer "wholly within Nietzsche's formula: 'How we are still pious.'"[1]

Deleuze argues that cinema, in contrast to theater, reveals the link between humanity and the world as one founded in bodily presence. Transforming Sigmund Freud's argument about religion as an "illusion" void of any future, Deleuze not only suggests that cinematic illusion restores our belief in the world, but it does so precisely at the moment when the system of knowledge that once replaced religion is about to collapse into radical skepticism. The slope that leads from

religious faith to pragmatic beliefs is a slippery one given the fact that secure metaphysical truth today no longer seems available. It causes Deleuze to emphasize the role of the body as a last resort of meaning and identity: "What is certain is that believing is no longer believing in another world, or in a transformed world. It is only, it is simply believing in the body. . . . We must believe in the body, but as in the germ of life."[2]

Deleuze focuses his argument on the cinema of Roberto Rossellini and Robert Bresson, of Carl Dreyer and Jean-Luc Godard. But it might also be interesting to have a closer look at films made by younger postwar directors, directors whose cradle stood in the hall of European art movies and whose Sunday school convened in Hollywood. In contrast to the grand auteurs of twentieth-century European art cinema, the work of von Trier and Tykwer engages quite different issues and sources. Rather than addressing the former question, whether our desire for illusion expresses a strong belief in the world, they start with the postmodern problem of metaskepticism. What their work reckons with is the assumption that any strong belief seems impossible in a world in which everything is just another illusion. What their films work through is, in Deleuze's word, the fact "that we no longer believe in this world. We do not even believe in the events which happen to us, love, death, as if they only half concerned us. It is not we who make cinema; it is the world who looks at us like a bad film."[3]

The following pages argue that the films of both von Trier and Tykwer address this conversion of the world into a film in an exemplary fashion. One of the shared signs of their longing for this kind of conversion is, for example, the way in which their films switch from video to film material, a switch we find in von Trier's *Dancer in the Dark* (2000) as much as in Tykwer's *Lola rennt* (Run Lola Run, 1998), and whose use was expounded by Tykwer as follows: "I'm not using video because it looks good now, but I'm using video for example for a certain level of the film, which means the whole world around Lola and Manni is always shot in 35 millimeters, because for me, that's the only real world in this film. Their love makes it become true. Anything else which is parallel, like the father with his girlfriend and all the elements that are happening while Manni and Lola are not present, they are all shot in video because that's a kind of synthetic reality, a parallel reality to theirs."[4]

Love creates the world, a world which is cinematic and in which objects of lesser concern are shot in video so as to mark hierarchies of significance and define areas of indifference. Lars von Trier pursues

Dancer in the Dark (2000, dir. Lars von Trier). (Courtesy Filmmuseum Berlin—Deutsche Kinemathek.)

similar strategies of conversion. Considerable segments of *Dancer in the Dark* were initially shot on video in order to evoke a cinema verité style, one in which fading colors and blurred brilliance evade the pictorial transparency of classical cinema. This video material, as much as the film's overall montage style, was then juxtaposed with conventionally filmed material with the aim to provide, during the dance and song interludes, clearer colors and more distinct framing and lighting possibilities. In the final product, the lucidity and transparency of filmic images thus evoke the mental imagery of a nearly blind woman, the imaginary world picture of someone increasingly bereaved of sight. Werner Herzog has engaged a similar, albeit reverse, practice in his 1971 documentary *Land des Schweigens und der Dunkelheit* (Land of Silence and Darkness). In Herzog's film, visionary images and mental processes of deaf and blind people are captured in experimental style, while the observational camera on the deaf blind uses sharp focus and real-time recording. In von Trier's musical, by contrast, inner-diegetic video sequences encode the shabbiness of a malfunctioning industrial world, whereas the clarity of celluloid images picture the transcending power of inner vision.

Tykwer and von Trier's aesthetic conversion of transcendence into fiction and fantasy, as well as their de-aestheticization of the diegetic world into a worn-out document, signals what I called earlier a response to the postmodern crisis of narrative. It is also a crisis of the

narrativity of the world itself, one in whose context—to paraphrase Deleuze—the world looks at us as a bad TV report and film alone provides clear visions of a world tainted in passion and love, a world we can really see in front of our eyes.

II

As mentioned earlier, the underlying assumption of this essay is that Tykwer and von Trier respond to a crisis in narration and storytelling that has emerged in the wake of postmodern ironization. Let me start my discussion with an early film by Lars von Trier, the title of which caused some confusion: the multi-European co-production *Europa* (1991). The international distributor gave the film the title *Zentropa*. While "Europe" is an extradiegetic object and the historic location of the film, "Zentropa" is the inner-diegetic name for a railway company whose owners are central characters in the film. The blurring of external and internal diegetic references is by no means something that has been forced onto the film from outside. It is part of the film itself and, as such, a symptom of the gulf between the two levels of the story.

The film opens with a nighttime shot of pure movement that appears to lead into the center of the frame, quite similar to the opening shot of David Lynch's *Lost Highway* (1997).[5] We hear a mesmerizing voice from off-screen, expressing a kind of threat, promise, or curse—exactly what is not clear—aimed at someone who is being told that he will be in Europe when the count has reached the number ten. And then the voice starts counting. On the count of ten, the image of the dark tunnel is succeeded by a shot of steel skeletons and rubble in which we can see the person who is being talked to for the first time, albeit from behind. At the end of the film we will return to this initial scene of counting. By the count of ten, however, the protagonist will now be told that he will drown, and in the last scene we will see his corpse float in the sea leaving the shores of Europe, the unforgettable dark continent of fatal history.

It doesn't take much to draw connections between the mesmerizing voice and its counting to the principle of hidden storytellers in narrative texts. In taking on the role of the hidden storyteller who counts out life and death, thus setting in motion the whole machinery of narrative illusion, the film director proposes an equally old and strong answer to the crisis of narrativity in question here. Endowing his own fiction with the spell of a superhuman creator, he tells us that telling is counting, that he wants to tell what counts.

In an essay entitled "Recounting Gains, Showing Losses," Stanley Cavell argues that counting already figured as principle of storytelling

in Shakespeare's *The Winter's Tale:* "Consider that counting by numbers contains within itself the difference between fiction and fact, since one learns both to count the numbers, that is to recite them, intransitively, and to count things, that is to relate, or to co-ordinate numerals and items, transitively."[6] Chronological counting can mean different things: it mimics the gruesome practices of exclusion in children's counting rhymes, but it can also reestablish the magic of the biblical tale of creation that combines God's speech act with the counting of days. In situating the hidden storyteller as an almost godlike character, Lars von Trier simultaneously evokes the symptom of the crisis according to which the author/God is dead, and has the figure of the author return triumphantly in order to talk about his very death. The telling of a story as a symbolic unity of events adds up to a deadly curse: even in the short course of European history, we are all dead.

III

Many admirers of Lars von Trier's films were perplexed when he presented the viewer with religious imagery in *Breaking the Waves* (1996). The film culminates in a final apotheosis in which the skies break open and two gigantic church bells start to toll: a sign from heaven indicating that poor Bess (Emily Watson), who had been doomed to Hell by local church officials, has found mercy and redemption. Von Trier's bells lead us to believe that Bess's sacrifice for her sick and dying husband Jan (Stellan Skarsgård) has been accepted, and that her suffering of a sadistic orgy on a ship full of gruesome seamen was not in vain. The final scene of the film initially shows Jan inside the ship, stretched out on his bunk and utterly despairing about the death of his wife. Recorded with the help of a handheld camera, this shot of Jan's pain denies any sense of composure or conclusion. It makes the contrast to the closing vision even more triumphant, in particular when his colleagues pull him out of the cabin in order to show him the heavenly signs of miracle and redemption.

In Tom Tykwer's *Der Krieger und die Kaiserin* (The Princess and the Warrior, 2000), a man (Benno Fürmann) unwillingly causes a serious accident: a truck runs over a young woman (Franka Potente) who was just about to cross the road. Trapped under the truck, the girl fights for her life, gasping for air to stay alive, and it is the man who has caused the accident who crawls under the truck and slits her windpipe to give her the air to breathe. This overwhelmingly dramatic and touching moment of intimacy at the edge of death is the start of the story. The young woman says: "I want to know if it means anything that you were

under the truck that day, or if it was just a coincidence. I want to know if my life has to change and if you are the reason for it." She asks for reasons and causes, she tries to make sense out of the accident, turn it into something that is no longer a mere coincidence, the accident in the end becoming a lucky chance to change her life.

The narrative of *Der Krieger und die Kaiserin* offers a narrative of conversion whose climax is located at the end when the converted protagonist bids farewell to his own former sad and melancholic self and embraces a world of love. To show a conversion from a state of denial to one of accepting the world is the ultimate aim of this love story. And Tykwer's great cinematographic talent here manifests itself not simply in the narrative construction of this conversion plot, but in his ability to grasp conversion as a filmic style.

Let me illustrate this thesis with a few examples. In both the earlier film *Winterschläfer* (Winter Sleepers, 1997) and in *Der Krieger und die Kaiserin,* Tykwer repeatedly uses various dissolve techniques in a conspicuous and significant way. In *Winterschläfer* this formal element culminates in the conclusion, the young ski teacher's endless surreal spiral as he jumps over the edge of a cliff and falls, twirls, sails, and turns slowly into the valley below. The camera follows him from above only to then disappear in a black hole in the snow that both evokes the moment of final impact and sets the stage for the next shot. In this next shot, the black screen transforms into a rotating black tunnel. When the movement stops, the black screen resembles the blackness of a dark room while we suddenly hear the sound of a light switch fading in. Then, the room lights up and the camera presents a close-up shot of a baby. Light, the "art of light," gives birth and energizes a conversion from death to life.

Within the film's diegesis itself, Tykwer's long dissolves from one black hole to another convert the death of a man into the birth of a child, and in this way they transform the guilt of the child's father into a sacrifice of a man who mistakenly believes he is responsible for the death of a young woman he once seduced. It could be said that he takes the guilt of another man onto his own shoulders and as a result allows the sinners to convert into members of a holy family. This basic Christian tale, taking place between Christmas Day and New Year's Day, as it were, entails the motifs of sacrifice and redemption, even though it is far from being a merely religious tale, a remake of the Bible. My suggestion instead is to read the film as a formal conversion from one image to another, and as such as a tale about cinema itself. Here, conversion means style—a style of cinema or cinema as style.

This becomes even more apparent in the *Der Krieger und die Kaiserin,* in which the technique of the dissolve plays an essential role throughout. Movements of jumping, falling, and merging are already present in the film's first shot. In this shot, a letter falls through the slit of a mail box into a tunnel whose sight first resembles the look of the interior of a shell and then turns into the image of a woman's hearing canal, her voice about to start the narration. At the end of the vertiginous spiral, the film's male hero turns up, running at full speed. Once again, it is the voice that starts the story, and the images represent this voice's materialization, its becoming light and flesh. Yet what opens up between the voice and the narration is an unbridgeable gap, and it is perhaps here that the author dies and the audience is born, or to put it cinematographically, it is here that the film starts and leaves its storyteller and producer behind.

The figure of conversion, which drives the aesthetic of so many of Tykwer's films, refers to a long tradition of religious conversions, understood not so much as the conversion from one religion to another, as from a state of sin to one of redemption. If the Christian meaning of conversion is the attainment of a better self, then this is exactly what one witnesses at the end of both Tykwer's and von Trier's films.

To speak of conversion as a style, on the other hand, is to remind us of another tradition that used religious vocabulary so as to celebrate certain stylistic breakthroughs. It is quite telling that the French words *fondre* and *convertir* can be used interchangeably. Both terms express what in English film vocabulary is commonly referred to as "fade in/out" and "convert." But aside from this amusing play on words, the congruence of both concepts in the vocabulary of aesthetic modernism indicates an author's will to fill the gap between himself and his use of style. In her book *The Orient of Style,* an analysis of Proust's comments about Flaubert, Beryl Schlossmann suggests: "The gap between the speaking subject and art is a mystery that poses the following question: How can the subject attain the sublime?"[7] Schlossmann detects a possible answer in the figure of a double conversion: *convertir* language into style, and the self-reflexive "conversion" of the author into a subject of writing. If applied to film, Schlossmann's insight would read as follows: "Filmmakers such as Tykwer and von Trier convert formal means such as the dissolve and the change between different materials such as video and film into a visual style and the self-reflexive conversion of the author into a subject of directing."

In conclusion I suggest that we understand the conspicuous pres-

Der Krieger und die Kaiserin (The Princess and the Warrior, 2000, dir. Tom Tyk-wer). (Courtesy Filmmuseum Berlin—Deutsche Kinemathek.)

ence of religious motifs in recent European filmmaking neither as a coincidence nor as something to be taken literally. Instead, we may consider them as a catalyst of a cinematic style whose primary function is to represent the power of making us believe in aesthetic illusions, a power that exceeds a merely ideological response to some kind of epistemological problem. At first this might sound like an act of regressive romanticism dressed up as postmodern irony, but at closer inspection we should realize that Tykwer's and von Trier's quest for style also responds to the challenge of presenting and closing the gap between telling and showing, voice and body, sound and image, most memorably expressed in *Dancer in the Dark* when the blind Selma (Björk) intones a song saying "seeing is believing" while the director shows us how she sees the world in which she believes.

My argument, then, is not that Lars von Trier, because of his conversion to Catholicism, came to make Catholic films about miracles and wonders. What I would like to suggest instead is that he may have converted to Catholicism because, for him, to be a Catholic means to believe in something that shows itself through images. Von Trier's and Tykwer's "Catholicism" is nothing other than the name for a pictorial

style, a style enabling us to live in images, a style whose universal func-
tion in our predominantly Protestant and ever more global culture is
similar to the role of Greek antiquity for the nineteenth century.

Notes

1. Gilles Deleuze, *Cinema 2: The Time-Image,* trans. Hugh Tomlinson and
Robert Galeta (Minneapolis: University of Minnesota Press, 1994), 171.

2. Deleuze, *Cinema 2,* 171–72.

3. Deleuze, *Cinema 2,* 171.

4. http://www.projecta.net/tykwer3.htm, accessed June 9, 2006.

5. The difference from Lynch is Lynch's refusal to go back to straight narration
and to replace the unknown and uncanny with wonder or faith.

6. Stanley Cavell, *Disowning Knowledge: In Six Plays of Shakespeare* (New
York: Cambridge University Press, 1987), 205.

7. Beryl Schlossmann, *The Orient of Style: Modernist Allegories of Conversion*
(Durham: Duke University Press, 1991), 36.

The Politics of Contempt
and the Ecology of Images
Michael Haneke's *Code inconnu*

Fatima Naqvi

I

> Thoroughly mediatized society vibrates in a state in which millions can no
> longer appear as a concurrently assembled totality, as a conspiratorial, collec-
> tive living creature, which streams together and breaks loose, black, dense,
> and boisterous. Rather, the mass today only experiences itself in its particles,
> as individuals, which—as elementary particles of an invisible meanness—dedi-
> cate themselves to those programs in which their massification and meanness
> are presupposed.
>
> —Peter Sloterdijk, *Die Verachtung der Massen*[1]

In his short and controversial treatise, *Die Verachtung der Massen:
Versuch über Kulturkämpfe in der modernen Gesellschaft* (The Con-
tempt of the Masses: On Culture Wars in Modern Society), the Ger-
man philosopher Peter Sloterdijk offers a pessimistic evaluation of
Western society.[2] His text, published in the year 2000, certainly
bespeaks a millennial malaise common to much contemporary art and
philosophy. In assessing this malaise, it is particularly fitting that Slo-
terdijk alludes to Michel Houellebecq's bleak best-seller, *Les particules
élémentaires* (Elementary Particles, 1998) in the above quotation.[3]
 Where does the problem with mass society lie in the late twentieth
and incipient twenty-first century? According to Sloterdijk, four cen-
turies of democratization and egalitarian efforts have resulted in a
mass society lacking all vertical differentiation: there are no longer
God-given prerogatives or natural, in-born privileges such as genius.
The mass, striving for full subjectivity, has now achieved its goal—only
horizontal, that is, constructed and revocable, differences between
people exist. In the German philosopher's estimation, the leveling of
difference leads to a permutation of contempt, or *Verachtung*, an emo-

tion linked to the mass from its inception. As a tremendously powerful affect influencing social behavior, contempt is directed at those in a superior position of power as well as at underlings deemed inferior; it is also leveled at all who are perceived as threats to one's own position. Respect, the reverence once reserved for those on a higher rung of the societal ladder, is now demanded by all and offered by none. Sloterdijk even implies that the *Gleichachtung,* literally the "equal attention" or mutual regard, of equivalence (a foundational tenet of mass democratic society) is illusory. Were it possible, it would nonetheless make esteem, or *Hochachtung,* impossible.

Sloterdijk relates the prevalence of contempt to the rapid rate of change in present society, which puts a premium on differentiation. Precisely because of the swift rate of change, difference becomes a matter of taste and subject to trends. Borrowing from Jean Baudrillard, Sloterdijk writes: "The cult of differentiation in contemporary society, as it spreads from fashion to philosophy, has its reason in the fact that all horizontal differences are seen, and rightly so, as weak, retractable, and constructed . . . difference, that makes no difference, is the logical title of the mass . . . differentiated indifference is the formal secret of the mass."[4]

"Differentiated indifference" could be inverted, and Sloterdijk's thoughts further developed, to become "indifferent differences." Contempt arises because horizontal differences do not guarantee that an individual who has striven to differentiate him- or herself will be viewed with anything other than indifference. This knowledge renders differences moot per se and difference, as a concept, contemptuous. The mutual imbrications of "differentiated indifference" and "indifferent differences" exacerbate the struggle for recognition in the public sphere, where the effort is made to garner or even coerce respect—even though it is only temporary and, in the end, for naught.

No doubt, Sloterdijk's reflections are of a conservative nature, but this conservativism seems to me a wider Continental trend, well illustrated by Michael Haneke's film *Code inconnu: Récit incomplet de divers voyages* (Code Unknown: Incomplete Tales of Several Journeys). *Code inconnu,* released in 2000, also evinces interest in the contemporary "mass" culture of western Europe and proffers an equally dismal appraisal.[5] The film's assessment of the frictions and competing demands for respect in a city of postcolonial hybrid identities and post-Communist immigration shares more commonalities with Sloterdijk's *Die Verachtung der Massen,* one could argue, than other Austrian films dealing with similar issues, such as Barbara Albert's *Nordrand* (North-

ern Skirts, 1999) or Goran Rebic's 1996 *Jugofilm.* Unlike Albert or Rebic, who focus on change in Vienna, Haneke removes his film from the Austrian capital. Situated principally in contemporary Paris, *Code inconnu* questions the cohesiveness and, ultimately, the viability of an emergent multiethnic and transnational society, in which human beings act like "elementary particles." A shared sense of purpose across ethnic- and class-based lines becomes nearly impossible when seen against such a backdrop. In *Code inconnu,* this lack of communality is in no small part due to the psychosocial dynamics of particularized mass society, dynamics determined by the explosive affect of contempt.[6] The media's predominance in Western society further complicates the relations between individuals, intensifying the struggle for recognition in the public sphere, thwarting cohesion, and engendering contempt.

Presenting western European life as an atomistic aggregation, Haneke continues the rigorous and sometimes forbidding aesthetic developed in his earlier "Trilogy of Glaciation," particularly in *71 Fragmente einer Chronologie des Zufalls* (Seventy-One Fragments of a Chronology of Chance, 1994). It is no coincidence that the director sometimes refers to the three films about the "glaciation of emotion" as a "civil war trilogy."[7] The war in the former Yugoslavia becomes a metaphor for the state of being in late capitalist Europe,[8] and the forced fragmentation of the narrative mimics the bellicose nature of contemporary existence.[9] *Code inconnu* expands the focus of the "Trilogy of Glaciation," concerned as it is with the conflict in the Balkans and with immigration from the formerly Communist Eastern bloc to a highly abstracted Austria, to include issues of decolonization and the African and Arabic communities in France. *Code inconnu* is comprised of forty-five incomplete scenes separated by two-second long black leaders and harshly cut—characters' speech is often clipped midsentence or even midword. As in *71 Fragmente,* the film follows diverse groups of people during an unspecified period of time along their trajectories, paths that briefly intersect.[10] There is something glibly multicultural about this French-German-Romanian co-production, as it presents us with representatives from "target" groups.[11] *Code inconnu* includes not only the French actress Anne, but also a Malian family, where the children belong to a second-generation born in France, and a Romanian immigrant, who attempts to work illegally in Paris. While the fragmentary nature of the film seems to preclude a chronological ordering, the meticulous editing, returning us at the end to the entrance door from which Anne emerges at the outset, suggests a sequential

arrangement. As in *71 Fragmente,* chance has a chronology,[12] with the end of *Code inconnu* occurring relatively shortly (weeks, a few months) after the beginning of the story (in 1998) and implying a progression.

Sloterdijk's assertions about the indifference engendered by horizontal difference resonate with Haneke's film. Where all life stories demand an equal right to be heard and told, no subplot takes—or can take—precedence. The actress Anne appears in approximately the same number of scenes as the Malian family, the eastern European immigrant and her kin, and the French farmers in the provinces.[13] We could say, in a more cynical vein, that, since all players are of equal importance, they are of equal unimportance. The equal attention (*Gleichachtung*) we as spectators pay to the assorted characters prevents identification with them. Haneke's pronounced use of long takes with little camera mobility and lack of close-ups emphasize the distance between the figures themselves and our distance as viewers from what occurs on screen.[14] The use of one-take horizontal tracking shots, which follow the miscellaneous characters back and forth along the street before and after their lives intersect in the embedded narrative, emphasizes the film's point about horizontal rather than vertical differentiation—and its consequences for psychosocial concord.

The indifferent differences and differentiated indifference the characters in the film manifest toward each other, as well as we as viewers toward them, is intimately related to a public sphere conceived as a site of fierce competition. Groups, as they vie for a fleeting place in the public spotlight, utilize threats of violence, claim victim positions, and manipulate the moral high ground. As Sloterdijk argues:

> Violence and idealism are the universal languages through which new groups generate interest for themselves; they are the special effects that infallibly arouse attention on the modern political stage. Each newly emerging political subject achieves importance and recognition by, on the one hand, behaving like the center of action that can threaten like a master and declare a state of emergency and, on the other, by recognizing in itself the acme of true humanity.[15]

The second of *Code inconnu*'s sequences epitomizes these pervasive politics of contempt and the violence that goes hand in hand with moral idealism. As part of the *plan-séquence,* an unbroken long take lasting nearly eight minutes, a young black man named Amadou confronts a white teenager, Jean, for throwing a crumpled paper bag in a beggar woman's lap. Amadou's claims center on respect for the beg-

Code inconnu (2000, dir. Michael Haneke). (Video still.)

gar, and he demands an apology. Amadou attempts to raise the beggar
from being viewed with contempt, *Verachtung,* to equal respect,
Gleichachtung. In doing so, he arrogates the moral high ground and
implicitly appeals to a universal humanitarian ethos. (His demand for
an apology, as compensation for the beggar's humiliation, even
demands an exaggerated respect, or *Hochachtung.*) Amadou resorts to
force to stake his claim, and fighting erupts between the two men. The
young men tussle, and the police arrive to hear a nearby shop owner
blame "the hooligans" and the homeless for harming his business, indi-
cating the black man and the beggar in particular. The police's rough
treatment—predictably enough—is directed at the Romanian beggar
and at the black, Parisian French-speaking Amadou, rather than at
Jean and the Frenchwoman Anne, who intercedes for Jean. The
alliance the young man of African descent forms with the eastern
European woman, an alliance presumably based on the identification
with another outsider to French society, is ultimately self-defeating.
Amadou is arrested and Maria, the beggar, is deported.

As this scene makes apparent with the camera's movements (right,
left, back, forward, etc.), the endogenous tensions in the social body,
which are influenced by exogenous forces, threaten to pull apart the
fragile social fabric. Violence subtends all human encounters in *Code*

inconnu.[16] It is present most explicitly when the competing and inter-
secting axes of class and culture are influenced by an ethnic elsewhere,
here Mali and Romania. Ethnic background and projected racism
become motivating factors in the effort to compel respect. In this
regard, Haneke's film goes beyond Sloterdijk's race-blind account.
Indeed, this scene gives the lie to the multicultural West's assertion that
ethnicity is an "indifferent difference." Ethnicity appears to reestablish
a vertical hierarchy despite the West's avowal of its unimportance.

The fortieth scene in *Code inconnu* refracts the politics of affect at
the outset of the film, complicating the second scene between Amadou,
Jean, and the white policemen, where tenuous social bonds are formed
in stressful situations. Now a young man of North African descent
confronts Anne on the subway, flirting with her. When she refuses his
attentions, he mocks the other passive passengers. He follows her as
she remains silent and finds another seat; eventually he spits in her face.
What begins as a belligerent demand for respect or, at least, for equiv-
alent status on the part of a young Arab man in the Métro ends as a
display of contempt. The recognition on which he insists, as the young
man's self-posturing reveals, plays self-consciously with his marginal-
ization in French society. He cynically presents himself as the ultimate
outsider, a victim of general prejudice and past wrongdoing. Provoca-
tively coming on to Anne, he projects onto her the simplified views he
believes the French hold of him as an Arabic-speaking youth from a
particular socioeconomic stratum and of a particular age group, who
wears a certain type of clothing.[17] He vocalizes these unspoken stereo-
types in a sarcastically inverted manner, gesturing mock-apologetically
toward his tracksuit. He taunts Anne with distorted sociological expla-
nations to account for his behavior—"What am I going to do alone in
this big, bad city . . . I'm just a little Arab looking for a little affection,"
he sarcastically pleads—and thereby unmasks these explanations as
inadequate.[18] His behavior shows that, in an age of global reflexivity,
common interpretative procedures and explanatory models are used to
give violence a reason *post facto.* These are secondary rationalizations,
which leave the motivations unexplained and the symptom
untouched.[19]

The young man's demand for *Gleichachtung* goes hand-in-hand
with a projected *Verachtung,* as he imagines Anne's contempt for him.
She remains silent and changes seats to avoid eye contact. Anne with-
holds, in his opinion, the minimum acknowledgment of his human
equality. Perhaps the film itself lends credence to his demand for
greater attention: *Code inconnu* generally avoids subjective point-of-

Code inconnu (2000, dir. Michael Haneke). (Video still.)

view shots, underlining the camera's lack of identification with any of the figures. It also remains at a distance from them in long shots, emphasizing on a metalevel what the young Arab perceives as a lack of human respect. He, too, is shown first at a great remove, in a long shot where he and Anne take up less than a quarter of the screen, both caught in the vanishing point of the subway car (the camera moves slightly, but, like the other passengers, refrains from involvement). In a reverse projection, the beautiful Anne becomes at once supermodel and arrogant high-society woman for him. He returns the contempt he assumes she has for him, following her down the aisle, sitting next to her in the foreground, then suddenly pivoting in his seat and spitting in her face. Anne's contempt, which was perhaps latent previously, will presumably be engendered or strengthened by the young man's actions. Only the intervention of a nonwhite stranger, who kicks the ruffian as he dashes out of the subway car and yells in Arabic, may modify her negative perceptions. As this scene renders explicit, affect in a mass society centered on mutual contempt is complexly related to racism and to its internalized and projected inversion, reverse racism.[20] In the end, the film suggests that race is on the order of horizontal difference after all, albeit with an explosive potential.[21] While race remains fundamentally more important than, say, differences in ideol-

ogy or fashion, ethnic difference does not guarantee immediate superiority to any one group, nor does it assure communality among members of one ethnicity.

II

> Such is Haneke's way, and very discomforting it is, too: those in official relationships—father and son, boyfriend and girlfriend—seem badly out of joint, whereas those who are tossed together by circumstances are likely, however fleetingly, to find common ground. Where, the movie asks, can you ever reach safe haven, or even drop anchor for a while?
> —Anthony Lane, "The Great Divide"[22]

As we have seen, mutual contempt is the main hindrance to both human solidarity and active intervention in *Code inconnu.* The middle-aged subway rider's gesture of support, kicking the young Arab as he exits the train, takes place only after a prolonged silence and after Anne has been severely humiliated. Moments of communality or solidarity, when a bond is formed across lines of gender and class, as well as of race and nation, are "fleeting," to use Lane's characterization. These moments entail the clear identification of a victim and the desire to intervene on her behalf, thereby raising the victim's status to parity, if not higher.[23] The subway rider may intervene because the lack of response by the other passengers finally overwhelms him or because he is acting the part of the chivalrous gentleman. However, the casting of Maurice Benichou as the commuter overdetermines his support for Anne, since he could be of North African extraction. He may intervene because he is embarrassed by the behavior of a fellow Arabic-speaker, or, alternatively, he has perhaps been the recipient of humiliating treatment as member of a minority in French society and now identifies with Anne, the victim of abuse. Indeed, *Code inconnu* at times suggests that bonds are formed only on the part of those who have been the objects of contempt in the past and for whom the experience of contempt has somehow been internalized.

In this sense, Haneke's Austrian nationality—mentioned by the director in interviews, and stressed by Austrian film publications as well as international reviewers[24]—seems to make him particularly suited for engaging the victim politics that are articulated in the film. In the international reception of Haneke's previous work, it is not uncommon to find reference to the director's excavation of Austria's repressed past.[25] Dominique Païni's appraisal in *Cahiers du cinema* of Haneke's *Funny Games* (1997)—a film about two polite young men who gain entry into an upper-class weekend home and proceed to kill

off the three family members to satisfy inexplicable ludic impulses—is representative of critical assessments of Haneke's oeuvre, particularly outside the German-speaking world:

> *Funny Games* is indissociable from the Austrian nationality of its director. It is impossible to forget this throughout a film where the "cleanliness" of the natural scenery and the comfort of bourgeois life coexist with the memory of Nazism, of Hitler, the country's son, of Chancellor [*sic*] Waldheim, former officer of the Wehrmacht, cleansed after the war by national and international parliamentarism.[26]

The director is implicitly deemed one of the nation's cultural avatars who attacks the "founding myth" that Austria was Hitler's first victim, a myth widely questioned after the election of the former Wehrmacht officer Kurt Waldheim as president in 1986. In Haneke's earlier films, in particular in *Benny's Video* (1992), the investigation of victim politics is present. *Benny's Video* is about a teenage boy who kills a girl "to see what it's like" (in the protagonist's own words) and whose parents then hope to cover up his crime by disposing of the body. *Benny's Video* suggests that the young killer attains a Christian-inflected salvation once he is capable of empathizing and fully identifying with his victim.[27]

We might expect the results of Haneke's investigation of the victim-and-perpetrator dynamic in a specifically Austrian situation to be brought to bear on larger, transnational concerns as articulated in *Code inconnu*. Yet *Code inconnu* makes possible no shift from the side of perpetrators to that of victims; the social and historical fluid in which these individuals move does not allow us to take sides. In this respect, the film most clearly marks Haneke's departure from the Austrian framework that has been used to describe, define, and delimit his concerns. While the director's professed reasons for leaving Austria to work in France are generally of a practical nature (including the possibility of working with renowned French actors and easier access to more abundant funding),[28] one cannot help but suspect that his shift in interests plays a role in this decision to relocate. For the global concerns that *Code inconnu* articulates, even the highly abstracted Austrian milieu of his earlier trilogy would be too constraining, and these problems require a megalopolis as their backdrop. The portrayal of tensions in a heterogeneous, globalized mass society, a portrayal that moves away from the dualistic victim rhetoric of his earlier work,

makes the nation framework largely irrelevant as an explanatory model applicable to Haneke's output.

III

Inherent in this marked departure from Haneke's prior works—away from questions regarding national historical accountability to those relating to transnational mass society—is a pessimistic appraisal of the possibilities for a "safe haven" in the current social order, where communality with others would be possible. In *Code inconnu,* the fortieth scene in particular implies that feeling a sense of human solidarity across and within national boundaries, one that leads to active intervention, is a difficult endeavor. In his book *Feeling Global: Internationalism in Distress,* Bruce Robbins argues for such an "empowered form of worldliness" that extends outward the same "potent . . . solidarity" to be found in the nation-state.[29] He admits that "feeling global" has a certain utopian component to it, since "radical democratic politics rarely permits a direct or simple expression of group interest. . . . [A] given group will articulate its interests together with the interests of other groups, negotiating strategic commonalities. Neither the interests nor the group identities themselves emerge from this process unchanged."[30] We witness this process in *Code inconnu:* the temporary alliances between individuals—to speak of groups seems almost an impossibility in this case—occur haphazardly in a democratic polity lacking binding differences. Provisional coalitions generally arise on the basis of a shared contempt and the experience of victimhood, a victimhood that does not preclude victimizing others.[31] However, the solidarity Robbins assumes exists within a nation-state has already become brittle in Haneke's France, as issues of class, age, and metropolitan allure undermine cohesion.

Robbins points out a serious problem in many theories relating to the public sphere in an age of transnationalism: he singles out for criticism the "contempt for ordinary life" inherent in most explanations that try to envision solidarity that stretches beyond national boundaries.[32] In his view, this denigration of daily life—despite its global commonalities—is the largest theoretical hurdle in the false opposition between national solidarity and transnational humanism.[33] However, we have to ask ourselves whether the "contempt for ordinary life" evinced by theorists is not inherent in the emerging mass culture, which Robbins calls the "odds and ends of transnational experience produced by global commodities and global tourism, mass migrations and mass media,"[34] and Antonio Negri and Michael Hardt term the "new

imperial order."[35] If this is so, and *Code inconnu* insinuates that it is, is there a way to envision a solution to the politics of mutual contempt outlined by Haneke and Sloterdijk? Can we avoid the fatalities that make transnational solidarities impossible in a public arena revolving around contempt? Following *Code inconnu*, we seem condemned to a politics of *Verachtung*, shifting victim positions, and mutual resentment—all aided by the media, trafficking in images that spur the desire for recognition and respect.

The ambivalence about the media's function lends an iconoclastic bent to Haneke's works, a skepticism vis-à-vis the image that manifests itself in the director's pronouncements about film as an art form,[36] as well as in his own sparing style. His reticent use of close-ups and medium close-ups, shot/reverse shots, and subjective point-of-view shots emphasizes this skepticism, as if conforming to classical continuity editing debases the veracity of the image and the represented situation.[37] However, rather than restore integrity to the falsified image, Haneke's method cannot overcome the perceived gap between extrafilmic truth and its representation.[38] In the "Trilogy of Glaciation" and *Funny Games,* the violence that is *not* shown is all the more palpable since it takes place off-screen on the soundtrack, where the screaming of maimed individuals is clearly audible.[39] Even in *Code inconnu,* where there are no suicides and murders, the fragmentation of the characters' bodies deprives the figures of a physical wholeness (most noticeable when the Métro rider confronts the young Arab and the torsos, headless, are shown in a medium close-up, the upper bodies partially occluded by a handrail in front of the camera lens). The lack of camera involvement, as suggested earlier, mimics the lack of communication and solidarity among the figures. The camera abrogates its "editorial prerogatives" and "postpones emotional investment."[40] The engagement with the epistemological questions of the image influences the solutions to political issues: images do not and cannot offer a solution to the impasses of today's particularized masses.[41]

The media—ever-present in Haneke's films—do not help maintain an equilibrium in the mass' psychic and emotional economy, as Sloterdijk postulates. In Sloterdijk's view, the media serve an indispensable function in contemporary society, supporting social "regulators" such as sports competitions and financial and art markets. By broadcasting the losers and winners in the merry-go-round of taste and fashion and reassuring everyone that all rankings are reversible, the media provide a form of social ventilation. We should note the impersonal formulation in Sloterdijk's account of a self-regulating social system:

Here an historically unprecedented psycho-political act of force announces itself: the attempt to prevent agile, jealous, demanding masses, which exhaust themselves in permanent competition for preferable rankings, from falling into an impending loser's depression. Without a continuous exertion to compensate the ranked ones, a society of subjectivized masses would break due to the endogenous tensions created by envy.[42]

Sloterdijk sees the mass media involved in compensatory gestures, assuaging and pacifying the losers and duping people with programs that turn them into "media masses."[43] Haneke, on the other hand, sees the media's permanent circulation of images as having an ambivalent function. Although images are meant to inform or impel into action against violence, maybe even generating a counterviolence, they can also dull our responses.[44] While *Code inconnu,* in contrast to *Der Siebente Kontinent* (The Seventh Continent, 1989), *Benny's Video,* and *71 Fragmente,* does not intersperse clips from TV news or radio broadcasts (Balkans, Somalia, Haiti) throughout the film, the media is present here in the figure of Anne's boyfriend Georges, a photojournalist.

Traveling from one conflagration to another, Georges ponders the relationship between the media and the mass, which is affected by the images he peddles. The "indifferent differences," which Sloterdijk sees as the main factor in current social struggles, manifest themselves in two of Georges's photo series and are accompanied by his voice-over narration. The first shows photos near Drenica in Kosovo. The local conflict between Albanian fighters and Serbian police, with its bloodied bodies and shocked civilians, registers immediately and globally. However, despite the fact that news is available instantaneously and worldwide via CNN and *Newsweek,* agencies for which Georges works, these graphic images of violence suffer from "the paradox of incommunicability"—they do not inspire struggles or even solidarity elsewhere. As Michael Hardt and Antonio Negri write: "The struggles do not communicate despite their being hypermediatized, on television, the Internet, and every other imaginable medium." This incommunicability seems to be the inevitable outcome of an entirely horizontal paradigm; Negri and Hardt speak of a "horizontal articulation of struggles."[45] The images do not evoke a sense of difference from other conflicts. Traumatic experience elsewhere does not register on a somatic or psychic level for Georges or, presumably, for the viewer of his images. Georges is able to speak calmly about his son's impending fifth birthday as the still images of aggrieved individuals pass on the screen.

Near the end of the film, in the thirty-fourth scene, a second photomontage appears. This time, as Georges recounts his harrowing experiences in Kabul, we see a series of Walker Evans–like portrait photos of commuters in the Métro that Georges took surreptitiously.[46] Georges's voice-over, a description of the Taliban in Afghanistan and his nearly fatal encounter with them, creates an odd commentary to the portraits. Forty images of ethnically diverse faces appear. Coupled with the journalist's reflections on the value of his work, this portrait gallery belatedly deals with questions the photomontage of Drenica had posed. Georges displays a new skepticism toward his work, self-reflexively returning to an earlier dinner conversation with a friend, who provocatively asked whether it was necessary to see pictures of starving children to imagine hunger. Paraphrasing the French director Robert Bresson,[47] who in his *Notes sur le cinématographe* upholds an economy of means as the key to film art, Georges now speculates: "From a distance it is easy to discuss the 'ecology of images' and the 'value of the non-transmitted message.' What matters is the consequence." Then, in a resigned and pensive tone, he asks whether his friend may be right after all.

Georges still seems reluctant to admit that his photos may engage in their own kind of violence, erasing physical distance by transmitting visceral information to people at a remove from the sites of ethnic and religious strife. His new portrait series seems, on the one hand, to underline the existence of difference at home, and perhaps suggests that horizontally differentiated society has led to a state of warfare in the heart of Europe (this would be in line with Haneke's preceding "Trilogy of Glaciation"). On the other hand, the close-up photos are endowed with a quiet dignity at odds with this first interpretation, and they seem fundamentally opposed to the graphic color photographs of the war between Albanians and Serbs. The second photo series can therefore be seen as a response to his friend's demand for an "ecology of images."[48] Georges now implicitly condones a movement away from the obsessive depiction of violence that engenders apathy as well as the nausea of overfamiliarity, an obsessiveness that reinforces the "paradox of incommunicability." Rather than focus on the images of war-torn Kosovo or the repressive regime of the Taliban, the new portrait series shows an interest in—and not indifference to—the local and the immediate, in its extreme diversity.

In the thirty-fourth scene, Haneke's film thus extends a promise of redemption from vituperative stances and mutual disregard via the mediated image that his film, indeed his oeuvre, problematizes. If the

media produces a new sense of temporality, as Thomas Elsaesser has argued, namely that of obsessive repetition generally associated with trauma, these forty portraits hold out the possibility of a "negative performative."[49] A "negative performative" arises from traumatic experience, according to Elsaesser, and speaks with delay (*Nachträglichkeit*) and deferral. It avoids narrating directly the trauma that has been suffered and is present, paradoxically, only in an absence of traces. Chronicling the lacunary, incomplete relation of the subject and the subjectivized mass to history and to memory, negatively performative images demand a new evaluation of horizontal difference without contempt. *Code inconnu* suggests that this reevaluation can occur by avoiding sensationalistic images, as in the second photomontage and in the film in general. *Code inconnu* partially restores the trajectories that have brought the people in the photo series together in the Parisian Métro, a fragmentary restoration of lives beyond national borders: after a temporal delay, the film shows brief scenes of the beggar Maria's home in Romania and the young Amadou's father in Mali. The glimpses we get of their private lives are devoid of great upheavals. Were we to extend Haneke's earlier metaphor of war to *Code inconnu* as well, then the uncommunicative camera and its long takes could be more positively interpreted as chronicling, in a negatively performative manner, life in a contemporary western Europe with its own traumas.

IV

> At around eleven the heat began to become oppressive and Michel went back to his apartment. He undressed and lay down. In the three weeks that followed, he barely moved. It is easy to imagine that a fish, bobbing to the surface to gulp the air, sees a beautiful but insubstantial new world. Then it retreats to its world of algae, where fish feed on one another. But for a moment it has a glimpse of a different world, a perfect world—ours.
> —Michel Houellebecq, *The Elementary Particles*[50]

Sloterdijk ends his text *Die Verachtung der Massen* rather questionably, with a plea for the normative role of culture and with a reminder that art criticism's responsibility is to respect the truly unique in art. Artistic "exercises in provocation," which place demands on the audience to rise above itself and its middling taste, counter the contempt inherent in society by reestablishing a vertical difference, and these *Provokationsübungen* demand admiration. In Sloterdijk's estimation, this vertical difference is a "difference for the better,"[51] and allows us a "glimpse of a different world," a more "perfect" one. Haneke ends his film with a similar entreaty: the rhythmic drumming of a group of deaf

children underlies scènes forty-one through forty-four, which show Amadou, Maria, Anne, and Georges in short segments. By acoustically binding together individuals who are still at cross-purposes (Maria is begging close to Anne's apartment a second time, Georges does not know the entry code to the building, and Anne seems to be out), the soundtrack hints at a rapprochement.[52] If, as Robert Bresson has written, rhythm is "all-powerful" and sound is more commanding than the visual image in suggesting an inner world, the rhythmic drumming adds an emotional climax and leads us to believe in a greater spiritual bond between the characters.[53]

Immediately thereafter, when the drums fall silent, the final scene closes the frame established at the outset of *Code inconnu:* we see a deaf boy playing charades with his deaf-mute classmates. In contrast to the young girl in the first scene, who had cowered against the wall as she mimicked fright, apprehension, or dread, he seems to espy something hopeful in the distance. He smiles and his hands mime a bird fluttering upward, released into the vertical difference of the art house film. The paradox at the heart of Haneke's *Code inconnu* is that an art house film tries to valorize the dignity of the everyday, whereas mainstream cinema presumably only fuels contempt for the mass and among the mass.[54]

Notes

1. Peter Sloterdijk, *Die Verachtung der Massen: Versuch über Kulturkämpfe in der modernen Gesellschaft* (Frankfurt am Main: Suhrkamp, 2000), 19. All translations, unless otherwise noted, are my own.

2. The dismissal of the Munich Kammerspiele's director, Dieter Dorn, by the cultural affairs officer Julian Nida-Rümelin was the instigator for Sloterdijk's text. *Die Verachtung der Massen* can be read as a defense of the "last élites" like Dorn, whom mass democratic society subjugates. While parts of the text defend high culture as the last salvation in a commodified world, I am more interested in the affective dynamics Sloterdijk outlines as existing in current society.

3. Michel Houellebecq, *Les particules élémentaires* (Paris: Flammarion, 1998).

4. Sloterdijk, *Die Verachtung der Massen,* 86–87.

5. *Code inconnu: Récit incomplet de divers voyages,* dir. Michael Haneke, perf. Juliette Binoche, Thierry Neuvic, Ona Lu Yenke, Alexandre Hamidi, Luminita Gheorghiu, Josef Bierbichler, Djibril Kouyaté, Maimouna Hélène Diarra, 2000.

6. Cf. Sloterdijk, *Die Verachtung der Massen,* 19.

7. Michael Haneke, "Interview mit Michael Haneke," *La Quinzaine des Réalisateurs* (1994): 5–7.

8. Slavoj Žižek explores the dynamics involved in this kind of argument, where the Balkans act as a metaphor for Europe's Other. See his *The Fragile Absolute— or, Why Is the Christian Legacy Worth Fighting For?* (London: Verso, 2000).

9. In many interviews Haneke has given, he stresses that narrative fragmentation is an exigency—today's reality cannot be presented as a coherent totality according to the conventions of nineteenth-century literary realism. Haneke sounds much like the director Robert Bresson; cf. Robert Bresson, *Notes sur le cinématographe* (Paris: Éditions Gallimard, 1975), 95. See his interviews with Stéphane Goudet, "Code inconnu. La main tendue," *Positif* 478 (December 2000): 23–29, and with Margret Köhler, "Fremd ist jeder: 'Kunst kann nicht ohne Rigorosität stattfinden, aber die versaut den Konsum,'" *Berliner Morgenpost,* 1 February 2000, http://www.berliner-morgenpost.de/archiv2001/010201/feuilleton/story389537.html.

10. Some reviewers have claimed that *Code inconnu* presents a desiccated, overly intellectual approach to important issues. See the review, for example, by Andrew James Horton, "Locked Out: Michael Haneke's *Code Inconnu,*" *Central European Review,* 10 May 2002, http://www.ce-review.org/01/19/kinoeye19_horton.html.

11. Haneke argues that he departs from his earlier method of presenting paradigmatic models in *Code inconnu.* Michael Haneke, interview with Martin Holler and Markus Reuter, "Zur Berlinale komme ich nie. . . ," *Metronaut Magazin,* 2 March 2002, http:www.metronaut.de.

12. In this respect, too, Haneke's narratives follow those of his model, Robert Bresson. Paul Schrader has written about the role of predestination and choice in Bresson: "Man must *choose* that which has been predestined" (93). See Schrader's *Transcendental Style in Film: Ozu, Bresson, Dreyer* (Berkeley and Los Angeles: University of California Press, 1972).

13. Anne (Juliette Binoche) is in fourteen scenes. The Malian teenager Amadou (Oma Yu Lenke) is in nine, including discussions of him by his Malian parents (Djibril Kouyate, Maimouna Hélène Diarra). Romanian Maria (Luminita Gheorghiu) is in ten scenes, and Jean (Alexandre Hamidi), the French farmer's son, in eight scenes where action or discussion centers on him. Georges (Thierry Neuvic), the boyfriend of Anne and the brother of Jean, accounts for nine scenes. This equal weighting of all stories diminishes Juliette Binoche's "starring" role.

14. The director does not often use the long take together with a more customary mobile frame in scenes where violence erupts. By *not* shifting our view, Haneke withholds the comfort of emplacement.

15. Sloterdijk, *Die Verachtung der Massen,* 47.

16. Anthony Lane, "The Great Divide: Unsettling Pictures of Parisian Life," rev. of *Code inconnu, New Yorker,* 3 December 2001, 105–8.

17. The young man's track suit mirrors that of the French teenager, Jean. The costumes suggest basic similarities across ethnic and class lines. This is also the case for the Romanian Maria and the French Anne.

18. A comparable scene occurs in Haneke's *Funny Games,* where the two young torturers marshal all typical sociological explanations (drug abuse, familial neglect, poverty) that could account for their sadistic behavior.

19. Žižek, *The Fragile Absolute,* 9.

20. This complex racism comes to the fore in the twentieth and twenty-eighth scenes, where the Malian mother and another African woman claim that white people are responsible for their children's problems. An undercurrent of racism is

also present in Maria's tearful story in scene 35, where she recounts her own disgust at a Gypsy beggar in Romania.

21. This perhaps explains why the French Left, which had supported Haneke's past films, showed less enthusiasm for *Code inconnu*. The French reception is mentioned in Nick James, "Code Uncracked," *Sight & Sound* 11.6 (2001): 8.

22. Lane, "The Great Divide," 105–6.

23. The explicit victims in the film are always women and girls, a subject that warrants further treatment.

24. Haneke himself makes reference to the current political situation in Austria, with the election of the right-leaning Freedom Party in an interview (Holler and Reuter, "Zur Berlinale komme ich nie"). The Austrian Film Commission's yearly catalog lists Haneke's *Code inconnu* in the section entitled "Austrian Directors Abroad"; see *Austrian Films 2000* (Wien: PVS, 2000), 108, as well as the catalogs from 1997 (18, 28), 1996 (115), 1993–94 (21), 1992–93 (83), 1991–92 (12, 81, 162), 1988 (16), 1981–86 (228).

25. See also Lane, "The Great Divide," 106–7. The connection to Austria's Nazi past and President Waldheim is also present in Eric Derobert's "Le Septième Continent, Benny's Video: Désagrégation et impuissance," *Positif* 388 (June 1993): 22–24. In Philippe Rouyer's "Funny Games: Souffrir n'est pas jouer," *Positif* 443 (January 1998): 37–38, he discusses the film's portrayal of totalitarian power, and Alain Masson's critical review, "*Funny Games:* Une allégorie fallacieuse," in the same journal issue alludes to Nazism as well (39–40). Finally, Stéphane Goudet's introduction to his interview with the filmmaker makes mention of the far Right's role in Austria's coalition government (23).

26. Dominique Païni, "L'empêcheur de filmer en rond: A propos de *Funny Games* de Michael Haneke," *Cahiers du cinema* 514 (June 1997): 36–37.

27. On *Benny's Video,* see my article "Opfer: Zur strukturellen Gewalt in den Filmen Michael Hanekes," *Ich kannte den Mörder, wußte nur nicht wer er war: Zum Kriminalroman der Gegenwart,* ed. Friedbert Aspetsberger and Daniela Strigl (Innsbruck: Studienverlag, 2004), 171–88. Also see Jörg Metelmann, *Zur Kritik der Kino-Gewalt: Die Filme von Michael Haneke* (Munich: Wilhelm Fink, 2003), esp. 86–108. Metelmann also briefly touches on *Code inconnu,* 272–77.

28. Köhler, "Fremd ist jeder."

29. Bruce Robbins, *Feeling Global: Internationalism in Distress* (New York: New York University Press, 1999), 5–6.

30. Robbins, *Feeling Global,* 171.

31. Robbins pleads for a new "cosmopolitics" beyond any "high moral ground" (*Feeling Global,* 171). It would take into account group self-interest but nonetheless conceive of human solidarity beyond national borders. Also see his coedited volume, *Cosmopolitics: Thinking and Feeling beyond the Nation,* ed. Pheng Cheah and Bruce Robbins (Minneapolis: University of Minnesota, 1998), 1–19.

32. Kwame Anthony Appiah also argues for ordinary life in "Cosmopolitan Patriots," when he defends the "smaller scale" on which human beings create "rich possibilities of association" (Cheah and Robbins, *Cosmopolitics,* 97).

33. Robbins criticizes models such as Benedict Anderson's, which have focused solely on death as the test case for solidarity (*Feeling Global,* 171–72).

34. Robbins, *Feeling Global,* 172.

35. Michael Hardt and Antonio Negri, *Empire* (Cambridge: Harvard University Press, 2000).

36. In an essay Haneke wrote about Bresson, he lauds Bresson's concentrated images, as well as his use of nonprofessional actors for their "respect" and "truth" (555). See Michael Haneke, "Terror and Utopia of Form. Addicted to Truth: A Film Story about Robert Bresson's *Au hazard Balthazar,*" *Robert Bresson,* trans. Robert Gray, ed. James Quandt (Toronto: Cinematheque Ontario, 1998), 551–59. See also Haneke's interview with Camille Nevers, "L'oeil de Benny," *Cahiers du cinéma* 466 (April 1993): 66–67.

37. Only one scene—footage from Anne's film to which postproduction sound is being added—conforms to the rules of classical continuity editing, foregrounding the viewer's usual manipulation. See Holler and Reuter, "Zur Berlinale komme ich nie."

38. Karl-Markus Gauß, "Was ich aus eigenem nicht zu sehen vermag. Zu *Funny Games, Die Schuld der Liebe* und *Jugofilm,*" *Meteor* (March 1998): 53–63.

39. Masson, *"Funny Games,"* 39.

40. Schrader uses these terms, also applicable to Haneke, to characterize Bresson's work (*Transcendental Style in Film,* 67).

41. Haneke argues that this is not the responsibility of the filmmaker in Nick James's article: "I'm trying to show that life is full of ambiguities and film-makers are not there to give advice but to ask the right questions" ("Code Uncracked," 8). Also see Köhler, "Fremd ist jeder."

42. Sloterdijk, *Die Verachtung der Massen,* 91.

43. Sloterdijk, *Die Verachtung der Massen,* 19.

44. See his interview with Holler and Reuter, "Zur Berlinale komme ich nie."

45. Hardt and Negri, *Empire,* 56–57.

46. The portraits are by photojournalist Luc Delahaye.

47. Regarding the influence of Bresson on Haneke, also see Wolfram Knorr, "Trilogie der Vereisung," *Profil* 40 (October 1994): 117–18.

48. Dirk Schneider and Jakob Hesler, "Ist es ein Regisseur oder ist es ein Irrer?" *filmtext.com,* 17 May 2002, http://www.filmtext.com/framesets/interviews.htm?/themen/interviews/michaelhaneke.htm.

49. Thomas Elsaesser, "Postmodernism as Mourning Work," *Screen* 42.2 (2001): 193–201.

50. Michel Houellebecq, *The Elementary Particles,* trans. Frank Wynne (New York: Vintage, 2000), 17.

51. Sloterdijk, *Die Verachtung der Massen,* 95.

52. There is never "background" music in Haneke's films.

53. Bresson, *Notes sur le cinématographe,* 51, 61, 68–69.

54. See Haneke's interview with Holler and Reuter, "Zur Berlinale komme ich nie," as well as his comments in "Die letzten Zuckungen des verendenden Tieres," *Celluloid News,* 18 May 2002, http://www.celluloid.at/Haneke.htm.

Addressing the Global in Recent Nonfiction Film Production

Nora M. Alter

I

The near obsessive fixation on national and regional identities that dominated theoretical and cultural discourses throughout the end of the 1980s and the 1990s was essentially a red herring masking the more systemic shift of globalization. In place of nation-states, a new world order emerged, what Michael Hardt and Antonio Negri have productively described as "Empire," driven by economic exchanges that supersede distinct conceptions of individual nations.[1] As Hardt and Negri point out, "In contrast to imperialism, Empire establishes no territorial center of power and does not rely on fixed boundaries or barriers. It is a *decentered* and *deterritorialized* apparatus of rule that progressively incorporates the entire global realm within its open, expanding frontiers. Empire manages hybrid identities, flexible hierarchies, and plural exchanges through modulating *networks of command.*"[2] Indeed, the concept of globalization encompasses transnational corporations or nongovernmental organizations (NGOs), multinationals, high-speed transfers of information, and the perpetual flow of capital from one site to another in the postindustrial economy. As Slavoj Žižek noted in the mid-1990s, "the time has come to resuscitate the Marxian insight that Capital is the ultimate power of 'deterritorialization' which undermines every fixed social identity."[3] Yet, the impact of such "deterritorialization" on cultural production remains unclear. One effect is an increase in the phenomenon of standardization, which is often hidden under the guise of cultural pluralism. According to Fredric Jameson, "it is essentially standardization that effaces the difference between the center and the margins."[4] What emerges in this process is a dialectical structure that superficially appears to appeal to and advocate diversity but in actuality promotes homogeneity.[5]

But what if we do not accept this overdetermined and fundamentally pessimistic conclusion by Jameson and instead choose a more optimistic path that points toward resistance? For despite the seeming impenetrability of their work, Hardt and Negri see globalization, because of its very diffusion, as particularly vulnerable to subversion, revolution, and rebellion. What strategies for critique might today's filmmakers and other cultural and intellectual workers employ to negotiate and yet not succumb to the new postindustrial condition of globalization?[6] How might an aesthetic practice emerge that would parallel the disruption caused by WTO, IMF, or G-8 demonstrators in Seattle, Quebec City, Genoa? The artist Mary Kelly argued years ago that in order for counterideological productions, such as artwork informed by feminism, to be successful, they have to be discourse specific and not merely site specific. Likewise, a critique that fully takes into consideration capital's dependence on circulation for its strength and survival must itself be mobile, guerrilla-like, and not as static as a "site" specific work. What this would mean for the context of filmmaking is that if one wants to be involved in a counterhegemonic cinema, then it is no longer enough merely to make films about a particular nation. Instead, one has to move beyond the concept of a fixed geopolitical site, making critical films that are not nationally specific.

II

The work of German filmmakers Hartmut Bitomsky and Harun Farocki has leapt across the gap between the local and the global and moved from a markedly "national" cinematic production to one that often does not reference Germany. Rather than coded productions with complicated metaphors, allegories, or allusions to the German or even European state, their more recent films function as part of a geopolitical aesthetic, one marked by cultural interventions and crucial interruptions in processes of globalization. Instead of wholly integral works of art, Farocki and Bitomsky produce texts whose function is more akin to a practice, a distinction delineated by Raymond Williams some years ago. A practice is active, wrote Williams, and "subject to conventions which in themselves are forms of social organization and relationship, and this is radically different from an object."[7] From this perspective, to understand the operation of both Farocki's and Bitomsky's work is not a matter of "isolating the object and then discovering its components," but rather of analyzing its condition of practice—the artistic conventions at work and the social relationships in which it is enmeshed.

From a slightly different perspective these films could be addressed as manifestations of Third Cinema. As a historical phenomenon, Third Cinema is a political cinema that emerged in the 1960s and 1970s within the context of the third world, but that today is no longer confined to that context.[8] Indeed, as Mike Wayne notes in his recent study on political film, "Third Cinema can work with different forms of documentary and across the range of fictional genres. It challenges the way cinema is conventionally made (for example, it has pioneered collective and democratic production methods) and the way it is consumed. . . . Although it has precursors, particularly in the Soviet cinema of the 1920s, it emerged in the decade after and was influenced by the 1959 Cuban Revolution."[9] An early theorist of Third Cinema, Paul Willemen describes it as "a cinema made by intellectuals who, for political and artistic reasons, at one and the same time assume their responsibilities as socialist intellectuals and seek to achieve through their work the production of social intelligibility."[10] From this point of view, the works of Bitomsky and Farocki, persistent in their challenge of the conventions of cinema, are examples of the continuing vitality of Third Cinema.

The mode of production of these two filmmakers over the years has diverged in different directions, though they both continue to produce sociocritical essay films on the margins of dominant film production, as they have now for over four decades. Early in their careers they collaborated with each other on several films, including *Die Teilung aller Tage* (The Division of All Days, 1970), *Eine Sache, die sich versteht* (An Unquestionable Matter, 1971), and *Einmal wirst Du mich Liebe* (At Some Point You will Love Me, 1973). In addition, both were editors of the important and influential journal *Filmkritik* in the 1970s. This is consistent with their cinematic practice that extends beyond the production of films to the creation of sites for dialogue and discourse about cinema. These dialogues often took the form of a type of cultural critique based on that of the Frankfurt School. Indeed, their interest in the Frankfurt School was demonstrated by their involvement with *Filmkritik,* which republished essays by Walter Benjamin, Siegfried Kracauer, Bertolt Brecht and others. Indeed, when the journal was still named *F: Film 58* it featured a reprint of the infamous 1944 essay co-authored by Adorno and Horkheimer, "Aufklärung als Massenbetrug" (Enlightenment as Mass Deception).

Farocki has made over ninety independent film or video productions to date. His career began in the 1960s—he was a member of the first-year class of the DFFB (Deutsche Film und Fernsehakademie

Berlin). In 1968, he was one of the first German directors with access to a Sony PortaPak, which enabled him (as it did for others with limited financial means) to make films with a bare-bones budget. Farocki's first productions are pointedly agitational and focus on topics such as student protest movements, Germany between the Word War I and World War II, the explosion of and reliance on self-help groups in the former Bundesrepublik, and several meditations on the interrelationship between photography, film, perception, mechanization, and war. These would include *Wie man sieht* (As You See, 1986), as well as what is perhaps his best-known film to date, *Bilder der Welt und Inschrift des Krieges* (Images of the World and the Inscription of War, 1989). After the reunification of Germany, Farocki shifted his concerns beyond the German border to examine the fall of the Ceaușescu regime in Romania in *Videogramme einer Revolution* (Videograms of a Revolution, 1992), the impact of globalization on factory workers in *Arbeiter verlassen die Fabrik* (Workers Leaving the Factory, 1995), and the effect of surveillance systems and technological vision on everyday life in *Ich glaubte Gefangene zu sehen* (I Thought I Was Seeing Convicts, 2000) and *Auge/Maschine* (Eye/Machine, 2001–3). Below, I will concentrate primarily on these latter two video productions.[11] The focus, however, will not merely be on the subject matter of these two works, but also on their formal construction and on how they are exhibited, for these are the aspects that reveal an attempt to advance or transform Adorno's cultural critique to a level beyond the negative dialectic.

Bitomsky's path follows a similar trajectory to that of Farocki's. After a period of intense political engagement in the 1960s and 1970s, he began to make film essays that self-reflexively explored the history of cinema specifically and culture more generally. Until recently, however, he was perhaps best known for his trilogy of films concerned with Germany: starting in 1983 with *Deutschlandbilder* (Images of Germany), followed three years later by *Reichsautobahn* (1986), and culminating in 1989 with *Der VW Komplex*.[12] Most recently, Bitomsky has made the timely *B-52* (2001), a full length, 122-minute film, in which he explores one of the most vaunted weapons in American history—the B-52 bomber—as an instrument of strategic and tactical warfare since the beginning of the cold war. His critique of this military machine doubles as a parable for American culture generally. Thus, as with Farocki's more recent productions, Bitomsky's focus has largely shifted away from Germany. Furthermore, although the location of much of the filming is in the United States, home of the B-52 and of the Corcoran Prison where Farocki's *Ich glaubte Gefangene zu sehen* is

located, the actual site is not fixed, for, as I have already suggested, the filmic texts are not nationally based but are transnational, tapping into the phenomenon of globalization that Hardt and Negri call "networks of command." In both of these instances, surveillance and military war machines circulate literally and metaphorically as an economic body. They have a material presence and institutionalized practice: prisons, the actual aircraft, and technological vision machines. Yet they are also connected to immaterial concepts such as surveillance, cold war ideology, and alienated vision. As such, these works can be productively related once again to the notion of Third Cinema, which as a "theory looks in films for this capacity to be *porous* (to use a concept from Walter Benjamin) in relation to the historical context."[13]

The opening sequence of Bitomsky's *B-52* bears a strong resemblance to the first shots of the omnibus production, *Loin du Vietnam* (Far from Vietnam, 1967, dir. Joris Ivens et al.), as it records pilots preparing to take off in their B-52 bombers. The visual allusion to *Loin du Vietnam* is a strategy of Third Cinema that often seeks to engage in intertextual dialogues with other similar films. In this instance, Bitomsky singles out that earlier film because of both the role of the B-52 in the Vietnam War, and the significance of that war for United States as well as global politics. For many, the Vietnam War accentuated the United States' status as a global superpower whose military was given carte blanche to carry out operations throughout the world under the auspices of protecting freedom. Even operations that in actuality bombed civilian populations were unchecked when the rationale advanced was that the actions were carried out in the name of "freedom." Vietnam thus constituted a new stage in cold war politics.[14]

After the opening sequence, Bitomsky provides a history of the development of the B-52 aircraft. Designed in 1948, this bomber from the beginning "represented the strength of the country," and as we learn in the film, is expected to continue to be in service until the year 2037. The voice-over alternates between a female and a male voice. They speak in an irregular and punctuated oral style, narrating statistical information about, for instance, the different types of bombs carried by the B-52, the varying flight patterns, and the logistical makeup of the crew. What unfolds is an institutional history of the most powerful bomber ever, and its role in the formation and development of U.S. cold war ideology. In an earlier film, *Reichsautobahn,* Bitomsky argues that "the Autobahn introduces perspective into the landscape."[15] This has led scholars such as Edward Dimenberg to conclude that "the open road becomes a powerful allegory for continuity and

B-52 (2001, dir. Hartmut Bitomsky). (Video stills.)

progression, a historical teleology and vision for the future *projected into the landscape itself.*"[16] In a similar way, the B-52, as a war machine, seeks to conquer airspace and establishes a perspective of international domination.

Yet there is another level to Bitomsky's film that is decidedly more self-reflexive. For *B-52* doesn't just focus on the official history of the bomber, but also on its secret histories, such as when one of these nuclear-equipped airplanes crashed in North Carolina in the 1961, or another off the coast of Spain in 1966. Bitomsky also spends a considerable amount of time on the labor history of the B-52. Each airplane is basically a megaproject; each a factory in its own right, proliferating like franchises over the years. The military-industrial complex is thus presented as at once the means by which to advance America's might, and the backbone of the U.S. economy. Hence Bitomsky's more general claim, "the true scene of the Cold War was its production plants."

Significantly, the film ends at the Boeing manufacturing plant in Seattle, where Boeing 777s are being built from parts made out of recycled scrap metal from B-52s.

Labor history for Bitomsky does not end with production. *B-52* is also attentive to the maintenance of these flying superbombers, as well as to their afterlife. Indeed, Bitomsky spends a considerable amount of time focusing on the work it takes to disassemble these war machines. The entire second part of the film involves tracking the long and complicated process of dismantling and de-accessing one of these behemoths. Although the voice-over states that it only takes four men to take apart a plane, the camera betrays the simplicity of this assertion by recording the long and involved process that begins in the Arizona desert and ends in a Chicago art gallery. The "nose art" is carefully removed, and the entire plane is thoroughly probed for recyclable parts. "Everything can be used a second time," intones the voice-over. What is left at the end is a carcass that is then compacted for its metal. This is consistent with Bitomsky's claim that a film should "show the amount of work that is in reality as being equal or equivalent to everything else."[17] Labor should not be hidden but revealed. To that extent, Bitomsky's film seeks to redress observations such as Adorno's in *Minima Moralia,* which notes that under capitalism the representation of the proletarian disappears.[18] Importantly, however, as the labor that goes into all stages of producing, operating, and even dismantling the bomber is systematically revealed in *B-52,* so too is the work that goes into the production of the film. We see extended shots of the film crew, and even of Bitomsky, who reflexively appears first as a disembodied voice, then as a lone interviewer, and finally by the end of the film as a figure surrounded by his crew.[19]

What then is the relationship between culture, labor, and the war machine? Hardt and Negri propose that the "postmodernization of production" is founded on "immaterial labor," the labor, for instance, in culture, reproduction, and style, that comprises the creativity of everyday life.[20] Hence, for the authors of *Empire* the "levels" of politics, economics, and culture are deeply indistinguishable from globalization, and the work of the intellectual is aligned a priori and materially with that of service workers and other primary producers of the new economy. In a parallel way, Bitomsky structures his film around an international concept of work and its interrelated *practice.* For him, documentary films "shouldn't reveal reality but rather articulate and structure reality," which he sees as an entire "concept" and not just a reflection of "the world, environment, or life."[21]

Unlike Bitomsky's previous work, which had relatively low production values and was often cobbled together from existent footage, *B-52* took almost ten years to produce. Aesthetically, the 35 mm images that fill the screen are overwhelming. Bitomsky's camera lingers on and seemingly adores the subject matter. To that extent this essay film in and of itself becomes an artwork, thereby throwing into question the level of critique. But let us recall that the essay, according to Georg Lukács, resembles art only as a gesture, and what separates it from art is the former's character as an open-ended critique or investigation without strong conclusions.[22] Bitomsky's film accomplishes sovereignty by using style as *Umfunktionierung* or *detournement. B-52* thus performs an immanent critique of the ideology that informs the military-industrial complex. As such, the operation of the film evokes Adorno's call for a critical practice that shatters "culture's claims by confronting texts with their own emphatic concept, with the truth that each one intends even if it doesn't want to intend it, and to move culture to become mindful of its own untruth, of the ideological illusion in which culture reveals its bondage to nature." "Under the essay's gaze," Adorno continues, "second nature recognizes itself as first nature."[23] Seen from this perspective, the very excess of the high production filmic style Bitomsky strategically employs in *B-52* underscores its ideological nature and serves to reveal the highly deceptive visual and linguistic rhetorics of the cold war.

When Bitomsky appears in the film, he wears a pilot's flak jacket. This costume inevitably recalls the public outfit the artist Joseph Beuys often wore during his filmed performances. In many of the latter, Beuys cast himself as a shaman, transforming amorphous material such as lard and felt into his own mythical signature. The flight jacket, like the lard, was meant to connote Beuys's experience as a Luftwaffe pilot during World War II (he claimed to have been shot down in Eurasia and to have been covered in lard by the locals who attended to his wounds). With Beuys, then, we have an aestheticization of war that romanticizes the violent past to aid in the construction of the artist's mythical self. By contrast, Bitomsky's *B-52* at once aestheticizes and critiques the aestheticization of military aircraft. Indeed, the film's sarcasm reaches fever pitch when the focus shifts to artists and art dealers who exalt the aesthetic dimension of the aircraft. Bitomsky thus places *B-52* firmly within the context of documentary filmmaking, and generally disavows institutionalization of what is essentially a killing machine in art galleries and museums. Genuine critique, Bitomsky

seems to suggest, must go beyond the inherent ambivalence and poly-valence of the aesthetic.

III

Farocki's relationship to galleries and museums is quite different from Bitomsky's. Indeed, some of his recent work was produced almost explicitly for an art context. This would include *Ich glaubte Gefangene zu sehen* and *Auge/Maschine,* which have been coupled together in exhibitions as two complimentary parts. *Ich glaubte Gefangene zu sehen* is a two-channel video installation. The piece is comprised in part of found footage from the maximum security Corcoran prison in California.[24] The footage includes training tapes of supervisors instructing rookie prison guards on how best to respond to disturbances or violent confrontations among prisoners. More remarkably, however, Farocki also managed to obtain from the same prison (through a defense lawyer) surveillance tapes that record actual outbreaks of violence by inmates and the often lethal response by prison guards. The found tapes also reveal that the guards are not only witnesses to explosive situations, but in fact often purposefully enable violent confrontations in the common exercise areas between members of rival gangs for their own pleasure and entertainment. The prisoners function as gladiators for the thrill of the watching guards, who, the voice-over claims, often place bets on the outcome of such battles. Should the encounter threaten to get out of hand, the guards have the right and the means to open fire on (and often kill) the fighting convicts. Captured on surveillance cameras, the prisoners in the courtyard are reduced to shadowy, depersonalized figures who battle each other spectacularly. As Farocki notes in his reflections on the film: "The surveillance cameras run at reduced speed in order to save on material. In the footage available to us, the intervals were extended so that the movements are jerky and not flowing. The fights in the yard look like something from a cheap computer game. It is hard to imagine a less dramatic representation of death."[25] Thus, *Ich glaubte Gefangene zu sehen* begins as a video essay on discipline and punishment. Yet, as the work progresses, it becomes increasingly apparent that its meaning is considerably broader. The narrative of the installation's video component emphasizes the fact that electronic surveillance technology proliferates not only in prisons, but also in many sites of everyday life in our own era. For instance, interspersed with shots from the prison are electronic images tracking consumer patterns and behavior in a large department store. Farocki

Ich glaubte Gefangene zu sehen (I Thought I Was Seeing Convicts, 2000, dir. Harun Farocki). (Reproduced by permission of the artist.)

reveals that more than ever before society is today painstakingly surveilled and thereby controlled.

Each of the two screens that comprise the video installation features footage from one of the recording cameras. The different camera placement promises to provide the observer with a more accurate view of what is depicted. Yet, as is underscored by the mediating screens, natural vision is never achieved. According to Farocki, the ideal installation of this piece would have the spectator seated on an industrial chair looking up at television monitors in order to approximate the position of a guard in a booth watching the surveillance monitors. The viewer would thus be even more completely positioned as the surveiller—remote, distanced, and voyeuristic. At the same time, though, the viewer of Farocki's work is unable to discern what is depicted without the aid of the controlling and informing voice-over. Thus a tension

is created between seeing and understanding, as the relationship between the two is shown to be more complex than it initially appears.

Farocki's double-channel video installation, *Auge/Maschine,* continues the filmmaker's investigation of technologically mechanized vision. The piece opens silently with images taken by "suicide cameras" from the U.S. bombing of Iraq during the Gulf War. Sound is introduced a full six minutes into the twenty-two-and-a-half-minute video, but even then it consists of only a few muffled background noises of machines. For the most part the video runs in complete silence, with a written text appearing infrequently outside of the image frame. The first commentary bluntly states, "The war was soon forgotten." The effect of the silence in *Auge/Maschine* is striking since the narrative of most of Farocki's earlier works is moved forward by a controlling voice-over. Instead, what follows is an abundance of practically still and flat images evocative of photographs. Occasionally, written commentaries run along the sidelines, giving the spectator another text to decode. The use of written text is part of Farocki's filmic strategy. As he notes in an interview with Thomas Elsaesser, "I occupy myself with writing, in order to determine the difference between film and text. I want to make films that are not that far removed from texts, and that are nonetheless very distinct."[26]

The images from the Gulf War are followed by an array of intelligence weapons, including bomb detectors, mobile surveillance machines and medical cameras. *Auge/Maschine* therefore underscores the dialectic of these "camera eyes," which are at once benevolently utilized to perform minimally invasive surgery in medicine and malevolently employed to wage deadly "surgical strikes" in war. Additionally, the videotapes maintain that with global cameras there is "no real need to invade foreign space in order to collect data," and suggest that in future wars human targets too will likely be obsolete. Once again, however, the viewer is never quite sure of what she is seeing and is thus made to feel remote and detached. Anticipating this alienation, the written commentary reads that "without connecting to everyday experiences the images fail to grip." Indeed, almost none of the images are the product of a human eye looking through a camera; instead, they have all been produced entirely by computer-programmed machines. Sometimes video images of the machine in question appear on one screen, while the other depicts images produced by these very machines. The text, meanwhile, observes that industrial labor has replaced not only manual but also visual work, for these machines are utterly devoid of social context. The result is a proliferation of images

Auge/Maschine (Eye/Machine, 2001–3, dir. Harun Farocki). (Reproduced by permission of the artist.)

"of the world to be processed," as technological vision comes to fully supplant natural vision.

But what sort of evidence or historical trace do these images leave? Can one construct a memory from images that have not been taken by humans? Recall that the videotape's opening text maintains, "The war was soon forgotten." The implication is that for most of the world the images of the first Gulf War were completely abstracted and at times unrecognizable. Without any connection to the real, they failed to "grip." War thus resembles a cheap computer game; it is hard to imagine a less dramatic representation. In turn, history is transformed into a simulation for which the video medium is particularly attuned. And here, of course, it is significant that Farocki works in the same medium as that which he critiques.

Farocki's exhibition format is markedly different from the single-

channel projections of Bitomsky. Unlike his earlier videos, including *Bilder der Welt und Inschrift des Krieges* and *Videogramme einer Revolution,* Farocki conceived of *Auge/Maschine* as a double projection with the two videotapes designed to be projected in a continuous loop onto a large single screen in the exhibition space. The installation transforms the content of the videotapes in several ways. First, the continuous loop at once recalls the constant replay of media images on television, as well as satellite surveillance cameras that continuously record visual matter. Second, the silence of the installation places the spectator in the position of a surveiller of information. The piece thus stimulates vision, but in an alienated and meaningless way, and the viewer functions as a silent observer watching mute images. Finally, Farocki employs two separate screens within one viewing space to create what he refers to in a dialogue with Kaja Silverman focusing on Jean-Luc Godard's *Numero Deux* (1975) as a "soft montage." This unique form of montage is comprised of a "general relatedness" of images, "rather than a strict opposition of equation" produced by a linear montage of sharp cuts.[27] Soft montage therefore allows for an increased flexibility and openness of the text for the spectator—associations are suggested but not formally mandated. This form of montage is essentially a filmic parallel to Adorno's essayistic schema in which "discrete elements set off against one another come together to form a readable context . . . [as] the elements crystallize as a configuration through their motion. The constellation is a force field, just as every intellectual structure is necessarily transformed into a force field under the essay's gaze."[28] Such lability is in stark contrast to the dehumanized visual controlling systems critiqued by Farocki's videotapes—systems that permit little or no space for interpretation or flexibility of vision. By creating a space between two images within which to meditate and make associations, Farocki interrupts the mechanized image-making systems and restores the gap between perception and cognition—namely, natural vision. For in contrast to single-channel videotape that would impose a monocular, technologized vision on the spectator by the very nature of its regime, the two-channel installation opens a space for thought, interpretation, and reflection. The associations constructed by the viewer thereby form a historical narrative—one the viewer plays an active role in putting together.

Thus, unlike Bitomsky's *B-52,* where the history and the memory activated is fully predetermined and the viewer remains outside the text, two important shifts occur in Farocki's recent videotapes. First, the observer is posited as a participant in the act of surveillance and in

the acceptance of technologized vision. The almost complete silence of the videotapes sutures the spectator into the point of view of the machine, or of those whose job it is to examine the endless flow of abstracted images rendered even more dislocated because of the eery silence surrounding them. Second, Farocki restores the possibility of the viewer playing an active interpretive role by splitting the gaze into two screens and creating with montage a new space for the production of meaning. As a result, Farocki formally moves beyond the political filmic montage of Sergei Eisenstein in which narrative is achieved through a linear succession of images. Instead, his practice of montage is closer to the work of photomontagists such as John Heartfield and artists of the surrealist avant-garde for whom narrative was dialectically constructed by simultaneous juxtapositions of images rather than by linear sequences over time.

IV

In the themes they treat and the subject matter they develop, both Bitomsky and Farocki have steadily moved beyond a nationally based (in this case German) film production. Though there remain allusions to the German state in footage of the bombing of Germany by U.S. pilots, or in aerial photographs of Nazi prison camps, the main focus of the more recent productions of these filmmakers is on transnational structures, networks of command that in our increasingly global era are impervious to national borders. In the context of the new world order and its global economy, both filmmakers try to develop a filmic practice that wholly acknowledges and attends to the essentially decentered and deterritorialized condition of the global post-Fordist Empire. Just as B-52 planes, like spy satellites above *them,* endlessly circulate in airspace, fully equipped with cameras and weapons of mass destruction, technologized vision is at the same time rapidly replacing natural vision, and surveillance systems are proliferating at a rate that is nothing short of alarming. Both Farocki and Bitmosky adopt strategies of critique that are based to a certain degree on the mimesis of the very structures that they are investigating. To that extent, they manage to enter into these global systems and subvert them from the inside out.

Notes

1. Michael Hardt and Antonio Negri, *Empire* (Cambridge, MA: Harvard University Press, 2000).
2. Hardt and Negri, *Empire,* xii.
3. Slavoj Žižek, "Enjoy Your Nation as Yourself," *Austrian Contribution to the 45th Biennale of Venice 1993* (Vienna: REMAprint, 1993), 327.

4. Fredric Jameson, "Notes on Globalization as a Philosophical Issue," *The Cultures of Globalization,* ed. Fredric Jameson and Masao Mitoshi (Durham: Duke University Press, 1998), 66.

5. An example of this in mainstream and independent cinema is Fatih Akin's recent film *Im Juli* (In July, 2000), which gives the appearance of promoting multiculturalism, but ultimately ends quite traditionally with the two heterosexual couples falling into lines determined by ethnic/national identities: Germans with Germans, Turks with Turks—no miscegenation here!

6. In using the term *postindustrial* I am taking as a premise that we have moved from preindustrial labor practices of the eighteenth century, through the industrial revolution of the nineteenth century and its twentieth century developments such as Taylorism and Fordism, to its present post-Fordist and fully global—or perhaps one should say multinational and corporate—condition.

7. Raymond Williams, "Base and Superstructure in Marxist Cultural Theory," *New Left Review* 82 (1973): 15.

8. See Mike Wayne, *Political Film: The Dialectics of Third Cinema* (London: Pluto Press, 2001).

9. Wayne, *Political Film,* 5.

10. Paul Willemen and Jim Pines, *Questions of Third Cinema* (London: British Film Institute, 1989), qtd in Wayne, *Political Film,* 121.

11. For a critical appraisal of Farocki, see *Der Ärger mit den Bildern: Die Filme von Harun Farocki,* ed. Rolf Aurich and Ulrich Kriest (Stuttgart: Europäisches Medienforum, 1998); and Tilman Baumgärtel, *Vom Guerillakino zum Essayfilm: Harun Farocki,* Ph.D. diss., Heinrich-Heine Universität 1997. Some of Farocki's own writings have been reprinted in a bilingual English/German edition, *Nachdruck/Imprint, Texte/Writings* (New York: Lukas and Sternberg, 2001). For a recent collection of essays in English by film scholars supplemented with seminal texts by Farocki, see *Harun Farocki: Working on the Sight-Lines,* ed. Thomas Elsaesser (Amsterdam: Amsterdam University Press, 2004).

12. For a brief overview of Bitomsky's work, including several of his own writings and screenplays, see *Die Wirklichkeit der Bilder: Der Filmemacher Hartmut Bitomsky,* ed. Jutta Pirtschtat (Essen: Filmwerkstatt, 1992). More recently, see *Hartmut Bitomsky: Kinowahrheit,* ed. Ilka Schaarschmidt (Berlin: Vorwerk 8, 2003). For a gloss on *Reichsautobahn,* see Edward Dimendberg, "The Will to Motorization: Cinema, Highways, and Modernity," *October* 75 (1995): 91–137.

13. Wayne, *Political Film,* 138.

14. Of course, the Korean conflict of the 1950s was a precedent, though it did not receive nearly the same amount of publicity.

15. Hartmut Bitomsky,"Das Kino und der Wind und die Photographie," in Pirtschtat, *Die Wirklichkeit der Bilder* 71.

16. Dimendberg, "The Will to Motorization," 108.

17. Bitomsky, "Das Kino," 113.

18. Theodor W. Adorno, *Minima Moralia: Reflections from Damaged Life,* trans. E. F. N. Jephcott (New York: Verso, 1974), 193–94.

19. Interestingly enough, this occurs when Bitomsky interviews two artists who collect parts of B-52s and create assisted ready-mades with these objects, devoting an entire gallery to their productions. Like the "nose art" and the aircraft painter

referenced earlier on, the B-52, the quintessential cold warrior, is ultimately archived, museumified, and transformed into Americana, just like the film crew who will put together footage of the B-52 to create the film in the editing process. An early interview with artist Michael H. prefigures this transformation as the artist shows his paintings, which are entirely of U.S. military planes. War becomes art.

 20. Hardt and Negri, *Empire*, 290–94.

 21. Bitomsky, "Das Kino," III–12.

 22. For Lukács the essay "is a judgment, but the essential, the value-determining thing about it is not the verdict . . . but the process of judging" (18). What is important to emphasize is that Lukács believes that the essay is both a work of art because of what he calls its autonomous, "sovereign" status, and not a work of art because of its status as critique (18). Georg Lukács, "On the Nature and Form of the Essay: A Letter to Leo Popper," *Soul and Form,* trans. Anna Bostock (Cambridge: MIT Press, 1978).

 23. Theodor W. Adorno, "Essay as Form," *Notes to Literature,* trans. Shierry Weber Nicholsen (New York: Columbia University Press, 1991), I, 20.

 24. As is well known, the use of existent footage is a trademark of Farocki's antiauteurist image production, and he is persistent in researching image archives for material. Images thus function like quotations, systematically organized within the overall scheme, in a manner not unlike Walter Benjamin's *Passagenwerk* project. And like Benjamin's, Farocki's project, too, is to tell history—often an alternative one.

 25. Farocki, *Nachdruck/Imprint,* 308.

 26. Elsaesser, *Harun Farocki,* 180.

 27. Kaja Silverman and Harun Farocki, *Speaking about Godard* (New York: New York University Press, 1998), 142.

 28. Adorno, "Essay as Form," 13.

The New Media Artist and the Matrix

Telemediation and the Virtual World of Bjørn Melhus

Alice A. Kuzniar

I

Three initial premises govern this contribution on the role of visual artists in an era of global, instantaneous, virtual communications. First is that we need to revisit the question of how we privilege film as a medium. The subtitle of this volume—"German Cinema and the Global Imaginary"—implies that we do not question its dominance, and, lamentably, most of our teaching and scholarship continues to reinforce this fiction of celluloid's hegemony, oddly anachronistic in an era of digital mass communication. Clearly, cinema becomes shorthand for film, video, and digital production, which is to say, the term pretends to be inclusive. But this shorthand all too often marks an elision of nonfilmic visual practice. Consequently, the feature-length entertainment film is granted attention over shorter, experimental works that explore other visual and virtual media, including multimedia, Internet, and interactive art. To investigate the global imaginary of German film today entails, at least for me, the acknowledgment of visual artists not in the mainstream of German cinematic production— my excuse for the indulgence of talking about lesser-known artists.

My second premise is that new media art, as it reflects upon its own digital production and distribution, does so in the context of globalization, mass communication, and postnationalism. Given that this art is structured on the principle of networking (especially with Internet art but also with interactive installations), it critically reassesses how virtual connections operate and how they condition the individual user. To rephrase, it scrutinizes the intensity, integrity, and actuality of video gaming, television addiction, or online consumerism. It interrogates the dependency of the hookup into a large, anonymous network. Postcolonial theory has stressed the mixedness, intersectionality, and

hybridity of identity and postulated a varied spectatorship in response to cultural uniformity via the hegemony of mass media and the global, wired village. But rather than revisiting the sites of German cinema through the lens of hybridity or heterogeneity, I want to focus on art that comments on the homogenization and derealization brought about by new virtual technologies; this art takes as a given that it is highly problematic to speak of the local or the individual. What defines the local, at its most basic but seemingly only remaining level, is the body itself—resistant in its very materiality to virtuality. Yet, must one not question where the body resides in the global network? What is the individual body but a prosthesis of current technologies, an appendage to the larger virtual body into which it is plugged? Is the body not a cyborg through its electronic interfaces? Moreover, how is the body to be located in the nonplace of cyberspace? Displacement and dislocation today need to be examined in terms of the alienation and anxiety produced by interaction with computers that so often operate (or don't) beyond the layman's control. But is displacement even an applicable concept in an age of telemediation—when we are already residing inside technology and its fictional space, when CNN broadcasts are identical every half hour in airports around the country, and when we can teleconference around the world?

Third, the nonexistence of place or locale forces me to leave questions of German identity behind. In the works I propose to discuss, German nationality is marked primarily by its absence—by the refusal of the media artist to embrace national affiliation. It is almost entirely incidental that he or she is of German extract. Conversely, the issues of global communications and capital flow, entailing the erasure of individual agency, play a significant role. Ironically, what allows me to include this contribution in a volume on German cinema's cosmopolitan gaze is merely the German birth or residency of the artists discussed. Paradoxically, then, I return to the framework of the local (the country of origin of an artist), an issue that is to a large extent immaterial to the works under discussion but that reinvokes the significance of personal life circumstance (despite the theme of impersonal telemediation). I intend to address the issues of identity, agency, and originality—all marks of the individual—in a more theoretically productive manner than via national affiliation. It bears reiterating, however, that German (cinema) studies cannot afford to ignore the import of virtual technologies in its discussions of globalization: German visual artists are exploring this topic in exciting ways, even though they may not highlight their nationality. As German studies scholars we should not,

out of our own location abroad and as defenders of our curriculum, tether ourselves to discussions of national or linguistic inflection of identity. Perhaps we need to render incidental the German origin of the texts we examine but stress that the contribution of these texts to such debates as globalization is *not* marginal, however much they might seem to American cultural isolationism and to the division of disciplines in American academe that shunts aside the nonlinguistic-based contribution of foreign language departments.

II

I want to concentrate on the work of the visual artist Bjørn Melhus, but will introduce and illustrate the problems outlined above by turning to Melhus's occasional collaborator, Michael Brynntrup. Brynntrup has premiered his work more than ten times at the Berlinale and shown thrice at the Museum of Modern Art—at the 1987 Cineprobe Film Exhibition, in a retrospective entitled "Lebende Bilder: Still Lives" in 1992, and again in 1998. This Mephistophelian manipulator of screen images is indisputably one of Germany's most significant filmmakers today. Unfortunately, as with his cohorts in the experimental, underground vein, the venues for his work are still few and far between. The list of his works is long. Most of his films play off of and into the ability of the camera to reproduce, and in so doing distort, the image. Throughout his twenty years of filmmaking, Brynntrup has put himself before the camera, foregrounding the tension between individuality and its electronic reproduction, between original and copy, between mirror and warp. When you look up his website (www.brynn trup.de) you navigate through his stylish self-indulgence: you can click on him "live," where a video camera is set up in his apartment; on a minutely detailed curriculum vitae; on extensive press excerpts; on various self-portraits; even on a site where pages from his diary flit by the screen and from which you can select one to order. The sales pitch, misleading as all sales pitches are but here ironically so, promises you an "original copy." Brynntrup in the age of digital reproduction; Brynntrup to the rhythm of the double click. He presents the human subject as serialized in images, supplemented by the Internet, seamlessly fitted into the matrix.

Leading up to this self-styling website are several films and videos that chronicle Brynntrup's life or manipulate an image of himself. They include *Handfest—freiwillige Selbstkontrolle / Handfest* (Voluntary Self-Control, 1984), *Tabu I–IV* (1988), *Die Statik der Eselsbrücken* (Engineering Memory Bridges, 1990), *Herzsofort. Setzung* (Heart.

Instant(iation), 1994), *Loverfilm: An Uncontrolled Dispersion of Infor-
mation* (1996), and *Tabu V* (1998). With all his aliases, Brynntrup asks
us to ponder what the status of the subject is in the world of digital pro-
cessing and cyberspace. He himself has stated in an eerie, yet enchant-
ing metaphor: "Das Leben ist eine Silberscheibe" (Life is a silver disk).
And indeed, he has put his life work on a CD-ROM entitled *Netc.etera*
that links to his homepage. The project creates a *Gesamtkunstmedium,*[1]
a mammoth undertaking that is conceivable only via the new technol-
ogy of the Internet.

 Film theoretician D. N. Rodowick, in his recent book, *Reading the
Figural, or, Philosophy after the New Media,* has written:

> [T]he increasing velocity of information and the global reach of the
> electronic image world have made us all too aware of the gravity of
> our bodies—their slowness, fragility, and diminutive size, their vul-
> nerability to time and force. Thus what most widely defines the con-
> temporary cultural meaning of the virtual is an (illusory) sense of a
> becoming immaterial, not only of discourse but also of the body in
> its communicational exchanges, leading to a phenomenon that has
> been called "cyborg envy."[2]

Whether in his films, videos, CD-ROMs, or Internet art, Brynn-
trup's reproduced selves are schizophrenically metastasizing or self-
cloning, as if in an attempt to seize the immaterial, illusory body of
which Rodowick speaks—or to freeze it into an image with which the
self could then prosthestically identify. Yet such hopes are in vain:
Brynntrup takes to the limit the contingencies and disintegration of
natural appearances that the camera accomplishes and on which vir-
tual technologies capitalize. The transmission of data in high-tech cul-
ture demands ever increasing acceleration and dissolving of the previ-
ous image. As in all our virtual environments (whether in virtual reality
or on the Internet), everything is a process of ongoing, often enigmatic
screening. Cyborgesquely, Brynntrup presents himself as the sum of
ever mutating, disassembled image parts.

 To give one example: in *Herzsofort. Setzung,* via rephotography and
digital alteration, Brynntrup manipulates an already stylized image of
himself, transforming it to the rapid patter of a camera clicking, so that
we are left with the impression of the total, albeit virtuoso, mutability
of the subject-image. Brynntrup subtitles this work "autogenic manip-
ulations," a phrase not without masturbatory suggestion. His face is
cut into frames, rephotographed, rephotocopied, and rearranged like a
cubist puzzle that is set into motion via the pulse of the clicking camera

and a liquid, repetitious techno score by Jay Ray that sutures over each retake. The serialization draws us closer and closer into the face, forcing us to study it. Yet in the maelstrom, depth reverts into its opposite: sheer surface. Precisely because the human visage can be so malleable and anamorphically changed, our eyes are captivated by its two-dimensional image. It exerts a fascination not unlike the optical illusions of Baroque, allegorical still life.[3] In the process, nothing is revealed about the intimate self, although here as elsewhere in his films, Brynntrup puts himself on display.

And yet, what Brynntrup also performs is what Rodowick calls the gravity and fragility of our bodies. What makes Brynntrup so fascinating is this resistance to the virtual, cyborgesque self through the materiality of his own, unique body. Despite the digital morphing, he insists on inscribing his own body into his films, as if this gesture marks the very signature of his works. Signature? Originality? Authenticity? Creativity? This artist asks whether such terms have any meaning in an age fashioned by the simulacra and digital alteration, which mask any original referent. And he is not alone in engaging his own person as experiment in the new media: other German-speaking artists who do the same include Claudia Schillinger, Hans Scheirl and Ursula Pürrer, Pippilotti Rist, and Oliver Hussain. Bjørn Melhus also installs his self as a character into his films, this time from inside the TV monitor.

Unlike Brynntrup, Melhus does directly address issues of mass media and the indifferentiation of the global network, which is why I want to concentrate on him in this essay. He explores how we are disciplined by and yield to virtual worlds and electronic media, in which we float and are transported like Dorothy into the land of Oz. What he shares with Brynntrup is the demonstration of the tension between the desire for the cyborgesque, transmutable body and the resistance to it via the inscription of one's material self into one's art. As with Brynntrup, Melhus's very inventiveness militates against the reductiveness of the simulacra he illustrates. His individual creative expression counteracts the mass-produced consumer culture with which he engages. Insofar as he takes his own body as the object to be filmed and manipulated in its disguises and digitized remodelling, he enacts this tension between the technologized self and the ingenious self, between postmodern cloning and modernist self-reflexivity.

III

Born in 1966, Bjørn Melhus studied, as Brynntrup did, in Braunschweig with the experimental filmmaker Birgit Hein and has won several awards, prizes, and fellowships for his films. "Limboland" is what

he christened a recent retrospective of his films and videos. The title is apt, for Melhus suspends his ever-replicating doppelgänger inside virtual worlds. Because Melhus plays all roles himself, they are both doubles of himself and each other. All works from 1991 to the present Melhus playing various doppelgängers and lip-synching to a dubbed, reiterative soundtrack. These include *Das Zauberglas* (The Magic Glass, 1991, video, 6 min.), *Weit Weit Weg* (Far Far Away, 1995, 16mm, 39 min.), *No Sunshine* (1997, video and installation, 6 min., 15 sec., in loop), and *Again & Again / The Borderer* (1998, video and installation on eight monitors, 6 min., 15 sec., in loop), *Primetime* (2001, video installation, 20 min.), *The Oral Thing* (2001, video, 8 min.), *Auto Center Drive* (2003, 16 mm, 25 min.), and *Captain* (2005, video loop, 14 min.).

One of the first shots in *Das Zauberglas* is of a TV filled with humming static on its screen, cut to a close-up. The rest of the video explores how impossible any communication is via this medium, for the images and sounds it presents are as empty as this buzz. Melhus appears in black and white as a man shaving his head. His female incarnation emerges in color in the television set. She asks with stereotypical feminine concern and blank stupidity what he is doing and if it hurts. Their dialogue consists of snippets from a dubbed version of a kitschy 1950 American Western (*Broken Arrow,* dir. Delmer Daves). As gender roles are here predetermined, their communication is doomed from the start. Man and woman encounter their likenesses, their soul mates, only via television; they can perceive each other only via the proper gender roles television prescribes and rehearses ad nauseum. Because it is impossible to escape and lead an existence outside these roles, the woman touches the glass that she entraps her, as if she cannot move out of it. She calls it a "Zauberglas," in which she sees herself better than in a pool of water. Apparently the glass is not transparent enough for her to see her interlocutor, or her reflection prevents it. Her choice of phrasing ("darin sieht man sich") suggests that one never can perceive oneself outside the images television recycles. But these manufactured media images, in which one likes to recognize oneself (or, more properly, imagine seeing oneself), are lovely and captivating. The man responds to her that whenever she looks into the magical glass, it will reveal to her how beautiful she is.

According to the Lacanian *fort/da* logic of the Imaginary, when the joy at recognizing one's mirror image gives way to the disappointment of inevitably seeing distortion, the immaculate double has to disappear. The man cries out: "Don't go away" and "Wait" as she fades back into static. Notwithstanding, he claims that he is now happy since

he has met her. Indeed he has encountered in narcissistic jouissance only himself, that is, only what he wants to see and hear from a woman. As if to reinforce his blindness, at the close he covers his eyes and rubs them. Throughout, and typically for Melhus, phrases from the dialogue are repeated over and over, as if the characters were unable to be heard, were locked in language, or tried to force meaning from words they uselessly utter. Language, like the simulacric image, is empty reiteration. The other imitative actions of dubbing and lip-synching likewise point to the absence of any original, authentic discourse. These elements also underscore the discordance between image and sound—an allusion to the impossibility of a pure correspondence of the subject and its speech. Similarly, Melhus will never coincide with the doubles that he plays, no matter how they proliferate throughout his work. In all his work, Melhus thus plays wistful characters that seem to long for communication with their doubles but experience instead the trauma of separation.

In *Weit Weit Weg* Melhus again plays a female role—Dorothy from *The Wizard of Oz* (1939, dir. Victor Fleming), dressed in pigtails and a lime green bow and dress. Living in the lonely concrete, imprisoning world of German apartment blocks and TV antennae, with only a porcelain Toto to talk to and images of Lassie on TV, Dorothy longs to go "beyond the moon, beyond the rain, far, far away." She arrives there via a luminescent yellow phone that allows her to conjure up a replicant of herself across the ocean in New York. Her insipid phrases, "Hello, my name is Dorothy" and "It is wonderful," echo back to her, so that it seems, to her limited imagination, that she is carrying on a conversation. To compensate for the isolation the high-tech world creates, Dorothy can imagine that she is connected via her cell phone. It serves as her yellow brick (road). For this Dorothy (Dorothy 1) there is no place like her uncanny home for security; in fact, her needs for homeland security result in the walls of her apartment closing in on her as the film ends.

Meanwhile, Dorothy 2, dressed in a more masculine fashion with a baseball cap and a T-shirt that says "Dorothy," thrives on being in the new world. She squeals repeatedly, "Oooo Look!" and continues to reduplicate across the sea- and airwaves, finally to appear on *Prime Time News,* the Oz of the 1990s. TV news anchors introducing themselves with the phrase "My name is Dorothy," begin to mimic her. And, why not—for the formula "Hi, I'm Dan Rather, and this is the *CBS Evening News*" is copied on every network station, belying the intimacy and individuation that the personal name implies. Despite

Weit Weit Weg (Far Far Away, 1995, dir. Bjørn Melhus). (Reproduced by permission of the artist.)

the irreality of this simulacric existence, once inside the TV world, Dorothy 2 feels a sense of belonging, and she affirms to her TV audience, saying in Judy Garland's voice: "I'm not going to leave here ever, ever again, because I love you all." As her image proliferates over the airwaves and she becomes surrounded by look-alikes, she exclaims (again from *The Wizard of Oz*), "Oh, you're the best friends anybody's ever had, and it's funny but I feel like I've known you all the time, but I couldn't have, could I?" She forgets lonely Dorothy 1 back in Germany, indicating the erasure of Germany, or any other country, in the U.S. media interest. Instead Dorothy 2 participates in the euphoria of American de-differentiation and global dominance.

In his subsequent films, Melhus continues to play idiotic characters suspended in the never-never land of the media and echoing phrases

from it. For example, in *No Sunshine* he plays genderless, plastic twin dummies who float around like astronauts and lip-synch to snatches of "luv me . . . luv you" and "yeaaah" and "nooo," which are replayed sound bites from Stevie Wonder and the child Michael Jackson. The doubles gaze in narcissistic rapture at each other, echoing each other and singing, "You gonna look for me?" The one does not want the other to grow separate. Thus he begins to worry, as his double peers into a screen embedded behind them where two more twins, this time wearing skinlike suits, appear and act out aggression against each other. The doubling that occurs within Melhus's virtual, spaceless, telemediated realms always reveals a latent hatred and exercise of power that undercuts the seemingly innocuous harmony between look-alikes.

In *Again & Again,* the critique of the uniformity in consumer culture becomes even more biting: once more playing clones, Melhus lip-synchs to snippets of a discussion between two identical doubles of himself—one a saleswoman on the Shopping Network and the other an eager buyer. The saleswoman says, "Look at this . . . This is a great opportunity. . . . I tell you, this is true, this is real, it is not cosmetic." The camera pans to the prospective buyer, who asks, "Can I see that?" What is for sale is one's reduplication as "fabulous," "beautiful," and "perfect." Melhus demonstrates the emptiness of these phrases by applying them to the ridiculous scenario of peddling oneself. To the words "kill, kill, kill" the one figure holds a laser-like, green-leaf pod that gives birth to a clone. The process repeats itself again and again, to the point where multiple doubles gaze at each other in open admiration—an effect especially powerful in the installation version of the video, where several terminals are lined up together. The Shopping Network buyer is delighted and exclaims, "I'm in love with it," to which the saleswoman responds, "What's there not to love." The purchase of commodities serves to create homogeneity and thus happiness. We love ourselves insofar as we become, through commodity consumption, identical with the ideal image we see in television.

As in *No Sunshine,* Melhus videotapes himself inside the podlike world of the technosphere where he reproduces himself ad infinitum. He illustrates the passionless imitation of desire (which in consumer society can never be fulfilled, only copied) and which results in a series of undifferentiated human doubles. In all his films, the mimicry becomes sheer, hollow repetition, matched by Melhus's wonderful ability to put on an inane, expressionless smile. The composition of the soundtracks, too, by repeating fragments ad nauseum, points to the

deadening effect of the simulacrum. Repetition, of course, lies at the heart of the TV mode: commercials and reruns are shown over and over again. Melhus parodies the self-sameness inherent in the genre of the commercial. He also captures its shallowness. Hence the "reversible" clones flatten into two-dimensional boards when they turn around. The saleswoman describes the one side as "high polish, beautiful finish" and the other as "satin finish—a little bit quieter, a little bit more demure." In producing the same in the world of digital simulacra, it becomes impossible (both literally and figuratively) to make a difference: self-replication occurs without progress or purpose. Most importantly, Melhus shows how the commodity is sold via a form of technoculture. Here we have an example of what A. R. Stone has called "cyborg envy"—the dream of being transformed via technology. Hence, Melhus's character is not just any random consumer; she interactively manufactures her own body via the marvels of digital technology.

Repetition in the form of ritual pervades both the daytime talk show and televangelism. In his more recent works, *Primetime* and *The Oral Thing,* Melhus links the two, suggesting that both represent the culture of puerile fascination with the immoral and the spectacle as tribunal. Because *Primetime* is a complex, multiroomed installation that merits more attention than space here permits, I shall concentrate on the similarly themed, shorter piece, *The Oral Thing.* In this video, Melhus plays all roles and dubs the soundtrack from bits and pieces from the morning talk show *Maury.* He performs the talk-show host (portrayed here as a judgmental televangelist), the two warring participants, as well as a chorus of identical audience participants cloaked and hooded in a manner reminiscent of monks or even cloned grim reapers. The show starts with a fanfare, accompanied by the appearance of three intertwined silver, red, and green circles, evoking the fascist logo of a Krupp or Mercedes-Benz. Messiah-like, the silver-haired, white-robed televangelist descends a "staircase to heaven" to preside over the accusations between freakishly armless and legless sisters who are restrained in, respectively, green and red large plastic tubes. Like the logo, the iconography suggests the Trinity. The video initially appears to be a hilarious parody of such talk-show revelations of ugly family secrets, class and gender bias (the host being a wealthy white male and the participants sluttish black or white-trash women), and the shameless reveling in one's victim status. The tone, however, darkens as child sexual abuse is intimated in the snippets of dialogue, followed by the child-victim's admission of engaging in "the oral thing." Curiously, the taboo is first suggested by the participating chorus; as often occurs in

trials of day-care workers accused of satanic child molestation, words are put into the mouth of babes, although here the child is shamed for committing such a perversity. According to Michel Foucault, discourse delimits and precedes sex, and here too there is no originary act, only talk, however much the talk show as genre presumes the exhibition of real life. By abstracting, stylizing, and parodying elements from the talk show, Melhus unveils the repetitiveness and artificiality of the genre, an exhibition of surreal life, as it were.

In recent years, Melhus has moved from screening his work at small film festivals to exhibiting it in galleries, conceptualizing it as installation art. By moving out of the darkened space of the theater into the open space of a gallery where visitors come and go, he comments on how the spectacle defines the public sphere. Once in the gallery, the morning talk show appears outed, as if the confessions made on it should have been reserved for the privacy of home viewing. This transposition of the private raises the question of how the individual is defined today. A priori the individual is called into question, given that Melhus, by playing all roles, demonstrates one's cloning. But, more specifically, *The Oral Thing* suggests that the boundaries of the private are created by the public confession on television. The desire of the talk-show guests is to act out before a television audience and to gain self-importance by being watched, even if this means being under the judging gaze of others. One revels in being what the other fantasizes one to be. With the assignment of the roles of sexual abuser or abuse victim by a collective, one becomes somebody important, a TV celebrity. One's uniqueness is histrionically reified by staging one's hurt and hatred. The role of the talk-show host is to divulge the personal secrets of the individual. In *The Oral Thing* he asks, "Is that true?" thereby reducing truth to the banal revelation of sexual misconduct. Finally, the audience serves to reinforce and police the boundaries of the private by witnessing the confession of their transgression.

The comforting yet deadening effect of this world of telemediation is summed up well in the title for a catalog for the exhibition of Melhus's work in Saarbrücken and Göppingen: *Du bist nicht allein / You are not alone.* Melhus, however, repeatedly demonstrates that this direct, personal reassurance (to the "Du") is a false promise. Oz, of course, was a world of Technicolor, a rainbow of colors, and marked our first step over, out, and into a prestidigous high-tech parallel universe. From *Zauberglas* to *Auto Center Drive,*[4] Melhus's wistful, melancholic characters long to escape into virtual worlds, but they are predestined to encounter their own narcissistic depression on the other side. Longing

for communication with their doubles, they experience instead the trauma of separation. The elation one feels at finding a friend in cyberspace (Dorothy exclaims, "You're the best friend one has ever had"), soon gives way to alienation and redundancy. The delusion of phatic telepathy replaces actual communication. Dorothy's desires will never be fulfilled in the technological world and the limited spatial coordinates that it offers. Playing on the invisibility of high-tech and wireless communication, Melhus hangs his characters in *No Sunshine* and *Again & Again* in limbo, engulfed by a void. In *Weit Weit Weg,* the airwaves, humming with wireless transmission, claustrophobically surround Dorothy. In the economy of melancholy described by Sigmund Freud,[5] there is no way out of a system where, in narcissistic self-absorption, the lost object is never recognized as separate from the self. Instead, the ego interiorizes the loss, becoming impoverished and empty. Melhus not only plays all the roles in his works, but also entombs all personages into himself, such as the Smurfs of his childhood in *Blue Moon,* or the dead icons James Dean, Jim Morrison, and Janis Joplin in *Auto Center Drive,* while the impoverishment of the ego is displayed in the hollow redundancy of the doppelgänger. The world disappears into a black depressive backdrop, as in *Again & Again.* Unlike mourning, there is no end to the melancholy, as is mirrored in the video loop installation.

To be trapped within this void is to live inside the virtual environment. Anchors broadcast their names with a false intimacy as they enter our homes on the evening news. When Dorothy sighs, "There's no place like home," she refers to the familiarity and commonalty that TV lends as we sit cozily on the couch in our spectral, anaesthetized passivity. The coaxing voice from the Shopping Network, like a female confidante, offers the intimate help only a friend could provide ("OK, but you have to trust me"). But the sphere of consumption is depersonalized. Melhus's art reflects back to us how our own consumption relies on TV for the formation of our desires, which is to say, in his reversal of the metonymic categories of inside and out, prosthesis and self: we live our commodified selves as if we existed in TV. Like virtual reality, the environments Melhus creates have an uncanny autonomy of their own through which characters float and navigate. The fact that he acts in his own films further signifies how engulfed the subject is by technological culture. Melhus refuses to disengage himself from the morphed spaces that are his creation but representative of our techno-culture; in fact, he lodges himself within these spaces. The global network and the local thus seem to collapse and become undifferentiated.

Ironically, solitary home viewing becomes the primary site of interaction with the world, which is held at a distance and domesticated on the television monitor—hence the cocoonlike tubes in which Melhus's character transforms himself in *Again & Again.* In this safe world of the selfsame, there is no threat of implosion from the exterior world.

Melhus's posthuman characters, in the absence of personal development, morph in what Vivian Sobchack calls the "culture of quick-change."[6] In *Weit Weit Weg,* Melhus uses the narrative trope of the journey, but Dorothy (unlike her original) no longer matures. She actually never leaves home. Although his films are about autoregeneration, there is no sense of where this becoming leads. Thus in the continuous loop installations for *Again & Again* and *Primetime,* he aligns the monitors in a row, playing the same image. The homogenization of his replicants reinforces the slumbering state of their consciousness. Here Melhus points to the primitive trancelike quality of our lives in the technosphere.

Melhus also questions the false sense of agency in virtual environments. R. L. Rutsky has written, "[M]odernity and modern technology have always been haunted by an insistent return of the 'dead,' a return of what has been repressed by the instrumental or 'technological' view of the world."[7] The repetition compulsion embodies the death drive, seen in *Again & Again* through the coffin-shaped pods in which reproduction occurs or in *The Oral Thing* in the multiplied hooded faces, reminiscent of the grim reaper. Via the doubles that Melhus's Shopping Network patron creates for herself, Melhus alludes to what Lunenfeld has called the "narcissism inherent in contemporary technology,"[8] in which the so-called interactivity between user and terminal screen is actually self-absorption. These "pleasures of vicarious agency"[9] can also be seen in video games. Melhus makes fun of this simulation of agency in that the viewer of the Shopping Channel is given the choice to buy and thereby remake herself. Self-creation is therefore only simulated by self-replication and by confirmation to a preexisting axis. Since the rival sisters have no arms, hands, or lower body in *The Oral Thing,* they too lack the means of agency—their only sexuality must be orality, here represented as talk.

Where agency does occur, however, is on the level of the artist as performer. In speaking about new media genres, cultural critic Andrew Darley suggests that "even in its 'de-centered' guise, the idea of authorial freedom has become so attenuated by the workings of the system itself, that quite simply it is no longer an issue."[10] Darley could not be more wrong in the case of Melhus or Brynntrup. As if challenged by

Sobchack's "culture of quick-change," these artists master the morph by performing it themselves. Celia Lury has called our society a "Prosthetic Culture," and argues that we already live inside technology, that we don't just use it as a tool, but live within its constructed space (for instance, when we become agents in a video game or in virtual reality).[11] Melhus and Brynntrup would not pretend that one can disengage oneself from this incarcerating space—they physically implant themselves into it—but they also reflect critically on the medium, and, as in the modernist tradition, take (self-) representation as their very subject matter. They unravel the fabric of the simulacra itself—a singular accomplishment in an era of fake agency.

IV

A word on Melhus's unique brand of drag. In *Zauberglas* he dons a wig in contrast to the male double's baldness; in *Weit Weit Weg* Dorothy wears a bright green dress; in *Again & Again* he is merely wearing white male underwear that contrasts with his dubbed female voice. In all cases Melhus as performer makes no attempt to camouflage his biological sex or appear feminine. His costuming appears ludicrous, especially when he plays Dorothy in pigtails with a large green bow crowning her head. The drag does not enhance any sense of character or persona that Melhus would slip into. Instead, it seems to be inessential and arbitrary. Femininity resides primarily in the voice so that the discrepancy, as in *Weit Weit Weg,* is not just between male body and female dress, but also between the voice and body. To put it another way, Melhus underscores through the discordancy of dress the unnaturalness, deformity, and redundancy created by the technological media to which he submits himself. One could thus say that in this unconventional drag he takes on gender signifiers of the opposite sex in order to show the artificiality of gender construction in the media: it too is canned, consisting of snippets of phrases, as when Dorothy expresses domesticated femininity with the words "There's no place like home." In addition, the queerness of gender performance is no respite from the uniform world of TV and video. Drag, which usually emphasizes gender difference and transgression, here paradoxically reinforces the overwhelming sense of sameness and lethargy that Melhus signifies through his use of TV commercials and reruns of old film classics. Melhus reminds us that mimicry contains an element of undead replication; gender impersonation signifies redundancy and not the dynamism of playful performance that both Judith Butler and Margorie Garber highlight.[12]

Melhus's female, childlike, or even genderless roles also signal the passive abandonment we experience upon entrance into the virtual realm. Feminized, fluid, empathetic, excessive, and vulnerable (to, for example, the lures of the Shopping Network), one indulges in the pleasure of the interface. Plugged into a new world, flowing within it, the boundaries between genders are confused; Melhus can easily switch between them. In short, by becoming cyborgesque, he becomes female, with more permeable ego boundaries, so porous that his characters replicate themselves. Allucquère Roseanne Stone has written, "To become the cyborg, to put on the seductive and dangerous cybernetic space like a garment, is to put on the female."[13] But Melhus's travesty is ultimately disabling and not empowering, contra Stone. The canned female voice, as in *Weit Weit Weg* or *Again & Again,* clashes with the facticity of the male body, as if one's voice and desires are appropriated once they are technologically reproduced. The performance of gender dysphoria is not liberating; instead, it underscores the haunting, spectral quality of imitation. Melhus acts out the inability to pass as the opposite sex, thereby highlighting the discordance between the performing self and its role. As prosthetic devices, TVs, satellites, and cellular phones also point to deficiencies, to the incomplete body that relies on these hookups. Nor is Melhus's transvestism erotically tinged. Sexual reproduction is replaced by the cloning acts of *Again & Again.* In fact, the body itself disappears in *No Sunshine* under the fantastical suits he wears. He thereby raises the problem of embodiment in the virtual realm. But the half-naked body does resurface in *Again & Again;* its thereness, emphasized by the meager white underwear, clashes with the "high polish" and "satin finish" that the dubbed/dumb female voice advertises.

Melhus not only drags as female, he does so as an American. The voice-over hides his German accent and indicates that we have all become undifferentiated in a globalized American consumer culture: one's unique voice disappears. In closing, I want to speculate on the extent to which Melhus, from his vantage point as a German or European, comments on America. Like Dorothy 2, he transplanted himself to the United States. During his year at the California Institute of the Arts he produced *Again & Again,* while his works from 2001 and 2002 were made in New York. It is not unproblematic that he shares Baudrillard's fascination with and revulsion toward America.[14] Nor is it insignificant that Melhus maps onto the national difference the difference between his practice of high art and the lowest of popular entertainment. Yet I have also argued that Melhus depicts himself as insep-

arable from the virtual realm. While he engages in the ironic distancing of drag, he does incorporate the voice of the Other, thereby implying that he cannot extricate himself from American consumerism, nor from the cultural imperialism of daytime talk shows and prime-time news. He signifies the desire to merge with the American imaginary, conceivably because he stands as an outsider to it. Likewise, Melhus performs the inseparability of high and low culture. Will his German audience feel the same before his installations? One would hope that his work demonstrates clearly enough one's inextricable involvement in the matrix of telemediation, regardless of one's nationality. Rather than marking his difference as German, Melhus acknowledges and underscores the de-differentiation formed by the global networks of telecommunications and commodity culture. And while he recognizes that no images exist today outside the corporate media, his deployment of video and digital media for alternative art contests the former's hegemony. He thus illustrates the necessity of re-presenting mass media and the resourcefulness of such artistic intervention.[15]

Notes

1. I borrow this neologism from Peter Lunenfeld, *Snap to Grid: A User's Guide to Digital Arts, Media, and Culture* (Cambridge: MIT Press, 2001), 120ff. and 172.

2. D. N. Rodowick, *Reading the Figural, or, Philosophy after the New Media* (Durham: Duke University Press, 2001), 213.

3. One sees Brynntrup's indebtedness to Baroque allegorical iconography (and to Peter Greenaway) in *Orpheus—der Tragödie erster Theil* (Orpheus—First Part of the Tragedy, 1983–84), *Testamento memori* (1986), *Totentanz* (Death Dance, 1988), and *Narziss und Echo* (Narcissus and Echo, 1989).

4. In his *Auto Center Drive*, Melhus resurrects the characters of James Dean, Jim Morrison, and Janis Joplin, as if to suggest that those who die young in America never grow old but melancholically haunt its cultural imagination.

5. Sigmund Freud, "Trauer und Melancholie," *Studienausgabe* (Frankfurt am Main: Fischer, 1975), 3:193–212.

6. Vivian Sobchack, ed., *Meta-Morphing: Visual Transformation and the Culture of Quick-Change* (Minneapolis: University of Minnesota Press, 2000).

7. R. L. Rutsky, *High Technè: Art and Technology from the Machine Aesthetic to the Posthuman* (Minneapolis: University of Minnesota Press, 1999), 132.

8. Lunenfeld, *Snap to Grid,* 150.

9. Lunenfeld, *Snap to Grid,* 164.

10. Andrew Darley, *Visual Digital Culture: Surface Play and Spectacle in New Media Genres* (London: Routledge, 2000), 141.

11. Celia Lury, *Prosthetic Culture: Photography, Memory and Identity* (London: Routledge, 1998).

12. Judith Butler, *Bodies that Matter: On the Discursive Limits of "Sex"* (New York: Routledge, 1993); and Marjorie Garber, *Vested Interests: Cross-Dressing and Cultural Anxiety* (New York: Routledge, 1992).

13. Allucquère Roseanne Stone, "Will the Real Body Please Stand Up: Boundary Stories about Virtual Culture," *Cyberspace: First Steps,* ed. Michael Benedikt (Cambridge,: MIT Press, 1991), 105.

14. Jean Baudrillard, *America,* trans. Chris Turner (London: Verso, 1988).

15. Interested readers can further consult the essays included in the catalogs that have accompanied Bjørn Melhus's installations: *Departure-Arrival, Arrival-Departure* (Niedersächsisches Ministerium für Wissenschaft und Kultur, 1998–99); *Du bist nicht allein / You are not Alone,* ed. Bernd Schulz (Heidelberg: Kehrer, 2001); *Primetime* (Kunstverein Hannover, 2001); *Bjørn Melhus,* ed. Wulf Herzogenrath and Anne Buschhoff (Bremen: Hauschild, 2002).

Bibliography

Aciman, André. *Letters of Transit: Reflections on Exile, Identity, Language and Loss.* New York: New Press, 1990.

Adorno, Theodor W. "The Culture Industry: Enlightenment as Mass Deception." *Dialectic of Enlightenment.* By Theodor W. Adorno and Max Horkheimer. Trans. John Cumming. New York: Continuum, 1995. 120–67.

———. *Notes to Literature.* Trans. Shierry Weber Nicholsen. New York: Columbia University Press, 1991.

———. *Minima Moralia: Reflections From Damaged Life.* Trans. E. F. N. Jephcott. New York: Verso, 1974.

———. "Résumé über Kulturindustrie." *Gesammelte Schriften.* Frankfurt am Main: Suhrkamp 1977. 10:337–45.

Agawu, Kofi. "Representing African Music." *Critical Inquiry* 18.2 (1992): 245–66.

Althusser, Louis. "Cremonini, Painter of the Abstract." *"Lenin and Philosophy" and Other Essays.* Trans. Ben Brewster. London: New Left Books, 1971. 209–20.

Altmann, Rick. *Film/Genre.* Bloomington: Indiana University Press, 1999.

Ames, Eric. "The Sound of Evolution." *Modernisim/Modernity* 10.2 (2003): 297–325.

Appiah, Kwame Anthony. "Cosmopolitan Patriots." *Cosmopolitics: Thinking and Feeling Beyond the Nation.* Ed. Pheng Cheah and Bruce Robbins. Minneapolis: University of Minnesota, 1998. 91–114.

Ascheid, Antje. *Hitler's Heroines: Stardom and Womanhood in Nazi Cinema.* Philadelphia: Temple University Press, 2003.

Aurich, Rolf, and Ulrich Kriest, eds. *Der Ärger mit den Bildern: Die Filme von Harun Farocki.* Stuttgart: Europäisches Medienforum, 1998.

Bach, Steven. *Marlene Dietrich: Life and Legend.* New York: Da Capo, 1992.

Barlet, Olivier. "If Your Song is No Improvement on Silence, Keep Quiet!" *African Cinemas: Decolonizing the Gaze.* Ed. and trans. Chris Turner. London: Zed Books, 1996. 183–95.

Barton, Ruth. *Irish National Cinema.* London: Routledge, 2004.

Baudrillard, Jean. *America.* Trans. Chris Turner. London: Verso, 1988.

Baumann, Max Peter. "'Listening to the voices of indigenous peoples . . .' On traditional music as policy in intercultural encounters." *Echo der Vielfalt / Echoes of Diversity / Traditionelle Musik von Minderheiten / ethnischen Gruppen / Traditional Music of Ethnic Groups / Minorities.* Ed. Ursula Hemeteik. Vienna: Böhlau, 1996. 31–39.

Baumgärtel, Tilman. "Vom Guerillakino zum Essayfilm: Harun Farocki." Ph.D. diss., Heinrich-Heine Universität, 1997.

Beck, Ulrich. *Der kosmopolitische Blick oder: Krieg ist Frieden.* Frankfurt am Main: Suhrkamp, 2004.

Benjamin, Walter. *Illuminations: Essays and Reflections.* Trans. Harry Zohn. Ed. Hannah Arendt. New York: Schocken, 1969.

Bergfelder, Tim. "Between Nostalgia and Amnesia: Musical Genres in 1950s German Cinema." *Musicals: Hollywood and Beyond.* Ed. Bill Marshall and Robynn Stilwell. Exeter: Intellect Books, 2000. 80–88.

Bergfelder, Tim, Erica Carter, and Deniz Göktürk, eds. *The German Cinema Book.* London: British Film Institute, 2002.

Berghahn, Klaus L., Jürgen Fohrmann, and Helmut J. Schneider, eds. *Kulturelle Repräsentationen des Holocaust in Deutschland und den Vereinigten Staaten.* New York: Peter Lang, 2002.

Bergman, Paul, and Michael Astimow. *Reel Justice: The Courtroom Goes to the Movies.* Kansas City: Andrews and McKeel, 1997.

Berman, Russell A. *Enlightenment or Empire: Colonial Discourse in German Culture.* Lincoln: University of Nebraska Press, 1998.

———. "'The Recipient as Spectator': West German Film and Poetry of the Seventies." *German Quarterly* 55.4 (1982): 499–510.

Bessen, Ursula. *Trümmer und Träume. Nachkriegszeit und fünfziger Jahre auf Zelluloid. Deutsche Spielfilme als Zeugnisse ihrer Zeit. Eine Dokumentation.* Bochum: Studienverlag Dr. N. Brockmeyer, 1989.

Beyer, Frank. *Wenn der Wind sich dreht. Meine Filme, mein Leben.* Munich: Ullstein, 2001.

Blank, Les, and James Bogan, eds. *Burden of Dreams: Screenplay, Journals, Reviews, Photographs.* Berkeley: North Atlantic Books, 1984.

Blum, Heiko R., and Katharina Blum. *Gesichter des neuen deutschen Films.* Berlin: Parthas, 1997.

Braudy, Leo. Afterword. *Play It Again, Sam: Retakes on Remakes.* Ed. Andrew Horton and Stuart Y. McDougal. Berkeley and Los Angeles: University of California Press, 1998. 328–33.

Bresson, Robert. *Notes sur le cinématographe.* Paris: Éditions Gallimard, 1975.

Bronfen, Elisabeth. "Zwei deutsche Stars." *Filmmuseum Berlin.* Ed. Wolfgang Jacobsen et al. Berlin: Nicolai, 2000. 169–90.

Butler, Alison. *Women's Cinema: The Contested Screen.* London: Wallflower, 2002.

Butler, Judith. *Bodies that Matter: On the Discursive Limits of "Sex."* New York: Routledge, 1993.

Caprio, Temby. "Women's Cinema in the Nineties: *Abgeschminkt!* and *Happy Ends?*" *Seminar* 33.4 (1997): 374–86.

Cavell, Stanley. *Disowning Knowledge: In Six Plays of Shakespeare.* New York: Cambridge University Press, 1987.

———. *Pursuits of Happiness: The Hollywood Comedy of Remarriage.* Cambridge: Harvard University Press, 1981.

Cheah, Pheng, and Bruce Robbins, eds. *Cosmopolitics: Thinking and Feeling beyond the Nation.* Minneapolis: University of Minnesota, 1998.

Chernoff, John Miller. *African Rhythm and African Sensibility: Aesthetics and*

Social Action in African Musical Idioms. Chicago: University of Chicago Press, 1979.

Collins, Richard, and Vincent Porter. *WDR and the Arbeiterfilm: Fassbinder, Ziewer, and Others.* London: British Film Institute, 1981.

Comolli, Jean-Luc. "Historical Fiction: A Body Too Much." *Screen* 19.2 (1978): 41–53.

Connell, John, and Chris Gibson. *Sound Tracks: Popular Music, Identity and Place.* London: Routledge, 2003.

Corrigan, Timothy. *A Cinema Without Walls: Movies and Culture After Vietnam.* New Brunswick, NJ: Rutgers University Press, 1991.

———. *New German Film: The Displaced Image.* Austin: University of Texas Press, 1983.

Crofts, Stephen. "Concepts of National Cinema." *The Oxford Guide to Film Studies.* Ed. John Hill and Pamela Church Gibson. Oxford: Oxford University Press, 1998. 385–94.

Crowe, Cameron. *Conversations with Wilder.* New York: Knopf, 1999.

Custen, George F. *Bio/Pics: How Hollywood Constructed Public History.* New Brunswick, NJ: Rutgers University Press, 1992.

Darley, Andrew. *Visual Digital Culture: Surface Play and Spectacle in New Media Genres.* London: Routledge, 2000.

Davidson, John E. "As Others Put Plays upon the Stage: Aguirre, Neocolonialism, and the New German Cinema." *New German Critique* 60 (Fall 1993): 101–30.

———. *Deterritorializing the New German Cinema.* Minneapolis: University of Minnesota Press, 1999.

de Lauretis, Teresa. "Rethinking Women's Cinema: Aesthetic and Feminist Theory." *Issues in Feminist Film Criticism.* Ed. Patricia Erens. Bloomington: Indiana University Press, 1990. 140–61.

Deleuze, Gilles. *Cinema 2: The Time-Image.* Minneapolis: University of Minnesota Press, 1994.

de Man, Paul. *Allegories of Reading: Figural Language in Rousseau, Nietzsche, Rilke, and Proust.* New Haven: Yale University Press, 1979.

Dietrich, Marlene. *Marlene Dietrich's ABC.* Garden City, NY: Doubleday, 1961.

Dillmann-Kühn, Claudia. *Artur Brauner und die CCC: Filmgeschäft, Produktionsalltag, Studiogeschichte 1946–1990.* Frankfurt am Main: Deutsches Filmmuseum, 1990.

Dimendberg, Edward. "The Will to Motorization: Cinema, Highways, and Modernity." *October* 75 (1995): 91–137.

Diner, Dan. "Über Schulddiskurse und andere Narrative. Epistemologisches zum Holocaust." *Bruchlinien: Tendenzen der Holocaustforschung.* Ed. Gertrud Koch. Cologne: Böhlau, 1999. 61–84.

Doane, Mary Ann. *The Desire to Desire: The Woman's Film of the 1940s.* Bloomington: Indiana University Press, 1987.

Doneson, Judith. *The Holocaust in American Film.* Philadelphia: Jewish Publication Society, 1987.

Eisner, Lotte. *The Haunted Screen.* Trans. R. Greaves. Berkeley and Los Angeles: University of California Press, 1979.

Elsaesser, Thomas. "Ethnicity, Authenticity, and Exile: A Counterfeit Trade? German Filmmakers and Hollywood." *Home, Exile, Homeland: Film, Media, and the Politics of Place.* Ed. Hamid Naficy. New York: Routledge, 1999. 97–123.

———. "Die Gegenwärtigkeit des Holocausts im Neuen Deutschen Film—am Beispiel Alexander Kluge." *Die Vergangenheit in der Gegenwart: Konfrontationen mit den Folgen des Holocaust im deutschen Nachkriegsfilm.* Ed. Deutsches Filminstitut. Munich: Edition Text und Kritik, 2001. 54–67.

———. "A German Ancestry to Film Noir?" *Iris* 12 (1996): 129–44.

———. *New German Cinema: A History.* New Brunswick, NJ: Rutgers University Press, 1989.

———. "Postmodernism as Mourning Work." *Screen* 42.2 (2001): 193–201.

———. "Tarnformen der Trauer: Herbert Achternbuschs *Das letzte Loch.*" *Lachen über Hitler: Auschwitz-Gelächter? Filmkomödie, Satire und Holocaust.* Ed. Margrit Frölich, Hanno Loewy, and Heinz Steinert. Munich: Edition Text und Kritik, 2003. 155–80.

———. *Weimar Cinema and After: Germany's Historical Imaginary.* London: Routledge, 2000.

———, ed. *Harun Farocki: Working on the Sight-Lines.* Amsterdam: Amsterdam University Press, 2004.

El-Tayeb, Fatima. *Schwarze Deutsche: Der Diskurs um Rasse und nationale Identität, 1890–1933.* Frankfurt am Main: Campus Verlag, 2001.

Farocki, Harun. *Nachdruck/Imprint, Texte/Writings.* New York: Lukas and Sternberg, 2001.

Fehrenbach, Heide. "Rehabilitating the Fatherland: Race and German Remasculinization." *Signs* 24 (1998): 107–28.

Feuer, Jane. *The Hollywood Musical.* 2nd ed. Houndmills: Macmillan, 1993.

Flinn, Caryl. "Embracing Kitsch: Werner Schroeter, Music and *The Bomber Pilot.*" *Film Music: Critical Approaches.* Ed. Kevin Donnelly. Edinburgh: Edinburgh University Press, 2001. 129–51.

Foucault, Michel. "What Is An Author?" *Textual Strategies.* Ed. Josué V. Harari. Ithaca, NY: Cornell University Press, 1979. 141–60.

Fox, Thomas C. *Stated Memory: East Germany and the Holocaust.* Rochester: Camden House, 1999.

Freud, Sigmund. *Collected Works.* Ed. James Strachey. London: Hogarth Press, 1959.

———. *The Interpretation of Dreams.* 3rd ed. New York: Avon, 1998.

Frieden, Sandra, Richard W. McCormick, Vibeke R. Petersen, and Laurie Melissa Vogelsang, eds. *Gender and German Cinema: Feminist Interventions.* 2 vols. Providence, RI: Berg, 1993.

Friedrich, Otto. *City of Nets: A Portrait of Hollywood in the 1940s.* Berkeley and Los Angeles: University of California Press, 1986.

Garber, Marjorie. *Vested Interests: Cross-Dressing and Cultural Anxiety.* New York: Routledge, 1992.

Gauß, Karl-Markus. "Was ich aus eigenem nicht zu sehen vermag. Zu *Funny Games, Die Schuld der Liebe* und *Jugofilm.*" *Meteor* (March 1998): 53–63.

Gemünden, Gerd. "Space Out of Joint: Ernst Lubitsch's *To Be or Not to Be.*" *New German Critique* 89 (Spring–Summer 2003): 59–80.

Gersdorf, Catrin. "Globalization and Cultural Ecology: Race, Space, and the American Desert." Ph.D. diss., University of Leipzig, 2002.

Glaser, Hermann. *Kulturgeschichte der Bundesrepublik Deutschland.* Munich: Hanser, 1985.

Gorbman, Claudia. *Unheard Melodies: Narrative Film Music.* Bloomington: Indiana University Press, 1987.

Goudet, Stéphane. "Code inconnu. La main tendue." *Positif* 478 (December 2000): 23–29.

Hagener, Malte, and Jens Hans, eds. *Als die Filme laufen lernten: Innovation und Tradition im Musikfilm 1928–1938.* Munich: Edition Text und Kritik, 1999.

Hake, Sabine. *German National Cinema.* London: Routledge, 2002.

———. "Mapping the Native Body: On Africa and the Colonial Film in the Third Reich." *The Imperialist Imagination: German Colonialism and Its Legacy.* Ed. Sara Friedrichsmeyer, Sara Lennox, and Susanne Zantop. Ann Arbor: University of Michigan Press, 1998. 163–88.

———. *Popular Cinema of the Third Reich.* Austin: University of Texas Press, 2002.

Hall, Stuart. "New Ethnicities." *Stuart Hall: Critical Dialogues in Cultural Studies.* Ed. David Morley and Kuan-Hsing Chen. London: Routledge, 1996. 441–49.

Halle, Randall. "'Happy Ends' to Crises of Heterosexual Desire: Toward a Social Psychology of Recent German Comedies." *Camera Obscura* 44 (2000): 1–40.

Haneke, Michael. "Interview mit Michael Haneke." *La Quinzaine des Réalisateurs* (1994): 5–7.

———. "Terror and Utopia of Form. Addicted to Truth: A Film Story about Robert Bresson's *Au hazard Balthazar.*" *Robert Bresson.* Trans. Robert Gray. Ed. James Quandt. Toronto: Cinematheque Ontario, 1998. 551–59.

Hardt, Michael, and Paolo Negri. *Empire.* Cambridge: Harvard University Press, 2000.

Hariman, Robert. "Performing the Laws: Popular Trials and Social Knowledge." *Popular Trials: Rhetoric, Mass Media, and the Law.* Ed. Robert Hariman. Tuscaloosa: University of Alabama Press, 1990. 17–30.

Harris, Thomas. *Courtroom's Finest Hour in American Cinema.* Metuchen, NJ: Scarecrow Press, 1987.

Hart, Mickey. *Drumming at the Edge of Magic.* San Francisco: HarperCollins, 1990.

———. *Planet Drum: A Celebration of Percussion and Rhythm.* San Francisco: HarperCollins, 1991.

Hayward, Susan. *French National Cinema.* London: Routledge, 1993.

Herzog, Dagmar. "'Pleasure, Sex, and Politics Belong Together': Post-Holocaust Memory and the Sexual Revolution in West Germany." *Critical Inquiry* 24.2 (1998): 393–444.

Herzogenrath, Wulf, and Anne Buschhoff, eds. *Bjørn Melhus.* Bremen: Hauschild, 2002.

Hirsch, Marianne. *Family Frames: Photography, Narrative, and Postmemory.* Cambridge: Harvard University Press, 1997.

Hochman, Stanley, ed. *The Blue Angel: The Novel by Heinrich Mann. The Film by Josef von Sternberg.* New York: Ungar, 1979.

Hoffman, Eva. *Lost in Translation: A Life in a New Language.* New York: Penguin, 1990.

Hollaender, Friedrich. *Menschliches Treibgut.* Bonn: Weidle, 1995.

Horak, Jan-Christopher. "German Exile Cinema, 1933–1950." *Film History* 8 (1996): 373–89.

Houellebecq, Michel. *The Elementary Particles.* Trans. Frank Wynne. New York: Vintage, 2000.

———. *Les particules élémentaires.* Paris: Flammarion, 1998.

Huyssen, Andreas. *Present Pasts: Urban Palimpsests and the Politics of Memory.* Stanford: Stanford University Press, 2003.

Jameson, Fredric. "Notes on Globalization as a Philosophical Issue." *The Cultures of Globalization.* Ed. Fredric Jameson and Masao Mitoshi. Durham: Duke University Press, 1998. 54–77.

Jansen, Wolfgang. *Glanzrevuen der zwanziger Jahre.* Berlin: Edition Hentrich, 1992.

Jary, Micaela. *Traumfabriken made in Germany: Die Geschichte des deutschen Nachkriegsfilms 1945–1960.* Berlin: Edition Q, 1993.

Johnston, Claire. "Women's Cinema as Counter Cinema." *Movies and Methods I.* Ed. Bill Nichols. Berkeley and Los Angeles: University of California Press, 1976. 208–17.

Kaes, Anton. *From "Hitler" to "Heimat": The Return of History as Film.* Cambridge: Harvard University Press, 1989.

———. "German Cultural History and the Study of Film: Ten Theses and a Postscript." *New German Critique* 65 (1995): 47–58.

———. "Holocaust and the End of History: Postmodern Historiography in Cinema." *Probing the Limits of Representation.* Ed. Saul Friedlander. Cambridge: Harvard University Press, 1992. 206–22.

Kalinak, Kathryn. *Settling the Score: Music and the Classical Hollywood Film.* Madison: University of Wisconsin Press, 1992.

Kaplan, Caren. *Questions of Travel: Postmodern Discourses of Displacement.* Durham: Duke University Press, 1996.

Kaplan, E. Ann. *Women and Film: Both Sides of the Camera.* London: Routledge and Kegan Paul, 1982.

Karasek, Hellmuth. *Billy Wilder: Eine Nahaufnahme.* Munich: Heyne, 1995.

Kassabian, Anahid. *Hearing Film: Tracking Identifications in Contemporary Hollywood Film Music.* London: Routledge, 2001.

Kästner, Erich. "Das doppelte Lottchen." *Werke.* Hamburg: Carl Hanser Verlag, 1998. 13:163–245.

Kater, Michael H. *Different Drummers: Jazz in the Culture of Nazi Germany.* New York: Oxford University Press, 1992.

Klooss, Reinhard, and Thomas Reuter. *Körperbilder: Menschenornamente in Revuetheater und Revuefilm.* Frankfurt am Main: Syndikat, 1980.

Knopp, Guido. *Hitlers Frauen und Marlene.* Munich: Bertelsmann, 2001.

Knorr, Wolfram. "Trilogie der Vereisung." *Profil* 40 (October 1994): 117–18.

Koch, Gertrud. *Die Einstellung ist die Einstellung: Visuelle Konstruktionen des Holocaust.* Frankfurt am Main: Suhrkamp, 1992.

———. "Exorcised: Marlene Dietrich and German Nationalism." *Women and*

Film: A Sight and Sound Reader. Ed. Pam Cooke and Philip Dodd. Philadelphia: Temple University Press, 1993. 10–15.

———. "Wir tanzen in den Urlaub. Musikfilm als Betriebsausflug." *Filme* 3 (1980): 24–29.

Koebner, Thomas. "Caligaris Wiederkehr in Hollywood? Stummfilm-Expressionismus, 'Filmemigranten' und Film noir." *Innen-Leben: Ansichten aus dem Exil.* Ed. Hermann Haarmann. Berlin: Fannei & Walz, 1995. 107–19.

Koepnick, Lutz. "Colonial Forestry: Sylvan Politics in Werner Herzog's *Aguirre* and *Fitzcarraldo.*" *New German Critique* 60 (Fall 1993): 133–59.

———. "Consuming the Other: Identity, Alterity, and Contemporary German Cinema." *Camera Obscura* 15.2 (2000): 41–73.

———. *The Dark Mirror: German Cinema between Hitler and Hollywood.* Berkeley and Los Angeles: University of California Press, 2002.

———. "Reframing the Past: Heritage Cinema and Holocaust in the 1990s." *New German Critique* 87 (Fall 2002): 47–82.

Kosta, Barbara. "*Everything Will Be Fine:* An Interview with Fatima El-Tayeb." *Women in German Yearbook* 18 (2002): 31–44.

Kracauer, Siegfried. *From Caligari to Hitler: A Psychological History of the German Film.* Princeton: Princeton University Press, 1947.

———. *Das Ornament der Masse.* Frankfurt am Main: Suhrkamp, 1963.

Kramer, Karen Ruoff. "Representations of Work in the Forbidden DEFA Films of 1965." *DEFA: East German Cinema 1946–1992.* Ed. Sean Allen and John Sanford. New York: Berghahn, 1999. 131–45.

Kratzer-Juilfs, Silvia. "Return, Transference, and the Constructedness of Experience in German/Turkish Documentary Film." *Feminism and Documentary.* Ed. D. Waldman and J. Walker. Minneapolis: University of Minnesota Press, 1999. 187–201.

Kreimeier, Klaus. *The UFA Story: A History of Germany's Greatest Film Company, 1918–1945.* Trans. R. and R. Kimber. New York: Hill and Wang, 1996.

Kristeva, Julia. *Fremde sind wir uns selbst.* Trans. Xenia Rajewsky. Frankfurt am Main: Suhrkamp, 1990.

Kuhn, Annette. *Women's Pictures: Feminism and Cinema.* 2nd ed. London: Verso, 1994.

Laduke, Winona. *Last Standing Woman.* Stillwater, MN: Voyageur Press, 1997.

Lally, Kevin. *Wilder Times: The Life of Billy Wilder.* New York: Holt, 1996.

Lane, Anthony. "The Great Divide: Unsettling Pictures of Parisian Life." *New Yorker,* December 3, 2001, 105–08.

Laster, Kathy, with Krista Breckweg and John King. *The Drama of the Courtroom.* Sidney: Federation Press, 2000.

Leppert, Richard, and Susan McClary, eds. *Music and Society: The Politics of Composition, Performance, and Reception.* New York: Cambridge University Press, 1987.

Lukács, Georg. "On the Nature and Form of the Essay: A Letter to Leo Popper." *Soul and Form.* Trans. Anna Bostock. Cambridge: MIT Press, 1978. 1–18.

Lunenfeld, Peter. *Snap to Grid: A User's Guide to Digital Arts, Media, and Culture.* Cambridge: MIT Press, 2001.

Lury, Celia. *Prosthetic Culture: Photography, Memory and Identity.* London: Routledge, 1998.

Lutz-Kopp, Elisabeth. *"Nur wer Kind bleibt . . ." Erich Kästner-Verfilmungen.* Frankfurt am Main: Bundesverband Jugend und Film e.V., 1993.

Maase, Kaspar. "Freizeit." *Die Bundesrepublik Deutschland: Geschichte in drei Bänden.* Ed. Wolfgang Benz. Frankfurt am Main: Fischer, 1983. 2:209–33.

Mennel, Barbara, and Amy Ongiri. "In a Desert Somewhere between Disney and Las Vegas: The Fantasy of Interracial Harmony and American Multiculturalism in Percy Adlon's *Bagdad Café*." *Camera Obscura* 44 (2000): 150–75

Metelmann, Jörg. *Zur Kritik der Kino-Gewalt: Die Filme von Michael Haneke.* Munich: Wilhelm Fink, 2003.

Mintz, Alan. *Popular Culture and the Shaping of Holocaust Memory in America.* Seattle: University of Washington Press, 2000.

Moeller, Robert. *War Stories: The Search for a Usable Past in the Federal Republic of Germany.* Berkeley and Los Angeles: University of California Press, 2001.

Mulvey, Laura. *Visual and Other Pleasures.* Bloomington: Indiana University Press, 1989.

Naficy, Hamid. *The Accented Cinema: Exile and Diasporic Filmmaking.* Princeton: Princeton University Press, 2001.

———, ed. *Home, Exile, Homeland: Film, Media, and the Politics of Place.* New York: Routledge, 1999.

———. *The Making of Exile Culture: Iranian Television in Los Angeles.* Minneapolis: University of Minnesota Press, 1993.

Naqvi, Fatima. "Opfer. Zur strukturellen Gewalt in den Filmen Michael Hanekes." *Ich kannte den Mörder wußte nur nicht wer er war: Zum Kriminalroman der Gegenwart.* Ed. Friedbert Aspetsberger and Daniela Strigl. Innsbruck: Studienverlag, 2004. 171–88.

Naremore, James. *Acting in the Cinema.* Berkeley and Los Angeles: University of California Press, 1988.

Neale, Stephen. *Genre and Hollywood.* New York: Routledge, 2000.

———. "Questions of Genre." *Film Genre Reader II.* Ed. Barry Keith Grant. Austin: University of Texas Press, 1995. 159–83.

Negt, Oskar, and Alexander Kluge. *Geschichte und Eigensinn.* Frankfurt am Main: Zweitausendeins, 1981.

———. *Maßverhältnisse des Politischen: 15 Vorschläge zum Unterscheidungsvermögen.* Frankfurt am Main: Fischer, 1992.

———. *Öffentlichkeit und Erfahrung: Zur Organisationsanalyse von bürgerlicher und proletarischer Öffentlichkeit.* Frankfurt am Main: Suhrkamp, 1972.

Neumann, Carl, Curt Belling, and Hans-Walther Betz. *Film-"Kunst," Film-Kohn, Film-Korruption.* Berlin: Scherping, 1937.

Neutsch, Erich. *Spur der Steine.* Leipzig: Faber & Faber, 1996.

Niethammer, Lutz. "'Normalization' in the West: Traces of Memory Leading Back into the 1950s." *The Miracle Years: A Cultural History of West Germany, 1949–1968.* Ed. Hanna Schissler. Princeton: Princeton University Press, 2001. 237–65.

Oksiloff, Assenka. *Picturing the Primitive: Visual Culture, Ethnography, and Early German Cinema.* New York: Palgrave, 2001.

O'Regan, Tom. *Australian National Cinema.* London: Routledge, 1996.

Pavsek, Christoper. "History and Obstinacy: Negt and Kluge's Redemption of Labor." *New German Critique* 68 (Spring–Summer 1996): 137–63.

Penley, Constance. *Feminism and Film Theory.* New York: Routledge, 1988.

Petro, Patrice. *Aftershocks of the New: Feminism and Film History.* New Brunswick, NJ: Rutgers University Press, 2002.

———. *Joyless Streets: Women and Melodramatic Representation in Weimar Germany.* Princeton: Princeton University Press, 1989.

Petri, Rolf. "Deutsche Heimat 1850–1950." *Comparativ: Leipziger Beiträge zur Universalgeschichte und vergleichenden Gesellschaftsforschung* 11 (2001): 77–127.

Pfannenschmidt, Christian, and Joseph Vilsmaier. *Marlene. Der Film.* Hamburg: Europa, 2000.

Pirtschtat, Jutta, ed. *Die Wirklichkeit der Bilder: Der Filmemacher Hartmut Bitomsky.* Essen: Filmwerkstatt, 1992.

Poiger, Ute. "A New 'Western' Hero? Reconstructing German Masculinity in the 1950s." *The Miracle Years: A Cultural History of West Germany, 1949–68.* Ed. Hanna Schissler. Princeton: Princeton University Press, 2001. 412–27.

Postone, Moishe. *Time, Labor, and Social Domination: A Reinterpretation of Marx's Critical Theory.* Cambridge: Cambridge University Press, 1993.

Projektgruppe deutscher Heimatfilm. *Der deutsche Heimatfilm: Bildwelten und Weltbilder.* Tübingen: Tübinger Vereinigung für Volkskunde e.V., 1989.

Redmond, Layne. *When the Drummers Were Women: A Spiritual History of Rhythm.* New York: Three Rivers, 1997.

Reid, J. H. "Erich Neutsch's *Spur der Steine:* The Book, the Play, the Film." *Geist und Macht: Writers and the State in the GDR.* Ed. Axel Goodbody and Dennis Tate. Amsterdam: Rodopi, 1991. 58–67.

Reitz, Edgar. *Bilder in Bewegung: Essays, Gespräche zum Kino.* Reinbek bei Hamburg: Rowohlt, 1995.

Rentschler, Eric. "From New German Cinema to the Post-Wall Cinema of Consensus." *Cinema and Nation.* Ed. Mette Hjort and Scott Mackenzie. London: Routledge, 2000. 260–77.

———. *German Cinema in the Course of Time.* Bedford Hills: Redgrave, 1984.

———. *The Ministry of Illusion: Nazi Cinema and Its Afterlife.* Cambridge: Harvard University Press, 1996.

———. "Springtime for Ufa." *Quarterly Review of Film & Video* 15.2 (1994): 75–87.

Rich, B. Ruby. *Chick Flicks: Theories and Memories of the Feminist Film Movement.* Durham: Duke University Press, 1998.

Rieke, Christiane. *Feministische Filmtheorie in der Bundesrepublik Deutschland.* Frankfurt am Main: Peter Lang, 1998.

Riva, Maria. *Marlene Dietrich by Her Daughter.* New York: Knopf, 1992.

Robbins, Bruce. *Feeling Global: Internationalism in Distress.* New York: New York University Press, 1999.

Rodowick, D. N. *Reading the Figural, or, Philosophy after the New Media.* Durham: Duke University Press, 2001.

Rosen, Philip. *Change Mummified: Cinema, Historicity, Theory.* Minneapolis: University of Minnesota Press, 2001.

Ross, Kristin. *Fast Cars, Clean Bodies: Decolonization and the Reordering of French Culture.* Cambridge: MIT Press, 1995.

Rosta, Andrea, ed. *Werner Herzog in Bamberg.* Bamberg: Universität Bamberg, 1986.

Rupp, Hans Karl. "'Wo es aufwärts geht, aber nicht vorwärts . . .': Politische Kultur, Staatsapparat, Opposition." *Die fünfziger Jahre: Beiträge zu Politik und Kultur.* Ed. Dieter Bänsch. Tübingen: Narr, 1985.

Rushdie, Salman. *Imaginary Homelands: Essays and Criticism, 1981–1991.* New York: Penguin, 1991.

Rutsky, R. L. *High Technè: Art and Technology from the Machine Aesthetic to the Posthuman.* Minneapolis: University of Minnesota Press, 1999.

Sahl, Hans. *Memoiren eines Moralisten.* Munich: DTV, 1990.

Said, Edward. "Reflections on Exile." *Out There: Marginalization and Contemporary Culture.* Ed. Russell Ferguson et al. Cambridge: MIT Press, 1990. 357–66.

Santner, Eric. *Stranded Objects: Mourning, Memory, and Film in Postwar Germany.* Ithaca, NY: Cornell University Press, 1990.

Schaarschmidt, Ilka, ed. *Hartmut Bitomsky: Kinowahrheit.* Berlin: Vorwerk 8, 2003.

Schenk, Ralf, ed. *Regie: Frank Beyer.* Berlin: Hentrich, 1995.

Schildt, Axel, and Arnold Sywottek. *Modernisierung im Wiederaufbau: Die westdeutsche Gesellschaft der 50er Jahre.* Bonn: Dietz, 1998.

———, eds. "'Reconstruction' and 'Modernization': West German Social History during the 1950s." *West Germany under Construction: Politics, Society, and Culture in the Adenauer Era.* Ed. Robert Moeller. Ann Arbor: University of Michigan Press, 1997. 413–43.

Schlant, Ernestine. *The Language of Silence: West German Literature and the Holocaust.* New York: Routledge, 1999.

Schlossmann, Beryl. *The Orient of Style: Modernist Allegories of Conversion.* Durham: Duke University Press, 1991.

Schmieding, Walter. *Kunst oder Kasse: Der Ärger mit dem deutschen Film.* Hamburg: Rütten & Loening, 1961.

Schrader, Paul. *Transcendental Style in Film: Ozu, Bresson, Dreyer.* Berkeley and Los Angeles: University of California Press, 1972.

Schulte-Sasse, Linda. *Entertaining the Third Reich: Illusions of Wholeness in Nazi Cinema.* Durham: Duke University Press, 1996.

Schulz, Bernd, ed. *Du bist nicht allein / You are not Alone.* Heidelberg: Kehrer, 2001.

Schwarz, Hans-Peter. *Die Ära Adenauer: Gründerjahre der Republik 1949–1957.* Stuttgart: DVA, 1981.

Seeßlen, Georg. "Der Heimatfilm: Zur Mythologie eines Genres." *Der Sprung im Spiegel: Filmisches Wahrnehmen zwischen Fiktion und Wirklichkeit.* Ed. Christa Blümlinger. Vienna: Sonderzahl, 1990. 342–62.

Seidl, Claudius. *Der deutsche Film der fünfziger Jahre.* Munich: Wilhelm Heyne, 1987.

Senocak, Zafer. *Atlas of a Tropical Germany: Essays on Politics and Culture, 1990–1998.* Trans. and ed. Leslie Adelson. Lincoln: University of Nebraska Press, 2000.

Shandley, Robert R. "Rubble Canyons: *Die Mörder sind unter uns* and the West-ern." *German Quarterly* 74.2 (2001): 132–47.

Shaw, Robert. *The Man in the Glass Booth.* New York: Harcourt Brace, 1967.

Shohat, Ella, and Robert Stam. *Unthinking Eurocentrism: Multiculturalism and the Media.* New York: Routledge, 1994.

Shore, Elliott. "Gained in Translation: Hollywood Films, German Publics." *The German-American Encounter: Conflict and Cooperation between Two Cultures, 1800–2000.* Ed. Frank Trommler and Elliott Shore. New York: Berghahn Books, 2001. 285–91.

Sieg, Katrin. *Ethnic Drag: Performing Race, Nation, Sexuality in Postwar Germany.* Ann Arbor: University of Michigan Press, 2002.

Sikov, Ed. *On Sunset Boulevard: The Life and Times of Billy Wilder.* New York: Hyperion, 1998.

Silberman, Marc. "What is German in the German Cinema?" *Film History* 8 (1996): 297–315.

Silverman, Kaja. *The Acoustic Mirror: The Female Voice in Psychoanalysis and Cinema.* Bloomington: Indiana University Press, 1988.

Silverman, Kaja, and Harun Farocki. *Speaking about Godard.* New York: New York University Press, 1998.

Slane, Andrea. *A Not So Foreign Affair: Fascism, Sexuality, and the Cultural Rhetoric.* Durham: Duke University Press, 2001.

Sloterdijk, Peter. *Die Verachtung der Massen: Versuch über Kulturkämpfe in der modernen Gesellschaft.* Frankfurt am Main: Suhrkamp, 2000.

Sobchack, Vivian, ed. *Meta-Morphing: Visual Transformation and the Culture of Quick-Change.* Minneapolis: University of Minnesota Press, 2000.

Sontag, Susan. "Reflections on *The Deputy.*" *Against Interpretations and Other Essays.* New York: Dell Publishing, 1967. 124–31.

Sorlin, Pierre. *Italian National Cinema, 1896–1996.* London: Routledge, 1996.

Spieker, Markus. *Hollywood unterm Hakenkreuz. Der amerikanische Spielfilm im Dritten Reich.* Trier: Wissenschaftlicher Verlag, 1999.

Steingröver, Reinhild, and Patricia Mazon, eds. *Not So Plain as Black and White: Afro-German History and Culture from 1890–2000.* Binghamton: SUNY Press, 2002.

Stern, Frank. "Film in the 1950s: Passing Images of Guilt and Responsibility." *The Miracle Years: A Cultural History of West Germany, 1949–1968.* Ed. Hanna Schissler. Princeton: Princeton University Press, 2001. 266–80.

Stone, Allucquère Roseanne. "Will the Real Body Please Stand Up: Boundary Stories about Virtual Culture." *Cyberspace: First Steps.* Ed. Michael Benedikt. Cambridge: MIT Press, 1991. 81–118.

Street, Sarah. *British National Cinema.* London: Routledge, 1997.

Südbeck, Thomas. "Motorisierung, Verkehrsentwicklung und Verkehrspolitik in Westdeutschland in den 50er Jahren." *Modernisierung im Wiederaufbau: Die westdeutsche Gesellschaft der 50er Jahre.* Ed. Alex Schildt and Arnold Sywottek. Bonn: Dietz, 1998. 170–87.

Sywottek, Arnold. "From Starvation to Excess? Trends in Consumer Society from the 1940s to the 1970s." *The Miracle Years: A Cultural History of West Germany,*

1949–1968. Ed. Hanna Schissler. Princeton: Princeton University Press, 2001. 341–58.

Thiele, Martina. "Publizistische Kontroversen über den Holocaust im Film." Ph.D. diss., University of Göttingen, 2000.

Thompson, Michael. *Rubbish Theory: The Creation and Destruction of Value.* Oxford: Oxford University Press, 1979.

Thomson, David. *The New Biographical Dictionary of Film.* New York: Morrow, 2002.

Tornow, Ingo. *Erich Kästner und der Film.* Munich: DTV, 1998.

Triana-Toribio, Nuria. *Spanish National Cinema.* London: Routledge, 2003.

Trumpener, Katie. "*La Guerre est Finie:* New Waves, Historical Contingencies, and the GDR 'Rabbit Films.'" *The Power of Intellectuals in Contemporary Germany.* Ed. Michael Geyer. Chicago: University of Chicago Press, 2001. 113–37.

Uhlenbrok, Katja, ed. *MusikSpektakelFilm: Musiktheater und Tanzkultur im deutschen Film.* Munich: Edition Text und Kritik, 1998.

Vennum, Thomas. *The Ojibway Dance Drum: Its History and Construction.* Washington, DC: Smithsonian Institution, 1982.

von Moltke, Johannes. "*Heimat* and History: *Viehjud Levi.*" *New German Critique* 87 (Fall 2002): 83–106.

———. *No Place Like Home: Locations of Heimat in German Cinema.* Berkeley and Los Angeles: University of California Press, 2005.

———. "Trapped in America: The Americanization of the Trapp-Familie." *German Studies Review* 19.3 (1996): 455–78.

Wayne, Mike. *Political Film: The Dialectics of Third Cinema.* London: Pluto Press, 2001.

Welsch, Wolfgang. "Modernity and Postmodernity in Post-War Germany (1945–1995)." *Culture in the Federal Republic of Germany, 1945–1996.* Ed. Reiner Pommerin. Oxford: Berg, 1996. 109–32.

White, James Boyd. "Is Cultural Criticism Possible?" *Michigan Law Review* 84 (1986): 1373–87.

———. "Telling Stories in the Law and in Ordinary Life: The *Oresteia* and 'Noon Wine.'" *Heracles' Bow: Essays on the Rhetoric and Poetics of the Law.* Madison: University of Wisconsin Press, 1985. 168–91.

Wiebrecht, Ulrike. *Blauer Engel aus Berlin: Marlene Dietrich.* Berlin: be.bra, 2001.

Wiedmer, Caroline. *The Claims of Memory. Representations of the Holocaust in Contemporary Germany and France.* Ithaca, NY: Cornell University Press, 1999.

Wildt, Michael. "Privater Konsum in Westdeutschland in den 50er Jahren." *Modernisierung im Wiederaufbau: Die westdeutsche Gesellschaft der 50er Jahre.* Ed. Alex Schildt and Arnold Sywottek. Bonn: Dietz, 1998. 275–89.

Willemen, Paul. "The National." *Fields of Vision: Essays in Film Studies, Visual Anthropology, and Photography.* Ed. Leslie Devereaux and Roger Hillman. Berkeley and Los Angeles: University of California Press, 1995. 21–34.

Willemen, Paul, and Jim Pines. *Questions of Third Cinema.* London: British Film Institute, 1989.

Williams, Raymond. "Base and Superstructure in Marxist Cultural Theory." *New Left Review* 82 (1973): 3–16.

Witte, Karsten. "Gehemmte Schaulust. Momente des deutschen Revuefilms." *Wir tanzen um die Welt: Deutsche Revuefilme 1933–1945.* Ed. Helga Belach. Munich: Hanser, 1979. 7–52.

Wolf, Christa. *Lesen und Schreiben.* Berlin: Luchterhand, 1980.

Young, James E. *At Memory's Edge: After-Images of the Holocaust in Contemporary Art and Architecture.* New Haven: Yale University Press, 2000.

Zantop, Susanne. *Colonial Fantasies: Conquest, Family, and Nation in Precolonial Germany, 1770–1870.* Durham: Duke University Press, 1997.

Zhang, Yingjin. *Chinese National Cinema.* New York: Routledge, 2004.

Žižek, Slavoj. *Did Somebody Say Totalitarianism.* New York, Verso, 2001.

———. "Enjoy Your Nation as Yourself." *Austrian Contribution to the 45th Biennale of Venice 1993.* Vienna: REMAprint, 1993. 303–32.

———. *The Fragile Absolute—or, Why Is the Christian Legacy Worth Fighting For?* London: Verso, 2000.

Zolotow, Maurice. *Billy Wilder in Hollywood.* New York: Limelight, 1987.

Contributors

Nora M. Alter is Professor of German, Film and Media Studies at the University of Florida. She is affiliate faculty in the programs in European Studies, Jewish Studies, and Woman and Gender Studies. Her teaching and research have been focused on twentieth-century cultural and visual studies from a comparative perspective. She is author of *Vietnam Protest Theatre: The Television War on Stage* (1996), *Projecting History: Non-Fiction German Film* (2002), *Chris Marker* (2006) and coeditor with Lutz Koepnick of *Sound Matters: Essays on the Acoustics of Modern German Culture* (2004). She has published numerous essays on German and European studies, film and media studies, cultural and visual studies and contemporary art. In 2005 she was awarded the DAAD Prize for Distinguished Scholarship in German and European Studies and the Florida Blue Key Distinguished Faculty Award. She is currently completing a new book on the international essay film.

Hester Baer is Assistant Professor of German at the University of Oklahoma, where she is also on the faculty of the Film and Video Studies and Women's Studies programs. She has published on various aspects of German cinema and film culture in the 1950s and 1960s. She is currently completing a book manuscript, *Dismantling the Dream Factory: Gender, German Cinema, and the Postwar Quest for a New Film Language.*

John E. Davidson is Associate Professor of Germanic Languages and Literatures and Director of Film Studies at The Ohio State University, where he teaches film, literature, and cultural theory. He is author of *Deterritorializing the New German Cinema* (1999) and serves on the editorial board for *Studies in European Cinema*. He is currently at work on a book entitled *Mobilizing Labor in German Film*, and a collection of essays on the politics of cinematic space in the New German Cinema and beyond.

Caryl Flinn is the author of *The New German Cinema: Music, History, and the Matter of Style* (2004); *Strains of Utopia: Gender, Nostalgia, and Hollywood Film Music* (1992); and the forthcoming *Life and Legends of Ethel Merman*. She is coeditor of *Music and Cinema* (2000) and a special issue of the Canadian journal *Arachne* on gender and contemporary German film. Her articles appear in a wide array of scholarly journals and anthologies. Flinn is currently Professor of Women's Studies at the University of Arizona (Tucson), where she also teaches in the Department of Media Arts.

Lilian Friedberg is a percussionist, translator, and independent scholar (Ph.D., Germanic Studies) whose work has appeared in *German Quarterly, New German Critique,* and *Monatshefte.* She is the coeditor, with Sander Gilman, of *A Jew in the New Germany: Selected Writings of Henryk Broder* (2003). Her translations of Ingeborg Bachmann (*Last Living Words: The Ingeborg Bachmann Reader,* 2005) received the Kayden National Translation Award, and she is currently commissioned as translator for several works by Elfriede Jelinek.

Gerd Gemünden is the Ted and Helen Geisel Third Century Professor in the Humanities at Dartmouth College. He is the author of *Framed Visions: Popular Culture, Americanization, and the Contemporary German and Austrian Imagination* (1998) and *Filmemacher mit Akzent: Billy Wilder in Hollywood* (2006). His volumes as editor include *Wim Wenders: Einstellungen* (1993); *The Cinema of Wim Wenders* (1997); *Germans and Indians: Fantasies, Encounters, Projections* (2002); as well as special issues of *New German Critique* on the director Rainer Werner Fassbinder and Film and Exile. A volume on Marlene Dietrich, coedited with Mary Desjardins, will be published in 2007.

Sabine Hake is the Texas Chair of German Literature and Culture in the Department of Germanic Studies at the University of Texas at Austin. She is the author of *German National Cinema* (2002, published in German in 2004 as *Film in Deutschland: Geschichte und Geschichten ab 1895*); *Popular Cinema of the Third Reich* (2001); *The Cinema's Third Machine: German Writings on Film, 1907–1933* (1993); *Passions and Deceptions: The Early Films of Ernst Lubitsch* (1992); as well as numerous articles on German film and Weimar culture. Her current book project deals with urban architecture and mass utopia in Weimar Berlin.

Sara Hall is Assistant Professor of Germanic Studies at the University of Illinois at Chicago, where she teaches courses in German language and culture and film studies. Her articles on film, gender and moder-

nity, and the culture of law enforcement have appeared in *German Quarterly, Österreichische Zeitschrift für Geschichtswissenschaften,* and various scholarly volumes. She is currently completing a book on film and the police in Weimar Germany.

Gertrud Koch is Professor of Film Studies at the Freie Universität Berlin. Her publications include *Herbert Marcuse zur Einführung* (together with Hauke Brunkhorst, 1987); *"Was ich erbeute, sind Bilder". Zur filmischen Repräsentation der Geschlechterdifferenz* (1988); *Die Einstellung ist die Einstellung. Zur visuellen Konstruktion des Judentums* (1992); and *Siegfried Kracauer zur Einführung* (1996). She is the editor and coeditor of *Auge und Affekt. Wahrnehmung und Interaktion* (1995); *Bruchlinien—Zur Holocaustforschung* (1999); *Kunst als Strafe* (2003); and *Zwischen Zeichen und Ding* (2005).

Lutz Koepnick is Professor of German, Film and Media Studies at Washington University in St. Louis. He is the author of *Framing Attention: Windows on Modern German Culture* (2007); *The Dark Mirror: German Cinema between Hitler and Hollywood* (2002); *Walter Benjamin and the Aesthetics of Power* (1999); and *Nothungs Modernität: Wagners Ring und die Poesie der Politik im neunzehnten Jahrhundert* (1994). Koepnick is the coauthor of *[Grid < > Matrix] / Screen Arts and New Media Aesthetics I* (2006) and the coeditor of *Sound Matters: Essays on the Acoustics of German Culture* (2004), and *Caught by Politics: Hitler Exiles and American Visual Culture* (2007).

Alice A. Kuzniar is a Professor of German and Comparative Literature at the University of North Carolina at Chapel Hill. Her first book, *Delayed Endings: Nonclosure in Novalis and Hölderlin* (1987) was the winner of the South Atlantic Modern Languages Association Award. She has also edited *Outing Goethe and His Age* (1996), while her most recent books are *The Queer German Cinema* (2000) and *Melancholia's Dog: Reflections on Our Animal Kinship* (2006).

Joseph Loewenstein, Professor of English at Washington University in St. Louis, is a specialist in Renaissance literature. An editor of the *Oxford Collected Works of Edmund Spenser,* he is most recently the author of *The Authors Due: Printing and the Prehistory of Copyright* (2002) and of *Ben Jonson and Possessive Authorship* (2002). Lynne Tatlock and he have written together on Heinrich von Kleist, and on Marlene Dietrich and German-American film relations.

Hanno Loewy established the Fritz Bauer Institute—Study and Documentary Centre on the History and Impact of the Holocaust in

Frankfurt am Main, functioning as the director between 1995 and 2000. Since January 2004 he has been the director of the Jewish Museum Hohenems in Austria. He is working on a major study on Holocaust, genre, and fiction in film and is a visiting fellow at the University of Konstanz for film theory. He curated several exhibitions on Jewish history, the Holocaust, and Palestine. His publications include *Before They Perished: Photographies Found in Auschwitz* (ed. together with Kersten Brandt and Krystyna Oleksy, 2001); *Béla Balázs. Märchen, Ritual und Film* (2003); *Taxi nach Auschwitz* (2002); and *Lachen über Hitler—Auschwitz-Gelächter? Filmkomödie, Satire und Holocaust* (ed. together with Margrit Frölich and Heinz Steinert, 2003).

Fatima Naqvi is Assistant Professor of German at Rutgers University. Her research has focused largely on twentieth-century Austrian literature and film. She has written on Thomas Bernhard, Elfriede Jelinek, Michael Haneke, Ingeborg Bachmann, Christoph Ransmayr, and Rainer Maria Rilke. Her current work, *The Literary and Cultural Rhetoric of Victimhood: Western Europe 1970–2005* (2007), explores the cultural construction of victimhood in western Europe at the end of the twentieth century (Peter Sloterdijk, René Girard, Friederike Mayröcker, Michel Houellebecq, Giorgio Agamben, etc.).

Eric Rentschler is the Arthur Kingsley Porter Professor of Germanic Languages and Literatures at Harvard University. He received his academic training in European literary, cultural, and intellectual history, studying in Stuttgart, Bonn, and Prague, before taking his doctoral degree at the University of Washington. His publications have concentrated on film history, theory, and criticism, with particular emphasis on German cinema during the Weimar Republic, the Third Reich, and the postwar and the postwall eras. His books include *West German Film in the Course of Time* (1984); *German Film and Literature* (1986); *West German Filmmakers on Film* (1988); *Augenzeugen* (1988); *The Films of G.W. Pabst* (1990); and *The Ministry of Illusion* (1996). He is currently finishing two books: *Courses in Time: Film in the Federal Republic of Germany, 1962–1989* and *The Continuing Allure of Nazi Attractions*.

Stephan K. Schindler is Professor of German, Comparative Literature, and Film Studies at Washington University in St. Louis. He is the author of *Das Kind als Subjekt. Die Erfindung der Kindheit im Roman des 18. Jahrhunderts* (1994) and *Eingebildete Körper: Phantasierte Sexualität in der Goethezeit* (2001). He is the coeditor of *Knowledge, Sci-*

ence and Literature in the Early Modern Period (1996) and the yearbook *Gegenwartsliteratur* (2002–). His current work explores representations of the Holocaust in film.

Lynne Tatlock, Hortense and Tobias Lewin Distinguished Professor in the Humanities at Washington University in St. Louis, has published widely on German literature and culture from 1650 to the 1990s. Her recent work investigates questions of gender, literature and medicine, nineteenth-century regionalism and nationalism, and literature, history, and politics. Recent publications include a translation of Justine Siegemund's *The Court Midwife* (2005) and a coedited volume, *German Culture in Nineteenth-Century America: Reception, Adaptation, Transformation* (2005).

Johannes von Moltke is Associate Professor in the Departments of German, Dutch and Scandinavian Studies and of Screen Arts and Cultures at the University of Michigan. He is the author of *No Place Like Home: Locations of Heimat in German Cinema* (2005) and numerous articles on German cinema and popular culture. He is currently serving as coeditor for *Germanic Review* and is preparing a manuscript on the relationship between film, history, and emotion.

Index

Note: Page numbers in italic refer to illustrations.